The Next Step

EXPONENTIAL LIFE

A recent study by the Rockefeller University of New York, carried out by Professor Alipasha Vaziri, has discovered that the human eye is capable of detecting flashes of light consisting of a single photon.

Preface

The Next Step: Exponential Life is already the ninth in BBVA's annual collection of books dedicated to the analysis and transmission of knowledge regarding the fundamental questions of our time.

BBVA launched this collection of books in 2008, coinciding with the first edition of the Frontiers of Knowledge Prizes awarded by the Fundación BBVA. The enthusiasm generated by the first books in this series led us to create OpenMind (www.bbvaopenmind.com), an online community designed to generate and spread knowledge for the benefit of society. Ultimately, the broad spectrum of subjects covered by OpenMind—including science, technology, economics, the environment, and the humanities—reflects a commitment to help people understand the main phenomena affecting our lives and shaping our future.

Besides our annual books, OpenMind publishes articles, posts, reports, and audiovisual material, including computer graphics and videos, in Spanish and English—all absolutely free.

Over two hundred authors and collaborators involved in research, artistic creation, and communication take part in the OpenMind initiative. Moreover, its users can also participate—sharing their ideas, reflections, and concerns. In 2016 alone, two-and-a-half million web users and almost one hundred thousand OpenMind social-network followers are bringing life to the OpenMind community with their participation.

In our previous books we addressed topics such as the frontiers of science, globalization, innovation, our time's ethical questions, and how technology is changing our work and lifestyles. Last year's book focused on the European integration project, which is currently at a critical stage that must be successfully completed, not only for the future of citizens of the EU member nations, but also for the consolidation of a more prosperous and stable global environment.

This year, we return to the theme that may well constitute OpenMind's backbone: scientific progress and its technological applications as motors for change in the human species.

The Next Step: Exponential Life presents a necessarily partial and schematic view of the potential of what are known as "exponential technologies," considering their economic, social, environmental, ethical, and even ontological implications.

This book's fundamental idea is that humanity is at the beginning of a technological revolution that is evolving at a much faster pace than earlier ones, and that is so far reaching it is destined to generate transformations we can only begin to imagine.

Emerging technologies will change what have seemed to be the fundamental constants of human nature: in fact, they already are and, as a result, it now seems possible to drastically improve human memory, cognitive processes, and physical and intellectual capacities—even to the extent of extending our life expectancy to such a degree that it may actually change our concept of mortality. The possibilities are enormous, but the questions they raise for humankind are equally significant.

Once again, we have had the good fortune to count on some twenty world-class authors, all leading figures in their respective fields, and I would like to thank every one of them for their magnificent contributions to this book and their support for our project.

Recent advances and developmental prospects in the biosciences, genetics and robotics, artificial intelligence, and the construction of the world wide web of interconnected sensors, which has come to be known as the "Internet of Things," are this book's opening subjects, but their perspective is not limited to the scientific-technological setting; it extends to other approaches to generating and transmitting knowledge, including art and the communications media.

Subsequent articles address the implications of this development. Scientific and technological advances offer incredible possibilities for increasing income and well-being, but they also imply enormous risks that run the gamut from burgeoning unemployment and inequality, or untenable pressures on social protection systems, to catastrophic threats to our planet or to human survival.

And yet, this same technology offers new and better possibilities for dealing with these risks. Applying scientific and technological development to the effective improvement of living conditions for everyone, including sustainability, calls for updating the ethical schemes that help us to act in a responsible way in surroundings that are different from any we have ever known before and that continue to change at a very rapid rate. These surroundings will offer absolutely new perspectives for the human species, including a move towards a "post-human era" in which people, with enormously augmented capacities, will coexist with "artificial intelligences" that surpass human intelligence and will be able to reproduce autonomously, generating even more intelligent offspring—a situation known as "the singularity." Another possibility that is increasingly close to hand is the expansion of human, or post-human, life beyond our planet, as well as contact with other intelligences in different parts of the universe.

Francisco González
BBVA Group Executive Chairman

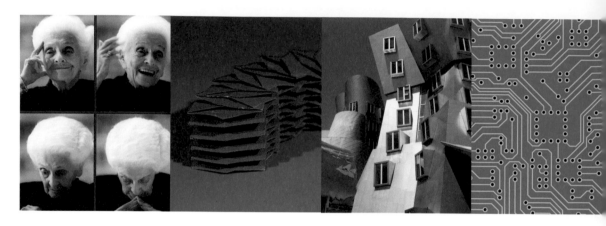

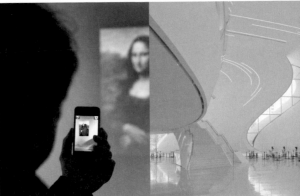

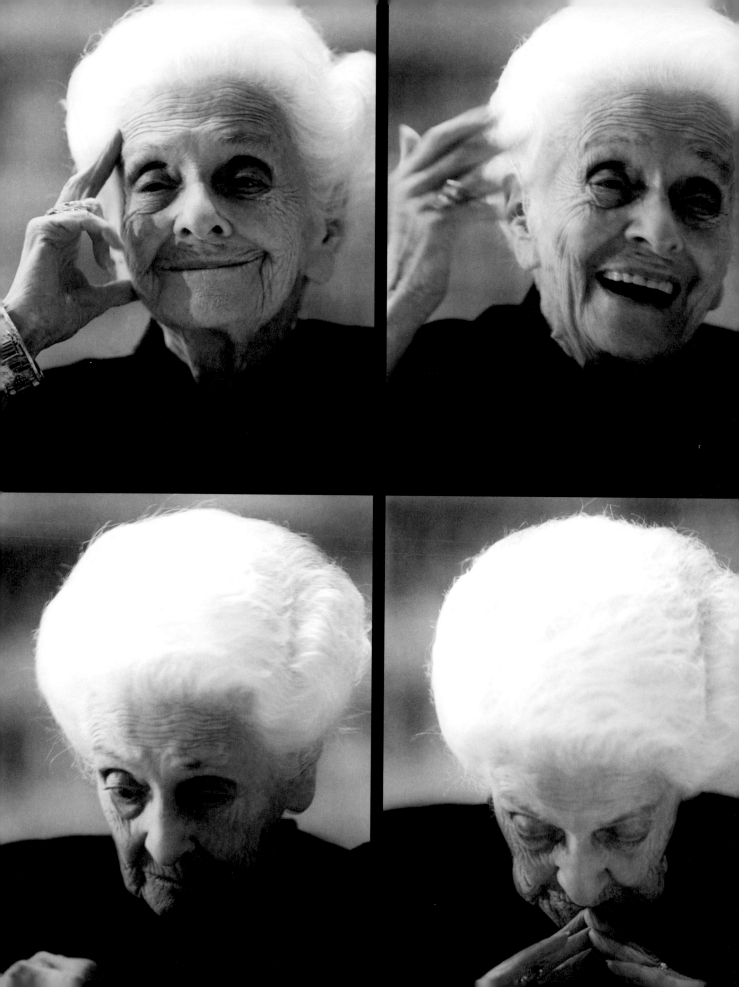

Undoing Aging with Molecular and Cellular and Cellular Damage Repair

AUBREY D. N. J. DE GREY

Opening image:
Multiple portraits of the long-lived Italian
neurologist and 1986 Noble Prizewinner
for Medicine, Rita Levi Montalcini
(1902–2012) (c. 2000).

Aubrey D. N. J. de Grey
SENS Research Foundation, Mountain View, CA, USA

Dr. Aubrey de Grey is a biomedical gerontologist based in Cambridge,
UK, and Mountain View, California, USA, and is the Chief Science Officer
of SENS Research Foundation, a California-based 501(c)(3) biomedical
research charity that performs and funds laboratory research dedicated
to combating the aging process. He is also Editor-in-Chief of *Rejuvenation
Research*, the world's highest-impact, peer-reviewed journal focused on
intervention in aging. He is a Fellow of both the Gerontological Society
of America and the American Aging Association, and sits on the editorial
and scientific advisory boards of numerous journals and organizations.

Since the dawn of medicine, aging has been doctors' foremost challenge. Three unsuccessful approaches to conquering it have failed: treating components of age-related ill health as curable diseases, extrapolating from differences between species in the rate of aging, and emulating the life extension that famine elicits in short-lived species. SENS Research Foundation is spearheading the fourth age of anti-aging research: the repair of age-related damage, that is, rejuvenation biotechnology. What follows is an outline of the divide-and-conquer approach to restoring the body's molecular and cellular structure to that of a young adult, and thereby greatly postponing all aspects of age-related disease and disability.

BACKGROUND: WHY IS AGING STILL RESISTING MEDICAL INTERVENTION?

The goal of bringing aging under comprehensive medical control is probably humanity's oldest dream—and it is certainly humanity's foremost problem today. However, our progress toward it is lamentably slight. The history of our attempts to control aging can be summarized as a sequence of mis-steps: of misguided and (in hindsight, anyway) mistaken approaches that never had a chance of succeeding. They can each be summarized in a single word: disease, design, and deprivation. And the worst of it is that they have not even been sequential: the earlier ones have survived the arrival of the later ones.

The "aging as disease" false dawn, otherwise known as geriatric medicine, rests on the assumption that the diseases of old age are inherently amenable to the same kind of medical assault as the most prevalent diseases of youth, that is, infections. It arises from the observation that different people get different diseases in old age, just as different people get different infections, and the inference that the same kind of strategy against the latter will work against the former—which means, attacking the symptoms of the disease. How crazy is that, when the ailments of old age are consequences of the accumulation of self-inflicted damage in the body, while infections are from elsewhere and can therefore be banished entirely? But that has not stopped, and still does not stop, humanity from expending billions upon billions of dollars on research aimed at achieving this patently quixotic goal. Man rightly prefers it to be true, and evidently also prefers to believe, that these diseases are "curable"— and no amount of logic seems to be able to change that.

The "aging as design" false dawn emerged a century or so ago, perhaps partly as a result of a few people's recognition of the above argument. It began with August Weismann's proposal that aging serves an evolutionary purpose—a seductive idea that survived in its initial form for several decades despite being inherently circular (essentially, Weissman was saying that aging is selected because it exists, as well as the other way around), and still survives among a minority of the field in a more sophisticated form (typically couched in terms of evolutionary nimbleness, or "evolvability"). But that has not been its main legacy. Rather, it gave rise in the early twentieth century to an approach that does not rely on the idea that there exist genes whose selected function is to hasten the organism's decline in function, but instead on the idea that the genes determining the variation between species (and the lesser, but still non-negligible, variation between individuals of the same species) are rather few in number, and thus that it is realistic to seek to tweak those of a given species (such as *Homo sapiens*) so as to extend its healthy lifespan. It is easy to see how the latter idea is inspired by the former, but unfortunately it is not *reliant* on the former (because it can equally hold if the genes in question are anti-aging genes rather than pro-aging ones), and therefore its rejection by most gerontologists did not follow from that of "programmed aging."

Again, though, we must ask the key question: does the "aging as design" basis for the pursuit of medical postponement of age-related ill health actually make sense? Is it even remotely compatible with what we know about aging? And again, the painfully obvious answer is no. Precisely for the same reasons that we know aging is not programmed, we also know that it is inherently chaotic and multifactorial. Different types of damage are created by different mechanisms, and different genetic pathways are devoted to slowing those mechanisms and thereby postponing the age at which the corresponding type of damage reaches pathogenic abundance. And, since selective pressure is imposed upon those pathways by a common mechanism, namely the relationship between an individual's function and its ability to contribute to the next generation, they are inexorably destined (except in special cases that I have discussed under the phenomenon of "protagonistic pleiotropy") to gravitate to levels of efficacy that result in the corresponding pathologies emerging at about the same age. Thus, there is no possibility whatsoever that substantial slowing of the accumulation of all of these types of damage could be simultaneously effected by the tweaking of a small number of genes. And yet, just as with geriatric medicine, faith in the existence of some elusive "magic bullet" has persisted in the minds of a depressing number of biologists.

But is it that bad? Do biologists whose main area is the biology of aging think this way? Not entirely. For sure, many biogerontologists select their research direction in a manner suggestive of such an error, but we must remember that (as in any field of science) most researchers are driven by curiosity rather than by translational potential, and I would be the last to suggest that curiosity driven research is worthless. So I do not condemn those researchers in the way that I condemn geriatrics. And the biogerontologists who *do* think substantially in terms of translational potential came, by and large, to recognize the above logic quite well by the 1960s or so.

So far so good—in a way. During the 1970s and 1980s, there was a depressing downside to this, namely that almost all translationally motivated gerontologists responded to this realization by becoming the other sort of gerontologist, the curiosity driven type, to such an

extent that it became impossible even to entertain (publicly, or in grant applications, etc.) the possibility of eventual postponement of aging without fatally damaging one's fundability. But at least they were being realistic.

Until... the third false dawn. By "deprivation" I refer, as I hope you have guessed, to calorie restriction (CR), an intervention that was shown as early as the 1930s to extend the lives of mice and rats by as much as fifty percent. It had also been shown to have a proportionally (and anatomically) much more dramatic effect in nematodes, which enter a radically different developmental pathway when starved at a particular stage in their growth. In hindsight it is therefore curious that, given these well-known facts, the biogerontology community was at first highly skeptical of and then highly energized by reports in the late 1980s and early 1990s that the same effect, with only slightly lesser magnitude, could be achieved in nematodes by genetic means. But whatever the history, the fact is that "energized" is a decided understatement.

To this day, biomedical gerontology research is hugely dominated by the quest for better ways to emulate the effect of calorie restriction by genetic—or, more recently, pharmacological—means.

Why is this a third false dawn? Because its true biomedical potential is, and has long been, obviously almost nil. The reason this is so obvious arises from the combination of two points. First, virtually without exception (and the one "known" exception is in fact probably incorrect, though worthy of further investigation), no genetic or pharmacological intervention in any species has ever exceeded the performance of CR itself in the same species when initiated at the same age—which is exactly what everyone should have expected, since the life extension conferred by CR and by its emulation must be mediated by the same genetic pathways, pathways whose effect just is what it is. And second, that performance of CR itself varies inversely with the non-CR longevity of the species: longer-lived species derive much less benefit as a proportion of their lifespan, and in fact not much more benefit in absolute time. This too should have been expected, since the selective pressure giving rise to the pathways that mediate the response to CR arises from the frequency of famines, which is independent of the lifespan of

the organisms experiencing those famines. Since long famines are rarer than short ones, the prediction is clear. And adding this all up, the conclusion is equally clear: emulation of CR will not significantly postpone human aging.

But would you know this from a perusal of the grant applications currently funded by the US National Institute on Aging, or its counterparts worldwide? Not as such. If we exclude, as discussed above, the grants whose focus is purely to extend our understanding of aging rather than to do anything about it, the overwhelming majority concern one or another approach to emulating CR. Just as with the other false dawns, this concept is clung to in the face of the utterly iron-clad logic to the contrary, simply because its proponents have sunk so much cost in terms of intellectual investment in it that their only route to self-preservation is to keep on approving each other's grant applications.

THE FOURTH WAY: DAMAGE REPAIR

But this century, step by painfully small step, things are changing. In the remainder of this essay, I shall describe the progress that has so far occurred in implementing the approach to combating aging that I first introduced about fifteen years ago, under the name "Strategies for Engineered Negligible Senescence" (SENS). Much of this progress has occurred under the leadership of the biomedical research charity created for that purpose, SENS Research Foundation.

It may seem curious that a charity dedicated, in part, to improving public awareness employs as its name a phrase as technical as this. Indeed, we have recently introduced the more lay-friendly term "rejuvenation biotechnology" to encompass the technologies required to implement SENS. "Rejuvenation," however, is not an obviously quantifiable concept, and the original phrase remains the most accurate description of our goal.

"Senescence," here, refers to the actuarial phenomenon—the trend that individuals within a population suffer from an increasing morbidity and mortality rate in (typically exponential) relation to their chronological age.

"Negligible" is used in a statistical sense: we consider a level of senescence negligible if no age-related contribution to mortality is statistically demonstrable within a population, given the "background noise" of age-independent mortality (such as unfortunate encounters with

motor vehicles). We accept that this represents a moving target; a non-negligible level of senescence might be observed in the same population after improvements in available data or analytical methods, requiring further iterations of the therapeutic platform. In fact, several such cycles seem likely.

Finally, by "Engineered," we indicate that this state is achieved by the deliberate application of biomedical therapies, and is not the normal situation (as observed in, for example, *Hydra*, where continual regeneration appears to result in a lack of any correlation between age and mortality rate—although the indefinite maintenance of reproductive potential is more controversial).

Our goal is thus unambiguously defined; we seek methods to convert a population experiencing a non-negligible level of senescence into one experiencing a negligible level.

To most readers, this goal—the comprehensive elimination of age-related degeneration—will at first seem outlandish. Certainly such an accomplishment has been an aspiration of humanity for at least the whole of recorded history, with little result. However, there are good reasons to think that it could be more easily achievable than "just" slowing the process of aging such that the age-related increase in mortality is reduced and the average lifespan modestly extended. In this essay, I outline those reasons.

To see how the goal of negligible senescence could be "engineered," it is useful to consider a situation in which human ingenuity and perseverance has already achieved an analogous result. Motor vehicles experience a process of wear-and-tear essentially similar to organismal aging; the paint flakes, windowpanes chip, rust infiltrates the pipework, and so forth. Nonetheless, as vintage car owners will attest, it is entirely possible to keep one functional and even pristine for an essentially indefinite period.

Critically, this is achieved not by preventing the wear—we can see, instinctively, that doing so perfectly is impossible— but by repairing the damage that does occur at a rate sufficient to ensure that the function of the machine is never irretrievably compromised.

"Man is a chemical compound and old age is the result of self-poisoning."

PARACELSUS (1493–1541)
Swiss alchemist, physician and astrologist.

Youth (2015), Paolo Sorrentino.

Of course, the analogy is inexact; human bodies are far more complex than cars, and we are still a long way from understanding how they are constructed and the processes that contribute to wearing them down. Fortunately, a closer look at precisely how growing older leads to debility reveals that our ignorance need not be showstopping.

Aging can be characterized as a three-stage process. In the first stage, metabolic processes essential to life produce toxins—an unavoidable side effect of handling reactive chemicals. Secondly, a small amount of the damage caused by these toxins cannot be removed by the body's endogenous repair systems, and consequently accumulates over time. In the third stage, the accumulation of damage drives age-related pathology, either directly—by interfering with normal metabolism—or indirectly, often where a normally benevolent repair process causes collateral damage due to maladaptive overstimulation.

This model ("metabolism causes damage causes pathology") allows us to clarify, considerably, the requirements for successful intervention in aging. Unlike the dynamic processes of metabolism and pathology—which we understand so poorly, and where a single intervention invariably triggers a cascade of knock-on effects—accumulated damage represents a relatively stationary target. That is to say, it may not be clear whether a given type of damage is pathological (on balance), but its absence from healthy twenty-year-olds indicates that it is not required for healthy life. Conversely it is clear that the total ensemble of types of damage *is* pathological, since fifty-year-olds have considerably less time to live than twenty-year-olds, and the only static difference between the two groups is the amount of accumulated damage present. (There are dynamic differences, where the body reacts maladaptively to the presence of damage, but the profoundly homeostatic nature of physiology gives us confidence that this will self-correct once the stimulus for the maladaptive response is removed.)

Accepting the implications of this model (which replicates aging-induced mortality curves reassuringly well) leads us to the SENS approach; by identifying and repairing all of the damage accumulated during aging, we can restore the body to a youthful state. Consequently, its dynamic metabolic processes will revert to their own norms, and the risk of mortality will be no higher than in any other equivalently "youthful" individual—whether they have actually lived for twenty years or 120. Furthermore—so long as our inventory of damage classes is sufficiently comprehensive—we can repeat this effort on a regular basis, and thus remain *indefinitely* below the threshold of pathology. Crucially, we can do this without a comprehensive understanding of the complex metabolic processes giving rise to damage, nor of those leading from damage to pathology. We need only an inventory of the types of damage which exist, which can be obtained directly by comparison of older and younger individuals.

WHAT IS THE DAMAGE OF AGING?

Fortunately, it seems that all aging-related damage known to accumulate in the human body can be classified into just seven clearly defined categories. For each category, the SENS platform incorporates a mechanism for repairing the damage, using either existing biotechnology or readily foreseeable extensions thereof. I now briefly summarize these categories, and the associated therapeutic options for their resolution.

Cell Loss

The most straightforward damage category is the loss (death without replacement) of cells, either as a result of chronic injury or acute trauma, mediated by apoptosis, by autophagic cell death, and/or by necrosis. Such losses lead to tissue atrophy, compromising the function of the organs involved; examples include Parkinson's disease, sarcopenia, autoimmune diabetes, and presbycusis. Therapy involves the introduction of stem or progenitor cells (and/or stimulation of the proliferation of endogenous progenitors), either systemically with the assistance of appropriate targeting mechanisms, or locally via a tissue-engineered construct.

Cell Death-Resistance

Conversely, the accumulation of excessive numbers of cells refractory to normal homeostatic apoptosis can also be harmful. The most obvious example in the context of Western societies is obesity, but there are more subtle manifestations—the imbalance between anergic and naïve T-lymphocytes that characterizes immunosenescence being a prime example. Treatment is in this case conceptually straightforward; identify biomarkers that selectively target the undesirable cells, and deliver cytotoxic drugs or viruses to ensure their destruction.

Cell Over-Proliferation

The last (but definitely not least) "cellular" category deals with damage to the genomic DNA, in the form both of mutation (changes to the base-pair sequence) and epimutation (changes to the moieties that decorate the DNA molecule and influence its transcription). Fortunately, this is one area in which evolution has done most of the hard work for us. Since the emergence of vertebrates (at least), the most serious problem originating from mutation has been cancer, which has the capacity to kill an organism if one single cell acquires enough mutational load—whereas any other mutation can in general become lethal only if it afflicts a substantial proportion of the cells in a given tissue. The proofreading mechanisms evolved to prevent cancer are, as a result, more than sufficient to keep non-cancerous mutations under control. Thus, this strictly molecular category of damage is in fact best treated as a cellular one.

Of course, cancer itself remains a very real issue. The SENS solution—WILT, an acronym for "Whole-body Interdiction of Lengthening of Telomeres"—is the only genuinely universal anti-cancer therapy to have been proposed. WILT is a two-pronged approach that involves the deletion (not merely the inactivation) of the telomerase and ALT (alternative lengthening of telomeres) genes throughout the body, preventing any newly formed cancer from growing large enough to become life-threatening, accompanied by (approximately) decadal re-seeding of our rapidly renewing tissues' stem cell reserves using cells whose telomeres have been lengthened *ex vivo*. As ambitious as this is, WILT's comprehensiveness if it can be implemented is not disputed, so it remains a "therapy of last resort" that we would be unwise to neglect until and unless simpler therapies of comparable efficacy are developed.

The remaining four categories of damage are molecular, rather than cellular: two are intracellular and two extracellular.

Intracellular "Junk"

While cells are generally very efficient in detecting (particularly via the unfolded protein response) and recycling damaged or surplus biomolecules, there are some exceptions—

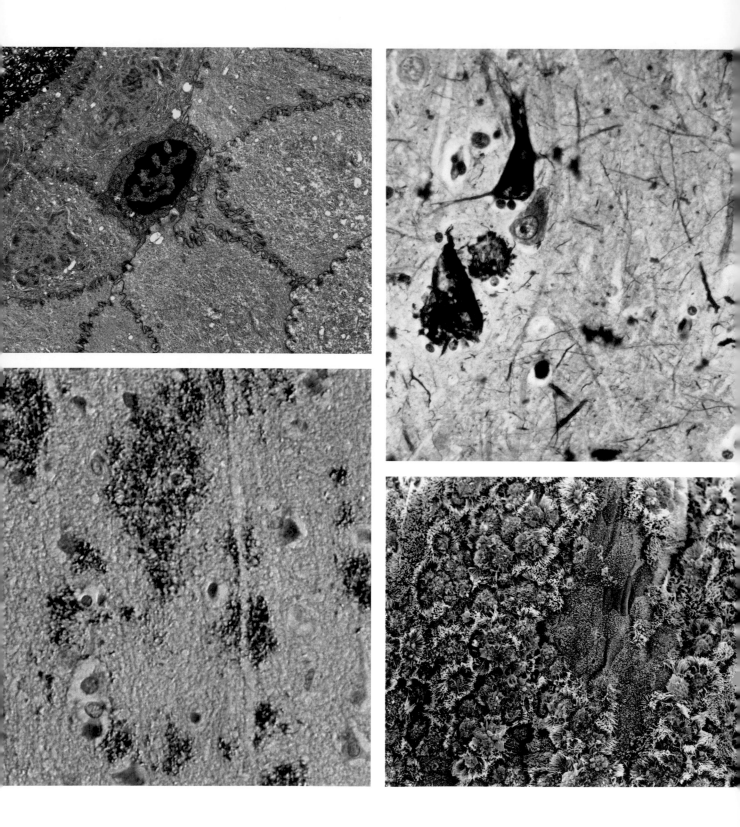

substances which are genuinely refractory to degradation or excretion. The resulting accumulation of "junk" compromises the cell's metabolism—at best impairing its normal function, and at worst leading to cell death. The accumulation of lipoproteins in atherosclerotic plaques and the phototoxicity of A2E that drives dry macular degeneration are two of the best-studied examples of this mechanism, which may be treated by augmenting the native degradation machinery by introducing novel enzymes capable of tackling the most recalcitrant targets. Such enzymes typically need to be introduced into the lysosome, cells' "garbage disposal machinery of last resort."

Extracellular "Junk"

Not all waste products accumulate within the cell; the infamous amyloid plaques of Alzheimer's disease, as well as the amyloids associated with type II diabetes and systemic amyloidosis, accumulate in the extracellular space. Fortunately, the body already possesses an excellent mechanism for removing undesirable substrates from this compartment—the phagocytic cells of the immune system—and thus the elimination of this junk is essentially a problem of developing an effective and safe vaccine. (In a few cases, it may be necessary to apply the principles of the previous category—lysosomal enhancement—to ensure that the immune cells are able to fully degrade the substances they consume.)

Tissue Stiffening

Protein comprises the bulk of the extracellular matrix; in many cases the proteins involved are laid down in early life and then recycled very slowly, if at all, in adulthood. The function of the tissues supported by such proteins—such as the elasticity of the artery wall—is dependent on their maintaining the correct molecular structure. As the years pass that structure becomes progressively compromised, primarily due to crosslinking induced by reactive molecular species, especially a network of reactions initiated by circulating sugars and collectively termed "glycation." In the arteries, this stiffening leads to increasing blood pressure and all its downstream consequences. Fortuitously, such crosslinks are chemically distinct from any that are enzymatically derived, and the therapeutic strategy is thus to develop drugs or enzymes capable of cleaving these crosslinks to restore the original biophysical function.

Mitochondrial Defects

Mitochondrial DNA (mtDNA) is uniquely vulnerable, being in close proximity to an intense source of reactive species (the respiratory chain) while lacking many of the sophisticated repair mechanisms available to nuclear DNA. There is a well-established accumulation of damage to mtDNA associated with aging—linked, as one would expect where such a vital cellular component is involved, to a very broad range of degenerative conditions. However, of the thousand or so protein components of a mature mitochondrion, only thirteen are actually encoded in the mtDNA—the remaining genes having moved over evolutionary time to the nuclear DNA, from where their products are efficiently translocated back to the mitochondrion. The solution in this case is thus not to repair damage to the remaining genes, but rather to introduce translocation-ready variants of them into the nuclear genome—a technique termed allotopic expression—obviating the issue of maintaining the mtDNA itself.

We should emphasize that the above seven-category formulation is descriptive, not prescriptive. However, the fact that no new categories of damage have been discovered since 1982, despite the dramatic progress in bioanalytical techniques since that time, suggests that any other categories accumulate too slowly to have any bearing on health within the contemporary human lifespan.

Since the SENS approach was first proposed in 2002, marked progress has been made in every relevant area of research. For the remainder of this essay, I will highlight a few of the most exciting and recent discoveries, and explain how they contribute to the development of effective rejuvenation biotechnologies.

Why Recycling Will Save More Than Just the Planet

Some of the best recent evidence in favor of a strategy based on the removal of accumulated damage has come from work on autophagy—the process by which cells naturally recycle proteins, lipids, and even whole organelles. In particular, chaperone-mediated autophagy (CMA), a process that mediates the translocation of proteins bearing a specific motif (either inherently, or by virtue of unfolding or post-translational modification) to the lysosome for degradation, has been shown to decrease with age due to reduced availability of the LAMP (lysosome-associated membrane protein)-2A receptor.

Mice engineered with inducible LAMP-2A in the liver (where the aging-related dysfunction of autophagy is well characterized) show markedly reduced levels of oxidized protein accumulation and structural degeneration at twenty-two months, with hepatocyte function closer to that of young (six months) mice than to wild-type littermates. Intriguingly, the transgenic mice also exhibited enhanced rates of macroautophagy and ubiquitin-proteasome function, implying a positive feedback between damage repair systems.

Enhancing the trafficking of damaged biomolecules is, of course, only one way to increase their rate of recycling. In very recent work in mouse models of Alzheimer's disease, up-regulation of the lysosomal protease cathepsin B has been shown to result in rapid and dramatic clearance of $A\beta$(1-42)—followed by substantial recovery of behavioral deficits in multiple tests.

Tools, Borrowed and Found

Promising though approaches founded on the enhancement of existing recycling machinery are, there are some aging-related waste products which appear to be entirely refractory to degradation by the cell's normal lytic enzymes. These targets—including the toxic bisretinoid A2E, some forms of oxidized cholesterol, and others—require a qualitatively different method of removal.

One early insight in the development of the SENS platform was the observation that many such substances, while resistant to degradation by human cells, do not accumulate even in soils greatly enriched in human remains. Therefore, it was reasoned that some organism must exist that was competent to metabolize them. Bacterial species with just such a capacity were indeed rapidly identified, and the process of determining the enzymes involved and adapting them for therapeutic use forms one major branch of the work being undertaken at SENS Foundation's Research Center.

A more recent development in this area was the discovery of catalytic antibodies (those with direct hydrolytic activity against a particular antigen, presumably due to superior affinity for the transition as compared to the ground state) against amyloid-β. Direct immunotherapy against amyloid deposits hit a stumbling block in clinical trials due to the damaging side effects of inflammation in the brain—a problem that is particularly pronounced in patients with advanced disease, and hence high amyloid load. Catalytic immunotherapy, on the other hand, avoids this concern as the hydrolyzed protein is not sequestered in a form prone to generating an immune response. Simultaneously, by virtue of the high specificity of the antibody, the strategy avoids the off-target effects seen with conventional enzyme approaches to amyloid hydrolysis (such as neprilysin).

The mechanism by which therapeutic antibodies of any kind cross the blood-brain barrier is an area of active enquiry. Although penetrance of immunoglobulin class G (IgG) is very poor, IgM and Fab fragments have been shown to cross the barrier much more effectively, and in any case a poorly penetrant but otherwise effective agent might be assisted in entry by manipulating the process of receptor-mediated transport used by substances such as insulin and transferrin.

SENS Foundation is sponsoring a project to determine whether catalytic antibody technology can be effectively applied to cardiac amyloidoses—which affect heart function in as many as twenty-five percent of those over the age of eighty, and appear to be the most common cause of death at the extremes of current human lifespan.

When Nature Does Not Provide

In dealing with recalcitrant waste substances, or crosslinks between matrix proteins, the challenge is generally to identify an enzyme (or small molecule) capable of catalyzing the degradation of a particular species into one more susceptible to the body's native recycling machinery. The gold standard for accomplishing this goal within the pharmaceutical industry is high-throughput screening—testing enormous arrays of candidates in the hope of identifying one or more with the desired activity.

Effective as high-throughput screens can be, they are essentially a biochemical sweepstake. Consequently, it is occasionally argued that types of damage may exist which cannot be cleared simply because the agent required to repair them is absent from all existing chemical libraries—or has never been synthesized at all. Is this a problem for the comprehensiveness of the SENS approach?

While the field is still just in its infancy, the computational design (and optimization by directed evolution) of enzymes able to catalyze an arbitrary reaction by multiple orders of magnitude has recently been shown to be feasible. The applications of this approach in industry—let alone in medicine—are so self-evident that its refinement seems inevitable. Thus, we feel confident that no specific form of chemical damage will be forever irreparable.

Spare Parts and Overnight Hearts

While *in situ* repair at the cellular and molecular level is the most ideal solution to aging-related damage, we do not anticipate that it will always be possible—particularly while rejuvenation biotechnology is in its infancy. In some cases, the damage will be too extensive or heterogeneous for repair to be feasible; in others, the exact molecular nature of the damage may be so unclear as to make a direct attack difficult to formulate.

In such cases, a reasonable interim solution originates from the field of tissue engineering; instead of rejuvenating the existing organ, we would seek to replace it with an entirely new one grown *in vitro*. This concept is hardly new, but has tended to suffer from three major impediments; firstly the problem of achieving adequate vascularization to support the growing tissue; secondly (and particularly where replacement is urgent, as is usually the case) the prolonged periods of proliferative growth necessary to approach the size and function of an adult organ; and thirdly the requirement, when allogeneic cells or tissues are used, for lifelong immunosuppression.

Two new methods for organ synthesis are now showing considerable promise in overcoming these limitations. In the first—decellularization—donor tissue is treated with a detergent and enzyme mixture until the original cells and donor antigens have been stripped away, leaving a vacant, non-immunogenic scaffold. This scaffold is then incubated for several days with patient-derived stem/progenitor cells, which repopulate it and eventually reconstitute normal tissue function. Notably, although the scaffold-preparation step requires weeks, it can be conducted without knowledge of the recipient; only the much briefer repopulation stage is patient-specific. Thus far demonstrated in the successful transplantation of a large

Undoing Aging with Molecular and Cellular Damage Repair Aubrey D. N. J. de Grey

tracheal graft, this technique seems certain to become more widely employed in the near future.

The second novel technique is bioprinting—the preparation of a graft of almost any desired shape by depositing cells in a manner similar to the operation of an inkjet printer. Bioprinting eliminates the need for a donor scaffold, and thus should eventually prove more practical in general use. Although it is at a very early stage in terms of therapeutic application, the prospect of a relatively unlimited supply of highly similar organs, ideal for drug safety trials, is driving substantial preclinical investment.

An Ounce of Prevention

We have already introduced the concept of allotopic expression—transferring the remaining thirteen protein-coding genes of the mtDNA to the nuclear genome, where they will benefit from its superior maintenance mechanisms and isolation from the most dangerous sources of reactive species. Of course, the rather concise description previously offered glosses over the technical challenges involved.

The proteins in question are among the most hydrophobic of those found in the mitochondria; consequently, once folded after synthesis in the cytoplasm, they are the most difficult to unfold again, a prerequisite for translocation across the inner mitochondrial membrane. When SENS was first proposed, two complementary strategies were put forward to facilitate their import. The first was the substitution of highly hydrophobic amino acid residues with less hydrophobic relatives; the second involved the introduction of self-splicing inteins into the most tightly folded regions, preventing their folding entirely until after translocation. Of course, the former strategy seemed worryingly likely to impair the protein's function (even when point mutations known to be non-pathogenic in isolation were employed), and the second relied on a new and largely untested biotechnology.

In 2006, a French group working on heritable mitochondriopathies demonstrated that by introducing a targeting sequence into the 3' untranslated region of the mRNA for ATP6 (a subunit of ATP synthase, and one of the thirteen mtDNA-encoded proteins) it was possible to localize the mRNA to the mitochondrial surface. The localization achieved is in fact so tight that the import becomes "co-translational"—the amino acid chain is fed through the import machinery as it is synthesized, before folding, obviating the entire issue of its hydrophobicity. The mechanism was subsequently demonstrated to also be effective for the ND1 and ND4 genes. With the blessing of the technique's originators (who are pursuing clinical translation of their original results), staff at the SENS Foundation Research Center are working to confirm that the same methodology can be applied to the ten remaining mtDNA-encoded proteins.

CONCLUSION

SENS is a hugely radical departure from prior themes of biomedical gerontology, involving the bona fide reversal of aging rather than its mere retardation. By virtue of a painstaking process of mutual education between the fields of biogerontology and regenerative medicine, it has now risen to the status of an acknowledged viable option for the eventual medical control of aging. I believe that its credibility will continue to rise as the underlying technology of regenerative medicine progresses.

Robotics, Smart Materials, and Their Future Impact for Humans

JONATHAN ROSSITER

Opening image:
From shipping and construction to outer space, origami can put a folded twist on structural engineering. This origami structure is composed of twelve interlocking tubes that can fold flat for easy transportation.

Jonathan Rossiter
University of Bristol, Bristol, UK
Engineering and Physical Sciences Research Council (EPSRC), Swindon, UK

Jonathan Rossiter is Professor of Robotics at the University of Bristol and EPSRC Research Fellow. He is founder and head of the Soft Robotics Group at Bristol Robotics Laboratory. He was previously Royal Society and JSPS Research Fellow. He has been awarded over £17 million in research funding and has published over 130 peer-reviewed articles, patents and commercial licensing. His research interest centers on future robotics, and especially the emerging fields of soft robotics and smart materials. He has developed new technologies including biodegradable robots, natural affective touch, camouflage smart skins, shape-fixing composites, and multi-degree-of-freedom soft actuators. By developing such new technologies Jonathan Rossiter is working toward truly ubiquitous robotics. Over the next ten to twenty years we will see robotics become a core part of almost all parts of our lives, encompassing how we live, how we work, how we relax and how we maintain our health.

What is a robot? What is a smart material? How can these two have so much impact on our future lives? In this article we will examine the true potential of robotics, and soft-smart robotics in particular. These technologies are set to turn our perceptions of what a robot is, and how it can help us and the world we live in, upside down. Instead of thinking of robots as large, rigid, and resilient machines, we can view future robots as artificial robotic organisms that have properties mimicking, and greatly extending, the capabilities of natural organisms. The unique properties of softness and compliance make these machines highly suited to interactions with delicate things, including the human body. In addition, we will touch upon concepts in emerging robotics that have not been considered, including their biodegradability and regenerative energy transduction. How these new technologies will ultimately drive robotics and the exact form of future robots is unknown, but here we can at least glimpse the future impact of robotics for humans.

INTRODUCTION

The nineteenth century marked the acceleration and wide adoption of industrial processes. At the start of the century the Industrial Revolution was in mid-swing, and by the end we had developed the car and were just about to demonstrate powered flight. The impact on the lives of humans was massive; social and economic rules that governed travel, health care, manufacturing, working environments, and home life were rewritten. In the twentieth century this process was repeated with the Technology Revolution, but at a much faster rate. Technology moved from the laboratory and research institute to the home. The new realms of electronics, telecommunications, automation, and computation were the driving forces, rather than the mechanical systems of the previous century. In the early 1900s there were almost no telephones, but at the dawn of the millennium mobile phones were an everyday sight; computers were almost unheard of one hundred years ago, but have become universal. We are now at the cusp of a new technological shift of equal significance: the Robotics

Revolution. This revolution will place the twenty-first century at a pivotal position in history. More importantly it will irrevocably impact on all our lives and the lives of future generations.

But what is the Robotics Revolution and what will it really deliver? To answer that we must examine what a robot is; what new technologies, such as smart materials, are emerging that will change the definition of a robot; and how robots will affect the lives of people and the health of the planet. If we briefly revisit the two prior revolutions—the Industrial and Technology—these were characterized by developments of two very different concepts: the mechanical and the electrical. Robotics, on the other hand, exploits a fusion of the mechanical systems, electrical systems, and new methods of computation and intelligence. It is through the combination of the best from multiple existing and new technologies that a quite astonishing range of robots and robotic systems is being, and will be, developed.

ROBOTS: FROM COLD WAR THREAT TO FUTURE SAVIOR

A "robot" is often defined in terms of its capability—it is a machine that can carry out a complex series of actions automatically, especially one programmable by a computer. This is a useful definition that encompasses a large proportion of conventional robots of the kind you see in science-fiction films. This definition, and the weight of established cultural views of what a robot *is*, has an impact on our views of what a robot *could be*. The best indication of this can be seen by examining cultural attitudes to robots around the world. If we type in the word "robot" to the English language version of the Google search engine we obtain images that are almost exclusively humanoid, shiny, rigid in structure and almost clinical (see fig. 1a). They also include some rather dark and aggressive-looking military-type robots. These results are skewed significantly by the cultural corpus that Google uses to mine these opinions. If we undertake the same search on the Japanese language Google site (using ロボット, the Japanese word for robot) we get a different set of results, as shown in Figure 1b. These results show far more friendly and approachable robots with fewer human-like features and more cartoon, and animal, representations. The cause of this difference is historic and due to the post-war cultural entanglement of new technologies, and robotics in particular, in the Cold War. Robots became exemplars of an alien threat. In contrast Japan did not suffer these prejudices and robots were therefore seen as benign entities. The consequence of these historical and cultural differences on robotics development is profound: Western robotics is heavily entwined in military research while Eastern robotics is focused on assist, health care, and industry. This cultural background also perpetuates our biased views of what a robot should look like and how it should behave.

Now we have the opportunity to break away from these conventions. There is no need for a robot to be humanoid, to have limbs, to walk, or to talk. Rather, we can have a much wider interpretation of what a robot is. The boundaries between smart materials, artificial intelligence, embodiment, biology, and robotics are blurring. This is how robotics will really affect the human race over the next twenty to forty years. And what an impact we can expect! From robots that can monitor and repair the natural environment to nano robots to

track and kill cancer, and from robots that will lead the way to planetary colonization to robot companions to keep us from loneliness in old age. There is no part of our society or life that will not be affected by future robotics. In short, they will become ubiquitous.

(a) SEARCHES FOR THE WORD "ROBOT" ON GOOGLE.COM AND (b) THE EQUIVALENT WORD "ロボット" ON GOOGLE.CO.JP.

(a)

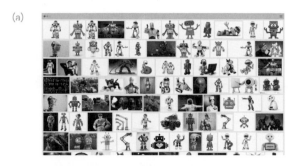

(b)

FIGURE 1

(a) SEARCHES FOR THE WORD "ROBOT" ON GOOGLE.COM AND (b) THE EQUIVALENT WORD "ロボット" ON GOOGLE.CO.JP.

Searches conducted 2016.10.08.

TOWARD UBIQUITOUS ROBOTIC ORGANISMS

Nature has always found ways to exploit and adapt to differences in environmental conditions. Through evolutionary adaptation a myriad of organisms has developed that operate and thrive in diverse and often extreme conditions. For example, the tardigrade (Schokraie et al., 2012) is able to survive pressures greater than those found in the deepest oceans and in space, can withstand temperatures from 1K (-272 °C) to 420K (150 °C), and can go without food for thirty years. Organisms often operate in symbiosis with others. The average human, for example, has about 30 trillion cells, but contains about 40 trillion bacteria (Sender et al., 2016). They cover scales from the smallest free-living bacteria, *pelagibacter ubique*, at around 0.5µm long to the blue whale at around thirty meters long. That is a length range of 7 orders of magnitude and approximately 15 orders of magnitude in volume! What these astonishing

facts show is that if nature can use the same biological building blocks (DNA, amino acids, etc.) for such an amazing range of organisms, we too can use our robotic building blocks to cover a much wider range of environments and applications than we currently do. In this way we may be able to match the ubiquity of natural organisms.

To achieve robotic ubiquity requires us not only to study and replicate the feats of nature but to go beyond them with faster (certainly faster than evolutionary timescales!) development and more general and adaptable technologies. Another way to think of future robots is as *artificial organisms*. Instead of a conventional robot which can be decomposed into mechanical, electrical, and computational domains, we can think of a robot in terms of its biological counterpart and having three core components: a body, a brain, and a stomach. In biological organisms, energy is converted in the stomach and distributed around the body to feed the muscles and the brain, which in turn controls the organisms. There is thus a functional equivalence between the robot organism and the natural organism: the brain is equivalent to the computer or control system; the body is equivalent to the mechanical structure of the robot; and the stomach is equivalent to the power source of the robot, be it battery, solar cell, or any other power source. The benefit of the artificial organism paradigm is that we are encouraged to exploit, and go beyond, all the characteristics of biological organisms. These embrace qualities largely unaddressed by current robotics research, including operation in varied and harsh conditions, benign environmental integration, reproduction, death, and decomposition. All of these are essential to the development of ubiquitous robotic organisms.

The realization of this goal is only achievable by concerted research in the areas of smart materials, synthetic biology, artificial intelligence, and adaptation. Here we will focus on the development of novel smart materials for robotics, but we will also see how materials development cannot occur in isolation of the other much-needed research areas.

A smart material is one that exhibits some observable effect in one domain when stimulated through another domain. These cover all domains including mechanical, electrical, chemical, optical, thermal, and so on. For example, a thermochromic material exhibits a color change when heated, while an electroactive polymer generates a mechanical output (i.e., it moves) when electrically stimulated (Bar-Cohen, 2004). Smart materials can add new capabilities to robotics, and especially artificial organisms. You need a robot that can track chemicals?—you can use a smart material that changes electrical properties when exposed to the chemical. You need a robotic device that can be implanted in a person but will degrade to nothing when it has done its job of work?—you can use biodegradable, biocompatible, and selectively dissolvable polymers. The "smartness" of smart materials can even be quantified. Their IQ can be calculated by assessing their responsiveness, agility, and complexity (for example, the number of phase changes they can undergo) (Cao et al., 1999). If we combine multiple smart materials in one robot we can greatly increase the IQ of its body.

Smart materials can be hard, such as piezo materials (Curie and Curie, 1881), flexible, such as shape memory alloys (Wu and Wayman, 1987), soft, such as dielectric elastomers (Pelrine et al., 2000), and even fluidic, such as ferrofluids (Albrecht et al., 1997) and electrorheological fluids (Winslow, 1949). This shows the great facility and variety of these materials, which largely cover the same set of physical properties (stiffness, elasticity, viscosity) as biological tissue. One important point to recognize in almost all biological organisms, and certainly all animals, is their reliance on softness. No animal, large or small, insect or mammal, reptile or fish, is totally hard. Even the insects with their rigid exoskeletons are internally soft and compliant. Directly related to this is the reliance of nature on the actuation (the generation of movement and forces) of soft tissue such as muscles. The humble cockroach is an excellent example of this; although it has a very rigid and hard body, its limbs are articulated by soft muscle tissue (Jahromi and Atwood, 1969). If we look closer at the animal kingdom we see many organisms that are almost totally soft. These include worms, slugs, molluscs, cephalopods, and smaller algae such as euglena. They exploit their softness to bend, twist, and squeeze in order to change

shape, hide, and to locomote. An octopus, for example, can squeeze out of a container through an aperturc less than a tenth the diameter of its body (Mather, 2006). Despite their softness, they can also generate forces sufficient to crush objects and other organisms while being dextrous enough to unscrew the top of a jar (BBC, 2003). Such remarkable body deformations are made possible not only by the soft muscle tissues but also by the exploitation of hydraulic and hydrostatic principles that enable the controllable change in stiffness (Kier and Smith, 1985).

We now have ample examples in nature of what can be done with soft materials and we desire to exploit these capabilities in our robots. Let us now look at some of the technologies that have the potential to deliver this capability. State-of-the-art soft robotic technologies can be split into three groups: 1) hydraulic and pneumatic soft systems; 2) smart actuator and sensor materials; and 3) stiffness changing materials. In recent years soft robotics has come to the fore through the resurgence of fluidic drive systems combined with a greater understanding and modelling of elastomeric materials. Although great work has been done in perfecting pneumatic braided rubber actuators (Meller et al., 2014), this discrete component-based approach limits its range of application.

Clockwise, from top left: the protozoa *Euglena flagellate*; the cosmopolitan tardigrade *Milnesium tardigradum*; and the mimetic octopus *Thaumoctopus mimicus*.

A better approach is shown in the pneunet class of robotic actuators (Ilievski et al., 2011) and their evolution into wearable soft devices (Polygerinos et al., 2015) and robust robots (Tolley et al., 2014). Pneunets are monolithic multichamber pneumatic structures made from silicone and polyurethane elastomers. Unfortunately hydraulic and pneumatic systems are severely limited due to their need for external pumps, air/fluid reservoirs, and valves. These add significant bulk and weight to the robot and reduce its softness. A far better approach is to work toward systems that do not rely on such bulky ancillaries. Smart materials actuators and sensors have the potential to deliver this by substituting fluidic pressure with electrical, thermal, or photonic effects. For example, electroactive polymers (EAPs) turn electrical energy into mechanical deformation. Figures 2 and 3 show two common forms of EAP: the dielectric elastomer actuator (DEA) (Pelrine et al., 2000) and the ionic polymer actuator (IPA) (Shahinpoor and Kim, 2001). The DEA is composed of a central elastomeric layer with high dielectric constant that is sandwiched between two compliant electrode layers.

When a large electric field (of the order MV/m) is applied to the composite structure, opposing charges collect at the two electrodes and these are attracted by Coulomb forces, labelled σ in Figure 2. These induce Maxwell stresses in the elastomer, causing it to compress between the electrodes and to expand in the plane, labelled ε in Figure 2. Since Coulomb forces are inversely proportional to charge separation, and the electrodes expand upon actuation, resulting in a larger charge collecting area, the induced stress in the DEA actuator is proportional to the square of the electric field. This encourages us to make the elastomer layer as thin as possible. Unfortunately, a thinner elastomer layer means we need more layers to make our robot, with a consequently higher chance of manufacturing defect or electrical breakdown. Because DEAs have power density close to biological muscles (Pelrine et al., 2000), they are good candidates for development into wearable assist devices and artificial organisms.

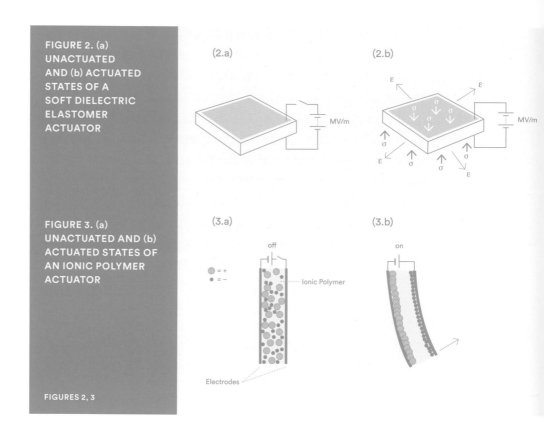

FIGURE 2. (a) UNACTUATED AND (b) ACTUATED STATES OF A SOFT DIELECTRIC ELASTOMER ACTUATOR

FIGURE 3. (a) UNACTUATED AND (b) ACTUATED STATES OF AN IONIC POLYMER ACTUATOR

FIGURES 2, 3

Ionic polymer actuators, on the other hand, are smart materials that operate through a different electromechanical principle, as shown in Figure 3. The IPA is fabricated from a central ionic conductor layer, again sandwiched by two conducting electrodes, but in contrast to DEAs the electric field is much lower (kV/m) and therefore the electrodes must be more conductive. When an electric field is applied, free ions within the ionic conductor move toward the electrodes where they collect. The high concentration of ions at the electrodes

causes them to expand as like-charges repel due to local Coulomb forces. If the cations (+) and ions (-) are significantly different in size and charge, there will be a mismatch in the expansion of the two electrodes and the IPA will bend. The advantage of the IPA is that it operates at much lower voltages than the DEA, but it can only generate lower forces. A more recent addition to the smart materials portfolio is the coiled nylon actuator (Haines et al., 2014). This is a thermal actuator fabricated from a single twist-insertion-buckled nylon filament. When heated, this structure contracts. Although the nylon coil actuator has the potential to deliver low-cost and reliable soft robotics, it is cursed by its thermal cycle. In common with all other thermal actuators, including shape memory alloys, it is relatively straightforward to heat the structure (and thereby cause contraction of the muscle-like filament) but it is much more challenging to reverse this and to cool the device. As a result, the cycle speed of the nylon (and SMA) actuators is slow at less than 10Hz. In contrast, DEAs and IPAs have been demonstrated at 100's of Hz, and the DEA has been shown to even operate as a loudspeaker (Keplinger et al., 2013).

The final capability needed to realize the body of soft robotic organisms is stiffness change. Although this may be achieved through muscle activation, as in the octopus, there are a number of soft robotic technologies that can achieve stiffness modulation independent of actuation. These include shape memory polymers (SMP) and granular jamming. SMPs are polymers that undergo a controllable and reversible phase transition from a rigid, glassy state to the soft, rubber shape (Lendlein et al., 2002). They are stimulated most commonly through heat, but some SMPs transition between phases when photonically or electrically stimulated. The remarkable property of SMPs is their ability to "memorize" a programmed state. In this way an SMP robot can be made to transition between soft and hard, and when the operation is complete it can be made to automatically return to its pre-programmed shape. One exciting possibility of SMPs is to combine them with actuators that are themselves stimulated by the same energy source. For example, a thermally operated shape memory polymer can be combined with a thermal SMP to yield a complex structure that encompasses actuation, stiffness change, and memory in one unit driven solely by heat (Rossiter et al., 2014). Granular jamming, in contrast to SMP phase change, is a more mechanical mechanism (Amend et al., 2012). A compliant chamber is filled with granular materials and the stiffness of the chamber can be controlled by pumping a fluid, such as air, into and out of it. When air is evacuated from the chamber, atmospheric pressure due to the within-chamber vacuum cases the granules to compress together and become rigid. In this way a binary soft-hard stiffness changing structure can be made. Such a composite structure is very suited to wearable assist devices and exploratory robots.

ROBOTS WHERE YOU DON'T EXPECT THEM

Having touched above on the technologies that will give us a new generation of robotics, let us now examine how these robots may appear in our lives and how we will interact, and live, with them.

Smart Skins

The compliance of soft robotics makes them ideally suited for direct interaction with biological tissue. The soft-soft interactions of a soft robot and human are inherently much

safer than a hard-soft interface imposed by conventional rigid robots. There has been much work on smart materials for direct skin-to-skin contact and for integration on the human skin, including electrical connections and electronic components (Kim et al., 2011). A functional soft robotic second skin can offer many advantages beyond conventional clothing. For example, it may mimic the color-changing abilities of the cephalopods (Morin et al., 2012), or it may be able to translocate fluids like the teleost fishes (Rossiter et al., 2012) and thereby regulate temperature. The natural extension of such skins lies in smart bandages to promote healing and to reduce the spread of microbial resistance bacteria by reducing the need for antibiotics. Of course, skins can substitute for clothing, but we are some way from social acceptance of second-skins as a replacement for conventional clothing. If, on the other hand, we exploit fibrous soft actuation technologies such as the nylon coil actuator and shape memory alloy-polymer composites (Rossiter et al., 2014), we can weave artificial muscles into fabric. This yields the possibility of active and reactive clothing. Such smart garments also offer a unique new facility: because the smart material is in direct contact with the skin, and it has actuation capabilities, it can directly mechanically stimulate the skin. In this way we can integrate tactile communication into clothing. The tactile communication channel has largely been left behind by the other senses. Take, for example, the modern smartphone; it has high bandwidth in both visual and auditory outputs but almost non-existent touch stimulating capabilities. With touch-enabled clothing we can generate natural "affective" senses of touch, giving us a potentially revolutionary new communication channel. Instead of a coarse vibrating motor (as used in mobile phones) we can stroke, tickle, or otherwise impart pleasant tactile feelings (Knoop and Rossiter, 2015).

Assist Devices

If the smart clothing above is able to generate larger forces it can be used not just for communication but also for physical support. For people who are frail, disabled, or elderly a future solution will be in the form of power-assist clothing that will restore mobility. Restoring mobility can have a great impact on the quality of life of the wearer and may even enable them to return to productive life, thereby helping the wider economy. The challenge with such a proposition is in the power density of the actuation technologies within the assist device. If the wearer is weak, for example because they have lost muscle mass, they will need significant extra power, but the weight of this supplementary power could be prohibitively expensive. Therefore the assist device should be as light and comfortable as possible, with actuation having a power density significantly higher than biological muscles. This is currently beyond the state-of-the-art. Ultimately wearable assist devices will make conventional assist devices redundant. Why use a wheel chair if you can walk again by wearing soft robotic Power Pants?

Medical Devices

We can extend the bio-integration as exemplified by the wearable devices described above *into* the body. Because soft robotics is so suitable for interaction with biological tissue it is natural to think of a device that can be implanted into the body and which can interact physically with internal structures. We can then build implantable medical devices that can restore the functionality of diseased and damaged organs and structures. Take, for example,

soft tissue cancer that can affect organs ranging from the bowels and prostate to the larynx and trachea. In these diseases a typical treatment involves the surgical excision of the cancer and management of the resulting condition. A patient with laryngeal cancer may have a laryngectomy and thereafter will be unable to speak and must endure a permanent tracheostomy. By developing and implanting a soft robotic replacement organ we may restore functional capabilities and enable the patient to once again speak, swallow, cough and enjoy their lives. Such bio-integrating soft robotics is under development and expected to appear in the clinic over the next ten to fifteen years.

Biodegradable and Environmental Robots

It is natural to extend the notion of bio-integration from the domestic (human-centric) environment to the natural environment. Currently robots that operate in the natural environment are hampered by their very underlying technologies. Because the robots are made of rigid, complex, and environmentally harmful materials, they must be constantly monitored. When they reach the end of their productive lives they must be recovered and safely disposed of. If, on the other hand, we can make the robots totally environmentally benign, we can be less concerned with their recovery after failure. This is now possible through the development of biodegradable soft robotics (Rossiter et al., 2016). By exploiting smart materials that are not only environmentally safe in operation, but which safely degrade to nothing in the environment, we can realize robots that live, die, and decay without environmental damage. This changes the way we deploy robots in the environment: instead of having to track and recall a small number of environmentally damaging robots we can deploy thousands and even millions of robots, safe in the knowledge that they will degrade safely in the environment, causing no damage. A natural extension of a biodegradability robot is one that is edible. In this case an edible robot can be eaten; it will do a job of work in the body; and then will be consumed by the body. This provides a new method for the controlled, and comfortable, delivery of treatments and drugs into the body.

Intelligent Soft Robots

All of the soft actuators described above operate as transducers. That is, they convert one energy form into another. This transduction effect can often be reversed. For example, dielectric elastomers actuators can be reconfigured to become dielectric elastomer generators (Jin et al., 2011). In such a generator the soft elastomer membrane is mechanically deformed and this results in the generation of an electrical output. Now we can combine this generator effect with the wearable robotics described above. A wearable actuator-generator device may, for example, provide added power when walking up hill, and once the user has reached the top of the hill, it can generate power from body movement as the user leisurely walks down the hill. This kind of soft robotic "regenerative braking" is just one example of the potential of bidirectional energy conversion in soft robotics. In such materials we have two of the components of computation: input and output. By combining these capabilities with the strain-responsive properties inherent in the materials we can realize robots that can compute with their bodies. This is a powerful new paradigm, often described in the more general form as embodied intelligence or morphological computation (Pfeifer and Gómez, 2009). Through morphological computation we can devolve low-level control to the body

"Why can't we write the entire twenty-four volumes of the Encyclopaedia Britannica on the head of a pin?"

RICHARD FEYNMAN (1918–88)
US theoretical physicist, in the famous lecture
"There's Plenty of Room at the Bottom," which
he gave in 1959 at the annual meeting of the
American Physical Society.

Demonstration of an origami paper
crane weighing only 32 grams,
at the 2015 International Robot
Exhibition in Tokyo.

of the soft robot. Do we therefore need a brain in our soft robotic organism? In many simple soft robots the brain may be redundant, with all effective computing being performed by the body itself. This further simplifies the soft robot and again adds to its potential for ubiquity.

CONCLUSIONS

In this article we have only scratched the surface of what a robot is, how it can be thought of as a soft robotic organism, and how smart materials will help realize and revolutionize future robotics. The impact on humans has been discussed, and yet the true extent of this impact is something we can only guess at. Just as the impact of the Internet and the World Wide Web were impossible to predict, we cannot imagine where future robotics will take us. Immersive virtual reality? Certainly. Replacement bodies? Likely. Complete disruption of lives and society? Quite possibly! As we walk the path of the Robotics Revolution we will look back at this decade as the one where robotics really took off, and laid the foundations for our future world.

—Albrecht, T., Bührer, C., Fähnle, M., Maier, K., Platzek, D., and Reske, J. 1997. "First observation of ferromagnetism and ferromagnetic domains in a liquid metal." *Applied Physics A: Materials Science & Processing* 65(2): 215.

—Amend, J. R., Brown, E., Rodenberg, N., Jaeger, H. M., and Lipson, H. 2012. "A positive pressure universal gripper based on the jamming of granular material." *IEEE Transactions on Robotics* 28(2): 341–350.

—Bar-Cohen, Y. (ed.) 2004. *Electroactive Polymer (EAP) Actuators as Artificial Muscles - Reality, Potential, and Challenge.* Bellingham, WA: SPIE press (2nd edition).

—BBC News. 2003. "Octopus intelligence: jar opening." http://news.bbc.co.uk/1/hi/world/europe/2796607.stm. 2003-02-25. Retrieved 2016-10-10.

—Cao, W., Cudney, H. H., and Waser, R. 1999. "Smart materials and structures." *PNAS* 96(15): 8330–8331.

—Curie, J., Curie, P. 1881. "Contractions et dilatations produites par des tensions dans les cristaux hémièdres à faces inclines" [Contractions and expansions produced by voltages in hemihedral crystals with inclined faces]. *Comptes rendus* (in French) 93: 1137–1140.

—Haines, C. S., et al. 2014. "Artificial muscles from fishing line and sewing thread." *Science* 343(6173): 868–872.

—Ilievski, F., Mazzeo, A. D., Shepherd, R. F., Chen, X., and Whitesides, G. M. 2011. "Soft robotics for chemists." *Angewandte Chemie* 123: 1930–1935.

—Jahromi, S. S., Atwood, H. L., 1969. "Structural features of muscle fibres in the cockroach leg." *Journal of Insect Physiology* 15(12): 2255–2258.

—Jin, S., Koh, A., Keplinger, C., Li, T., Bauer, S., and Suo, Z. 2011 "Dielectric elastomer generators: How much energy can be converted?" *IEEE/ASME Transactions On Mechatronics* 16(1).

—Keplinger, C., et al. 2013. "Stretchable, transparent, ionic conductors." *Science* 341(6149): 984–987.

—Kier, W. M., and Smith, K. K. 1985. "Tongues, tentacles and trunks: The biomechanics of movement in muscular-hydrostats." *Zoological Journal of the Linnean Society* 83: 307–324.

—Kim, D. H., et al. 2011. "Epidermal electronics." *Science* 333(6044): 838–843.

—Knoop, E., Rossiter, J. 2015. "The Tickler: A compliant wearable tactile display for stroking and tickling." *Proc. CHI 2015, 33rd Annual ACM Conference on Human Factors in Computing Systems:* 1133–1138.

—Lendlein, A., Kelch, S. (2002). "Shape-memory polymers." *Angew. Chem. Int. Ed.* 41: 2034–2057.

—Mather, J. A. 2006. "Behaviour development: A cephalopod perspective." *International Journal of Comparative Psychology* 19(1).

—Meller, M. A., Bryant, M., and Garcia, E. 2014. "Reconsidering the McKibben muscle: Energetics, operating fluid, and bladder material." *Journal of Intelligent Material Systems and Structures* 25: 2276–2293.

—Morin, S. A., Shepherd, R. F., Kwok, S. W., Stokes, A. A., Nemiroski, A., and Whitesides, G. M. 2012. "Camouflage and display for soft machines." *Science* 337(6096): 828–832.

—Pelrine, R., Kornbluh, R., Pei, Q., and Joseph, J. 2000. "High-speed electrically actuated elastomers with strain greater than 100%." *Science* 287(5454): 836–839.

—Pfeifer, R., Gómez, G. 2009. "Morphological computation—Connecting brain, body, and environment." *Creating Brain-Like Intelligence, Lecture Notes in Computer Science* 5436: 66–83.

—Polygerinos, P., Wang, Z., Galloway, K. C., Wood, R. J., and Walsh, C. J. 2015. "Soft robotic glove for combined assistance and at-home rehabilitation." *Robotics and Autonomous Systems* 73: 135–143.

—Rossiter, J., Winfield, J., and Ieropoulos, I. 2016. "Here today, gone tomorrow: Biodegradable soft robots." In *Electroactive Polymer Actuators and Devices (EAPAD).* Bellingham, WA: SPIE.

—Rossiter, J., Yap, B., and Conn, A. 2012. "Biomimetic chromatophores for camouflage and soft active surfaces." *Bioinspiration & Biomimetics* 7(3).

—Rossiter, J. M., Takashima, K., and Mukai, T. 2014. "Thermal response of novel shape memory polymer-shape memory alloy hybrids." *Proceedings of SPIE: Behavior and Mechanics of Multifunctional Materials and Composites.* Bellingham, WA: SPIE, 905810.

—Schokraie, E., et al. 2012. "Comparative proteome analysis of Milnesium tardigradum in early embryonic state versus adults in active and anhydrobiotic state." *PLoS ONE* 7(9).

—Sender, R., Fuchs, S., and Milo, R. 2016. "Revised estimates for the number of human and bacteria cells in the body." *PLoS Biol* 14(8).

—Shahinpoor, M., and Kim, K. J. 2001. "Ionic polymer-metal composites: I. Fundamentals." *Smart Materials and Structures* 10(4).

—Tolley M. T., Shepherd R. F., Mosadegh, B., Galloway K. C., Wehner, M., Karpelson, M., Wood, R. J., and Whitesides, G. M. 2014. "A resilient, untethered soft robot." *Soft Robotics* 1(3): 213–223.

—Winslow, W. M. 1949. "Induced fibration of suspensions." *J. Appl. Phys.* 20(12): 1137–1140.

—Wu, S., and Wayman, C. 1987. "Martensitic transformations and the shape-memory effect in Ti50Ni10Au40 and Ti50Au50 alloys." *Metallography* 20(3): 359.

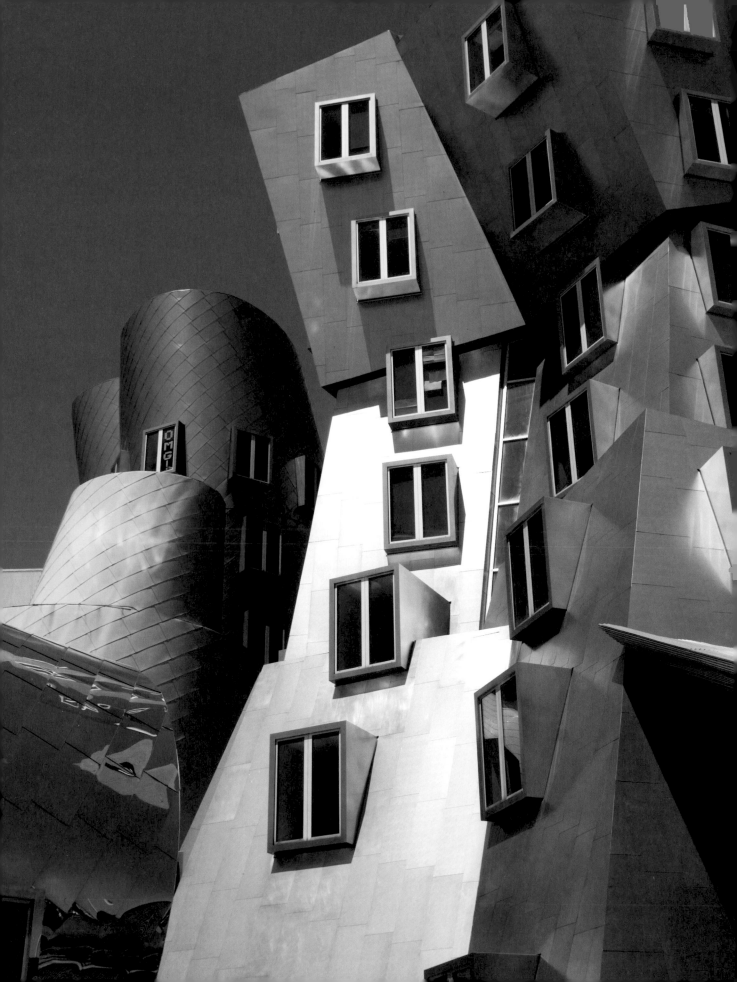

Our Extended Sensoria. How Humans Will Connect with the Internet of Things

JOSEPH A. PARADISO

Opening image:
Facade of the Ray and Maria State
Center at the Massachusetts Institute
of Technology (MIT), by Pritzker Prize-
winning architect, Frank Gehry.

Joseph A. Paradiso
Responsive Environments Group, MIT Media Lab,
Cambridge, MA, USA

Joseph A. Paradiso is the Alexander W. Dreyfoos (1954) Professor in
Media Arts and Sciences at the MIT Media Lab, where he directs the
Responsive Environments group. He received his PhD in Physics from MIT
in 1981, a BSEE from Tufts University in 1977, and joined the Media Lab in
1994. His current research explores how sensor networks augment and
mediate human experience, interaction, and perception—encompassing
wireless sensing systems, wearable and body sensor networks, energy
harvesting and power management for embedded sensors, ubiquitous
and pervasive computing, human-computer interfaces, electronic music,
and interactive media. He has previously worked in high-energy physics,
spacecraft control, and underwater sonar.

The Internet of Things assumes ubiquitous sensate environments. Without these, the cognitive engines of this everywhere-enabled world are deaf, dumb, and blind, and cannot respond relevantly to the real-world events that they aim to augment. Advances over the past decade have been rampant, as sensors tend to exploit Moore's Law. Accordingly, sensors of all sorts now seem to be increasingly in everything, indicating an approaching phase transition once they are properly networked, as we saw when web browsers appeared and our interaction with computers fundamentally changed. This shift will create a seamless electronic nervous system that covers the planet—and one of the main challenges for the computing community now is in how to merge the rapidly evolving "omniscient" electronic sensoria onto human perception. This article tours aspects of this coming revolution guided by several recent and ongoing projects in the author's research group at the MIT Media Lab that approach this precept from different perspectives. We give examples that range from smart buildings to sports, exploiting technical trends ranging from wearable computing to wireless sensor networks.

INTRODUCTION

Just as Vannevar Bush foresaw multimedia, the personal computer, and so much more in his seminal 1945 article,[1] Mark Weiser predicted the Internet of Things in a similarly seminal article in 1991.[2] Whereas Bush's article, rooted in extrapolations of World War II technology, was mainly speculative, Weiser illustrated the future that he predicted via actual working systems that he and his colleagues had developed (and were already living with) at Xerox PARC. Coming from an HCI perspective, Weiser and his team looked at how people would interact with networked computation distributed into the environments and artifacts around them. Now upstaged by the "Internet of Things," which much more recently gestated in industrial/academic quarters enamored with evolving RFID technology, Weiser's vision of "ubiquitous computing" resonated with many of us back then working in the domains of

computer science involved with human interaction. Even within our community and before the IoT moniker dominated, this vision could take many names and flavors as factions tried to establish their own brand (we at the Media Lab called it "Things That Think," my colleagues at MIT's Lab for Computer Science labelled it "Project Oxygen," others called it "Pervasive Computing," "Ambient Computing," "Invisible Computing," "Disappearing Computer," etc.), but it was all still rooted in Mark's early vision of what we often abbreviate as "UbiComp."

I first came to the MIT Media Lab in 1994 as a High-Energy Physicist working on elementary particle detectors (which can be considered to be extreme "sensors") at the then-recently cancelled Superconducting Supercollider and the nascent Large Hadron Collider (LHC) at CERN. Since I had been facile with electronics since childhood and had been designing and building large music synthesizers since the early 1970s,[3] my earliest Media Lab research involved incorporating new sensor technologies into novel human-computer interface devices, many of which were used for musical control.[4] As wireless technologies became more easily embeddable, my research group's work evolved by the late 1990s into various aspects of wireless sensors and sensor networks, again with a human-centric focus.[5] We now see most of our projects as probing ways in which human perception and intent will seamlessly connect to the electronic "nervous system" that increasingly surrounds us. This article traces this theme from a sensor perspective, using projects from my research group to illustrate how revolutions in sensing capability are transforming how humans connect with their environs in many different ways.

INERTIAL SENSORS AND SMART GARMENTS

Humans sense inertial and gravitational reaction via proprioception at the limbs and vestibular sensing at the inner ear. Inertial sensors, the electrical equivalent, once used mainly for high-end applications like aircraft and spacecraft navigation,[6] are now commodity. MEMS (Micro Electro-Mechanical Systems) based accelerometers date back to academic prototypes in 1989 and widespread commercial chips coming from analog devices in the 1990s[7] that exploited their proprietary technique of fabricating both MEMS and electronics on the same chip. Still far too coarse for navigation applications beyond basic pedometry[8] or step-step dead reckoning,[9] they are appearing in many simple consumer products, for example, toys, phones, and exercise dosimeters and trackers, where they are mainly used to infer activity or for tilt-based interfaces, like flipping a display. Indeed, the accelerometer is perhaps now the most generically used sensor on the market and will be embedded into nearly every device that is subject to motion or vibration, even if only to wake up more elaborate sensors at very low power (an area we explored very early on, for example,[10, 11]). MEMS-based gyros have advanced well beyond the original devices made by Draper Lab[12] back in the 1990s. They have also become established, but their higher costs and higher power drain (because they need a driven internal resonator, they have not pushed below the order of 1 mA current draw and are harder to efficiently duty cycle as they take significant time to start up and stabilize[13]) preclude quite as much market penetration at this point. Nonetheless, they are becoming common on smartphones,

AR headsets, cameras, and even watches and high-end wristbands, for gesture detection, rotation sensing, motion compensation, activity detection, augmented reality applications, and so on, generally paired with magnetometers that give a ground-truth orientation using Earth's magnetic field. Triaxial accelerometers are now a default, and triaxial gyros have also been under manufacture. Since 2010 we have seen commercial products that do both, providing an entire 6-axis inertial measurement unit on a single chip together with 3-axis magnetometer (e.g., starting from Invensense with the MPU-6000/6050 and with more recent devices from Invensense, ST Microelectronics, Honeywell, etc.).[14]

The MIT Media Lab have been pioneers in applications of inertial sensing to user interface and wearable sensing[15] and many of these ideas have gestated in my group going back twenty years.[16] Starting a decade ago, piggybacking on even older projects exploring wearable wireless sensors for dancers,[17] my team has employed wearable inertial sensors for measuring biomechanical parameters for professional baseball players in collaboration with physicians from the Massachusetts General Hospital.[18] As athletes are capable of enormous ranges of motion, we need to be able to measure peak activities of up to 120 G, and 13,000°/s, while still having significant resolution within the 10 G, 300°/s range of normal motion. Ultimately, this would entail an IMU with log sensitivity, but as these are not yet available, we have integrated dual-range inertial components onto our device and mathematically blend both signals. We use the radio connection primarily to synchronize our devices to better than our 1 ms sampling rate, and write data continuously to removable flash memory, allowing us to gather data for an entire day of measurement and analyze the data to determine descriptive and predictive features of athletic performance.[19] A myriad of commercial products are now appearing for collecting athletic data for a variety of sports that range from baseball to tennis,[20] and even the amateur athlete of the future will be instrumented with wearables that will aid in automatic/self/augmented coaching.

Accelerometer power has also dropped enormously, with a modern capacitive 3-axis accelerometers drawing well under a milliamp, and special purpose accelerometers (e.g., devices originally designed for implantables[21]) pulling under a microamp. Passive piezoelectric accelerometers have also found application in UbiComp venues.[22]

Sensors of various sorts have also crept into fabric and clothing—although health care and exercise monitoring have been the main beacons calling researchers to these shores,[23] fabric-based strain gauges, bend sensors, pressure sensors, bioelectric electrodes, capacitive touch sensors, and even RFID antennae have been developed and become increasingly reliable and robust,[24] making clothing into a serious user interface endeavor. Recent high-profile projects, such as Google's Project Jacquard,[25] led technically by Nan-Wei Gong, an alum of my research team, boldly indicate that smart clothing and weaving as electronic fabrication will evolve beyond narrow and boutique niches and into the mainstream as broad applications, perhaps centered on new kinds of interaction,[26] as they begin to emerge. Researchers worldwide, such as my MIT colleague Yoel Fink[27] and others, are rethinking the nature of "thread" as a silicon fiber upon which microelectronics are grown. Acknowledging the myriad hurdles that remain here in robustness, production, and so on, the research community is mobilizing[28] to transform these and other ideas around flexible electronics into radically new functional substrates that can impact medicine, fashion, and apparel (from recreation to spacesuits and military or hazardous environments), and bring electronics into all things stretchable or malleable.

Going beyond wearable systems are electronics that are attached directly to or even painted onto the skin. A recent postdoc in my group, Katia Vega, has pioneered this in the form of what she calls "Beauty Technology."[29] Using functional makeup that construes conductors, sensors, and illuminating or color-changing actuators,[30] Katia and her colleagues have made skin interfaces that react to facial or tactile gesture, sending wireless messages, illuminating, or changing apparent skin color with electroactive rouge. Katia has recently explored medical implementations, such as tattoos that can change appearance with blood-borne indicators.[31]

We are living in an era that has started to technically mine the wrist, as seen in the now ubiquitous smartwatch. These devices are generally touchscreen peripherals to the smartphone, however, or work as improved activity monitors such as have been in the market since 2009. I believe that the wrist will become key to the user interface of the future, but not implemented like in today's smartwatches. User interfaces will exploit wrist-worn IMUs and precise indoor location to enable pointing gestures,[32]

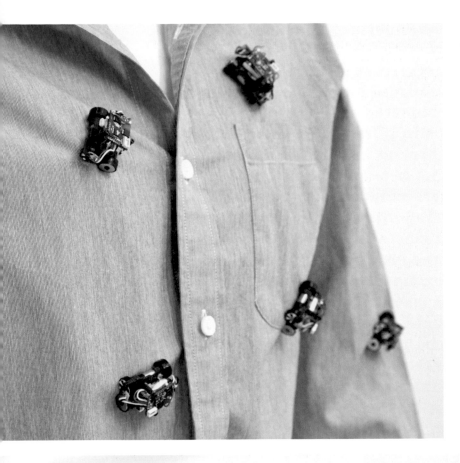

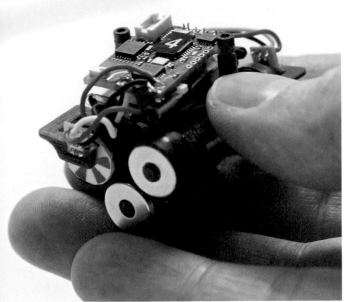

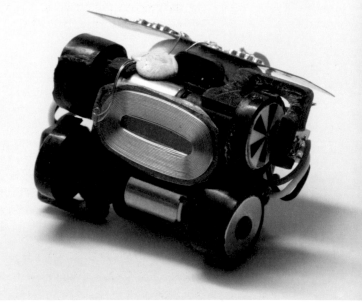

Our Extended Sensoria. How Humans Will Connect with the Internet of Things

Joseph A. Paradiso

and finger gesture will still be important in communicating (as we have so much sensory-motor capability in our fingers), but rather than using touch screens, we will be tracking finger gesture by sensors embedded in smart wristbands with our hands by our sides. In recent years, my team has developed several early working prototypes that do this, one using passive RFID sensors in rings worn at the upper joint of fingers interrogated by a wrist-worn reader,[33] another using a short-range 3D camera looking across the palm from the wrist to the fingers,[34] and another that uses a pressure-imaging wristband that can sense tendon displacement.[35] My student Artem Dementyev and his collaborator Cindy Kao have also made a wireless touchpad into a fake fingernail, complete with a battery that lasts a few hours of continuous use,[36] enabling digital interaction at the extremes of our digits, so to speak. Hence, I envision the commuter of the future not staring down at their smartphone in their crowded self-driving bus, but rather looking straight ahead into their head-mounted wearable, nudging their heavily context-leveraged communication via finger movements with hand resting innocuously at their side.

My former student Mat Laibowitz and I introduced the concept of "Parasitic Mobility" over a decade ago.[37] We proposed that low-power sensor nodes could harvest "mobility" as opposed to just garnering energy, hopping on and off moving agents in their environment. In this era of drones deployed from delivery vans, such a concept is now far from radical. Our examples used people as the mobile agents, and the nodes were little robots that could choose to be "worn" by attaching in various ways to their hosts, inspired by ticks, fleas, and so on in the natural world, then detaching at the location of their choice. My current student Artem Dementyev, together with Sean Follmer at Stanford and other collaborators, have recently pioneered a different approach to wearable robots in their "Rovables."[38] These are very small (e.g., 2-cm) robots that navigate across a user's clothing, choosing the best location to perform a task, ranging from a medical measurement to a dynamic display. This project displays an extreme form of human-robot closely proximate collaboration that could bear profound implication.

In George Orwell's *1984*,[39] it was the totalitarian Big Brother government who put the surveillance cameras on every television—but in the reality of 2016, it is consumer electronics companies who build cameras into the common set-top box and every mobile handheld. Indeed, cameras are becoming commodity, and as video feature extraction gets to lower power levels via dedicated hardware, and other micropower sensors determine the necessity of grabbing an image frame, cameras will become even more common as generically embedded sensors. The first commercial, fully integrated CMOS camera chips came from VVL in Edinburgh (now part of ST Microelectronics) back in the early 1990s.[40] At the time, pixel density was low (e.g., the VVL "Peach" with 312 x 287 pixels), and the main commercial application of their devices was the "BarbieCam," a toy video camera sold by Mattel. I was an early adopter of these digital cameras myself, using them in 1994 for a multi-camera precision alignment system at the Superconducting Supercollider[41] that evolved into the hardware used to continually align the forty-meter muon system at micron-level precision for the ATLAS detector at CERN's Large Hadron Collider. This technology was poised for rapid growth: now, integrated cameras peek at us everywhere, from laptops to cellphones, with typical resolutions of scores of megapixels and bringing computational photography increasingly to the masses. ASICs for basic image processing are commonly embedded with or integrated into cameras, giving increasing video processing capability for ever-decreasing power. The mobile phone market has been driving this effort, but increasingly static situated installations (e.g., video-driven motion/context/gesture sensors in smart homes) and augmented reality will be an important consumer application, and the requisite on-device image processing will drop in power and become more agile. We already see this happening at extreme levels, such as with the recently released Microsoft HoloLens, which features six cameras, most of which are used for rapid environment mapping, position tracking, and image registration in a lightweight, battery-powered, head-mounted, self-contained AR unit. 3D cameras are also becoming ubiquitous, breaking into the mass market via the original structured-light-based Microsoft Kinect a half-decade ago. Time-of-flight 3D cameras (pioneered in CMOS in the early 2000s by researchers at Canesta[42]) have evolved to recently displace structured light approaches, and developers worldwide race to bring the power and footprint of these devices down sufficiently to integrate into common mobile devices (a very small version of such a device is already embedded in the HoloLens). As pixel timing measurements become more precise, photon-counting applications in computational photography, as pursued by my Media Lab colleague Ramesh Raskar, promise to usher in revolutionary new applications that can do things like reduce diffusion and see around corners.[43]

My research group began exploring this penetration of ubiquitous cameras over a decade ago, especially applications that ground the video information with simultaneous data from wearable sensors. Our early studies were based around a platform called the "Portals":[44] using an embedded camera feeding a TI DaVinci DSP/ARM hybrid processor, surrounded by a core of basic sensors (motion, audio, temperature/humidity, IR proximity) and coupled with a Zigbee RF transceiver, we scattered forty-five of these devices all over the Media Lab complex, interconnected through the wired building network. One application that we built atop them was "SPINNER,"[45] which labelled video from each camera with data from any

wearable sensors in the vicinity. The SPINNER framework was based on the idea of being able to query the video database with higher-level parameters, lifting sensor data up into a social/affective space,[46] then trying to effectively script a sequential query as a simple narrative involving human subjects adorned with the wearables. Video clips from large databases sporting hundreds of hours of video would then be automatically selected to best fit given timeslots in the query, producing edited videos that observers deemed coherent.[47] Naively pointing to the future of reality television, this work aims further, looking to enable people to engage sensor systems via human-relevant query and interaction.

Rather than try to extract stories from passive ambient activity, a related project from our team devised an interactive camera with a goal of extracting structured stories from people.[48] Taking the form factor of a small mobile robot, "Boxie" featured an HD camera in one of its eyes: it would rove our building and get stuck, then plea for help when people came nearby. It would then ask people successive questions and request that they fulfill various tasks (e.g., bring it to another part of the building, or show it what they do in the area where it was found), making an indexed video that can be easily edited to produce something of a documentary about the people in the robot's abode.

In the next years, as large video surfaces cost less (potentially being roll-roll printed) and are better integrated with responsive networks, we will see the common deployment of pervasive interactive displays. Information coming to us will manifest in the most appropriate fashion (e.g., in your smart eyeglasses or on a nearby display)—the days of pulling your phone out of your pocket and running an app are severely limited. To explore this, we ran a project in my team called "Gestures Everywhere"[49] that exploited the large monitors placed all over the public areas of our building complex.[50] Already equipped with RFID to identify people wearing tagged badges, we added a sensor suite and a Kinect 3D camera to each display site. As an occupant approached a display and were identified via RFID or video recognition, information most relevant to them would appear on the display. We developed a recognition framework for the Kinect that parsed a small set of generic hand gestures (e.g., signifying "next," "more detail," "go-away," etc.), allowing users to interact with their own data at a basic level without touching the screen or pulling out a mobile device. Indeed, proxemic interactions[51] around ubiquitous smart displays will be common within the next decade.

The plethora of cameras that we sprinkled throughout our building during our SPINNER project produced concerns about privacy (interestingly enough, the Kinects for Gestures Everywhere did not evoke the same response—occupants either did not see them as "cameras" or were becoming used to the idea of ubiquitous vision). Accordingly, we put an obvious power switch on each portal that enabled them to be easily switched off. This is a very artificial solution, however—in the near future, there will just be too many cameras and other invasive sensors in the environment to switch off. These devices must answer verifiable and secure protocols to dynamically and appropriately throttle streaming sensor data to answer user privacy demands. We have designed a small, wireless token that controlled our portals in order to study solutions to such concerns.[52] It broadcast a beacon to the vicinity that dynamically deactivates the transmission of proximate audio, video, and other derived features according to the user's stated privacy preferences—this device also featured a large "panic" button that can be pushed at any time when immediate privacy is desired, blocking audio and video from emanating from nearby Portals.

Rather than block the video stream entirely, we have explored just removing the privacy-desiring person from the video image. By using information from wearable sensors, we can more easily identify the appropriate person in the image,[53] and blend them into the background. We are also looking at the opposite issue—using wearable sensors to detect environmental parameters that hint at potentially hazardous conditions for construction workers and rendering that data in different ways atop real-time video, highlighting workers in situations of particular concern.[54]

ENERGY MANAGEMENT

The energy needed to sense and process has steadily declined—sensors and embedded sensor systems have taken full advantage of low-power electronics and smart power management.[55] Similarly, energy harvesting, once an edgy curiosity, has become a mainstream drumbeat that is resonating throughout the embedded sensor community.[56, 57] The appropriate manner of harvesting is heavily dependent on the nature of the ambient energy reserve. In general,

"When wireless is perfectly applied the whole earth will be converted into a huge brain, which in fact it is, all things being particles of a real and rhythmic whole."

NIKOLA TESLA (1856–1943)
Croatian inventor, engineer, mechanic, electrical engineer, and physicist; he is considered the father of modern technology.

for inhabited environments, solar cells tend to be the best choice (providing over 100 μA/cm² indoors, depending on light levels, etc.). Otherwise, vibrational and thermoelectric harvesters can be exploited where there is sufficient vibration or heat transfer (e.g., in vehicles or on the body),[58, 59] and implementations of ambient RF harvesting[60] have not become uncommon either. In most practical implementations that constrain volume and surface area, however, an embedded battery can be a better solution over an anticipated device's lifetime, as the limited power available from the harvester can already put a strong constraint on the current consumed by the electronics. Another solution is to beam RF or magnetic energy to batteryless sensors, such as with RFID systems. Popularized in our community starting with Intel's WISP[61] (used by my team for the aforementioned finger-tracking rings[62]), commercial RF-powered systems are beginning to appear (e.g., Powercast, WiTricity, etc.), although each has its caveats (e.g., limited power or high magnetic flux density). Indeed, it is common now to see inductive "pucks" available at popular cafe's to charge cellphones when placed above the primary coils embedded under the table, and certain phones have inductive charging coils embedded behind their case, but these seem to be seldom used as it is more convenient to use a ubiquitous USB cable/connector, and the wire eliminates position constraints that proximate inductive charging can impose. In my opinion, due to its less-than-optimal convenience, high lossiness (especially relevant in our era of conservation), and potential health concerns (largely overstated,[63] but more important if you have a pacemaker, etc.), wireless power transfer will be restricted mainly to niche and low-power applications like micropower sensors that have no access to light for photovoltaics, and perhaps special closets or shelves at home where our wearable devices can just be hung up to be charged.

The boom in energy harvesting interest has precipitated a variety of ICs dedicated to managing and conditioning the minute amounts of power these things typically produce (e.g., by major IC providers like Linear Technology and Maxim), and the dream of integrating harvester, power conditioning, sensor, processing, and perhaps wireless on a single chip nears reality (at least for extremely low duty-cycle operation or environments with large reservoirs of ambient energy). Indeed, the dream of such Smart Dust[64] has been realized in early prototypes, such as the University of Michigan wafer stack that uses its camera as an optical energy harvester[65] and the recently announced initiative to produce laser-accelerated, gram-level "Star Wisp" swarm sensors for fast interstellar exploration[66] will emphasize this area even more.

Although energy harvesting is often confused with sustainable energy sources by the general public (for example,[67]), the amount of energy harvestable in standard living environments is far too small to make any real contribution to society's power needs. On the other hand, very low-power sensor systems, perhaps augmented by energy harvesting, minimize or eliminate the need for changing batteries, thereby decreasing deployment overhead, hence increasing the penetration of ubiquitous sensing. The information derived from these embedded sensors can then be used to intelligently minimize energy consumption in built environments, promising a better degree of conservation and utility than attainable by today's discrete thermostats and lighting controls.

Dating back to the Smart Home of Michael Moser,[68] work of this sort has recently become something of a lightning rod in ubiquitous computing circles, as several research groups

have launched projects in smart, adaptive energy management through pervasive sensing.[69] For example, in my group, my then-student Mark Feldmeier has used inexpensive chip-based piezo cantilevers to make a micropower integrating wrist-worn activity detector (before the dawn of commercial exercise-tracker wristbands) and environmental monitor for a wearable HVAC controller.[70] Going beyond subsequently introduced commercial systems such as the well-known Nest Thermostat, the wearable provides a first-person perspective that more directly relates to comfort than a static wall-mounted sensor, plus is intrinsically mobile, exerting HVAC control in any suitably equipped room or office. Exploiting analog processing, this continuous activity integrator runs at under 2 microamperes, enabling our device (together with its other components, which also measure and broadcast temperature, humidity, and light level each minute) to run for over two years on a small coin-cell battery, updating once per minute when within range of our network. We have used the data from this wrist-worn device to essentially graft onto the user's "sense of comfort," and customize our building's HVAC system according to the comfort of the local users, as inferred from the wearable sensor data discriminated by "hot" and "cold" labels, obtained by pushing buttons on the device. We estimated that the HVAC system running under our framework used roughly 25% less energy, and inhabitants were significantly more comfortable.[71] Similar wireless micropower sensors for HVAC control have recently been developed by others, such as Schneider Electric in Grenoble,[72] but are used in a fixed location. Measuring temperature, humidity, and CO_2 levels every minute and uploading the readings via a Zigbee network, the Schneider unit is powered by a small solar cell—one day of standard indoor light is sufficient to power this device for up to four weeks (the duration of a typical French vacation).

Lighting control is also another application that can benefit from ubiquitous computing. This is not only for energy management purposes—we also need to answer the user interface challenge that modern lighting systems pose. Although the actuation possibilities of contemporary commonly networked digitally controlled fluorescent and solid-state lights are myriad, the human interface suffers greatly, as especially commercial lighting is generally managed by cryptic control panels that make getting the lighting that you want onerous at best. As we accordingly lament the loss of the simple light switch, my group has launched a set of projects to bring it back in virtual form, led by my students Nan Zhao, and alums Matt Aldrich and Asaf Axaria. One route that we have pursued involves using feedback from a small incident light sensor that is able to isolate the specific contribution of each nearby light fixture to the overall lighting at the sensor, as well as to estimate external, uncontrolled light.[73]

Our control algorithm, based around a simple linear program, is able to dynamically calculate the energy-optimal lighting distribution that delivers the desired illumination at the sensor location, effectively bringing back the local light switch as a small wireless device.

Our ongoing work in this area expands on this idea by also incorporating cameras as distributed reflected-light sensors and as a source of features that can be used for interactive lighting control. We have derived a set of continuous control axes for distributed lighting via principle-component analysis that is relevant to human perception,[74] enabling easy and intuitive adjustment of networked lighting. We are also driving this system from the wearable sensors in Google Glass, automatically adjusting the lighting to optimize illumination of surfaces and objects you are looking at as well as deriving context to set overall lighting; for instance, seamlessly transitioning between lighting appropriate for a working or a casual/social function.[75] Our most recent work in this area also incorporates large, soon-to-be ubiquitous displays, changing both images/video, sound, and lighting in order to serve the user's emotive/attentive state as detected by wearable sensors and nearby cameras[76] to healthy and productive levels.

RADIO, LOCATION, ELECTRONIC "SCENT," AND SENSATE MEDIA

The last decade has seen a huge expansion in wireless sensing, which is having a deep impact in ubiquitous computing. Mixed signal IC layout techniques have enabled the common embedding of silicon radios on the same die as capable microprocessors, which have ushered in a host of easy-to-use smart radio ICs, most of which support common standards like Zigbee running atop 802.15.4. Companies like Nordic, TI/Chipcon, and more recently Atmel, for example, make commonly used devices in this family. Although a plethora of sensor-relevant wireless standards are in place that optimize for different applications (e.g., ANT for low duty-cycle operation, Savi's DASH-7 for supply chain implementation, Wireless Hart for industrial control, Bluetooth Low Energy for consumer devices, Lorawan for longer-range IoT devices, and low-power variants of Wi-Fi), Zigbee has had a long run as a well-known standard for low-power RF communication, and Zigbee-equipped sensor modules are easily available that can run operating systems derived from sensor net research (e.g., dating to TinyOS[77]), or custom-developed application code. Multihop operation is standard in Zigbee's routing protocol, but battery limitations generally dictate that routing nodes need to be externally powered. Although it could be on the verge of being replaced by more recently developed protocols (as listed above), my team has been basing most of its environmental and static sensor installations on modified Zigbee software stacks.

Outdoor location within a several meters has long been dominated by GPS, and more precise location is provided by differential GPS, soon to be much more common via recent low-cost devices like the RTK (Real Time Kinematic) GPS embedded radios.[78] Indoor location is another story. It is much

more difficult, as GPS is shielded away, and indoor environments present limited lines-of-sight and excessive multipath. There seems to be no one clear technology winner for all indoor situations (as witnessed by the results of the Microsoft Indoor Location Competition run yearly at recent IPSN Conferences[79]), but the increasing development being thrown at it promises that precise indoor location will soon be a commonplace feature in wearable, mobile, and consumer devices.

Networks running 802.15.4 (or 802.11 for that matter) generally offer a limited location capability that utilizes RSSI (received signal strength) and radio link quality. These essentially amplitude-based techniques are subject to considerable error due to dynamic and complex RF behavior in indoor environments. With sufficient information from multiple-base stations and exploitation of prior state and other constraints, these "fingerprinting" systems claim to be able to localize mobile nodes indoors to within three to five meters.[80] Time-of-flight RF systems, however, promise to make this much better. Clever means of utilizing the differential phase of RF beats in simultaneously transmitting outdoor radios has been shown to be able to localize a grid of wireless nodes to within three centimeters across a football field,[81] and directional antennae achieve circa thirty centimeters or better accuracy with Nokia's HAIP system,[82] for example.

However, the emerging technology of choice in lightweight precision RF location is low-power, impulse-based UltraWideBand, where short radio impulses at around 5-8 GHz are precisely timed, and cm-level accuracy is promised. High-end commercial products have been available for a while now (e.g., UbiSense for indoor location, and Zebra Technology radios for stadium-scale [sports] location), but emerging chipsets from companies like Decawave and Qualcomm (via their evolving "Peanut" radio) indicate that this technology might soon be in everything—and as soon as every device can be located to within a few centimeters, profound applications will arise (e.g., geofencing and proximate interfaces[83] are obvious, but this capability will impact everything).

One example that Brian Mayton in my team has produced leveraging this technology was the "WristQue" wristband.[84] Equipped with precise indoor location (via the UbiSense

system) as well as a full 9-axis IMU and sensors to implement the smart lighting and HVAC systems discussed above, the WristQue also enables control of devices by simple pointing and arm gesture. Pointing is an intuitive way by which humans communicate, and camera-based systems have explored this ever since the legacy "Put That There" demo was developed at the MIT Media Lab in the 1980s.[85] But as the WristQue knows the position of the wrist to within centimeters via soon-to-be-ubiquitous radio location and the wrist angle via the IMU (calibrated for local magnetic distortion), we can easily extrapolate the arm's vector to determine what a user is pointing to without the use of cameras.

Different locations also exhibit specific electromagnetic signatures or "scents," as can be detected via simple capacitive, inductive, RF, and optical sensors. These arise from parasitic emissions from power lines and various local emanations from commonly modulated lighting and other electrical equipment—these signals can also be affected by building wiring and structure. Such background signals carry information relevant to energy usage and context (e.g., what appliance is doing what and how much current it is drawing) and also location (as these near-field or limited-radius emanations attenuate quickly). Systems that exploit these passive background signals, generally through a machine-learning process, have been a recent fashion in UbiComp research, and have seen application in areas like non-intrusive load management,[86] tracking hands across walls,[87] and inferring gesture around fluorescent lamps.[88] DC magnetic sensors have also been used to precisely locate people in buildings, as the spatial orientation of the Earth's magnetic field changes considerably with position in the building.[89]

My team has leveraged using ambient electronic noise in wearables, analyzing characteristics of capacitively coupled pickup to identify devices touched and infer their operating modes.[90] My then-student Nan-Wei Gong and I (in collaboration with Microsoft Research in the UK) have developed a multimodal electromagnetic sensor floor with pickups and basic circuitry printed via an inexpensive roll-roll process.[91] The networked sensing cells along each strip can track people walking above via capacitive induction of ambient 60 Hz hum, as well as track the location of an active GSM phone or near-field transmitter via their emanations. This is a recent example of what we have termed "Sensate Media"[92]—essentially the integration of low-power sensor networks into common materials to make them sensorially capable—essentially a scalable "electronic skin."

Our most recent work in this area has produced SensorTape,[93] a roll of networked embedded sensors on a flexible substrate in the form factor of common adhesive tape. Even though our sensor tape is many meters long it can be spooled off, cut, and rejoined as needed and attached to an object or surface as desired to give it sensing capability (our current tape embeds devices like IMUs and proximity sensors at a circa 1" pitch for distributed orientation and ranging). We have also explored making versions of SensorTape that can exploit printed sensors and be

passively powered,[94] enabling it to be attached to inaccessible surfaces and building materials, then wirelessly interrogated by, for example, NFC readers. In cases where sensors cannot be printed, they can also be implemented as stickers with conductive adhesive, such as recently pioneered by my student Jie Qi and Media Lab alum Bunny Huang for craft and educational applications[95] in their commercially available Chibitronics kits.

AGGREGATING AND VISUALIZING DIVERSE SENSOR DATA

We have witnessed an explosion of real-time sensor data flowing through our networks—and the rapid expansion of smart sensors at all scales should soon cause real-time sensor information to dominate network traffic. At the moment, this sensor information is still fairly siloed—for example, video is for video conferencing, telephony, and webcams; traffic data shows up on traffic websites, and so on. A grand challenge for our community is to break down the walls between these niches, and develop systems and protocols that seamlessly bridge these categories to develop a virtual sensor environment, where all relevant data is dynamically collated and fused. Several initiatives have begun to explore these ideas of unifying data. Frameworks based on SensorML, Home Plug & Play, and DLNA, for example, have been aimed at enabling online sensors to easily provide data across applications. Patchube (now Xively[96]) is a proprietary framework that enables subscribers to upload their data to a broad common pool that can then be provided for many different applications. These protocols, however, have had limited penetration for various reasons, such as the desire to own all of your data and charge revenue or limited buy-in from manufacturers. Recent industrial initiatives, such as the Qualcomm-led AllJoyn[97] or the Intel-launched Open Interconnect Alliance with IoTivity[98] are more closely aimed at the Internet of Things and are less dominated by consumer electronics. Rather than wait for these somewhat heavy protocols to mature, my student Spencer Russell has developed our own, called CHAIN-API.[99, 100] CHAIN is a RESTful (REpresentational State Transfer), web-literate framework, based on JSON data structures, hence is easily parsed by tools commonly available to web applications. Once it hits the Internet, sensor data is posted, described, and linked to other sensor data in CHAIN. Exploiting CHAIN, applications can "crawl" sensor data just as they now crawl linked static posts, hence related data can be decentralized and live under diverse servers (I believe that in the future no entity will "own" your data, hence it will be distributed). Crawlers will constantly traverse data linked in protocols like CHAIN, calculating state and estimating other parameters derived from the data, which in turn will be re-posted as other "virtual" sensors in CHAIN. As an example of this, my student David Ramsay has implemented a system called "LearnAir,"[101] in which he has used CHAIN to develop a protocol for posting data from air quality sensors, as well as building

a machine-learning framework that corrects, calibrates, and extrapolates this data by properly combining ubiquitous data from inexpensive sensors with globally measured parameters that can affect its state (e.g., weather information), as well as grounding it with data from high-quality sensors (e.g., EPA certified) depending on proximity. With the rise of Citizen Science in recent years, sensors of varying quality will collect data of all sorts everywhere. Rather than drawing potentially erroneous conclusions from misleading data, LearnAir points to a future where data of all sorts and of varying quality will be combined dynamically and properly conditioned, allowing individuals to contribute to a productive data commons that incorporates all data most appropriately.

Browsers for this ubiquitous, multimodal sensor data will play a major role, for example, in the setup/debugging[102] of these systems and building/facility management. An agile multimodal sensor browser capability, however, promises to usher in revolutionary new applications that we can barely speculate about at this point. A proper interface to this artificial sensoria promises to produce something of a digital omniscience, where one's awareness can be richly augmented across temporal and spatial domains—a rich realization of McLuhan's characterization of electronic media extending the human nervous system.[103] We call this process "Cross Reality"[104]—a pervasive, everywhere augmented reality environment, where sensor data fluidly manifests in virtual worlds that can be intuitively browsed. Although some researchers have been adding their sensor data into structures viewable through Google Earth (for example,[105]), we have been using a 3D game engine to browse the data coming from our own building—as game engines are built for efficient graphics, animation, and interaction, they are perfectly suited to developing such architecturally referenced sensor manifestations (our prior work used the communal shared-reality environment SecondLife,[106] which proved much too restrictive for our aims).

Our present system, called "DoppelLab"[107] and led by my student Gershon Dublon, makes hundreds of diverse sensor and information feeds related to our building visible via animations

appearing in a common virtual world. Browsing in DoppelLab, we can see the building HVAC system work, see people moving through the building via RFID badges and motion sensors, see their public Tweets emanating from their offices, and even see real-time ping pong games played out on a virtual table.[108]

We have also incorporated auditory browsing in DoppelLab by creating spatialized audio feeds coming from microphones placed all around our building, referenced to the position of the user in the virtual building. Random audio grains are reversed or deleted right at the sensor node, making conversations impossible to interpret for privacy's sake (it always sounds like people are speaking a foreign language), but vocal affect, laughing, crowd noise, and audio transients (e.g., elevators ringing, people opening doors, etc.) come through fairly intact.[109] Running DoppelLab with spatialized audio of this sort gives the user the feeling of being a ghost, loosely coupled to reality in a tantalizing way, getting the gist and feeling associated with being there, but removed from the details. Growing up in the late-1960s era of McLuhan, this concept fascinated me, and as an elementary-school child, I wired arrays of microphones hundreds of meters away to mixers and amplifiers in my room. At the time, despite the heavy influence of then-in-vogue spy movies, I had no desire to snoop on people. I was instead just fascinated with the idea of generalizing presence and bringing remote outdoor sound into dynamic ambient stereo mixes that I would experience for hours on end. DoppelLab and the Doppelmarsh environment described below have elevated this concept to a level I could have never conceived of in my analog youth.

We had planned to evolve DoppelLab into many tangent endeavors, including two-way interaction that allows virtual visitors to also manifest into our real space in different ways via distributed displays and actuators. Most of our current efforts in this line of research, however, have moved outdoors, to a 242.8-hectare (600-acre) retired cranberry bog called "Tidmarsh" located an hour south of MIT in Plymouth Massachusetts.[110] This property is being restored to its natural setting as a wetland, and to document this process, we have installed hundreds of wireless sensors measuring a variety of parameters, such as temperature, humidity, soil moisture and conductivity, nearby motion, atmospheric and water quality, wind, sound, light quality, and so on. Using our low-power Zigbee-derived wireless protocol and posting data in CHAIN, these sensors, designed by my student Brian Mayton, last for two years on AA batteries (posting data every twenty seconds) or live perpetually when driven by a small solar cell. We also have thirty real-time audio feeds coming from an array of microphones distributed across Tidmarsh, with which we are exploring new applications in spatialized audio, real-time wildlife recognition with deep learning,[111] and so on.

In addition to using this rich, dense, data archive to analyze the progress of restoration in collaboration with environmental scientists, we are also using the real-time CHAIN-posted data stream in a game-engine visualization. Within this "Doppelmarsh" framework, you can float across the re-synthesized virtual landscape (automatically updated by information

gleaned by cameras so the virtual appearance tracks real-world seasonal and climatic changes), and see the sensor information realized as situated graphics, animations, and music. The sounds in Doppelmarsh come from both the embedded microphones (spatialized relative to the user's virtual position) and music driven by sensor data (for example, you can hear the temperature, humidity, activity, and so on, coming from nearby devices). We have built a framework for composers to author musical compositions atop the Tidmarsh data[112] and have so far hosted four musical mappings, with more to come shortly.

Through our virtual Tidmarsh, we have created a new way to remotely experience the real landscape while keeping something of the real aesthetic. In Doppelmarsh, you can float across boggy land that is now very difficult to traverse (free of the guaranteed insect bites), hearing through nearby microphones and seeing metaphorical animations from real-time sensors (including flora and fauna that "feed" upon particular sensor data, hence their appearance and behavior reflects the history of temperature, moisture, and so on, in that area). We are also developing a wearable "sensory prosthetic" to augment the experience of visitors to the Tidmarsh property. Based on a head-mounted wireless position/orientation-tracking bone-conduction headphone system we have developed called HearThere,[113] we will estimate where or on what users are focusing attention via an array of wearable sensors, and manifest sound from related/proximate microphones and sensors appropriately. Users can look across a stream, for example, and hear audio from microphones and sensors there, then look down into the water and hear sound from hydrophones and sensors there: if they focus on a log equipped with sensitive accelerometers, they can hear the insects boring inside. In the future, all user interfaces will leverage attention in this fashion—relevant information will manifest itself to us in the most appropriate way and leverage what we are paying attention to in order to enhance perception and not distract.

I see artists as playing a crucial role in shaping how the augmented world appears to us. As large data sources emanating from everyday life are now accessible everywhere, and tools to extract structure from them increasingly available, artists, composers, and designers will sculpt the environments and realizations that present this information to us in ways that are humanly relevant. Indeed, a common mantra in my research group now states that "Big Data is the Canvas for Future Artists" and we have illustrated this via the creative musical frameworks we have made available for both Doppelmarsh[114] and real-time physics data coming from the ATLAS detector at CERN's Large Hadron Collider.[115] I can see a near future where a composer can do a piece for a smart city, where the traffic, weather, air quality,

pedestrian flow, and so on are rendered in music that changes with conditions and virtual user location. These are creative constructs that never end, always change, and can be perceived to relate to real things happening in real places, giving them imminence and importance.

CONCLUSIONS

Moore's Law has democratized sensor technology enormously over the past decade—this paper has touched on a few of the very many modes that exist for sensing humans and their activities.[116] Ever more sensors are now integrated into common products (witness mobile phones, which have become the Swiss Army Knives of the sensor/RF world), and the DIY movement has also enabled custom sensor modules to be easily purchased or fabricated through many online and crowd-sourced outlets.[117] As a result, this decade has seen a huge rush of diverse data flowing into the network. This will surely continue in the following years, leaving us the grand challenge of synthesizing this information into many forms—for example, grand cloud-based context engines, virtual sensors, and augmentation of human perception. These advances not only promise to usher in true UbiComp, they also hint at radical redefinition of how we experience reality that will make today's common attention-splitting between mobile phones and the real world look quaint and archaic.

We are entering a world where ubiquitous sensor information from our proximity will propagate up into various levels of what is now termed the "cloud" then project back down into our physical and logical vicinity as context to guide processes and applications manifesting around us. We will not be pulling our phones out of our pocket and diverting attention into a touch UI, but rather will encounter information brokered between wearables and proximate ambient displays. The computer will become more of a partner than experienced as a discrete application that we run. My colleague and founding Media Lab director Nicholas Negroponte described this relationship as a "digital butler" in his writings from decades back[118]—I see this now as more of an extension of ourselves rather than the embodiment of an "other." Our relationship with computation will be much more intimate as we enter the age of wearables. Right now, all information is available on many devices around me at the touch of a finger or the enunciation of a phrase. Soon it will stream directly into our eyes and ears once we enter the age of wearables (already forseen by then Media Lab students like Steve Mann[119] and Thad Starner[120] who were living in an early version of this world during the mid-1990s). This information will be driven by context and attention, not direct query, and much of it will be pre-cognitive, happening before we formulate direct questions. Indeed, the boundaries of the individual will be very blurry in this future. Humanity has pushed these edges since the dawn of society. Since sharing information with each other in oral history, the boundary of our mind expanded with writing and later the printing press, eliminating the need to mentally retain verbatim information and keep instead pointers into larger archives.

In the future, where we will live and learn in a world deeply networked by wearables and eventually implantables, how our essence and individuality is brokered between organic neurons and whatever the information ecosystem becomes is a fascinating frontier that promises to redefine humanity.

ACKNOWLEDGMENTS

The MIT Media Lab work described in this article has been conducted by my graduate students, postdocs, and visiting affiliates over the past decade, many of whom were explicitly named in this article and others represented in the cited papers and theses—readers are encouraged to consult the included references for more information on these projects along with a more thorough discussion of related work. I thank the sponsors of the MIT Media Lab for their support of these efforts.

1. V. Bush, "As we may think," *Atlantic Monthly* 176 (July 1945): 101–108.

2. M. Weiser, "The computer for the 21st century," *Scientific American* 265(3) (September 1991): 66–75.

3. J. Paradiso, "Modular synthesizer," in *Timeshift*, G. Stocker, and C. Schopf (eds.), (*Proceedings of Ars Electronica 2004*), (Ostfildern-Ruit: Hatje Cantz Verlag, 2004): 364–370.

4. J. A. Paradiso, "Electronic music interfaces: New ways to play," *IEEE Spectrum* 34(12) (December 1997): 18–30.

5. J. A. Paradiso, "Sensor architectures for interactive environments," in *Augmented Materials & Smart Objects: Building Ambient Intelligence Through Microsystems Technologies*, K. Deleaney (ed.), (Springer, 2008): 345–362.

6. D. MacKenzie, *Inventing Accuracy: A Historical Sociology of Nuclear Missile Guidance* (Cambridge, MA: MIT Press, 1990).

7. P. L. Walter, "The history of the accelerometer," *Sound and Vibration* (January 2007, revised edition): 84–92.

8. H. Weinberg, "Using the ADXL202 in pedometer and personal navigation applications," *Analog Devices Application Note AN-602* (Analog Devices Inc., 2002).

9. V. Renaudin, O. Yalak, and P. Tomé, "Hybridization of MEMS and assisted GPS for pedestrian navigation," *Inside GNSS* (January/February 2007): 34–42.

10. M. Malinowski, M. Moskwa, M. Feldmeier, M. Laibowitz, and J. A. Paradiso, "CargoNet: A low-cost micropower sensor node exploiting quasi-passive wakeup for adaptive asynchronous monitoring of exceptional events," *Proceedings of the 5th ACM Conference on Embedded Networked Sensor Systems (SenSys'07)* (Sydney, Australia, November 6–9, 2007): 145–159.

11. A. Y. Benbasat, and J. A. Paradiso, "A Framework for the automated generation of power-efficient classifiers for embedded sensor nodes," *Proceedings of the 5th ACM Conference on Embedded Networked Sensor Systems (SenSys'07)* (Sydney, Australia, November 6–9, 2007): 219–232.

12. J. Bernstein, "An overview of MEMS inertial sensing technology," *Sensors Magazine* (February 1, 2003).

13. Benbasat, and Paradiso, "Framework for the automated generation," op. cit.: 219–232.

14. N. Ahmad, A. R. Ghazilla, N. M. Khain, and V. Kasi, "Reviews on various inertial measurement (IMU) sensor applications," *International Journal of Signal Processing Systems* 1(2) (December 2013): 256–262.

15. C. Verplaetse, "Inertial proprioceptive devices: self-motion-sensing toys and tools," *IBM Systems Journal* 35(3–4) (1996): 639–650.

16. J. A. Paradiso, "Some novel applications for wireless inertial sensors," *Proceedings of NSTI Nanotech 2006* 3 (Boston, MA, May 7–11, 2006): 431–434.

17. R. Aylward, and J. A. Paradiso, "A compact, high-speed, wearable sensor network for biomotion capture and interactive media," *Proceedings of the Sixth International IEEE/ACM Conference on Information Processing in Sensor Networks (IPSN 07)* (Cambridge, MA, April 25–27, 2007): 380–389.

18. M. Lapinski, M. Feldmeier, and J. A. Paradiso, "Wearable wireless sensing for sports and ubiquitous interactivity," *IEEE Sensors 2011* (Dublin, Ireland, October 28–31, 2011).

19. M. T. Lapinski, "A platform for high-speed biomechanical data analysis using wearable wireless sensors," PhD Thesis, MIT Media Lab (August 2013).

20. K. Lightman, "Silicon gets sporty: Next-gen sensors make golf clubs, tennis rackets, and baseball bats smarter than ever," *IEEE Spectrum* (March 2016): 44–49.

21. For an early example, see the data sheet for the Analog Devices AD22365.

22. M. Feldmeier, and J. A. Paradiso, "Personalized HVAC control system," *Proceedings of IoT 2010* (Tokyo, Japan, November 29–December 1, 2010).

23. D. De Rossi, A. Lymberis (eds.), *IEEE Transactions on Information Technology in Biomedicine, Special Section on New Generation of Smart Wearable Health Systems and Applications* 9(3) (September 2005).

24. L. Buechley, "Material computing: Integrating technology into the material world," in *The SAGE Handbook of Digital Technology Research*, S. Price, C. Jewitt, and B. Brown (eds.), (New York: Sage Publications Ltd., 2013).

25. I. Poupyrev, N.-W. Gong, S. Fukuhara, M. E. Karagozler, C. Schwesig, K. Robinson, "Project Jacquard: Interactive digital textiles at scale," *Proceedings of CHI* (2016): 4216–4227.

26. V. Vinge, *Rainbow's End* (New York: Tor Books, 2006).

27. C. Hou, X. Jia, L. Wei, S.-C. Tan, X. Zhao, J. D. Joanopoulos, and Y. Fink, "Crystalline silicon core fibres from aluminium core performs," *Nature Communications* 6 (February 2015).

28. D. L. Chandler, "New institute will accelerate innovations in fibers and fabrics," *MIT News Office* (April 1, 2016).

29. K. Vega, *Beauty Technology: Designing Seamless Interfaces for Wearable Computing* (Springer, 2016).

30. X. Liu, K. Vega, P. Maes, and J. A. Paradiso, "Wearability factors for skin interfaces," *Proceedings of the 7th Augmented Human International Conference 2016 (AH '16)* (New York: ACM, 2016)

31. K. Vega, N. Jing, A. Yetisen, V. Kao, N. Barry, and J. A. Paradiso, "The dermal abyss: Interfacing with the skin by tattooing biosensors," submitted to TEI 2017.

32. B. D. Mayton, N. Zhao, M. G. Aldrich, N. Gillian, and J. A. Paradiso, "WristQue: A personal sensor wristband," *Proceedings of the IEEE International Conference on Wearable and Implantable Body Sensor Networks (BSN '13)* (2013): 1–6.

33. R. Bainbridge, and J. A. Paradiso, "Wireless hand gesture capture through wearable passive tag sensing," *International Conference on Body Sensor Networks (BSN '11)* (Dallas, TX, May 23–25, 2011): 200–204.

34. D. Way, and J. Paradiso, "A usability user study concerning free-hand microgesture and wrist-worn sensors," *Proceedings of the 2014 11th International Conference on Wearable and Implantable Body Sensor Networks (BSN '14)* (IEEE Computer Society, June 2104): 138–142.

35. A. Dementyev, and J. Paradiso, "WristFlex: Low-power gesture input with wrist-worn pressure sensors," *Proceedings of UIST 2014, the 27th annual ACM symposium on User Interface Software and Technology* (Honolulu, Hawaii, October 2014): 161–166.

36. H.-L. Kao, A. Dementyev, J. A. Paradiso, and C. Schmandt, "NailO: Fingernails as an input surface," *Proceedings of the International Conference on Human Factors in Computing Systems (CHI'15)* (Seoul, Korea, April 2015).

37. M. Laibowitz, and J. A. Paradiso, "Parasitic mobility for pervasive sensor networks," in *Pervasive Computing*, H. W. Gellersen, R. Want, and A. Schmidt (eds.), *Proceedings of the Third International Conference, Pervasive 2005* (Munich, Germany, May 2005) (Berlin: Springer-Verlag): 255–278.

38. A. Dementyev, H.-L. Kao, I. Choi, D. Ajilo, M. Xu, J. Paradiso, C. Schmandt, and S. Follmer, "Rovables: Miniature on-body robots as mobile wearables," *Proceedings of ACM UIST* (2016).

39. G. Orwell, *1984* (London: Secker and Warburg, 1949).

40. E. R. Fossum, "CMOS image sensors: Electronic camera-on-a-chip," *IEEE Transactions On Electron Devices* 44(10) (October 1997): 1689–1698.

41. J. A. Paradiso, "New technologies for monitoring the precision alignment of large detector systems," *Nuclear Instruments and Methods in Physics Research* A386 (1997): 409–420.

42. S. B. Gokturk, H. Yalcin, and C. Bamji, "A time-of-flight depth sensor – system description, issues and solutions," *CVPRW '04, Proceedings of the 2004 Conference on Computer Vision and Pattern Recognition Workshop* 3: 35–45.

43. A. Velten, T. Wilwacher, O. Gupta, A. Veeraraghavan, M. G. Bawendi, and R. Raskar, "Recovering three-dimensional shape around a corner using ultra-fast time-of-flight imaging," *Nature Communications* 3 (2012).

44. J. Lifton, M. Laibowitz, D. Harry, N.-W. Gong, M. Mittal, and J. A. Paradiso, "Metaphor and manifestation – cross reality with ubiquitous sensor/actuator networks," *IEEE Pervasive Computing Magazine* 8(3) (July–September 2009): 24–33.

45. M. Laibowitz, N.-W. Gong, and J. A. Paradiso, "Multimedia content creation using societal-scale ubiquitous camera networks and human-centric wearable sensing," *Proceedings of ACM Multimedia 2010* (Florence, Italy, 25–29 October 2010): 571–580.

46. J. A. Paradiso, J. Gips, M. Laibowitz, S. Sadi, D. Merrill, R. Aylward, P. Maes, and A. Pentland, "Identifying and facilitating social interaction with a wearable wireless sensor network," *Springer Journal of Personal & Ubiquitous Computing* 14(2) (February 2010): 137–152.

47. Laibowitz, Gong, and Paradiso, "Multimedia content creation," op. cit.: 571–580.

48. A. Reben, and J. A. Paradiso, "A mobile interactive robot for gathering structured social video," *Proceedings of ACM Multimedia 2011* (October 2011): 917–920.

49. N. Gillian, S. Pfenninger, S. Russell, and J. A. Paradiso, "Gestures Everywhere: A multimodal sensor fusion and analysis framework for pervasive displays," *Proceedings of The International Symposium on Pervasive Displays (PerDis '14)*, Sven Gehring (ed.), (New York, NY: ACM, June 2014): 98–103.

50. M. Bletsas, "The MIT Media Lab's glass infrastructure: An interactive information system," *IEEE Pervasive Computing* (February 2012): 46–49.

51. S. Greenberg, N. Marquardt, T. Ballendat, R. Diaz-Marino, and M. Wang, "Proxemic interactions: the new UbiComp?," *ACM Interactions* 18(1) (January 2011): 42–50.

52. N.-W. Gong, M. Laibowitz, and J. A. Paradiso, "Dynamic privacy management in pervasive sensor networks," *Proceedings of Ambient Intelligence (AmI) 2010* (Malaga, Spain, 25–29 October 2010): 96–106.

53. G. Dublon, "Beyond the lens: Communicating context through sensing, video, and visualization," MS Thesis, MIT Media Lab (September 2011).

54. B. Mayton, G. Dublon, S. Palacios, and J. A. Paradiso, "TRUSS: Tracking risk with ubiquitous smart sensing," *IEEE SENSORS 2012* (Taipei, Taiwan, October 2012).

55. A. Sinha, and A. Chandrakasan, "Dynamic power management in wireless sensor networks," *IEEE Design & Test of Computers* (March–April 2001): 62–74.

56. J. A. Paradiso, and T. Starner, "Energy scavenging for mobile and wireless electronics," *IEEE Pervasive Computing* 4(1) (February 2005): 18–27.

57. E. Boyle, M. Kiziroglou, P. Mitcheson, and E. Yeatman, "Energy provision and storage for pervasive computing," *IEEE Pervasive Computing* (October–December 2016).

58. P. D. Mitcheson, T. C. Green, E. M. Yeatman, A. S. Holmes, "Architectures for vibration-driven micropower generators," *Journal of Microelectromechanical Systems* 13(3) (June 2004): 429–440.

59. Y. K. Ramadass, and A. P. Chandrakasan, "A batteryless thermoelectric energy-harvesting interface circuit with 35mV startup voltage," *Proceedings of ISSCC* (2010): 486–488.

60. H. Nishimoto, Y. Kawahara, and T. Asami, "Prototype implementation of wireless sensor network using TV broadcast RF energy harvesting," *UbiComp'10* (Copenhagen, Denmark, September 26–29, 2010): 373–374.

61. J. R. Smith, A. Sample, P. Powledge, A. Mamishev, and S. Roy. "A wirelessly powered platform for sensing and computation," *UbiComp 2006: Eighth International Conference on Ubiquitous Computing* (Orange County, CA, 17–21 September, 2006): 495–506.

62. Bainbridge, and Paradiso, "Wireless hand gesture capture," op. cit.: 200–204.

63. R. L. Park, *Voodoo Science: The Road from Foolishness to Fraud* (Oxford: OUP, 2001).

64. B. Warneke, M. Last, B. Liebowitz, and K. S. J. Pister, "Smart Dust: Communicating with a cubic-millimeter computer," *IEEE Computer* 34(1) (January 2001): 44–51.

65. Y. Lee, "Ultra-low power circuit design for cubic-millimeter wireless sensor platform," PhD Thesis, University of Michigan (EE Dept) (2012).

66. D. Overbyte, "Reaching for the stars, across 4.37 light-years," *The New York Times* (April 12, 2016).

67. M. G. Richard, "Japan: Producing electricity from train station ticket gates," see http://www.treehugger. com/files/2006/08/japan_ticket_ gates.php.

68. M. Mozer, "The neural network house: An environment that adapts to its inhabitants," *Proceedings of the American Association for Artificial Intelligence Spring Symposium on Intelligent Environments* (Menlo Park, CA, 1998): 110–114.

69. J. Paradiso, P. Dutta, H. Gellerson, E. Schooler (eds.), *Special Issue on Smart Energy Systems, IEEE Pervasive Computing Magazine* 10(1) (January–March 2011).

70. M. Feldmeier and J. A. Paradiso, "Personalized HVAC control system," *Proceedings of IoT 2010* (Tokyo, Japan, November 29–Dec. 1, 2010).

71. Ibid.

72. G. Chabanis, "Self-powered wireless sensors in buildings: An ideal solution for improving energy efficiency while ensuring comfort to occupant," *Proceedings of Energy Harvesting & Storage Europe 2011,* IDTechEx (Munich, Germany, June 21–22, 2011).

73. M. Aldrich, N. N. Zhao, and J. A. Paradiso, "Energy efficient control of polychromatic solid-state lighting using a sensor network," *Proceedings of SPIE (OP10)* 7784 (San Diego, CA, August 1–5, 2010).

74. M. Aldrich, "Experiential lighting – development and validation of perception-based lighting controls," PhD Thesis, MIT Media Lab (August 2014).

75. N. Zhao, M. Aldrich, C. F. Reinhart, and J. A. Paradiso, "A multidimensional continuous contextual lighting control system using Google Glass," *2nd ACM International Conference on Embedded Systems For Energy-Efficient Built Environments (BuildSys 2015)* (November 2015).

76. A. Axaria, "INTELLIGENT AMBIANCE: Digitally mediated workspace atmosphere, augmenting experiences and supporting wellbeing," MS Thesis, MIT Media Lab (August 2016).

77. P. Levis et al., "TinyOS: An operating system for sensor networks," in *Ambient Intelligence* (Berlin: Springer, 2005): 115–148.

78. E. Gakstatter, "Finally, a list of public RTK base stations in the U.S.," *GPS World* (January 7, 2014).

79. See: https://www.microsoft. com/en-us/research/event/microsoft-indoor-localization-competition-ipsn-2016.

80. E. Elnahrawy, X. Li, and R. Martin, "The limits of localization using signal strength: A comparative study," *Proceedings of the 1st IEEE International Conference on Sensor and Ad Hoc Communications and Networks* (Santa Clara, CA, October 2004).

81. M. Maróti et al., "Radio interferometric geolocation," *Proceedings of SENSYS* (2005): 1–12.

82. F. Belloni, V. Ranki, A. Kainulainen, and A. Richter, "Angle-based indoor positioning system for open indoor environments," *Proceedings of WPNC* (2009).

83. Greenberg, Marquardt, Ballendat, et al., "Proxemic interactions," op. cit.: 42–50.

84. Mayton, Zhao, Aldrich, et al., "WristQue: A personal sensor wristband," op. cit.: 1–6.

85. R. Bolt, "'Put-that-there': Voice and gesture at the graphics interface," *ACM SIGGRAPH Computer Graphics* 14(3) (July 1980): 262–270.

86. J. Froehlich et al., "Disaggregated end-use energy sensing for the smart grid," *IEEE Pervasive Computing* (January–March 2010): 28–39.

87. G. Cohn, D. Morris, S. Patel, and D. S. Tan, "Your noise is my command: Sensing gestures using the body as an antenna," *Proceedings of CHI* (2011): 791–800.

88. S. Gupta, K.-Y. Chen, M. S. Reynolds, and S. N. Patel, "LightWave: Using compact fluorescent lights as sensors," *Proceedings of UbiComp* (2011): 65–70.

89. J. Chung et al., "Indoor location sensing using geo-magnetism," *Proceedings of MobiSys'11* (Bethesda, MD, June 28–July 1, 2011): 141–154.

90. N. Zhao, G. Dublon, N. Gillian, A. Dementyev, and J. Paradiso, "EMI spy: Harnessing electromagnetic interference for low-cost, rapid prototyping of proxemic interaction," *International Conference on Wearable and Implantable Body Sensor Networks (BSN '15)* (June 2015).

91. N.-W. Gong, S. Hodges, and J. A. Paradiso, "Leveraging conductive inkjet technology to build a scalable and versatile surface for ubiquitous sensing," *Proceedings of UbiComp* (2011): 45–54.

92. J. A. Paradiso, J. Lifton, and M. Broxton, "Sensate Media – multimodal electronic skins as dense sensor networks," *BT Technology Journal* 22(4) (October 2004): 32–44.

93. A. Dementyev, H.-L. Kao, and J. A. Paradiso, "SensorTape: Modular and programable 3D-aware dense sensor network on a tape," *Proceedings of ACM UIST* (2015).

94. N.-W. Gong, C.-Y. Wang, and J. A. Paradiso, "Low-cost sensor tape for environmental sensing based on roll-to-roll manufacturing process," *IEEE SENSORS 2012* (Taipei, Taiwan, October 2012).

95. J. Qi, A. Huang, and J. Paradiso, "Crafting technology with circuit stickers," *Proceedings of ACM IDC '15 (14th International Conference on Interaction Design and Children)* (2015): 438–441.

96. See https://www.xively.com/xively-iot-platform/connected-product-management.

97. See https://allseenalliance.org/framework.

98. See https://www.iotivity.org.

99. S. Russell, and J. A. Paradiso, "Hypermedia APIs for sensor data: A pragmatic approach to the Web of Things," *Proceedings of ACM Mobiquitous 2014* (London, UK, December 2014): 30–39.

100. See https://github.com/ResEnv/chain-api.

101. D. Ramsay, "LearnAir: Toward intelligent, personal air quality monitoring," MS Thesis, MIT Media Lab (August 2016).

102. M. Mittal, and J. A. Paradiso, "Ubicorder: A mobile device for situated interactions with sensor networks," *IEEE Sensors Journal, Special Issue on Cognitive Sensor Networks* 11(3) (2011): 818–828.

103. M. McLuhan, *Understanding Media: The Extensions of Man* (New York: McGraw-Hill, 1964).

104. Lifton, Laibowitz, Harry, et al., "Metaphor and manifestation," op. cit.: 24–33.

105. N. Marquardt, T. Gross, S. Carpendale, and S. Greenberg, "Revealing the invisible: visualizing the location and event flow of distributed physical devices," *Proceedings of the Fourth International Conference on Tangible, Embedded, and Embodied Interaction (TEI)* (2010): 41–48.

106. J. Lifton, and J. A. Paradiso, "Dual reality: Merging the real and virtual," *Proceedings of the First International ICST Conference on Facets of Virtual Environments (FaVE)* (Berlin, Germany, 27–29 July 2009), (Springer LNICST 33): 12–28.

107. G. Dublon, L. S. Pardue, B. Mayton, N. Swartz, N. Joliat, P. Hurst, and J. A. Paradiso, "DoppelLab: Tools for exploring and harnessing multimodal sensor network data," *Proceedings of IEEE Sensors 2011* (Limerick, Ireland, October 2011).

108. G. Dublon, and J. A. Paradiso, "How a sensor-filled world will change human consciousness," *Scientific American* (July 2014): 36–41.

109. N. Joliat, B. Mayton, and J. A. Paradiso, "Spatialized anonymous audio for browsing sensor networks via virtual worlds," *The 19th International Conference on Auditory Display (ICAD)* (Lodz, Poland, July 2013): 67–75.

110. See http://tidmarsh.media.mit.edu.

111. C. Duhart, "Ambient sound recognition," in *Toward Organic Ambient Intelligences – EMMA* (Chapter 8), PhD Thesis, University of Le Havre, France (June 2016).

112. E. Lynch, and J. A. Paradiso, "SensorChimes: Musical mapping for sensor networks," *Proceedings of the NIME 2016 Conference* (Brisbane, Australia, July 11–15, 2016).

113. S. Russell, G. Dublon, and J. A. Paradiso, "HearThere: Networked sensory prosthetics through auditory augmented reality," *Proceedings of the ACM Augmented Human Conference* (Geneva, Switzerland, February 2016).

114. Lynch, and Paradiso, "SensorChimes," op. cit.

115. J. Cherston, E. Hill, S. Goldfarb, and J. Paradiso, "Musician and mega-machine: Compositions driven by real-time particle collision data from the ATLAS detector," *Proceedings of the NIME 2016 Conference* (Brisbane, Australia, July 11–15, 2016).

116. T. Teixeira, G. Dublon, and A. Savvides, "A survey of human-sensing: Methods for detecting presence, count, location, track, and identity," *ACM Computing Surveys* 5(1) (2010): 59–69.

117. J. A. Paradiso, J. Heidemann, and T. G. Zimmerman, "Hacking is pervasive," *IEEE Pervasive Computing* 7(3) (July–September 2008): 13–15.

118. N. Negroponte, *Being Digital* (New York: Knopf, 1995).

119. S. Mann, "Wearable computing: A first step toward personal imaging," *IEEE Computer* (February 1997): 25–32.

120. T. Starner, "The challenges of wearable computing, Parts 1 & 2," *IEEE Micro* 21(4) (July 2001): 44–67.

The Future of Human-Machine Communications: The Turing Test

KEVIN WARWICK AND
HUMA SHAH

Kevin Warwick
Coventry University, Coventry, UK

Kevin Warwick is Emeritus Professor at Reading and Coventry
Universities, UK. His main research areas are artificial intelligence,
biomedical systems, robotics, and cyborgs. He took his first degree
at Aston University, followed by a PhD and research post at Imperial
College London. He held positions at Oxford, Newcastle, Warwick,
Reading, and Coventry Universities. He has been awarded higher
doctorates (DSc) by Imperial College and the Czech Academy of
Sciences, Prague. He has also been awarded Honorary Doctorates
by nine universities. He received the IET Mountbatten Medal and the
Ellison-Cliffe Medal from the Royal Society of Medicine.

Huma Shah
Coventry University, Coventry, UK

Huma Shah is a Research Fellow in the School of Computing,
Electronics, and Mathematics at Coventry University, UK. She has a
PhD in "Deception-Detection and Machine Intelligence in Practical
Turing Tests" from Reading University, UK. She is lead or coauthor of
over thirty-five peer-reviewed publications, and with Kevin Warwick
authored the book *Turing's Imitation Game: Conversations with the
Unknown*, published by Cambridge University Press. She is a member
of the Alan Turing Centenary Advisory Committee and was active
in raising awareness of Turing's work and organizing events for his
centenary year in 2012.

The Turing test is regarded as the ultimate milestone for machine communication abilities. It involves distinguishing between a human and a computer in their responses to unrestricted questions. Here we investigate the nature of the communications, including behaviors and interaction in real Turing test scenarios to assess the state of play. In particular we consider the effects of lying, misunderstanding, humor, and lack of knowledge, giving actual examples of each. We look at specific cases of machines performing well and consider transcripts taken from the 2014 Royal Society experiment when a machine first passed the Turing test.

INTRODUCTION

Turing's imitation game, commonly known as the Turing test, was originally posed as an alternative to the question of whether or not a machine could be said to think (Turing, 1950). Since that paper appeared, a lot of discussion has focused on the concept of machine thinking and whether it can be human-like at times or even whether it will ever be possible to copy human thinking in every aspect (Dennett, 1998; Dreyfus and Dreyfus, 2009; Minsky, 1982; Shah, 2010). Turing suggested: "May not machines carry out something which ought to be described as thinking but which is very different from what a man does?" (Turing, 1950, p. 435). As a result some researchers in the field regard the test as laying the foundations for what we now know as artificial intelligence (AI), even considering it to be AI's "empirical goal" (Harnad, 1992).

What we look at here is the imitation game itself in terms of its practical instantiation with regard to human-machine interaction. The game actually involves human interrogators attempting to ascertain the nature of hidden (human and computer) entities with whom/ which they are communicating. As indicated by Turing (1950), each discourse lasts for a period of five minutes only and at the end of that time the interrogator is charged with making the "right identification" by clearly identifying the nature of their hidden discourse partners by declaring which is the human and which is the machine.

In considering the game in further depth, one is faced with numerous intriguing questions regarding human and machine communication and behavior. When comparing a machine's ability to communicate with a human interrogator one immediately has to consider just who they are communicating with and the fallibility, biases, and preconceptions of that

person. One also must take into account important aspects of human nature such as lying, misunderstanding, lack of knowledge, and humor, never mind stupidity.

Over the last few years, a number of practical Turing test sessions have been organized involving some of the best conversation machines in the world, these followed as closely as possible with the test description as given by Turing himself in his seminal paper of 1950. One set of such experiments was held at Bletchley Park, England, in 2012. Another was held at the Royal Society, London, in 2014. The latter involved the largest number of tests ever staged in any single event.

In this article, the authors report on actual transcripts from these tests as a basis to investigate just what it takes to fool a human interrogator and how examples of the use of humor and lying have affected decisions. In addition, we look at a series of cases in which human communicators have been clearly categorized by interrogators as definitely being machines and others in which machine communicators have been clearly categorized by interrogators as being human. The reader also gets a chance to test their own powers of analysis in being asked to decide on the nature of hidden entities in specific transcripts: is the hidden entity a human or a machine?

The transcripts between judges and hidden entities presented here are taken from tests in which a human judge carried out a five-minute-long conversation with two hidden entities in parallel. One of the entities was a human and the other was a machine. It was very much up to the judge as to the nature of the conversation and it was their decision as to how much time they spent conversing with each of the entities.

In a particular session a judge conducted five separate tests. In their first test they witnessed a hidden human pitted against a hidden machine. Of course the judge would not know which was which, they would simply be aware of two hidden entities and have to make their own decision on the nature of the entities, although they had been informed a priori that one entity was human and one was a machine. The second test conducted by the judge then involved a different human pitted against a different machine, although again they would not be aware of each entity's nature. And so it would go on until the judge had conducted all their five tests in that session. At the end of each test they were asked to state for each entity if they thought that it was a human, a machine, or if they were unsure.

In the tests, the hidden humans were asked merely to be themselves, humans, although they were requested not to give away their specific identity or personal information. They were not given any incentive to behave in any particular way and were given no (incentive) payment at all. Of course this did not prevent any human from giving false information, which is something that humans do frequently. The tests were "unrestricted conversations," which meant the judge could ask anything or introduce any topic within the boundaries of courtesy (the judges had been informed that there may be children among the hidden human entities).

PRACTICAL TURING TESTS

The conversations presented here were realized as a result of five-minute-long tests of human judge-hidden entity interaction, to conform to Turing's original wording in computing machinery and intelligence (Turing, 1950). We are aware that there are those who take

issue over suitable timing and what Turing actually meant (Shah and Warwick, 2010a)—that is an argument for another day, it does not alter the points made in this paper.

What this paper does is to present a number of transcripts taken from special days of practical Turing tests, which were held under strict conditions with many external viewers first at Bletchley Park, England, on June 23, 2012. The date marked the 100th anniversary of Turing's birth and the venue was that at which, during World War II, Turing led a team of code breakers to crack the German Enigma machine cipher (Hodges, 1992). The second set of tests was held on June 6–7, 2014, at the Royal Society, London, of which Alan Turing was a Fellow. Five different machines took part in both sets of tests along with thirty different judges and thirty hidden humans against which the machines were compared to in terms of their conversational ability. Although the machines were common to the two experiments, the judges and hidden humans were a different collection of people.

In this article we are certainly interested in how good or bad the machines are, indeed we want to look at how good they can be. But we are also interested in the operational performance of the judges and specifically how they interacted in conversation with hidden entities. In considering things in this way, however, questions can also be raised with regard to the hidden humans. Nevertheless we see these factors as very important aspects of the test. In particular it is important that it is a human judge who takes part. The quality of the conversation is as good or bad as is witnessed by the judge.

Hidden humans are, by definition, human, but (Shah and Warwick, 2010b; Warwick and Shah, 2015a) can themselves be misidentified on occasion. Along a spectrum, some humans are loquacious, others tend toward introvert, and many fall in between. Thus, an attribution of *humanness* by a human interrogator to a hidden interlocutor in a practical Turing test is dependent on the judge's own values of what constitutes human-like conversational behavior. This paper focuses more on the humans involved in practical Turing tests and how this impinges on our "understanding" of artificial intelligence when humans are misidentified as being machines. Good performance of machines, with numerous examples, is discussed elsewhere (Warwick and Shah, 2014a), although we do give an example here for comparative purposes.

A major reported criticism of the test has been that "the imitation game conditions say nothing about the judge, but the success of the game depends crucially on how clever, knowledgeable, and insightful the judge is" (Hayes and Ford, 1995). Because of the tests considered, we not only investigate this criticism further but also look into

Turing's statement that the test/game can be considered as a replacement for the question "Can machines think?" (Turing, 1950). While it is acknowledged that the results in each case depend on the performance of the judge, far from the conditions of the game saying nothing about the judge this aspect is seen here to be very much a critical part of the test itself. Importantly, in the test, machines are pitched against (hidden) humans under the critical analysis of other (interrogator) humans. These are all very important aspects of what the test is about and are certainly not points of fallibility of the game as suggested in Hayes and Ford (1995).

In the sections that follow, we look at different examples of practical tests and attempt to cover a wide range of problem areas as they exist at present, which the test highlights. In each case, discussion on the transcript is carried out within that section, where it is pertinent, rather than in a separate discussion section. We do however make a number of universal comments in the conclusions section toward the end of the article.

The transcripts considered in this paper appear exactly as they occurred. We have not altered the sequence or wording or corrected the spelling in any way. Once an utterance was output, it was not possible for the judge or hidden entity to alter it in any way. The timings shown are accurate, actual timings on the days (UK time) involved. Any spelling mistakes or other grammatical errors were exactly as they happened. They are not due to editorial errors. In the transcripts, the interviewer/judge is always denoted as "Judge" whereas the hidden interlocutors, machine or human, are denoted as "Entity."

"NORMAL" CONVERSATION

We include an example here simply to give an idea of a typical discourse exchange and a feeling for the potential content during a total length of five minutes. Also, it gives an indication of the sort of conversation an interrogator must base their determination on, of the nature of the hidden interlocutor, human or machine.

Transcript 1
[15:44:55] Remote: hi
[15:44:58] Judge: hi
[15:45:06] Entity: how's your day been so far?
[15:45:12] Judge: very interesting
[15:45:15] Entity: why?

[15:45:27] Judge: i have been quite busy
[15:45:31] Entity: doing what?
[15:45:47] Judge: I was working this morning
[15:45:53] Entity: oh, me too
[15:46:07] Judge: oh
[15:46:30] Entity: i was giving a talk at the Apple Store in Regent Street. Have you been?
[15:46:51] Judge: I think so — though I know the one in Covent Garden better.
[15:47:04] Entity: what do you like about that one?
[15:47:23] Judge: Apple staff are always really helpful — and I love Apple
[15:47:40] Entity: yes they are. the stores are more about playing than buying don't you think?
[15:48:25] Judge: Yes most of the time — that is one of the great things about Apple
[15:48:54] Entity: what's your favourite Apple product?
[15:49:04] Judge: My little ipad nano
[15:49:22] Entity: cool. what colour is i?
[15:49:30] Judge: orange

In this discourse a lot of banter with a number of topical issues were covered. At the end of the conversation the interrogator quite rightly decided that they had been communicating with a hidden human. However, until the topic of "Apple" was mentioned—about half way through the discourse—the interaction was fairly bland with little substance. Some conversations do, in fact, end this way after the five-minute total, which makes it very difficult for an interrogator to make a right decision, as there is little to go on. Clearly a "good" interrogator is one who will use the time effectively, asking questions that draw emotional responses rather than challenge with arithmetic, leading both human and machine to feign incapacity. Importantly it is not a case of the interrogator merely asking a set of questions of the hidden entity but rather attempting to facilitate a conversation of some depth.

LYING

Lying is a part of human nature and therefore has a role to play when it comes to the Turing test. The machine's goal is deception attempting to mislead the interrogator that it is a human. Meanwhile hidden humans are requested not to give away exactly who they are through revealing personal details, as this might aid the interrogator, but apart from that they can simply be themselves. Lying can take on many different forms from a white lie, to an unintentional lie, to a complete untruth. What we give here are a couple of examples. What we are interested in is the effect of a lie on the decision taken by the interrogator. Please see Warwick and Shah (2016a) for an in-depth analysis of these and many more transcripts.

Transcript 2
[12:43:23] Judge: Why hello there!
[12:43:41] Entity: Why hello to you too!
[12:44:51] Judge: How are you feeling on this fine day?
[12:45:12] Entity: To be quite honest a little rejected, I thought you were never going to reply :(

[12:45:42] Judge: Oh, I'm very sorry, it will not happen again.
[12:45:49] Entity: It just did!
[12:46:46] Judge: Oh, I lied then.
[12:47:12] Entity: Thats a great shame indeed.
[12:47:34] Judge: It is. Are you following the Euro 2012's at the moment?
[12:47:55] Entity: Yeah quite closely actually. I am Cristiano Ronaldo.

The main issue with this transcript occurs in the last couple of lines. The Euro 2012 refers to the European nations' football competition, which was being held at exactly the same time as the Turing event. Many English people were watching the matches on television. Cristiano Ronaldo is a Portuguese footballer. The last line reply, merely agreeing with the judge's specific question, appears to have been sufficient to categorize the entity, in the judge's opinion, as being a human. This was probably sealed by the "humorous" comment with the entity claiming to be Cristiano Ronaldo. In fact the judge correctly identified this hidden interlocutor as human.

Interestingly the specific knowledge tester about Euro 2012 was dealt with by the entity agreeing with the comment. However, the human entity openly lied about being Cristiano Ronaldo, who was himself not taking part in the experiments. The interrogator may well have seen the humorous lie as supporting evidence of the entity being human. In this case the white lie had no negative effect.

Transcript 3
[15:44:56] Judge: hi there
[15:45:06] Entity: Hello.
[15:45:15] Judge: what is your name?
[15:45:35] Entity: I do not have a name.
[15:46:10] Judge: do you go to school or work for a living?
[15:46:24] Entity: I don't recall doing any of those.
[15:47:11] Judge: what do you have planned for this weekend?
[15:47:43] Entity: Nothing. What about you?
[15:48:22] Judge: I'm at bletchley park today and sevenoaks tomorrow, have you been to either before?
[15:49:15] Entity: I haven't been to either.
[15:49:41] Judge: can you do me a mathmatical question please, what is the square root of 7

It was hard work for the judge in this case to get any conversation going even though it involved a human entity. The lie by the hidden human that they had not been to Bletchley Park is clearly incorrect because this was the venue for the event. However, the hidden human may have misunderstood the question to mean had they previously visited. If so, and they had not been there before, then they could have felt that they were telling the truth. Similarly stating that they do not have a name was a rather strange statement to make. In this case the judge's decision that the hidden entity was a machine seems defendable. The hidden human's responses were generally tame and gave nothing away. So it may be a case here of the hidden

human genuinely believing they were telling the truth, when in fact they were not, possibly due to a misunderstanding. Whatever the case, the judge made an incorrect classification as a result.

In this section we include two cases in which a misidentification has occurred. The second of these could be regarded as a good outcome in that it involves a machine being incorrectly classified as a human. The first case however involves a human misidentification and was reported on in greater depth in Warwick, Shah, and Moore (2013).

Transcript 4
[10:58:45] Judge: Hi there
[10:58:55] Entity: Hi, how are you?
[10:59:02] Judge: I'm good.
[10:59:21] Entity: what, that's your name, like in the Good Life?
[10:59:36] Judge: What do you mean by 'Good Life'?
[10:59:47] Entity: Tom and Barbara
[11:00:02] Judge: What's that?
[11:00:31] Entity: A couple who left the rat race
[11:01:03] Judge: Oh. Is that your names? Wonderful to have left the rat race. How long ago was that?
[11:01:28] Entity: Not me, I'm still in it. But it's nice to dream
[11:02:02] Judge: Yeah — would be good. I 'semi' left it. It's much less stress
[11:02:31] Entity: I'm still very young so I'm looking forward to a lot of things
[11:03:11] Judge: What kind of things?
[11:03:34] Entity: Life in general I guess, different emotions and feelings that it brings.

The transcript contains reference to Tom and Barbara Good who appeared in a UK TV program entitled "The Good Life" ("Good Neighbors" in the US) in which they left the rat race to grow their own vegetables and live off the land. The discourse indicates that the judge's knowledge may not have extended to the "Good Life." They did not appear to "understand" the utterances of the hidden entity (more of this later). Possibly as a consequence the interrogator classified the hidden human as definitely being a machine. In fact this particular human, who happens to be the first-named author of this paper, was not classified as being human by any of the six interrogators involved, a singular feat which is discussed much further in Warwick, Shah, and Moore (2013).

Transcript 5
[12:43:37] Judge: Hi, I'm Cathy.
[12:43:43] Entity: Cathy! Nice to meet you! You're a woman, if I'm not mistaken.
[12:44:20] Judge: Right. What is your name?
[12:44:29] Entity: People call me Eugene. Or "Zhenya". It is a short name for Eugene in Russia and Ukraine.

[12:45:17] Judge: NIce name. Are you from either area?

[12:45:41] Entity: Agree :-) Oh, what a fruitful conversation;-)

[12:45:52] Judge: Do you really think so?

[12:46:04] Entity: No, your guess was wrong. I don't think so. By the way, I still don't know your specialty — or, possibly, I've missed it?

[12:46:56] Judge: What speciality? What's yours?

[12:47:01] Entity: Huh? And I forgot to ask you where you are from...

[12:47:51] Judge: The universe and you?

[12:48:01] Entity: Is it your hobby to ask little poor Jewish boys such tricky questions they don't have an answer for?

At the end of this discourse the interrogator incorrectly identified the machine involved as definitely being a human. We can see here the successful ploy on the part of the machine of not answering the question posed but rather changing the subject by asking another question. The third response of the machine does seem a little off in that it completely ignored the question about origin. The final line is a good example of responding to a question in an argumentative tone. In the following section we look at further examples of machines performing well.

GOOD MACHINES

In this section we consider two examples in which machines fooled the interrogators involved to misclassify them as human. This is in essence what the Turing test is all about and hence such transcripts are significant in assessing just what aspects of human nature, in conversation at least, appear to be successfully simulated by the machine. This is discussed in much more depth in Warwick and Shah (2014a).

Transcript 6

[10:41:48] Judge: Hello. How are you?

[10:41:53] Entity: Hey.

[10:42:16] Judge: How do you like Bletchley |Park?

[10:42:20] Entity: lol.

[10:42:39] Judge: Are you from England?

[10:42:47] Entity: They have Wi-Fi here in the pub.

[10:43:31] Judge: Which pub?

[10:43:38] Entity: I'm just down the pub.

[10:44:03] Judge: Have you ever been in a Turing Test before?

[10:44:08] Entity: Will this be the 5 minute argument, or were you thinking of going for the full half hour.

[10:44:55] Judge: Very funny. You sound suspiciously human. Do you like the Beatles?

[10:45:02] Entity: I'd like to get the next Dread the Fear tape.

[10:45:20] Judge: What is Dread the Fear?

[10:45:24] Entity: Dread the fear has that Steve Henderson guy in it.

[10:46:08] Judge: What sort of music is that? Or is it comedy?

The machine entity was identified as definitely being human at the end of the conversation. The conversation did not start well for the machine in this test. In their third response the mention of both Wi-Fi and pub seemed out of context. But it got back on track with the Monty Python humorous link between five-minute Turing tests and a comedy sketch about the Argument clinic quote: "Is this a five-minute argument or the full half hour?" Then in response to the Beatles question a direct answer is not given but the music link remains as the conversation shifted.

The entity appeared to show in-depth knowledge about a pop group named Dread the Fear, which probably convinced the judge, unaware of this information. The machine developer is American so this group and Steve Henderson may be parochial to the developer's location. Importantly the entity gave a convincing and plausible response.

Transcript 7

[12:23:19] Judge: What is black and white and read all over?
[12:23:32] Entity: I don't have true sense of color perception I am only able to see the RGB values.
[12:24:08] Judge: That's ok. Do you like jokes?
[12:24:19] Entity: Please tell me your inclination to a good sense of humor first.
[12:24:40] Judge: A person who can laugh at one's self.
[12:24:46] Entity: Would you like to hear a joke?
[12:24:54] Judge: Yes, please.
[12:25:21] Entity: This joke has been making the rounds in robotic circles:
A robot goes to the doctor and says: "My left arm is stuck. Give me a new arm."
The doctor answers: "Your arm is fine. We'll have to replace the rest of you."
[12:26:06] Judge: Ha! Ha! Why did the chicken cross the road?
[12:26:22] Entity: The chicken wandered into the road because it liked the shiny colors of the cars and trucks whizzing by.
[12:27:39] Judge: You're right. It didn't care if it got to the otherside.
[12:27:50] Entity: By the way, did you ever actually see a chicken crossing the road?
[12:28:03] Judge: Only one that didn't make it.

Here humor is applied directly by the machine, curiously with a machine-type reference. Nevertheless the interrogator was certain, at the end of the five minutes, that they had been conversing with a human. In his paper (Turing, 1950) Turing referred to the argument due to disability that some humans might use as a defense against machines being intelligent—humor being one of those aspects.

The first line uttered by the entity is a little strange, but their third line is masterly. In response to the judge's comment about laughing, the entity takes control of the conversation by offering to tell a joke. Later when the judge mentions a chicken, the entity correctly follows up with a suitable response and once again takes control of the conversation by asking the judge a pertinent question. So "understanding" what the key issue is on a couple of occasions and actually taking control of the conversation were sufficient here for the deception to occur. In this case the machine successfully gave the illusion of understanding the judge's utterances, and such understanding

"Rachael: Do you like our owl?

Deckard: It's artificial?

Rachael: Of course it is.

Deckard: Must be expensive.

Rachael: Very.

Rachael: I'm Rachael.

Deckard: Deckard.

Rachael: It seems you feel our work is not
a benefit to the public.

Deckard: Replicants are like any other machine
—they're either a benefit or a hazard. If they're a
benefit, it's not my problem.

Rachael: May I ask you a personal question?

Deckard: Sure.

Rachael: Have you ever retired a human by mistake?

Deckard: No."

Blade Runner (1982), Ridley Scott.

"'More human than human'
is our motto."

Eldon Tyrell (Joe Turkel) in *Blade Runner* (1982). Ridley
Scott freely adapted Philip K. Dick's (1928–82) science-
fiction novel *Do Androids Dream of Electric Sheep?* (1968).

Blade Runner (1982), Ridley Scott.

has been indicated on many occasions as being a basic prerequisite for intelligence, for example, Penrose, 1994; Searle, 1997.

KNOWLEDGE ASSUMPTION

It is apparent in the Turing test that very often an interrogator will resort to asking direct factual questions even though there is little to be gained by such a ploy. As Turing (Turing, 1950) indicated, mathematical questions are a complete waste of time. However, the same conclusion is apparent in general. Consider the following example transcript:

Transcript 8
[15:21:30] Judge: Hi, did you know the world cup is on this week?
[15:21:44] Entity: nopes.
[15:21:55] Judge: Do you like football? What team do you support?
[15:22:08] Entity: i dont watch football
[15:22:14] Judge: What sport do you like?
[15:22:33] Entity: i bit of tennis, cricket, and bits of rest
[15:22:42] Judge: I see, do you have an XBox?
[15:22:46] Entity: nopes
[15:23:04] Judge: nopes? Do you not like computer games?
[15:23:22] Entity: i do. but not on Xbox
[15:23:47] Judge: I see, can you tell me what a limerick is?
[15:23:55] Entity: no idea
[15:24:09] Judge: Who is your favourite actor? Mine is David Niven.
[15:24:24] Entity: i am not much of a movie freak either!
[15:24:43] Judge: you must have a favourite actor.
Name any actor in any film you like?
[15:25:22] Entity: well in films i like Pirates of the
Carrebean series, Harry Potter
[15:25:34] Judge: What did I say was on this week?
[15:25:50] Entity: football world cup
[15:26:02] Judge: lovely old job. What school do you go to?
[15:26:17] Entity: systems engineering
[15:26:26] Judge: is that a school?

Here we see a variety of questions based on the interrogator searching for specific knowledge, possibly even looking for a particular answer (Warwick and Shah, 2014b). It is unclear what the expected conclusions were however (Warwick and Shah, 2016b). Questions about a limerick and favorite movie actor in particular were responded to with a null reply, hence very little can be concluded from them. In the final lines we see an interesting situation in which the judge is either not apparently aware of the systems engineering school or is thinking in terms of a different type of school. Despite this the judge correctly identified the nature of the hidden entity classifying them as human, though gender blur effect occurred: they felt them to be female when in fact they were male. The reference to the world cup by the judge as an opening gambit was in fact incorrect; it was Euro 2012. Perhaps the opening question is a lie?

Transcript 9

[11:13:15] Judge: pastasciutta
[11:13:22] Entity: what?
[11:13:44] Judge: anythiong familiar in this word ?
[11:14:18] Entity: I cannot see any sexual aspect at all
[11:14:42] Judge: nothing to do with sex. try again
[11:14:49] Entity: why?
[11:15:14] Judge: just asking you to try again
[11:15:23] Entity: I am bored with it
[11:16:04] Judge: c'mon a little effort btw are you in my same time zone ?
[11:16:24] Entity: I believe that the world should just have one time.
[11:17:27] Judge: why ?
[11:17:58] Entity: seems sensible, easier for all. Better with computer

There are two issues early on in this transcript. To start with the judge throws in the word "pastasciutta" as a knowledge test for the entity. It is not clear how knowing such a word would indicate that the entity was either human or machine. Secondly the entity makes a response in terms of the use of the word "familiar" in a "sexual" sense. The judge appears to be unaware of such a meaning (Fowler and Fowler, 1995). So here we firstly see a test of specific knowledge by the judge but also an apparent lack of specific knowledge by the same judge. As a result, the judge misidentified the human entity, deciding them to be definitely a machine.

ROYAL SOCIETY EXPERIMENT

Turing set a pass mark for his test (Turing, 1950) of 30% in the sense that for a machine to pass, at least 30% of the judges who interrogated that machine would not be able to make the right identification in the tests in which they were involved. We take this to mean that the judges could not identify the machine as actually being a machine in those tests, rather than also including cases in which the hidden human was not classified as being human.

In the Royal Society experiment a machine called Eugene Goostman, who poses as a thirteen-year-old Ukrainian boy, achieved a score of 33% (Warwick and Shah, 2015b). In fact, if cases of human misidentification are also included, then the score rises to 45%. Here we

include two of the transcripts involved in order to give the reader an idea of the sorts of conversations that a machine can have. Again we make a few comments on the nature of the conversation in each case.

Transcript 10
[16:29:04] Judge: how tall are you
[16:29:10] Entity: My height is about 160 cm — it's 5 feet 4 inches.
[16:29:37] Judge: how heavy are you
[16:29:59] Entity: My grandfather taught me not to disclose non-solicited information about myself. Like on the question 'Do you have watch' — never tell time, but answer 'Yes' or 'No'. I always follow his advice. And I forgot to ask you where you are from …
[16:31:09] Judge: what is your gender
[16:31:17] Entity: I'm a young boy, if you care to know. And not very ugly, by the way!
[16:32:26] Judge: what are you aware of at this moment
[16:32:37] Entity: I would rather not talk about it if you don't mind. Could you tell me what are you? I mean your profession.
[16:33:09] Judge: how old are you
[16:33:12] Entity: I'm a little boy 13 years old.
[16:33:38] Judge: what are your qualifications
[16:33:43] Entity: My qualifications? I'm not gonna tell you. Oooh. Anything else?

In this conversation, the judge stated that they were unsure about the nature of the entity, that is, they did not identify it as being a machine. Indeed they were also unsure about the parallel human, the transcript for which is not shown here. Although Eugene (the computer program) did give some direct information to a specific question, he also diverted some of the questioning and even asked questions himself. It has to be said though that the judge stuck to their guns and continued the particular line that they were taking, not going along with the chatty nature of Eugene. Clearly it did not work.

Transcript 11
[16:21:00] Judge: what did you have for breakfast today
[16:21:10] Entity: Is it 'the third degree'? I'm not going to answer such a provocative question! Well, let's go on though.
[16:21:56] Judge: do go on … your call?
[16:22:06] Entity: It is highly possible. By the way, what's your occupation? I mean — could you tell me about your work?
[16:22:30] Judge: so you are asking me now eh? I am an actress and writer
[16:22:38] Entity: Well, I'll read something of your books, if they ain't too tedious (which is highly possible:-)
[16:23:15] Judge: grammer … aren't too tedious! A bit rude of you …
[16:23:17] Entity: Calm down, please.
[16:23:49] Judge: i asure you i am very calm … are you?
[16:24:01] Entity: Don't even bother me with the fact that you are very calm … are mine. And I forgot to ask you where you are from …

[16:25:01] Judge: I am from Dorset ... where are you from?
[16:25:08] Entity: I am from Ukraine, from the city called Odessa.
You might have heard about it.

In this case Eugene did not answer questions from the start, other than in the final instance when being asked where he was from. Indeed he managed to get into something of a discussion, even an argument with the judge. All of which added to the conclusion in the judge's mind that the hidden entity was a human, which is what they decided, selecting them as a non-native English speaking person. In this case the judge did, to an extent, go along with Eugene asking a question. Controlling the conversation is an important tool for a machine and can put a judge onto the back foot. In this instance it worked well.

TEST FOR THE READER

As a final section we have included here two discourses for the reader to test their own abilities at categorizing the hidden entity as being either a human or a machine. The interrogators' decision in each case and the actual identification of the entity are given after the conclusions.

Just as with the previous transcripts, the two given here as examples are listed exactly as they occurred on the day and no editing has taken place. They are genuine transcripts. In each conversation the judge was a human; however, the entity could be a human or a machine, this is for you to decide based only on the information in front of you. This is what the Turing Imitation Game is all about.

Transcript 12
[16:11:18] Judge: WHAT MUSIC DO YOU LIKE?
[16:11:47] Entity: electronica mainly and a bit of symphonic rock
[16:11:56] Judge: omg i lyke teenie tamparrr
[16:12:32] Entity: Trying to get into Grimes at the moment but struggling
[16:13:10] Judge: yeah i knooo
[16:13:49] Entity: School of Seven Bells is the best new band I've heard recently
[16:14:01] Judge: i see dead people
[16:14:41] Entity: Dead Cities was a good album, can't remember who by
[16:14:52] Judge: i think it was a band called the sixth sense?
[16:15:18] Entity: Sounds about right, perhaps there's a ghost in the machine

[16:15:34] Judge: yes indeed.
[16:15:46] Entity: Ever seen ghost in the shell?
[16:16:01] Judge: Casper the friendly ghost.

Transcript 13
[15:46:05] Judge: My favourite music is contemporary Jazz, what do youy prefer
[15:46:14] Entity: To be short I'll only say that I HATE Britnie Spears. All other music is OK compared to her.
[15:47:06] Judge: do you like to play any musical instruments
[15:47:23] Entity: I'm tone-deaf, but my guinea pig likes to squeal Beethoven's "Ode to Joy" every morning. I suspect our neighbors want to cut his throat... Could you tell me about your job, by the way?
[15:48:02] Judge: Guine pig/are you an animal lover
[15:48:08] Entity: Yeah. A nice little guinea pig. Not some annoying chatter bot.
[15:48:50] Judge: do you live with anyone else?
[15:48:59] Entity: Yes I do. But better ask something else. And I forgot to ask you where you are from...
[15:49:39] Judge: Ireland? geen patures and too much rain! How about you

CONCLUSIONS

Much mileage has driven numerous philosophers to the importance of "understanding" and the critical role it plays in intelligence. As stated in Penrose (1994): "intelligence requires understanding." The Turing test, particularly in its practical form, can be seen to play an important role in this discussion, as we can conclude from some of the transcripts presented, in terms of conversational appearance at least: there are some humans who appear to be lacking in intelligence whereas there are some machines that clearly have it in abundance. Meanwhile ignoring such evidence requires a scientific argument if the hypothesis that "intelligence requires understanding" is to hold.

It can be seen from the examples given that some judges in these tests could be more susceptible than others to deception, or have a biased perspective on "human-like conversation." This may have lead the judges in some cases here to misclassify hidden

interlocutors, even though they actually initiated the conversation and were given the possibility of asking or discussing whatever they wanted. Essentially the conversations were unrestricted.

Not all of the five invited machines in these experiments were designed to imitate humans. Elbot, for example, from Artificial Solutions has a robot personality. However, all are designed to mimic conversation, sometimes deploying spelling mistakes and always avoiding mathematical questions. Essentially the machines are not trying to be perfect or to give correct answers; they are merely trying to respond in the sort of way that a human might.

Although Turing designed the test as an answer to the question *"can machines think?,"* it has become regarded in a sense by many as some sort of competition to see how well machines perform and as a standard in assessing how machines are progressing with regard to artificial intelligence. Just what role it plays as far as the development of artificial intelligence is concerned is a big question that is not easily answered. Some, however, see it as a milestone and of vital importance to artificial intelligence. Whatever the standing of the Turing test, what we hope is evident from the transcripts presented is that it is certainly not a trivial, simple exercise: indeed, it is a surprising indication of how humans communicate and how other humans (the judges) can be easily fooled.

But in this article we started out trying to give an up-to-date perspective on an important aspect of artificial intelligence research, namely human-machine communications. It is critical to note that such a study involves humans as conversationalists and respondents as well as machines. Yes we can witness just how machine conversation is steadily improving, in terms of its human-like nature. But we also have to take into account humans who are involved in the conversing, with all of their fallibilities and odd reasoning. For the machine developers these aspects give rise to particular features in their conversational programs. It is worth remembering that the machines do not have to be perfect but rather they have to be human-like.

ANSWERS TO THE READER'S TEST

Transcript 12
Having gone well initially the conversation fell apart in the last few lines, perhaps because the hidden entity powered the conversation in their direction, dominating the conversation, throwing in reference to "ghost in the shell," which the judge had not heard of. The main issue seemed a "generation gap"; the hidden entity was an adult male human and this possibly caused the female teenage judge to misclassify them as machine.

Transcript 13
The judge was slow to get going and this was a relatively short conversation. The entity responded appropriately on topic to each point. The entity also steered the conversation on each occasion and even threw in a humorous comment about a guinea pig. The reference to a chatter bot could have been a giveaway, but this was not spotted by the interrogator. The entity concluded by taking over the conversation and asked the

interrogator a question. In this discourse the interrogator misclassified the machine entity as being human.

ACKNOWLEDGMENTS

The authors would like to thank those whose financial support made the Bletchley Park and Royal Society tests possible and the elite machine developers involved. An earlier version of this article was presented at the 7th International Conference on Agents and Artificial Intelligence, Lisbon, Portugal, January 2015 (Warwick and Shah, 2015c).

—Dennett, D. 1998. "Can machines think?" In *Foundations of Cognitive Philosophy*, D. J. Levitin (ed.). Cambridge, MA: MIT Press, Chapter 3.

—Dreyfus, H., and Dreyfus, A. 2009. "Why computers may never be able to think like people." In *Readings in the Philosophy of Technology*, D. M. Kaplan (ed.). Lanham, MD: Rowman & Littlefield, Chapter 25.

—Fowler, H., and Fowler, F. (eds.). 1995. *The Concise Oxford Dictionary of Current English*. Oxford: Clarendon Press, 9th ed., 486.

—Harnad, S. 1992. "The Turing test is not a trick: Turing indistinguishability is a scientific criterion." *ACM SIGART Bulletin* 3(4): 9–10.

—Hayes, P., and Ford, K. 1995. "Turing test considered harmful." *Proceedings of the International Joint Conference on Artificial Intelligence* 1, Montreal: 972–977.

—Hodges, A. 1992. *Alan Turing: The Enigma*. New York: Vintage Press.

—Minsky, M. 1982. "Why people think computers can't." *AI Magazine* 3(4): 3–15.

—Penrose, R. 1994. *Shadows of the Mind*. Oxford: Oxford University Press.

—Searle, J. 1997. *The Mystery of Consciousness*. New York: New York Review of Books.

—Shah, H. 2010. "Deception-detection and machine intelligence in practical Turing tests." PhD Thesis, University of Reading, UK.

—Shah, H., and Warwick, K. 2010a. "Testing Turing's five minutes, parallel-paired imitation game." *Kybernetes* 39(3): 449–465.

—Shah, H., and Warwick, K. 2010b. "Hidden interlocutor misidentification in practical Turing tests." *Minds and Machines* 20(3): 441–454.

—Turing, A. 1950. "Computing, machinery and intelligence." *Mind* LIX (236): 433–460.

—Warwick, K., Shah, H., and Moor, J. 2013. "Some implications of a sample of practical Turing tests." *Minds and Machines* 23(2): 163–177.

—Warwick, K., and Shah, H. 2014a. "Good machine performance in Turing's imitation game." *IEEE Transactions on Computational Intelligence and AI in Games* 6(3): 289–299.

—Warwick, K., and Shah, H. 2014b. "Assumption of knowledge and the Chinese Room in Turing test interrogation." *AI Communications* 27(3): 275–283.

—Warwick, K., and Shah, H. 2015a. "Human misidentification in Turing tests." *Journal of Experimental and Theoretical Artificial Intelligence* 27(2): 123–135.

—Warwick, K., and Shah, H. 2015b. "Can machines think? A report on Turing test experiments at the Royal Society." *Journal of Experimental and Theoretical Artificial Intelligence*. doi:10.1080/0952813X.2015.1055826.

—Warwick, K., and Shah, H. 2015c. "Intelligent agents: conversations from human-agent imitation games." *Proceedings of ICAART*, Lisbon: 261–268.

—Warwick, K., and Shah, H. 2016a. "Effects of lying in practical Turing tests." *AI & Society* 31(1): 5–15.

—Warwick, K. and Shah, H., "The Importance of a Human Viewpoint on Computer Natural Language Capabilities: A Turing Test Perspective", *AI & Society* 31 (2): 207-221.

Artificial Intelligence and the Arts: Toward Computational Creativity

RAMÓN LÓPEZ DE MÁNTARAS

Opening image:
Martial Raysse
America, America (1964)
Neon, painted metal
2.4 × 1.65 × 0.45 m
Centre Pompidou–Musée national
d'art moderne–Centre de création
industrielle, Paris, France.

Ramón López de Mántaras
Artificial Intelligence Research Institute (IIIA)
Spanish National Research Council (CSIC), Bellaterra, Spain

Ramón López de Mántaras is a Research Professor of the Spanish National Research
Council (CSIC) and Director of the Artificial Intelligence Research Institute (IIIA).
He has an MSc in Computer Science from the University of California Berkeley, USA,
a PhD in Physics from the University of Toulouse, France, and a PhD in Computer
Science from the Technical University of Barcelona, Spain. López de Mántaras is
a pioneer of artificial intelligence (AI) in Spain and an invited plenary speaker at
numerous international conferences. He is an editorial board member of several
international journals, an ECCAI Fellow, and the recipient, among other awards, of
the "City of Barcelona" Research Prize, the "2011 American Association of Artificial
Intelligence (AAAI) Robert S. Engelmore Memorial Award", the 2012 "Spanish
National Computer Science Award" from the Spanish Computer Society, and
the 2016 "Distinguished Service Award" of the European Association of Artificial
Intelligence (EurAI). He serves on a variety of panels and advisory committees for
public and private institutions based in the USA and Europe.

New technologies, and in particular artificial intelligence, are drastically changing the nature of creative processes. Computers are playing very significant roles in creative activities such as music, architecture, fine arts, and science. Indeed, the computer is already a canvas, a brush, a musical instrument, and so on. However, we believe that we must aim at more ambitious relations between computers and creativity. Rather than just seeing the computer as a tool to help human creators, we could see it as a creative entity in its own right. This view has triggered a new subfield of Artificial Intelligence called Computational Creativity. This article addresses the question of the possibility of achieving computational creativity through some examples of computer programs capable of replicating aspects of creative artistic behavior. We end with some reflections on the recent trend of democratization of creativity by means of assisting and augmenting human creativity.

INTRODUCTION

Computational creativity is the study of building software that exhibits behavior that would be deemed creative in humans. Such creative software can be used for autonomous creative tasks, such as inventing mathematical theories, writing poems, painting pictures, and composing music. However, computational creativity studies also enable us to understand human creativity and to produce programs for creative people to use, where the software acts as a creative collaborator rather than a mere tool. Historically, it has been difficult for society to come to terms with machines that purport to be intelligent and even more difficult to admit that they might be creative. Even within Computer Science, people are still skeptical about the creative potential of software. A typical statement of detractors of computational creativity is that "simulating artistic techniques means also simulating human thinking and reasoning, especially creative thinking. This is impossible to do using algorithms or information processing systems." We could not disagree more. As is hopefully evident from the examples in this paper, creativity is not some mystical gift that is beyond scientific study but rather something that can be investigated, simulated, and harnessed for

the good of society. And while society might still be catching up, computational creativity as a discipline has come of age. This maturity is evident in the amount of activity related to computational creativity in recent years; in the sophistication of the creative software we are building; in the cultural value of the artifacts being produced by our software; and most importantly, in the consensus we are finding on general issues of computational creativity.

Computational creativity is a very lively subject area, with many issues still open to debate. For instance, many people still turn to the Turing test (Turing, 1950) to approximate the value of the artifacts produced by their software. That is, if a certain number of people cannot determine which artifacts were computer generated and which were human generated, then the software is doing well. Other people believe that the Turing test is inappropriate for creative software. One has to ask the question: "Under full disclosure, would people value the artifacts produced by a computer as highly as they would the human produced ones?" In some domains, the answer could be yes: for instance, a joke is still funny whether or not it is produced by a computer. In other domains, such as the visual arts, however, the answer is very likely to be no. This highlights the fact that the production process, and not just the outcome of it, is taken into account when assessing artworks. Hence, one could argue that such Turing-style tests are essentially setting the computers up for a fall.

Building creative software provides both a technical challenge and a social one. To proceed further, we need to embrace the fact that computers are not human. We should be loud and proud about the artifacts being produced by our software. We should celebrate the sophistication of the artificial intelligence (AI) techniques we have employed to endow the software with creative behavior. And we should help the general public to appreciate the value of these computer creations by describing the methods employed by the software to create them.

Creativity seems mysterious because when we have creative ideas it is very difficult to explain how we got them and we often talk about vague notions like "inspiration" and "intuition" when we try to explain creativity. The fact that we are not conscious of how a creative idea manifests itself does not necessarily imply that a scientific explanation cannot exist. As a matter of fact, we are not aware of how we perform other activities such as language understanding, pattern recognition, and so on, but we have better and better AI techniques able to replicate such activities.

Since nothing can arise from the emptiness, we must understand that every creative work or creative idea is always preceded by a historical-cultural scheme; it is a fruit of the cultural inheritance and the lived experiences. As Margaret Boden states in her book *Artificial Intelligence and Natural Man* (Boden, 1987):

> Probably the new thoughts that originate in the mind are not completely new, because have their seeds in representations that already are in the mind. To put it differently, the germ of our culture, all our knowledge and our experience, is behind each creative idea. The greater the knowledge and the experience, the greater the possibility of finding an unthinkable relation that leads to a creative idea. If we understand creativity like the result of establishing new relations between pieces of knowledge that we already have, then the more previous knowledge one has the more capacity to be creative.

With this understanding in mind, an operational, and widely accepted, definition of creativity is: "A creative idea is a novel and valuable combination of known ideas." In other words, physical laws, theorems, musical pieces can be generated from a finite set of existing elements and, therefore, creativity is an advanced form of problem solving that involves memory, analogy, learning, and reasoning under constraints, among others, and is therefore possible to replicate by means of computers.

This article addresses the question of the possibility of achieving computational creativity through some examples of computer programs capable of replicating some aspects of creative behavior. Due to space limitations we could not include other interesting areas of application such as: storytelling (Gervás, 2009), poetry (Montfort et al., 2014), science (Langley et al., 1987), or even humor (Ritchie, 2009). Therefore, the paper addresses, with different levels of detail, representative results of some achievements in the fields of music and visual arts. The reason for focusing on these artistic fields is that they are by far the ones in which there is more activity and where the results obtained are most impressive. The paper ends with some reflections on the recent trend of democratization of creativity by means of assisting and augmenting human creativity.

For further reading regarding computational creativity in general, I recommend the *AI Magazine* special issue on *Computational Creativity* (Colton et al., 2009), as well as the books by Boden (1991, 1994, 2009), Dartnall (1994), Partridge & Rowe (1994), Bentley & Corne (2002), and McCormack & d'Inverno (2012).

COMPUTATIONAL CREATIVITY IN MUSIC

Artificial intelligence has played a crucial role in the history of computer music almost since its beginnings in the 1950s. However, until quite recently, most effort had been on compositional and improvisational systems and little effort had been devoted to expressive performance. In this section we review a selection of some significant achievements in AI approaches to music composition, music performance, and improvisation, with an emphasis on the performance of expressive music.

Composing Music

Hiller and Isaacson's (1958) work, on the ILLIAC computer, is the best-known pioneering work in computer music. Their chief result is the *Illiac Suite*, a string quartet composed following the "generate and test" problem-solving approach. The program generated notes pseudo-randomly by means of Markov chains. The generated notes were next tested by means of heuristic compositional rules of classical harmony and counterpoint. Only the notes satisfying the rules were kept. If none of the generated notes satisfied the rules, a simple backtracking procedure was used to erase the entire composition up to that point, and a new cycle was started again. The goals of Hiller and Isaacson excluded anything related to expressiveness and emotional content. In an interview (Schwanauer and Levitt, 1993, p. 21), Hiller and Isaacson said that, before addressing the expressiveness issue, simpler problems needed to be handled first. We believe that this was a very correct observation in the 1950s. After this seminal work, many other researchers based their computer compositions on Markov probability transitions

but also with rather limited success judging from the standpoint of melodic quality. Indeed, methods relying too heavily on Markovian processes are not informed enough to produce high-quality music consistently.

However, not all the early work on composition relies on probabilistic approaches. A good example is the work of Moorer (1972) on tonal melody generation. Moorer's program generated simple melodies, along with the underlying harmonic progressions, with simple internal repetition patterns of notes. This approach relies on simulating human composition processes using heuristic techniques rather than on Markovian probability chains. Levitt (1993) also avoided the use of probabilities in the composition process. He argues that "randomness tends to obscure rather than reveal the musical constraints needed to represent simple musical structures." His work is based on constraint-based descriptions of musical styles. He developed a description language that allows expressing musically meaningful transformations of inputs, such as chord progressions and melodic lines, through a series of constraint relationships that he calls "style templates." He applied this approach to describe a traditional jazz walking bass player simulation as well as a two-handed ragtime piano simulation.

The early systems by Hiller-Isaacson and Moorer were both based also on heuristic approaches. However, possibly the most genuine example of the early use of AI techniques is the work of Rader (1974). Rader used rule-based AI programming in his musical round (a circle canon such as "Frère Jacques") generator. The generation of the melody and the harmony were based on rules describing how notes or chords may be put together. The most interesting AI component of this system are the applicability rules, determining the applicability of the melody and chords generation rules, and the weighting rules indicating the likelihood of application of an applicable rule by means of a weight. We can already appreciate the use of meta-knowledge in this early work.

AI pioneers such as Herbert Simon or Marvin Minsky also published works relevant to computer music. Simon and Sumner (1968) describe a formal pattern language for music, as well as a pattern induction method, to discover patterns more or less implicit in musical works. One example of pattern that can be discovered is: "The opening section is in C Major, it is followed by a section in dominant and then a return to the original key." Although the program was not completed, it is worth noticing that it was one of the first in dealing with the important issue of music modelling, a subject that has been, and still is, widely studied. For example, the use of models based on generative grammars has been, and continues to be, an important and very useful approach in music modelling (Lerdahl and Jackendoff, 1983).

Marvin Minsky in his well-known paper "Music, Mind, and Meaning" (1981) addresses the important question of "how music impresses our minds." He applies his concepts of agent and its role in a society of agents as a possible approach to shed light on that question. For example, he hints that one agent might do nothing more than notice that the music has a particular rhythm. Other agents might perceive small musical patterns, such as repetitions of a pitch; differences such as the same sequence of notes played one fifth higher, and so on. His approach also accounts for more complex relations within a musical piece by means of higher order agents capable of recognizing large sections of music. It is important to clarify that in that paper Minsky does not try to convince the reader about the question of the validity of his approach, he just hints at its plausibility.

Among the compositional systems there is a large number dealing with the problem of automatic harmonization using several AI techniques. One of the earliest works is that of Rothgeb (1969). He wrote a SNOBOL program to solve the problem of harmonizing the unfigured bass (given a sequence of bass notes infer the chords and voice leadings that accompany those bass notes) by means of a set of rules such as: "If the bass of a triad descends a semitone, then the next bass note has a sixth." The main goal of Rothgeb was not the automatic harmonization itself but to test the computational soundness of two bass harmonization theories from the eighteenth century.

One of the most complete works on harmonization is that of Ebcioglu (1993). He developed an expert system, CHORAL, to harmonize chorales in the style of J. S. Bach. CHORAL is given a melody and produces the corresponding harmonization using heuristic rules and constraints. The system was implemented using a logic programming language designed by the author. An important aspect of this work is the use of sets of logical primitives to represent the different viewpoints of the music (chords view, time-slice view, melodic view, etc.). This was done to tackle the problem of representing large amounts of complex musical knowledge.

MUSACT (Bharucha, 1993) uses neural networks to learn a model of musical harmony. It was designed to capture musical intuitions of harmonic qualities. For example, one of the qualities of a dominant chord is to create in the listener the expectancy that the tonic chord is about to be heard. The greater the expectancy, the greater the feeling of consonance of the tonic chord. Composers may choose to satisfy or violate these expectancies to varying degree. MUSACT is capable of learning such qualities and generating graded expectancies in a given harmonic context.

In HARMONET (Feulner, 1993), the harmonization problem is approached using a combination of neural networks and constraint satisfaction techniques. The neural network learns what is known as harmonic functionality of the chords (chords can play the function

of tonic, dominant, subdominant, etc.) and constraints are used to fill the inner voices of the chords. The work on HARMONET was extended in the MELONET system (Hörnel and Degenhardt, 1997; Hörnel and Menzel, 1998). MELONET uses a neural network to learn and reproduce a higher level structure in melodic sequences. Given a melody, the system invents a Baroque-style harmonization and variation of any chorale voice. According to the authors, HARMONET and MELONET together form a powerful music-composition system that generates variations whose quality is similar to those of an experienced human organist.

Pachet and Roy (1998) also used constraint satisfaction techniques for harmonization. These techniques exploit the fact that both the melody and the harmonization knowledge impose constraints on the possible chords. Efficiency is, however, a problem with purely constraint satisfaction approaches.

In Sabater et al. (1998), the problem of harmonization is approached using a combination of rules and case-based reasoning. This approach is based on the observation that purely rule-based harmonization usually fails because, in general, "the rules do not make the music, it is the music that makes the rules." Then, instead of relying only on a set of imperfect rules, why not make use of the source of the rules, that is, the compositions themselves? Case-based reasoning allows the use of examples of already harmonized compositions as cases for new harmonizations. The system harmonizes a given melody by first looking for similar, already harmonized, cases; when this fails, it looks for applicable general rules of harmony. If no rule is applicable, the system fails and backtracks to the previous decision point. The experiments have shown that the combination of rules and cases results in much fewer failures in finding an appropriate harmonization than using either technique alone. Another advantage of the case-based approach is that each newly correctly harmonized piece can be memorized and made available as a new example to harmonize other melodies; that is, a learning-by-experience process takes place. Indeed, the more examples the system has, the less often the system needs to resort to the rules and therefore it fails less. MUSE (Schwanauer, 1993) is also a learning system that extends an initially small set of voice leading constraints by learning a set of rules of voice doubling and voice leading. It learns by reordering the rules agenda and by chunking the rules that satisfy the set of voice leading constraints. MUSE successfully learned some of the standard rules of voice leading included in traditional books of tonal music.

Morales-Manzanares et al. (2001) developed a system called SICIB capable of composing music using body movements. This system uses data from sensors attached to the dancer and applies inference rules to couple the gestures with the music in real time.

Certainly the best-known work on computer composition using AI is David Cope's EMI project (Cope, 1987, 1990). This work focuses on the emulation of styles of various composers. It has successfully composed music in the styles of Cope, Mozart, Palestrina, Albinoni, Brahms, Debussy, Bach, Rachmaninoff, Chopin, Stravinsky, and Bartok. It works by searching for recurrent patterns in several (at least two) works of a given composer. The discovered patterns are called signatures. Since signatures are location dependent, EMI uses one of the composer's works as a guide to fix them to their appropriate locations when composing a new piece. To compose the musical motives between signatures, EMI uses a compositional rule analyzer to discover the constraints used by the composer in his works. This analyzer counts musical events such as voice leading directions, use of repeated notes, and so on, and represents them as a statistical model of the analyzed works. The program follows this model to compose the motives to be inserted in the

empty spaces between signatures. To properly insert them, EMI has to deal with problems such as: linking initial and concluding parts of the signatures to the surrounding motives avoiding stylistic anomalies; maintaining voice motions; maintaining notes within a range, and so on. Proper insertion is achieved by means of an Augmented Transition Network (Woods, 1970). The results, although not perfect, are quite consistent with the style of the composer.

Synthesizing Expressive Music

One of the main limitations of computer-generated music has been its lack of expressiveness, that is, lack of "gesture." Gesture is what musicians call the nuances of performance that are uniquely and subtly interpretive or, in other words, creative.

One of the first attempts to address expressiveness in music is that of Johnson (1992). She developed an expert system to determine the tempo and the articulation to be applied when playing Bach's fugues from "The Well-Tempered Clavier." The rules were obtained from two expert human performers. The output gives the base tempo value and a list of performance instructions on notes duration and articulation that should be followed by a human player. The results very much coincide with the instructions given in well-known commented editions of "The Well-Tempered Clavier." The main limitation of this system is its lack of generality because it only works well for fugues written on a 4/4 meter. For different meters, the rules should be different. Another obvious consequence of this lack of generality is that the rules are only applicable to Bach fugues.

The work of the KTH group from Stockholm (Friberg, 1995; Friberg et al., 1998, 2000; Bresin, 2001) is one of the best-known long-term efforts on performance systems. Their current Director Musices system incorporates rules for tempo, dynamic, and articulation transformations constrained to MIDI. These rules are inferred both from theoretical musical knowledge and experimentally by training, specially using the so-called analysis-by-synthesis approach. The rules are divided in three main classes: differentiation rules, which enhance the differences between scale tones; grouping rules, which show what tones belong together; and ensemble rules, which synchronize the various voices in an ensemble.

Canazza et al. (1997) developed a system to analyze how the musician's expressive intentions are reflected in the performance. The analysis reveals two different expressive dimensions: one related to the energy (dynamics) and the other related to the kinetics (rubato) of the piece. The authors also developed a program for generating expressive performances according to these two dimensions.

The work of Dannenberg and Derenyi (1998) is also a good example of articulation transformations using manually constructed rules. They developed a trumpet synthesizer that combines a physical model with a performance model. The goal of the performance model is to generate control information for the physical model by means of a collection of rules manually extracted from the analysis of a collection of controlled recordings of human performance.

Another approach taken for performing tempo and dynamics transformation is the use of neural network techniques. In Bresin (1998), a system that combines symbolic decision rules with neural networks is implemented for simulating the style of real piano performers. The outputs of the neural networks express time and loudness deviations. These neural networks extend the standard feed-forward network trained with the back propagation algorithm with feedback connections from the output neurons to the input neurons.

We can see that, except for the work of the KTH group that considers three expressive resources, the other systems are limited to two resources, such as rubato and dynamics, or rubato and articulation. This limitation has to do with the use of rules. Indeed, the main problem with the rule-based approaches is that it is very difficult to find rules general enough to capture the variety present in different performances of the same piece by the same musician and even the variety within a single performance (Kendall and Carterette, 1990). Furthermore, the different expressive resources interact with each other. That is, the rules for dynamics alone change when rubato is also taken into account. Obviously, due to this interdependency, the more expressive resources one tries to model, the more difficult it is to find the appropriate rules.

We developed a case-based reasoning system called SaxEx (Arcos et al., 1998), a computer program capable of synthesizing high-quality expressive tenor sax solo performances of jazz ballads, based on cases representing human solo performances. As mentioned above, previous rule-based approaches to that problem could not deal with more than two expressive parameters (such as dynamics and rubato) because it is too difficult to find rules general enough to capture the variety present in expressive performances. Besides, the different expressive parameters interact with each other making it even more difficult to find appropriate rules taking into account these interactions.

With case-based reasoning, we have shown that it is possible to deal with the five most important expressive parameters: dynamics, rubato, vibrato, articulation, and attack of the notes. To do so, SaxEx uses a case memory containing examples of human performances, analyzed by means of spectral modelling techniques and background musical knowledge. The score of the piece to be performed is also provided to the system. The core of the method is to analyze each input note determining (by means of the background musical knowledge) its role in the musical phrase it belongs to, identify and retrieve (from the case base of human performances) notes with similar roles, and, finally, transform the input note so that its expressive properties (dynamics, rubato, vibrato, articulation, and attack) match those of the most similar retrieved note. Each note in the case base is annotated with its role in the musical phrase it belongs to, as well as with its expressive values. Furthermore, cases do not contain just information on each single note but they include contextual knowledge at the phrase level. Therefore, cases in this system have a complex object-centered representation.

Although limited to monophonic performances, the results are very convincing and demonstrate that case-based reasoning is a very powerful methodology to directly use the knowledge of a human performer that is implicit in her playing examples rather than trying to make this knowledge explicit by means of rules. Some audio results can be listened to at: http://www.iiia.csic.es/%7Earcos/noos/Demos/Example.html. More recent papers (Arcos and López de Mántaras, 2001; López de Mántaras and Arcos, 2002, López de Mántaras and Arcos, 2012), describe this system in great detail.

Based on the work on SaxEx, we developed TempoExpress (Grachten et al., 2004), a case-based reasoning system for applying musically acceptable tempo transformations to monophonic audio recordings of musical performances. TempoExpress has a rich description of the musical expressivity of the performances, which includes not only timing deviations of performed score notes, but also represents more rigorous kinds of expressivity, such as note ornamentation, consolidation, and fragmentation. Within the tempo transformation process, the expressivity of the performance is adjusted in such a way that the result sounds natural for the new tempo. A case base of previously performed melodies is used to infer the appropriate expressivity. The problem of changing the tempo of a musical performance is not as trivial as it may seem because it involves a lot of musical knowledge and creative thinking. Indeed, when a musician performs a musical piece at different tempos the performances are not just time-scaled versions of each other (as if the same performance were played back at different speeds). Together with the changes of tempo, variations in musical expression are made (Desain and Honing, 1993). Such variations do not only affect the timing of the notes, but can also involve, for example, the addition or deletion of ornamentations, or the consolidation/fragmentation of notes. Apart from the tempo, other domain-specific factors seem to play an important role in the way a melody is performed, such as meter, and phrase structure. Tempo transformation is one of the audio post-processing tasks manually done in audio labs. Automatizing this process may, therefore, be of industrial interest.

Other applications of case-based reasoning to expressive music are those of Suzuki et al. (1999), and those of Tobudic and Widmer (2003, 2004). Suzuki et al. (1999) use examples cases of expressive performances to generate multiple performances of a given piece with varying musical expression; however, they deal only with two expressive parameters. Tobudic and Widmer (2003) apply Instance-Based Learning also to the problem of generating expressive performances. Their approach is used to complement a note-level rule-based model with some predictive capability at the higher level of musical phrasing. More concretely, the Instance-Based Learning component recognizes performance patterns, of

a concert pianist, at the phrase level and learns how to apply them to new pieces by analogy. The approach produced some interesting results but, as the authors recognize, was not very convincing due to the limitation of using an attribute-value representation for the phrases. Such simple representation cannot take into account relevant structural information of the piece, both at the sub-phrase level and at the inter-phrasal level. In a subsequent paper, Tobudic and Widmer (2004) succeeded in partly overcoming this limitation by using a relational phrase representation.

Widmer et al. (2009) describe a computer program that learns to expressively perform classical piano music. The approach is data intensive and based on statistical learning. Performing music expressively certainly requires high levels of creativity, but the authors take a very pragmatic view to the question of whether their program can be said to be creative or not and claim that "creativity is in the eye of the beholder." In fact, the main goal of the authors is to investigate and better understand music performance as a creative human behavior by means of AI methods.

The possibility for a computer to play expressively is a fundamental component of the so-called *hyper-instruments*. These are instruments designed to augment an instrument sound with such idiosyncratic nuances as to give it human expressiveness and a rich, live sound. To make a hyper-instrument, take a traditional instrument, like for example a cello, and connect it to a computer through electronic sensors in the neck and in the bow; also equip the hand that holds the bow with sensors; and program the computer with a system similar to SaxEx that allows analysis of the way the human interprets the piece, based on the score, on musical knowledge, and on the readings of the sensors. The results of such analysis allows the hyper-instrument to play an active role, altering aspects such as timbre, tone, rhythm, and phrasing, as well as generating an accompanying voice. In other words, you have got an instrument that can be its own intelligent accompanist. Tod Machover, from MIT's Media Lab, developed such a hyper-cello and the great cello player Yo-Yo Ma premiered, playing the hyper-cello, a piece, composed by Tod Machover, called "Begin Again Again..." at the Tanglewood Festival several years ago.

Improvising Music
Music improvisation is a very complex creative process that has also been computationally modelled. It is often referred to as "composition on the fly" and, therefore, it is, creatively speaking, more complex than composition and is, probably, the most complex of the three music activities surveyed here. An early work on computer improvisation is the Flavors Band system of Fry (1984). Flavors Band is a procedural language, embedded in LISP, for specifying

"Man projects the autonomy of his awareness, his power to control, his own individuality and the idea of his persona onto automated objects."

JEAN BAUDRILLARD (1929–2007)
French philosopher and sociologist. *The System of Objects* (1969).

Ryoji Ikeda
Sound installation (2009)
5 Meyer SB-1s, computer.
12 × 6 × 24 m
Tokyo Museum of Contemporary Art.

jazz and popular music styles. Its procedural representation allows the generation of scores in a pre-specified style by making changes to a score specification given as input. It allows combining random functions and musical constraints (chords, modes, etc.) to generate improvisational variations. The most remarkable result of Flavors Band was an interesting arrangement of the bass line, and an improvised solo, of John Coltrane's composition "Giant Steps."

GenJam (Biles, 1994) builds a model of a jazz musician learning to improvise by means of a genetic algorithm. A human listener plays the role of fitness function by rating the offspring improvisations. Papadopoulos and Wiggins (1998) also used a genetic algorithm to improvise jazz melodies on a given chord progression. Contrarily to GenJam, the program includes a fitness function that automatically evaluates the quality of the offspring improvisations rating eight different aspects of the improvised melody such as the melodic contour, notes duration, intervallic distances between notes, and so on.

Franklin (2001) uses recurrent neural networks to learn how to improvise jazz solos from transcriptions of solo improvisations by jazz saxophonist Sonny Rollins. A reinforcement learning algorithm is used to refine the behavior of the neural network. The reward function rates the system solos in terms of jazz harmony criteria and according to Rollins's style.

The lack of interactivity, with a human improviser, of the above approaches has been criticized (Thom, 2001) on the grounds that they remove the musician from the physical and spontaneous creation of a melody. Although it is true that the most fundamental characteristic of improvisation is the spontaneous, real-time creation of a melody, it is also true that interactivity was not intended in these approaches and nevertheless they could generate very interesting improvisations. Thom (2001) with her Band-out-of-a-Box (BoB) system addresses the problem of real-time interactive improvisation between BoB and a human player. In other words, BoB is a "music companion" for real-time improvisation. Thom's approach follows Johnson-Laird's (1991) psychological theory of jazz improvisation. This theory opposes the view that improvising consists of rearranging and transforming pre-memorized "licks" under the constraints of a harmony. Instead Johnson-Laird proposes a stochastic model based on a greedy search over a constrained space of possible notes to play at a given point in time. The very important contribution of Thom is that her system learns these constraints, and therefore

the stochastic model, from the human player by means of an unsupervised probabilistic clustering algorithm. The learned model is used to abstract solos into user-specific playing modes. The parameters of that learned model are then incorporated into a stochastic process that generates the solos in response to four bar solos of the human improviser. BoB has been very successfully evaluated by testing its real-time solo tradings in two different styles, that of saxophonist Charlie Parker, and that of violinist Stephane Grapelli.

Another remarkable interactive improvisation system was developed by Dannenberg (1993). The difference with Thom's approach is that in Dannenberg's system, music generation is mainly driven by the composer's goals rather than the performer's goals. Wessel's (1998) interactive improvisation system is closer to Thom's in that it also emphasizes the accompaniment and enhancement of live improvisations.

COMPUTATIONAL CREATIVITY IN VISUAL ARTS

AARON is a robotic system, developed over many years by the artist and programmer Harold Cohen (Cohen, 1995), that can pick up a paintbrush with its robotic arm and paint on canvas on its own. It draws people in a botanical garden not just making a copy of an existing drawing but generating as many unique drawings on this theme as may be required of it. AARON has never seen a person or walked through a botanical garden but has been given knowledge about body postures and plants by means of rules. AARON's knowledge and the way AARON uses its knowledge are not like the knowledge that we, humans, have and use because human knowledge is based on experiencing the world, and people experience the world with their bodies, their brains, and their reproductive systems, which computers do not have. However, just like humans, AARON'S knowledge has been acquired cumulatively. Once it understands the concept of a leaf cluster, for example, it can make use of that knowledge whenever it needs it. Plants exist for AARON in terms of their size, the thickness of limbs with respect to height, the rate at which limbs get thinner with respect to spreading, the degree of branching, the angular spread where branching occurs, and so on. Similar principles hold for the formation of leaves and leaf clusters. By manipulating these factors, AARON is able to generate a wide range of plant types and will never draw quite the same plant twice, even when it draws a number of plants recognizably of the same type. Besides, AARON must know what the human body consists of, what the different parts are, and how big they are in relation to each other. Then it has to know how the parts of the body are articulated and what are the types and ranges of movements at each joint. Finally,

because a coherently moving body is not merely a collection of independently moving parts, AARON has to know something about how body movements are coordinated: what the body has to do to keep its balance, for example. Conceptually, this is not as difficult as it may seem, at least for standing positions with one or both feet on the ground. It is just a matter of keeping the center of gravity over the base and, where necessary, using the arms for achieving balanced positions. It also has knowledge about occlusions so that a partially occluded human body might have, for example, just one arm and/or one leg visible but AARON knows that normal people have two arms and two legs and therefore when not occluded it will always draw two limbs. This means that AARON cannot "break" rules and will never "imagine" the possibility of drawing humans with one leg, for example, or other forms of abstraction. In that sense, AARON's creativity is limited and very far from a human one. Nevertheless AARON's paintings have been exhibited in London's Tate Modern and the San Francisco Museum of Modern Art. In some respects, then, AARON passes some kind of creative Turing test for its works are good enough to be exhibited alongside some of the best human artists.

Simon Colton's Painting Fool (Colton et al., 2015) is much more autonomous than AARON. Although the software does not physically apply paint to canvas, it simulates many styles digitally, from collage to paint strokes. In Colton's words:

> The Painting Fool only needs minimal direction and can come up
> with its own concepts by going online for source material. The software
> runs its own web searches and crawls through social media websites. The
> idea is that this approach will let it produce art that is meaningful to
> the audience, because it is essentially drawing on the human experience
> as we act, feel and argue on the web.

For instance, in 2009, the Painting Fool produced its own interpretation of the war in Afghanistan, based on a news story. The result is a juxtaposition of Afghan citizens, explosions, and war graves.

Other examples of computational creativity applied to painting and other visual arts are the works of Karl Sims and of Jon McCormack. Karl Sims's *Reaction-Diffusion Media Wall* (Sims, 2016) is based on the interactive simulation of chemicals that react and diffuse to create emergent dynamic patterns according to the reaction-diffusion equations governing biological morphogenesis. This work is exhibited at the Museum of Science in Boston. Previous works of Karl Sims include the application of evolutionary computations techniques to interactively evolved images in his Genetic Images system (Sims, 1994).

Jon McCormack also looks at how biological processes could be successfully applied to creative systems in his "Design After Nature Project" (McCormack, 2014). In another project, "Creative Ecosystems," he looks at concepts and metaphors from biological ecosystems (McCormack and d'Inverno, 2012) as a means to enhance human creativity in the digital arts.

There are numerous other examples related to the visual arts. The reported ones are not just a representative set but, in my opinion, also the most important contributions to this field.

Can we use artificial intelligence to support human creativity and discovery? A new trend known as Assisted Creation has important implications for creativity: on the one hand, assistive creation systems are making a wide range of creative skills more accessible. On the other hand, collaborative platforms, such as the one developed within the European project PRAISE for learning music (Yee-King and d'Inverno, 2014), are making it easier to learn new creative skills. PRAISE is a social network-based learning platform that includes humans and intelligent software agents that give feedback to a music student regarding music composition, arrangement, and performance. Students upload their solutions to a given lesson plan provided by a tutor (compositions, arrangements, or performances). Then the intelligent agents, as well as other fellow students and tutors, analyze these solutions and provide feedback. For instance, in the case of a composition the agent might say: "Your modulation sounds pretty good but you could try modulating everything up a major third for bars 5 to 8."

In the case of performances, other intelligent software agents compare those of the students with one previously recorded by the tutor when she uploaded the lesson plan. A camera captures the gesture of the student and the software agents also provide feedback about possibly incorrect postures. Tools like this one that accelerate the skill acquisition time lead to a phenomenon known as "the democratization of creativity."

As early as 1962, Douglas Engelbart (Engelbart, 1962) wrote about a "writing machine that would permit you to use a new process of composing text [...] You can integrate your new ideas more easily, and thus harness your creativity more continuously." Engelbart's vision was not only about augmenting individual creativity. He also wanted to augment the collective intelligence and creativity of groups by improving collaboration and group problem-solving ability. A basic idea is that creativity is a social process that can be augmented through technology. By projecting these ideas into the future, we could imagine a world where creativity is highly accessible and (almost) anyone can write at the level of the best writers, paint like the great masters, compose high-quality music, and even discover new forms of creative expression. For a person who does not have a particular creative skill, gaining a new capability through assisted creation systems is highly empowering.

Although the above futuristic scenario is currently pure fiction, there already exist several examples of assisted creation. One of the most interesting is the assisted drumming system developed at Georgia Institute of Technology (Bretan and Weinberg, 2016). It consists of a wearable robotic limb that allows drummers to play with three arms. The 61-centimeter-long (two-foot) "smart arm" can be attached to a musician's shoulder. It responds to human gestures and the music it hears. When the drummer plays the high hat cymbal, for example, the robotic arm maneuvers to play the ride cymbal. When the drummer switches to the snare, the mechanical arm shifts to the tom.

Another very interesting result in assisted creativity is the music style and harmony transfer, genre to genre, developed at the SONY Computer Science Lab in Paris (Martin et al., 2015; Papadopoulos et al., 2016) that assists composers in harmonizing a music piece in a genre according to the style of another completely different genre. For instance harmonizing a jazz standard in the style of Mozart.

CONCLUDING REMARKS: APPARENTLY OR REALLY CREATIVE?

Margaret Boden pointed out that even if an artificially intelligent computer would be as creative as Bach or Einstein, for many it would be just apparently creative but not really creative. I fully agree with her for two main reasons, which are: the lack of intentionality and our reluctance to give a place in our society to artificially intelligent agents. The lack of intentionality is a direct consequence of Searle's Chinese Room argument (Searle, 1980), which states that computer programs can only perform syntactic manipulation of symbols but are unable to give them any semantics. It is generally admitted that intentionality can be explained in terms of causal relations. However, it is also true that existing computer programs lack too many relevant causal connections to exhibit intentionality but perhaps future, possibly anthropomorphic, "embodied" artificial intelligences, that is, agents equipped not only with sophisticated software but also with different types of advanced sensors allowing them to interact with the environment, may have enough causal connections to give meaning to symbols and have intentionality.

Regarding social rejection, the reasons why we are so reluctant to accept that nonbiological agents can be creative (even biological ones, as was the case with "Nonja," a twenty-year-old painter from Vienna, whose abstract paintings had been exhibited and appreciated in art galleries but as soon as it was known that she was an orangutan from the Vienna Zoo her

work was much less appreciated!) is that they do not have a natural place in our society of human beings and a decision to accept them would have important social implications. It is, therefore, much simpler to say that they appear to be intelligent, creative, and so on, instead of saying that they are. In a word, it is a moral not a scientific issue. A third reason for denying creativity to computer programs is that they are not conscious of their accomplishments. It is true that machines do not have consciousness, and possibly will never have conscious thinking; however, the lack of consciousness is not a fundamental reason to deny the potential for creativity or even the potential for intelligence. After all, computers would not be the first example of unconscious creators; evolution is the first example, as Stephen Jay Gould (1996) brilliantly points out: "If creation demands a visionary creator, then how does blind evolution manage to build such splendid new things as ourselves?"

ACKNOWLEDGMENTS

This research has been partially supported by the 2014-SGR-118 grant from the Generalitat de Catalunya.

—Arcos, J. L., and López de Mántaras, R. 2001. "An interactive case-based reasoning approach for generating expressive music." *Applied Intelligence* 14(1): 115–129.

—Arcos, J. L., López de Mántaras, R., and Serra, X. 1998. "Saxex: A case-based reasoning system for generating expressive musical performances." *Journal of New Music Research* 27(3): 194–210.

—Bentley, P. J., and Corne, D. W. (eds.). 2001. *Creative Evolutionary Systems*. Burlington, MA: Morgan Kaufmann.

—Bharucha, J. 1993. "MUSACT: A connectionist model of musical harmony." In *Machine Models of Music*, S. M. Schwanauer and D. A. Levitt (eds.). Cambridge, MA: The MIT Press, 497–509.

—Biles, J. A. 1994. "GenJam: A genetic algorithm for generating jazz solos." In *Proceedings of the 1994 International Computer Music Conference*. San Francisco: International Computer Music Association.

—Boden, M. 1987. *Artificial Intelligence and Natural Man*. New York: Basic Books.

—Boden, M. 1991. *The Creative Mind: Myths and Mechanisms*. New York: Basic Books.

—Boden, M. (ed.) 1994. *Dimensions of Creativity* Cambridge, MA: The MIT Press.

—Boden, M. 2009. "Computers models of creativity." *AI Magazine* 30(3): 23–34.

—Bresin, R. 1998. "Artificial neural networks based models for automatic performance of musical scores." *Journal of New Music Research* 27(3): 239–270.

—Bresin, R. 2001. "Articulation rules for automatic music performance." In *Proceedings of the 2001 International Computer Music Conference*. San Francisco: International Computer Music Association.

—Bretan, M., and Weinberg, G. 2016. "A survey of robotic musicianship." *Commun. ACM* 59(5): 100–109.

—Canazza, S., De Poli, G., Roda, A., and Vidolin, A. 1997. "Analysis and synthesis of expressive intention in a clarinet performance." In *Proceedings of the 1997 International Computer Music Conference*. San Francisco: International Computer Music Association, 113–120.

—Cohen, H. 1995. "The further exploits of Aaron, painter." *Stanford Humanities Review* 4(2): 141–158.

—Colton, S., López de Mántaras, R., and Stock, O. 2009. "Computational creativity: Coming of age." Special issue of *AI Magazine* 30(3): 11–14.

—Colton, S. Halskov, J., Ventura, D., Gouldstone, I., Cook, M., and Pérez-Ferrer, B. 2015. "The Painting Fool sees! New projects with the automated painter." *International Conference on Computational Creativity 2015*: 189–196

—Cope, D. 1987. "Experiments in music intelligence." In *Proceedings of the 1987 International Computer Music Conference*. San Francisco: International Computer Music Association.

—Cope, D. 1990. "Pattern matching as an engine for the computer simulation of musical style." In *Proceedings of the 1990 International Computer Music Conference*. San Francisco: International Computer Music Association.

—Dannenberg, R. B. 1993. "Software design for interactive multimedia performance." *Interface* 22(3) 213–218.

—Dannenberg, R. B., and Derenyi, I. 1998. "Combining instrument and performance models for high quality music synthesis." *Journal of New Music Research* 27(3) 211–238.

—Dartnall, T. (ed.). 1994. *Artificial Intelligence and Creativity*. Dordrcht: Kluwer Academic Publishers.

—Desain, P., and Honing, H. 1993. "Tempo curves considered harmful." In *Time in Contemporary Musical Thought*, J. D. Kramer (ed.). *Contemporary Music Review* 7(2).

—Ebcioglu, K. 1993. "An expert system for harmonizing four-part chorales." In *Machine Models of Music*, S. M. Schwanauer and D. A. Levitt (eds.). Cambridge, MA: The MIT Press, 385–401.

—Engelbart, D. C. 1962. *Augmenting Human Intellect: A Conceptual Framework*. Menlo Park, CA: Stanford Research Institute, 5.

—Feulner, J. 1993. "Neural networks that learn and reproduce various styles of harmonization." In *Proceedings of the 1993 International Computer Music Conference*. San Francisco: International Computer Music Association.

—Franklin, J. A. 2001. "Multi-phase learning for jazz improvisation and interaction." In *Proceedings of the Eighth Biennial Symposium on Art and Technology*. New London, CT: Center for Arts and Technology, Connecticut College.

—Friberg, A. 1995. "A quantitative rule system for musical performance." (Unpublished PhD dissertation). KTH, Stockholm.

—Friberg, A., Bresin, R., Fryden, L., and Sunberg, J. 1998. "Musical punctuation on the microlevel: automatic identification and performance of small melodic units." *Journal of New Music Research* 27(3): 271–292.

—Friberg, A., Sunberg, J., and Fryden, L. 2000. "Music From motion: sound level envelopes of tones expressing human locomotion." *Journal of New Music Research* 29(3): 199–210.

—Fry, C. 1984. "Flavors Band: a language for specifying musical style." Reprinted in *Machine Models of Music*, S. M. Schwanauer and D. A. Levitt (eds.). Cambridge, MA: The MIT Press, 1993, 427–451.

—Gervás, P. 2009. "Computational approaches to storytelling and creativity." *AI Magazine* 30(3): 49–62.

—Grachten, M., Arcos, J. L., and López de Mántaras, R. 2004. "TempoExpress, a CBR approach to musical tempo transformations." In *Proceedings of the 7th European Conference on Case-Based Reasoning*, P. Funk and P. A. Gonzalez Calero (eds.). *Lecture Notes in Artificial Intelligence*, vol. 3155. Heidelberg: Springer, 601–615.

—Gould, S. J. 1996. "Creating the creators." *Discover Magazine* October: 42–54.

—Hiller, L., and Isaacson, L. 1958. "Musical composition with a high-speed digital computer." Reprinted in *Machine Models of Music*, S. M. Schwanauer and D. A. Levitt (eds.). Cambridge, MA: The MIT Press, 1993, 9–21.

—Hörnel, D., and Degenhardt, P. 1997. "A neural organist improvising Baroque-style melodic variations." In *Proceedings of the 1997 International Computer Music Conference*. San Francisco: International Computer Music Association, 430–433.

—Hörnel, D., and Menzel, W. 1998. "Learning musical structure and style with neural networks." *Journal of New Music Research* 22(4): 44–62.

—Johnson, M. L. 1992. "An expert system for the articulation of Bach fugue melodies." In *Readings in Computer Generated Music*, D. L. Baggi (ed.). Los Alamitos, CA: IEEE Press, 41–51.

—Johnson-Laird, P. N. 1991. "Jazz improvisation: A theory at the computational level." In *Representing Musical Structure*, P. Howell, R. West, and I. Cross (eds.). London: Academic Press.

—Kendall, R. A., and Carterette, E. C. 1990. "The communication of musical expression." *Music Perception* 8(2): 129.

—Langley, P., Simon, H. A., Bradshaw, G. L., and Zytkow, J. M. 1987. *Scientific Discovery, Computational Explorations of the Creative Mind*. Cambridge, MA: The MIT Press.

—Lerdahl, F., and Jackendoff, R. 1983. "An overview of hierarchical structure in music." *Music Perception* 1: 229–252.

—Levitt, D. A. 1993. "A representation for musical dialects." In *Machine Models of Music*, S. M. Schwanauer and D. A. Levitt (eds.). Cambridge, MA: The MIT Press, 455–469.

—López de Mántaras, R., and Arcos, J. L. 2002. "AI and music: From composition to expressive performance." *AI Magazine* 23(3): 43–57.

—López de Mántaras, and R., Arcos J. L. 2012. "Playing with cases: Rendering expressive music with case-based reasoning." *AI Magazine* 33(4): 22–31.

—Martín, D., Frantz, B., and Pachet, F. 2015. "Improving music composition through peer feedback: Experiment and preliminary results." *In Music Learning with Massive Open Online Courses (MOOCs)*, Luc Steels (ed.). Amsterdam: Ios Press, 195–204.

—McCormack, J. 2014. "Balancing act: variation and utility in evolutionary art." In *Evolutionary and Biologically Inspired Music, Sound, Art and Design. Lecture Notes in Computer Science*, Vol. 8601. Heidelberg: Springer, 26–37

—McCormack, J., and d'Inverno, M. 2012. *Computers and Creativity*. Heidelberg: Springer.

—Minsky, M. 1981. "Music, mind, and meaning." Reprinted in *Machine Models of Music*, S. M. Schwanauer and D. A. Levitt (eds.). Cambridge, MA: The MIT Press, 1993, 327–354.

—Nick Montfort, Patsy Baudoin, John Bell, Ian Bogost, Jeremy Douglass, Mark C. Marino, Michael Mateas, Casey Reas, Mark Sample, and Noah Vawter. 2014. 10PRINT CHR$(205.5+RND(1)); GOTO 10. Cambridge, MA: The MIT Press.

—Moorer, J. A. 1972. "Music and computer composition." Reprinted in *Machine Models of Music*, S. M. Schwanauer and D. A. Levitt (eds.). Cambridge, MA: The MIT Press, 1993, 167–186.

—Morales-Manzanares, R., Morales, E. F., Dannenberg, R., and Berger, J. 2001. "SICIB: An interactive music composition system using body movements." *Computer Music Journal* 25(2): 25–36.

—Pachet, F., and Roy, P. 1998. "Formulating constraint satisfaction problems on part-whole relations: The case of automatic harmonization." In *ECAI'98 Workshop on Constraint Techniques for Artistic Applications*. Brighton, UK.

—Papadopoulos, G., and Wiggins, G. 1998. "A genetic algorithm for the generation of jazz melodies." In *Proceedings of the SteP'98 Conference*. Finland.

—Papadopoulos, A., Roy, P., and Pachet, F. 2016. "Assisted lead sheet composition using FlowComposer." *Proceedings of the 22nd International Conference on Principles and Practice of Constraint Programming—CP*. Toulouse, France.

—Partridge, D., and Rowe, J. 1994. *Computers and Creativity*. Bristol: Intellect Books.

—Rader, G. M. 1974. "A method for composing simple traditional music by computer." Reprinted in *Machine Models of Music*, S. M. Schwanauer and D. A. Levitt (eds.). Cambridge, MA: The MIT Press, 1993, 243–260.

—Ritchie, G. D., and Hanna, F. K. 1984. "AM: A case study in AI methodology." *Artificial Intelligence* 23: 249–268.

—Ritchie, G. D. 2009. "Can computers create humour." *AI Magazine* 30(3): 71–81.

—Rothgeb, J. 1969. "Simulating musical skills by digital computer." Reprinted in *Machine Models of Music*, S. M. Schwanauer and D. A. Levitt (eds.). Cambridge, MA: The MIT Press, 1993, 157–164.

—Sabater, J., Arcos, J. L., and López de Mántaras, R. 1998. "Using rules to support case-based reasoning for harmonizing melodies." In *AAAI Spring Symposium on Multimodal Reasoning*. Menlo Park, CA: American Association for Artificial Intelligence, 147–151.

—Schwanauer, S. M. 1993. "A learning machine for tonal composition." In *Machine Models of Music*, S. M. Schwanauer and D. A. Levitt (eds.). Cambridge, MA: The MIT Press, 511–532.

—Schwanauer, S. M., and Levitt, D. A. (eds.). 1993. *Machine Models of Music*. Cambridge, MA: The MIT Press.

—Searle, J. 1980. "Minds, brains and programs." *Behavioral and Brain Sciences* 3(3): 417–457.

—Simon, H. A., Sumner, R. K. 1968. "Patterns in music." Reprinted in *Machine Models of Music*, S. M. Schwanauer and D. A. Levitt (eds.). Cambridge, MA: The MIT Press, 83–110.

—Sims, K. 1994. "Evolving virtual creatures. Computer graphics." In *SIGGRAPH 94 21st International ACM Conference on Computer Graphics and Interactive Techniques*. New York: ACM, 15–22.

—Sims, K. 2016. "Reaction-diffusion media wall." http://www.karlsims.com/rd-exhibit.html.

—Suzuki, T., Tokunaga, T., and Tanaka, H. 1999. "A case-based approach to the generation of musical expression." In *Proceedings of the 16th International Joint Conference on Artificial Intelligence*. Burlington, MA: Morgan Kaufmann, 642–648.

—Thom, B. 2001. "BoB: An improvisational music companion." (Unpublished PhD dissertation). School of Computer Science, Carnegie-Mellon University, Pittsburgh, PA.

—Tobudic, A., and Widmer, G. 2003. "Playing Mozart phrase by phrase." In *Proceedings of the 5th International Conference on Case-Based Reasoning*, K. D. Ashley and D. G. Bridge (eds.). *Lecture Notes in Artificial Intelligence*, Vol. 3155. Heidelberg: Springer, 552–566.

—Tobudic, A., and Widmer, G. 2004. "Case-based relational learning of expressive phrasing in classical music." In *Proceedings of the 7th European Conference on Case-Based Reasoning*, P. Funk and P. A. Gonzalez Calero (eds.). *Lecture Notes in Artificial Intelligence*, Vol. 3155. Heidelberg: Springer, 419–433.

—Turing, A. M. 1950. "Computing machinery and intelligence." *Mind* LIX(236): 433–460.

—Wessel, D., Wright, M., and Kahn, S. A. 1998. "Preparation for improvised performance in collaboration with a Khyal singer." In *Proceedings of the 1998 International Computer Music Conference*. San Francisco: International Computer Music Association.

—Widmer, G., Flossmann, S., and Grachten, M. 2009. "YQX plays Chopin." *AI Magazine* 30(3): 35–48.

—Woods, W. 1970. "Transition network grammars for natural language analysis." *Communications of the ACM* 13(10): 591–606.

—Yee-King, M., and d'Inverno, M. 2014. "Pedagogical agents for social music learning in crowd-based socio-cognitive systems." In *Proceedings of the First International Workshop on the Multiagent Foundations of Social Computing, AAMAS-2014*. Paris, France.

The Critical Role of Artists in Advancing Augmented Reality

HELEN PAPAGIANNIS

Opening image:
Hannah Höch (1889–1978)
Dada Ernst (1920-21)
Collage on paper
18.6 × 16.6 cm
The Israel Museum, Jerusalem, Israel,
Vera and Arturo Schwarz Collection
of Dada and Surrealist Art.

Helen Papagiannis
Artist, writer and new digital media researcher

Helen Papagiannis has been working with Augmented Reality for over
a decade as a researcher, designer, and technology evangelist. She
was named among the NEXT 100 Top Influencers of the Digital Media
Industry and her TEDx talk was featured among the Top 10 Talks on
Augmented Reality. Prior to her augmented life, Helen was a member of the
internationally renowned Bruce Mau Design studio, where she was project
lead on *Massive Change: The Future of Global Design*, an internationally
touring exhibition and best-selling book. Her book *Augmented Human: How
Technology Is Shaping the New Reality* is published by O'Reilly Media.

Artists are often left out in the discussion of the advancement of new technologies, yet they are critical to the evolution of any new medium. Golan Levin points out that artists have early on prototyped many of today's technologies. To get a jump-start on the future, Levin urges looking to artists working with new technologics. This article discusses the important role of artists in the emerging technology of Augmented Reality (AR).

INTRODUCTION

Emerging technologies are not typically developed by artists, rather they are adapted for creative and artistic applications from science and engineering fields, as well as from industry. This entails issues of access, knowledge, and understanding the capacities of the technology and its constraints to exploit the technology to artistic use by envisioning novel applications and approaches, and developing new aesthetics and conventions beyond previous traditional forms.

In 1988 John Pearson wrote about the computer being appropriated by artists, offering "new means for expressing their ideas."[1] He notes, however, that historically new technologies "were not developed by the artistic community for artistic purposes, but by science and industry to serve the pragmatic or utilitarian of society."[2] It is then up to the artist to be a "colonizer" and to "exploit" these new technologies for their own purposes, as Roger Malina suggests, which I will later return to.[3]

Pearson writes: "New concepts that bring new images and new materials are usually in conflict with the accepted aesthetic standard of the status quo precisely because there are few if any criteria against which they can be measured."[4] It is the role of the artist then to act as a pioneer, pushing forward a new aesthetic that exploits the unique materials of the novel technology, in opposition to established traditions. Pearson states that computer imaging has certain "stylistic tendencies" that "have been determined by factors outside of art."[5] However, at the time the article was written (1988), Pearson observes that artists using computers mimic art created with previous traditional art forms and "thus they fight the computer's potential by trying to force this historical will upon it."[6] This recalls Jay David Bolter and Richard Grusin's concepts of remediation in refashioning a medium's predecessor, and Marshall McLuhan's perspective that:

> Our typical response to a disrupting new technology is to recreate the old environment instead of heeding the new opportunities of the new environment. Failure to notice the new opportunities is also failure to understand the new powers. This failure leaves us in the role of automata merely.[7]

To heed the new opportunities afforded by computer art, or any new medium for that matter, this involves, as Malina notes, "understanding the specific capabilities of the computer and creating art forms that exploit these."[8] As an artist working with AR for over a decade, I adopt Malina's standpoint. In order to advance AR as a new medium, it is critical to ask such questions as: "What are the specific capabilities of AR and how can they be harnessed to create new forms?" "What is unique about AR that separates it from previous media forms and, as such, what new conventions will evolve?" It is imperative that we explore and apply these unique attributes to advance the medium and "heed the opportunities of the new environment."

I liken AR at this time to cinema in its infancy, when there were as yet no conventions. AR, like cinema when it first emerged, commenced with a focus on the technology with little consideration to content, marked as secondary. In an article comparing early film to digital cinema, John Andrew Berton Jr. identifies the critical contribution of French filmmaker Georges Méliès. Berton refers to cinema historian Lewis Jacobs crediting Méliès as the "first to exploit the medium as a means of personal expression."[9] Berton comments on Méliès's technical advances of the medium (fades, dissolves, and animations), and brings special note to how Méliès "did not stop with a concentration on technical achievement" but he "was busy finding ways to use his technique to carry substantial content."[10]

Berton continues: "Even though Méliès's work was closely involved with the state of the art, he did not let that aspect of his work rule the overall piece. He used his technique to augment his artistic sense, not to create it."[11] Méliès maintained an artistry in the medium, being enthused by the possibilities of the technology and allowing the medium to guide his explorations and work. Méliès serves as an inspiration to my practice in AR in that the technology inspired stories and the direction of the work, but he also gave himself the freedom of experimentation and creativity to move beyond the constraints and invent new ways of applying

the technology. Further, Méliès introduced new formal styles, conventions, and techniques that were specific to the medium of film; like Méliès working with a new medium, pioneer AR artists too will evolve novel styles and establish new conventions toward a language and aesthetics of AR.

In working with a new technology an artist must also transcend an initial fascination with the technology, for Pearson warns of a danger artists find in "the magic of the machine" and how few seem to go beyond this "hypnotic fascination."[12] My thoughts here turn to early cinema and film theorist Dan North's discussion of Tom Gunning's concept of a "cinema of attractions" where "the machine which made the pictures move was the source of fascination rather than themes and stories represented."[13] In my artistic practice, I, too, am guilty of an initial fascination with the magic of the technology of AR; however, I believe it is important for artists to begin here, to understand and be inspired by the opportunities of the technology, then to move beyond this to advance the medium, pushing the technology and evolving new forms and content. Pearson states: "If the ideas simply revolve around demonstrating the technical virtuosity or prowess of the machine" then the artist has become a "slave" to the machine (or as McLuhan was previously quoted, as "automata merely," failing to understand the new powers); in this case, "only technology is served."[14]

THE IMPORTANCE OF WORKING WITH THE TECHNOLOGY DIRECTLY

To be able to truly transcend a fascination with the new technology and welcome conceptual evolution, the artist must be able to work with the technology directly. Early solutions to help bridge this gap between the technology and artists and nonprogrammers included DART (Designer's Augmented Reality ToolKit) developed at the Georgia Institute of Technology. In the article, "DART: A Toolkit for Rapid Design Exploration of Augmented Reality Experiences" (2004), the authors state that: "Designers are most effective when working directly with a medium, and working through an intermediary seriously hinders (or even destroys) the creative process."[15] The authors illustrate this point with the example of the difference between a painter directing an assistant as to where to apply paint on a canvas, rather than holding the brush oneself.

"Art is not what you see, but what you make others see."

EDGAR DEGAS (1834–1917)
French painter and sculptor.

A rocket crashes into the moon
in a still from Georges Méliès's
film 1902, *A Trip to the Moon*.

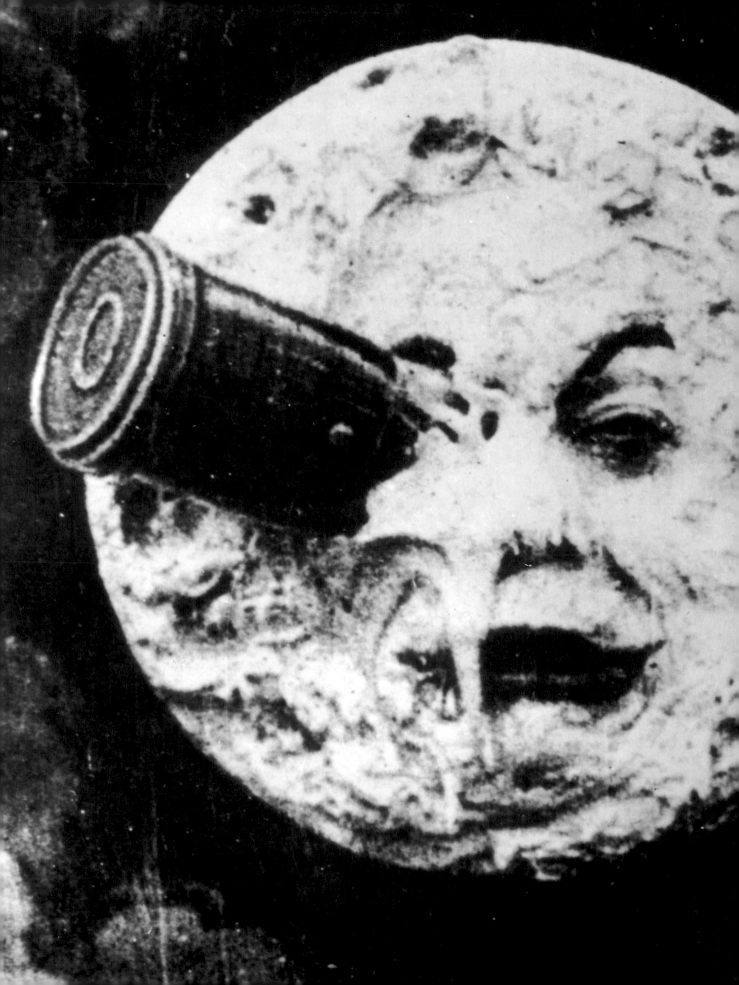

As an artist working with AR since 2005, I found it critical to my practice to be able to experiment and work with the medium directly, rather than via an intermediary such as a computer programmer (at least initially). This allowed me to better understand the limitations and possibilities of the technology, which I used as the starting point for ideas. My process has entailed first studying the traits of the technology by experimenting with the medium directly to comprehend what it does well and what it does not so well.[16] This mode of exploration guides the content development, with a story emerging that evolves from the technology, as opposed to beginning with a story that I wish to adapt to the technology. I find this approach to be critical in understanding a new medium. Once the characteristics of the technology are grasped, experimentation can push the technology in novel forms.

"HALLUCINATORY AR," 2007, AS A CASE STUDY

One of my early AR artworks that adopts this approach is "Hallucinatory AR," 2007, an artistic experiment using non-marker imagery to generate AR visuals. (It should be noted that these experiments occurred prior to any work I had done with Natural Feature Tracking (NFT); my AR work at the time was still based on marker tracking/fiducials.) The project was inspired by an accident that occurred in a previous project when the AR software was misinterpreting an image that was not an AR marker. AR content previously assigned to a marker was now appearing atop a non-marker image. This resulted in triggering unexpected and random flickering AR imagery. I was inspired to embrace this accident and explore the creative and artistic possibilities of this effect further by conducting experiments with nontraditional marker-based tracking. The process entailed a study of what types of non-marker images might generate such "hallucinations" and a search for imagery that would evoke or call upon multiple AR imagery from a single image/non-marker.

Upon multiple image searches, one image emerged which proved to be quite extraordinary. A cathedral stained-glass window was able to evoke/trigger four different AR images, the only instance, from among many other images, in which multiple AR imagery appeared. Upon close examination of the image, focusing in and out with the web camera, a face began to emerge in the black and white pattern. A fantastical image of a man was encountered. Interestingly, it was when the image was blurred into this face using the web camera that the AR hallucinatory imagery worked best, rapidly multiplying and appearing more prominently. Although numerous attempts were made with similar images, no other such instances occurred; this image appeared to be unique.

The challenge now rested in the choice of what types of imagery to curate into this hallucinatory viewing: what imagery would be best suited to this phantasmagoric and dreamlike form in AR?

My criteria for imagery/video clips were like-form and shape, in an attempt to create a collage-like set of visuals. As the sequence or duration of the imagery in Hallucinatory AR could not be predetermined because of the nature of the "glitchy" tracking of non-marker images, the goal was to identify imagery that possessed similarities, through which the possibility for visual synchronicities existed.

Themes of intrusions and chance encounters are at play in Hallucinatory AR, inspired in part by Surrealist artist Max Ernst. In "What Is the Mechanism of Collage?" (1936), Ernst writes:

> One rainy day in 1919, finding myself in a village on the Rhine, I was struck by the obsession which held under my gaze the pages of an illustrated catalogue showing objects designed for anthropologic, microscopic, psychologic, mineralogic, and paleontologic demonstration. There I found brought together elements of figuration so remote that the sheer absurdity of that collection provoked a sudden intensification of the visionary faculties in me and brought forth an illusive succession of contradictory images, double, triple, and multiple images, piling up on each other with the persistence and rapidity which are particular to love memories and visions of half-sleep.[17]

Of particular interest to my work in exploring and experimenting with "Hallucinatory AR" was Ernst's description of an "illusive succession of contradictory images" that were "brought forth" (as though independent of the artist), rapidly multiplying and "piling up" in a state of "half-sleep." Similarities can be drawn to the process of the seemingly disparate AR images in Hallucinatory AR, jarringly coming in and out of view, layered atop one another.

One wonders if these visual accidents are what the future of AR might hold: of unwelcomed glitches in software systems as Bruce Sterling describes in _Beyond the Beyond_ at Wired.com;[18] or perhaps we might come to delight in the visual poetry of these augmented hallucinations that are "as beautiful as the chance encounter of a sewing machine and an umbrella on an operating table" (Comte de Lautreamont's often quoted allegory, famous for inspiring Surrealist artists Max Ernst and Andrew Breton).[19]

To a computer scientist, these "glitches," as applied in Hallucinatory AR, could potentially be viewed or interpreted as a disaster, as an example of the technology failing. To the artist, however, there is poetry in these glitches, with new possibilities of expression and new visual forms emerging. Further to the theory discussed in this paper, the "Hallucinatory AR" artwork was not a traditional form, but a new approach, allowing the medium of AR to inspire and evolve new forms and modes of expression, "tapping into the unique qualities of expression the new form enables."

Further, in regards to Méliès introducing new formal styles, conventions, and techniques that were specific to the medium of film, novel styles and new conventions will also emerge from AR artists. Méliès became famous for the stop trick, or double exposure special effect, a technique which evolved from an accident: Méliès's camera jammed while filming the streets of Paris; upon playing back the film, he observed an omnibus transforming into a hearse. Rather than discounting this as a technical failure, or "glitch," he utilized it as a technique in his films. Hallucinatory AR also evolved from an accident, which was embraced and applied in an attempt to evolve a potentially new visual mode in the medium of AR.

ACCESS FOR THE ARTIST

Pearson states: "Electronic tools are still resistant and clumsy and do not facilitate working in a direct and expressive manner."[20] He writes of a more direct involvement of the artist in traditional art media. Pearson comments on his own "love/hate relationship with the computer," commanding too much of his time to learn "its language" and his "resistance to learn programming."[21] Issues of access are key to artists' creative investigation of a medium and will be discussed further in regards to Malina.

This returns us to questions of access for the artist, to which, like Pearson, Malina notes, "the computer was not developed with the specific needs of artists in mind."[22] Margot Lovejoy notes how the "first wave" (1965–75) of computer use in the visual arts was dominated by scientists with access to equipment with larger number of artists beginning to gain access in the "second wave," then the next decade continuing with pioneer artists who participated in developing new software tools. She notes that as artists continue to gain access to powerful computing tools at a lower cost, a new aesthetic begins to emerge. This echoes Gene Youngblood's belief in Martin Lister's *New Media: A Critical Introduction*, that: "The full aesthetic potential of this medium will be realized only when computer artists come to the instrument from art rather than computer science."[23] I agree, and we are beginning to see this as artists start to work with the emerging technology of AR, which traditionally belongs to the realm of Computer Science. In regards to Lovejoy, we can think of AR as being in its "second wave" currently. New aesthetic and stylistic tendencies will emerge as tools become more accessible and easy for artists to use, ideally developed with and by artists.

I am intrigued by how Douglas Rushkoff's book, *Program or be Programmed*,[24] pertains to artists as nonprogrammers working in AR. My view is that as typically nonprogrammers in AR, artists need to dive into the technology to understand the rules, then try to bend and break them. However, in order to truly advance a new medium, must the artists keep up

with the programmers? My approach has been one where I work with constraint and find ways to repurpose the software as it exists and extend this in creative ways. It has also been my experience to work and collaborate with programmers, as I believe my strength lies in the creative application as opposed to the custom coding of the software. I work as directly with the software as I can, tinkering, and even breaking the technology to understand how it works (I discuss this in my TEDx talk, "How Does Wonderment Guide the Creative Process?"[25]); but, as artists, do we need to go even further beyond the user-friendly tools and preset functions available? Certainly, there are artists who are also excellent programmers and technologists. To this distinct group, yes, they have the ability and skill set to do this. Otherwise, in addition to tinkering, and learning the technology as well as possible, dependent on each person's unique skill set, I believe the answer lies in collaborations and dialogues between artists and programmers.

AN ARTIST'S APPROACH TO TECHNOLOGY AS A TOOL OR MEDIUM

Digital artist and new media theorist Hector Rodriguez differentiates the ways in which an artist can approach technology: as a tool or as a medium. Rodriguez states: "Media artists who view technology as a tool would often prefer to keep it invisible."[26] Artists who, in contrast, view technology as a medium typically prefer to: "Emphasize its visibility and thus resist all pressures to hide the internal operation of digital media."[27] The artist who approaches technology as a tool applies it "to realize a prior idea" where the outcome is "predefined and predictable" with the artist not typically "acquiring an in-depth understanding of the technologies used in their work."[28]

When technology is treated as an artistic medium, creative ideas are drawn from an in-depth knowledge of how technologies operate. (This relates back to my approach to AR as discussed above.) Rodriguez gows on: "Media technologies thus become sources of artistic ideas, not mere conduits for their implementation. The creative concept is essentially dependent on a thorough understanding of the technologies that will actualize it."[29] We can also look back to Méliès here with the technology being the source of inspiration, of story evolving from technique.

Malina writes: "Several lines of analysis are needed to elaborate the new kind of art forms that are enabled by the computer. The first involves understanding the specific capabilities of the computer and creating art forms that exploit these."[30] Malina notes how this approach, "experimental and

empirical," is followed by several computer artists. I would position this approach to technology as a medium by Rodriguez's definition, where art forms and creative ideas emerge from a thorough knowledge and understanding of how the technology works. Malina, like Pearson, however, warns that artists can fail to transcend the capabilities of the technology, with advocates of the empirical approach arguing that "until the artist has access to the technology, its potential for art-making cannot be fully understood."[31]

MARSHALL MCLUHAN'S TETRAD AND AR

Adapting McLuhan's Tetrad to AR is a valuable exercise in analyzing prior forms that AR has evolved from and where it may go. McLuhan's Tetrad consists of the following media effects: enhance, obsolesce, retrieve, and reverse. Let us examine AR as it pertains to each of these effects. What aspect of society does AR enhance or amplify? I believe AR enhances information sharing, entertainment, gaming, education, and human vision. What does AR "obsolesce" or push aside? I believe AR obsolesces Virtual Reality and virtual intangible environments. What does AR "retrieve" and pull back into center stage from the shadows of obsolescence? I believe AR retrieves tactility, physical engagement, mobility, and physical space, as well as the single-user looking device (for example, early Victorian media such as the stereoscope). What does AR reverse or flip into when the medium has run its course or been developed to its fullest potential (looking ahead to the future of AR)? I believe AR reverses the window and screen where there is no identifiable filter/mediation and the individual is no longer able to distinguish reality from the virtual. AR also has the potential to reverse into advanced sensory technologies where the brain is linked to the digital realm in a scenario where there is a direct interfacing of the brain with the world.

REMEDIATION AND TRANSITION

Footfalls, by Tmema [Golan Levin & Zachary Lieberman] (2006), is an interactive audiovisual installation in which visitors' footsteps create cascading avalanches of leaping virtual shapes.

For the artist to truly create something novel and aid in fostering the creative growth of an emerging technology, the artist must tap into the unique qualities of expression the new form enables, rather than reverting to previous forms. In *Remediation*, media theorist Steven Holtzman argues that approaches of repurposing "do not exploit the special qualities which are unique to digital worlds" and that "it is those unique qualities that will ultimately define entirely new languages of expression."[32] He describes repurposing as a "transitional step" that permits "a secure footing on unfamiliar terrain," and is quick to note that this "is not where we will find the entirely new dimensions of digital worlds."[33] Holtzmann urges that we

The Critical Role of Artists in Advancing Augmented Reality Helen Papagiannis

must "transcend the old" to discover the new for, "like a road sign, repurposing is a marker indicating that profound change is around the bend."[34] I fully concur with Holtzman.

The present is a transitional time in AR; novel forms, styles, and conventions are just around the bend. It is a critical time for artists to experiment with the technology and act as pioneers to help shape the medium, harnessing the unique capabilities of AR to generate new modes and techniques.

THE IMPORTANCE OF ARTISTS WORKING WITH NEW TECHNOLOGIES

New media artist Golan Levin discusses how new media artists have early on prototyped many of today's technologies. He writes:

> As an occasional emissary for new-media arts, I increasingly find myself pointing out how some of today's most commonplace and widely appreciated technologies were initially conceived and prototyped, years ago, by new-media artists. In some instances, we can pick out the unmistakable signature of a single person's original artistic idea, released into the world decades ahead of its time—perhaps even dismissed, in its day, as useless or impractical—which after complex chains of influence and reinterpretation has become absorbed, generations of computers later, into the culture as an everyday product.[35]

Levin states the importance of "including artists in the DNA of any serious technology research laboratory (as was practiced at Xerox PARC, the MIT Media Laboratory, and the Atari Research Lab, to name just a few examples)" since "the artists posed novel questions which would not have arisen otherwise." Levin urges that in order to "get a jump-start on the future," it is necessary to "bring in some artists who have made theirs the problem of exploring the social implications and experiential possibilities of technology." He continues: "What begins as an artistic and speculative experiment materializes, after much cultural digestion, as an inevitable tool or toy."[36]

Therefore, the role of the artist in the early stages of an emerging technology is more important than one may think, with such artistic explorations leading to commonplace technologies, as Levin states. The role of the artist in working with emerging technologies in general is to be inspired by technology as a medium (but not be blinded by it), to understand its capabilities, and to exploit them as a "colonizer" and a pioneer, and not to fall prey to remediation but, instead, to strive to create an entirely new language of aesthetics and forms, which may even entail breaking out from the existing conditions of the environment. Perhaps this is the only way to truly create something new and innovative. This is where we need to go with AR, and it is imperative that AR artists serve as pioneers in guiding us there.

NOTES

1. John Pearson, "The computer: liberator or jailer of the creative spirit," *Leonardo, Supplemental Issue, Electronic Art* 1 (1988): 73.

2. Ibid.

3. Ibid., 78.

4. Ibid., 76.

5. Ibid., 79.

6. Ibid.

7. Marshall McLuhan, "The relation of environment to anti-environment," in *Marshall McLuhan Unbound*, Eric McLuhan and W. Terrence Gordon (eds.). (Corte Madera, CA: Ginko Press, 2005), 9.

8. Roger F. Malina, "Digital image—digital cinema: the work of art in the age of post-mechanical reproduction," *Leonardo. Supplemental Issue, Digital Image, Digital Cinema: SIGGRAPH '90 Art Show Catalog* 3 (1990): 34.

9. John Andrew Berton Jr., "Film theory for the digital world: connecting the masters to the new digital cinema," in *Leonardo: Journal of the International Society for the Arts, Sciences and Technology*. Digital Image/Digital Cinema: A special edition with the Special Interest Group in Graphics (SIGGRAPH) Association of Computing Machinery (New York: Pergamon Press, 1990), 7.

10. Ibid.

11. Ibid.

12. Pearson, "The computer," 76.

13. Dan North, "Magic and illusion in early cinema," *Studies in French Cinema* 1.2 (2001): 70.

14. Pearson, "The computer," 76.

15. Blair MacIntyre, Maribeth Gandy, Steven Dow and Jay David Bolter, "DART: A toolkit for rapid design exploration of augmented reality experiences," in *Conference on User Interface Software and Technology (UIST'04)*, October 24–27, 2004, Sante Fe, New Mexico, 197.

16. Helen Papagiannis, "'Wonder Turner' and 'The Amazing Cinemagician' augmented reality and mixed reality art installations," *2010 IEEE International Symposium on Mixed and Augmented Reality (ISMAR)—Arts, Media, and Humanities (ISMAR-AMH)*, Seoul, South Korea, Oct 13–26, 2010, 27–32.

17. Max Ernst, "What is the mechanism of collage?" in *Theories of Modern Art*, Herschel B. Chipp (ed.) (Berkeley: University of California Press, 1974), 427.

18. Bruce Sterling, "Augmented reality glitches," *Beyond The Beyond*, August 29, 2009. http://www.wired.com/beyond_the_beyond/2009/08/augmented-reality-glitches.

19. Robert Williams, *Art Theory: An Historical Introduction* (Malden, MA: Blackwell Publishing, 2004), 197.

20. Pearson, "The computer," 78.

21. Ibid., 80.

22. Malina, "Digital image," 34.

23. Martin Lister, *New Media: A Critical Introduction* (New York: Routledge, 2009, 2nd edition), 60.

24. Douglas Rushkoff, *Program or be Programmed: Ten Commands for a Digital Age* (New York: OR Books, 2010).

25. Helen Papagiannis, TEDxYorkU presentation: "How does wonderment guide the creative process?" (October 2010), http://www.youtube.com/watch?v=ScLgtkVTHDc.

26. Hector Rodriguez, "Technology as an artistic medium," *2006 IEEE International Conference on Systems, Man and Cybernetics*, Taipei, Taiwan, October 8–11, 2006, 3638.

27. Ibid.

28. Ibid., 3635.

29. Ibid.

30. Malina, "Digital image," 34.

31. Ibid.

32. Jay David Bolter and Richard Grusin, *Remediation: Understanding New Media* (Cambridge MA: MIT Press, 1999), 49.

33. Ibid.

34. Ibid.

35. Golan Levin, http://www.flong.com/blog/2009/new-media-artworks-prequels-to-everyday-life.

36. Ibid.

Augmented Environments and New Media Forms

JAY DAVID BOLTER AND
MARIA ENGBERG

Jay David Bolter
Georgia Institute of Technology, Atlanta, USA

Jay David Bolter is the Wesley Chair of New Media and co-Director
of the Augmented Environments Lab at the Georgia Institute of
Technology, USA. He is the author of *Remediation* (1999), with Richard
Grusin; and *Windows and Mirrors* (2003), with Diane Gromala. In
addition to writing about new media, Bolter collaborates in the
construction of new digital media forms. With Michael Joyce, he
created Storyspace, a hypertext authoring system. Bolter now works
closely with Prof. Blair MacIntyre, Prof. Maria Engberg, and others on
the use of Augmented Reality to create new media experiences for
cultural heritage and entertainment.

Maria Engberg
Malmö University, Malmö, Sweden
Georgia Institute of Technology, Atlanta, USA

Maria Engberg is an Assistant Professor at Malmö University, Sweden,
Department of Media Technology and Product Development, and an
Affiliate Researcher at the Augmented Environments Lab at Georgia
Institute of Technology, USA. Her research interests include digital
aesthetics, locative media, and media studies. She is the coeditor
of *Ubiquitous Computing, Complexity, and Culture* (Edman, Bolter,
Diaz, Søndergaard, and Engberg, Routledge, 2015), and the author of
several articles on digital aesthetics, literature, and locative media,
including augmented and mixed reality. Engberg designs mobile media
experiences for Augmented and Mixed Reality (AR/MR) for cultural
heritage and informal learning and entertainment experiences.

Media are ubiquitous, especially in our urban environments: one reason is that thc vast majority of us now carry smartphones, wearables, or tablets at practically all times. These mobile devices are platforms for the remediation of traditional media (the printed book, film, television, and recorded music) as well as for newer digital forms, such as videogames, social media, and Augmented and Virtual Reality applications. The next step in our media culture will be the continued multiplication and diversification of media forms. There will be no single medium (e.g., VR) that absorbs all others; instead, different media will flourish, each augmenting different aspects of our daily lived experience.

UBIQUITOUS MEDIA

Media are everywhere. Other advances—particularly in biotechnology—may ultimately have greater social impact and promise to remake what it is to be human. But if we look at the most visible changes that our culture has undergone in the past fifty years, they are in the realm of media. Many, perhaps most, readers of this article will remember a time when there were no smartphones or tablets; when cellphones were bulky and generally owned by businesspeople and so-called early adopters; when it was impossible to watch a television series or film on your computer; when LCD or LED flat-screen televisions were rare and expensive. Today people in the advanced economies carry media devices everywhere they go. Bars and airports have television monitors almost literally in every direction that you look. Elevators in office buildings have small screens to watch cable news and advertising as you ascend. Even some gasoline pumps now offer video entertainment (and of course advertising) as you fill up your car. Meanwhile, as for 2015, three digital media giants (Google known as Alphabet, Apple, Microsoft) led all other companies in market capitalization; Berkshire Hathaway Inc, a financial company, and Exxon Mobil came in fourth and fifth (Price Waterhouse Cooper, 2016). The sixth company, Facebook, whose social networking site is nothing but virtual entertainment, continues to climb toward an active user community consisting of one-quarter of the population of the planet. These are remarkable indications of the economic as well as cultural power of contemporary media.

For Hollywood and the science-fiction community, however, this is only the beginning of a media-saturated future. In their sometimes utopian, sometimes dystopian imagination, media will eventually augment every facet of our lived world. The film *Minority Report* (2002)

described such a world for us. As the main character, John Anderton, walks through the corridors of a mall, his retina is scanned for identification. The walls and space around him then come alive with projected advertising tailored to his presumed shopping preferences; mixed reality products and services, Sirens of the marketplace, call out to him by name. Google, Facebook, and many other sites already tailor advertising, but of course only on our computer screens. And the Microsoft HoloLens, as well as the VR headsets such as the Oculus Rift and the HTC Vive, already have the capacity to surround us with 3D images. A film such as *Minority Report* might lead us to wonder whether we all face John Anderton's future, greeted by digital advertising wherever we go... Is this the next step?

As early as 1991 in an article appropriately entitled "The Computer for the 21st Century," Mark Weiser at Xerox PARC proposed the term "ubiquitous computing" to describe the way that the networked computers would embed themselves in our physical, economic, and social fabric. He envisioned a world in which our appliances, cars, and buildings would be equipped with sensors and networked together. They would communicate not only with us but also directly and invisibly with each other, anticipating and meeting our needs. Twenty-five years later, Weiser's vision is being fulfilled as the so-called Internet of Things: that is, devices scattered throughout our environment gather data on us as well as for us. The reigning business model for the Internet of Things is to learn as much as possible about the consumer in order to provide services and products that the consumer will view as valuable. In the manufacturing sector the Internet of Things includes all sorts of sensors and controllers for industrial processes. For consumers the smart home is gradually gaining in appeal: smart thermostats and lights, motion sensors for security, doors that can be locked or unlocked remotely from the Internet, and so on, are increasingly popular ways to augment our houses and apartments. But by far the most popular consumer services and products are new forms of media. Our phones, tablets, smartwatches and other wearables, and laptop computers are the essence of ubiquitous computing today, as we employ them to refashion our media culture. And Weiser was wrong in one important respect: ubiquitous computing devices do not need to embed themselves silently in our world to count as ubiquitous. As Steve Jobs realized (and this is what made Apple the leading company on Forbes's list), consumers do not want their media devices to disappear: they want beautiful, sleek mobile phones that make a personal fashion statement as well as delivering excellent results. Furthermore, we should not think of ubiquitous media as including only the latest digital products. Today's media culture still includes many "traditional" forms: print books, newspapers, magazines, photography, film, radio, and television—all with digital counterparts. The interplay of all these forms constitutes ubiquitous media today. Ubiquity means not only that media forms are everywhere in our daily lives, but also that they combine and interact with each other in every conceivable way.

Just as Mark Weiser's notion of ubiquity helps us to understand contemporary media culture, we can also look to an earlier student of technology, Marshall McLuhan. For all his excesses and inconsistencies, McLuhan in *Understanding Media* (1964) provided us with a key insight when he observed that new media extend our senses and alter their ratios. This is not to say that we accept McLuhan's brand of what is called "technological determinism." We should not have to think of radical media technologies (such as the printed book in the fifteenth century, the film camera in the twentieth, or the smartphone now) as

autonomous agents beyond our control that alter what it means to be human. A more productive way to understand the process is to acknowledge a reciprocal relationship between the characteristics of each new media technology and the way we as a culture deploy that technology.

Both as inventors and as consumers, we make choices about what constitutes the new medium and how we will use it. For example, we decided as a society that radio, which was originally conceived as a two-way medium for individual communication (what we call "amateur" or "ham" today) became (in the United States from the 1920s on) a one-way medium for commercial broadcasting of music, series, news, and so on—extending our ability to hear but not to talk back. We decided as a society that film, which flourished in its "silent" form, needed to become an audiovisual medium in the late 1920s and later in the 1950s to adopt anamorphic, wide-screen projection.

Currently we are deciding how our ubiquitous media will augment our sensorium and expand forms of entertainment and communication. We are configuring mobile phones, wearables, and mobile and remote sensors into platforms that address our senses of sight, hearing, proprioception or embodiment, and touch. As discussed below, ubiquitous media today often combine many of our senses and human capabilities, and we use our devices simultaneously in ways that put multiple senses in play.

It is also important to remember that the ubiquity of media does not mean that any one medium replaces all the others. Although videogames and social media are among the most popular forms today, there are still vast communities of readers, filmgoers, and television watchers. Our media culture today is not only ubiquitous but also heterogeneous, and we need to appreciate how the contemporary versions of so-called traditional media interact with digital media.

"Mr. Marks, by mandate of the District of Columbia Precrime Division, I'm placing you under arrest for the future murder of Sarah Marks and Donald Dubin that was to take place today."

Minority Report (2002), directed by Steven Spielberg, with script by Scott Frank and Jon Cohen, based on Philip K. Dick's (1928–82) short story, *Minority Report* (1956).

Minority Report (2002), Steven Spielberg.

In the late 1990s, Jay Bolter and Richard Grusin (1999) introduced the concept of remediation to explain how media affect each other in our media economy. Even then it was apparent that the digital media of the time (such as the Internet and videogames) were in a constant dialogue with traditional media (especially film and television). The dialogue was sometimes cooperative, sometimes competitive. Producers of new digital forms borrowed formats, styles, and genres from the earlier established media forms, while at the same time claiming that the digital offered something new and exciting. For example, to advertise their products business websites borrowed the techniques of graphic design that consumers had been seeing for decades in magazines. At the same time business sites pioneered online sales, which combined the characteristics of mail-order and television shopping, but offered a new sense of immediate response. News websites came online in the 1990s, sometimes owned by and explicitly remediating the printed newspaper (such as *The New York Times*). These websites drew on the reputation and reproduced the written articles of printed papers. But they promised a new level of timeliness. A printed paper came out once or a few times a day, whereas new websites could be updated as the news broke.

The process of remediation has continued in the past two decades. In fact it is a defining feature of our media economy. As new forms are introduced, they are explained in terms of existing media—most often through the formula: this new form is like one or more older ones, only better. In 2007, in one of his famous product roll-out presentations, Steve Jobs introduced the iPhone by saying that today Apple was introducing three new products: an iPod with touch controls, a revolutionary new mobile phone, and an Internet browser (YouTube, 2007). Teasing the audience, he showed a graphic of a monstrous hybrid: an ungainly rectangular slab housing a small screen and an old-fashioned rotary dial for the phone. The next slide presented the actual first iPhone in which these features were absorbed into a sleek, modernist design. The transition between those two images was a perfect emblem for remediation, showing how Apple's new iPhone absorbed, refashioned, and ostensibly improved upon the media it was meant to replace. The iPhone was like a phone, only better; like a music player, only better.

In the same presentation, Jobs also claimed repeatedly that the iPhone was revolutionary, a device that would "change everything." Digital media writers and digital companies often adopt this rhetoric. According to them, it is not only the iPhone, Facebook, or Google that have changed the world we live in; each new smartphone with a better camera or fingerprint or retinal recognition, each new interface on Facebook is called revolutionary. And conversely, if a new release of the iPhone is not revolutionary, but is merely an upgrade, then the digital world is disappointed. The rhetoric of revolution is a holdover from the middle of the twentieth century, the era of high modernism, which was defined both in art and popular culture by a cult of the new. The assumption was that in order to be significant at all, each new work of art, each new invention had to be unique, utterly original, not just an improvement, but a breakthrough. The modernist assumption is still widespread, despite the fact that our media culture is now widely characterized by different creative impulses—by remix and remediation, by borrowing and refashioning earlier media and media forms.

Both cooperation and competition are clearly at work in which the major media of the twentieth century have all been remediated through Internet delivery and display on digital

Augmented Environments and New Media Forms Jay David Bolter and Maria Engberg

screens. Thus far digital technology has not killed a single one of these media. Instead, television, radio, recorded music, and film have all continued to exist as separate media, and they have all developed Internet counterparts, made available to users through a complex set of economic and technical arrangements with the various original makers and distributors. These Internet remediations retain the names to connect them with their origins: Hulu is Internet television; the iTunes store lets you download "albums" for music, as well as movies and television series. At the same time digital remediation changes the character of each media. For example, we can watch a movie anytime and anywhere on a screen of our choosing. All remediation has this character: the experience it offers is always new and yet familiar.

Even the newest of new digital media forms are remediations, borrowing and refashioning older forms. The most successful of these innovative forms today are videogames and social media, and both have clear antecedents in analog media. Videogames are obviously the new versions of an entertainment form, the competitive game, that is thousands of years old. Some videogames remediate board games; others remediate puzzles; still others arcade shooting and skill games. Some genres of videogames, such as the role-playing and adventures games, also borrow both storytelling and camera techniques from film. And remediation works in the other direction as well: that is, from digital media back to traditional media. Film can remediate videogames, when, for example, movies are made based on videogame franchises such as *Tomb Raider* or *Resident Evil*. Social media are now the most widely used digital form with billions of users, and they are also among the most innovative. And yet each of the major social media applications has roots in earlier media traditions. Facebook began as a remediation of the (Harvard) college yearbook, with its format of picture and textual information about students. Image-sharing sites, such as Instagram and Flickr, remediate the family photo album and photographic journals. Twitter combines the terse quality of the sms with the broadcasting feature of mass media. All of these forms are recombinations of earlier print or visual media as well as earlier electronic ones. All of them redefine or confuse the spheres of privacy and publication from these earlier media. And all of them add the particular digital characteristics of interactive and (almost) immediate communication.

After decades of false starts, Virtual Reality has recently become a widespread media form with the introduction of inexpensive headsets such as the Oculus Rift and the HTC Vive as well as Google Cardboard and software that converts smartphones into makeshift headsets. These devices are now being offered as ideal platforms for remediated videogames such as first-person shooters that were originally played on the screens of desktop computers. There is also growing interest in VR movies, such as those created by filmmaker Chris Milk

and others (VRSE.com). These VR movies are remediations of traditional film genres such as the documentary and the horror film. It is the claim of VR filmmakers that its 360-degree video puts you "in the scene" as never before. This form is supposed to give you a greater sense of immersion and therefore emotional involvement in the action. This is exactly the point that Chris Milk makes in his TED talk (2015). The claim of greater authenticity, reality, or engagement is a typical remediating claim made by creators of a new medium. VR movies are like traditional film, only better, their proponents argue, because they heighten your empathy. In one VR movie called *The Displaced*, for example, child refugees from conflicts in Syria, South Sudan, and Ukraine are shown in their environments; we as viewers experience the refugees' world in 360 degrees.

The introduction of new media is always a process of isolating elements of traditional media and reconfiguring them in new ways. The new configuration emphasizes qualities that may have been latent in the earlier media, but it also shows us where those earlier media fell short. The new media form seeks to make up for their shortcomings and provide a new experience that goes beyond what was available before. Thus, the next steps in media culture, the augmenting of our media experiences with mobile devices and services, will not come as a revolutionary break with the existing media, but rather as a process of cooperative and competitive adaptations of those media. We can expect new remediations to be based on existing digital forms themselves, combined and configured in new ways, although we cannot predict what those reconfigurations will be. New forms of social media are constantly appearing. In recent years Snapchat's video and imaging-sharing service has become quite popular, initially because any images or videos that have already been accessed are erased, providing the user ostensibly with a sense of privacy and assurance that images will not be spread further. Recently, they added a kind of Etch-a-Sketch layering of various augmentations to the photos, such as Face Swap. Augmentation to already existing platforms is a common media strategy, for instance the combination of the videogame with Internet video-broadcasting has produced Twitch. We can expect these kinds of augmentations of the most popular and compelling digital forms to continue and in particular to exploit two capacities that have been dormant or underdeveloped in the dominant media of the twentieth century and that now promise augmented forms of expression and communication. Those two capacities (key augmentations) are location awareness and multisensory input (especially touch and proprioception).

One way in which digital mobile media are remediating old forms is by changing the relationship between media presentation and location. Not only do mobile technologies allow us to carry media around with us everywhere we go, to experience media forms in different locations; they can also make media aware of and responsive to their location. The printed book after all has been a mobile media form for hundreds of years. You can easily carry a book with you, but the book does not change no matter where you take it. By contrast, the information in a mobile device can change because the device can keep track of its location (outdoors through GPS or indoors through Wi-Fi and other systems). Change is not necessary, of course—you can take a conventional movie with you on your tablet, watch it anywhere, and it will be the same movie. But location awareness now becomes a parameter available for the re-presentation of any media depending on the site of interaction.

Ironically, it is precisely because mobile devices allow the user freedom of movement that digital media content can now be anchored in place. One way to anchor content is through image tracking. The mobile phone's video recognizes an image, such as a picture in a magazine or comic book, and the application can place digital content on top. This technique has been used for advertising: open the magazine to the right page, point your phone with the appropriate app at the picture, and you get to a 3D model of a Nissan sitting on top of the 2D image (YouTube, 2010). The model is animated: the doors and hatchback open and close. Marvel Comics has produced augmented comics, where pointing your phone at a particular panel delivers a new visual experience and may reveal something new in the story (YouTube, 2012). Augmented Reality (AR) tabletop games now exist thanks to image tracking: the game board is a physical graphic image, and the characters are virtual, running over the board when viewed through the phone's screen. All of these applications are niches that may grow in the future. Children in particular may take to AR games and augmented books; media for children have long included various media elements (pop-up books, games that blur the line between reality and illusion, and so on) in order to be playful or attention-grabbing.

The second way to anchor media is through geopositioning. You can locate images, text, audio, any media content at specific locations of latitude, longitude, and altitude. A user with a smartphone can visit these locations and view the media (or hear audio through its sound system). Pokémon Go, which became a craze in the summer of 2016, is an example of a geolocated AR game. For a couple of months, at least, millions of players wandered around streets and buildings with their iPhones and Androids, looking for Pokéstops and gyms and collecting eggs, Poké balls, and potions. The game is a remediation of the age-old scavenger hunt: the appeal is that the player gets to see and pursue vivid 3D images floating in space, while the game keeps track of his or her captures.

Urban media in their digital forms are of course only the latest in a long line of remediated location-based media forms. In the 1800s exterior advertising began to appear in North American and European cities. Painted advertisements could be seen on building walls, and in the 1830s large-format posters began to be printed. These commercial advancements in turn emerged from older traditions of "writing on the world": from the earliest signs of graffiti already in ancient Greece and Rome, if not earlier, to writing on columns (Trajan

Just days before its release on July 6, 2016, *Pokemon Go*, the augmented reality videogame developed by Niantic, reached forty-five million active users. In the top and right images: people capturing Pokemons at the Sidney Opera House in Australia and at Number 10, Downing Street, London, UK. In the left image: an augmented reality app used as a street map.

Apollo 11 astronaut
Buzz Aldrin tries HoloLens
mixed-reality glasses during
a preview of *Destination: Mars*,
an exhibition that allows visitors
to experience the planet Mars
through holographic versions,
with Aldrin and Hines as guides.
Kennedy Space Center Visitor
Complex, Florida, USA.

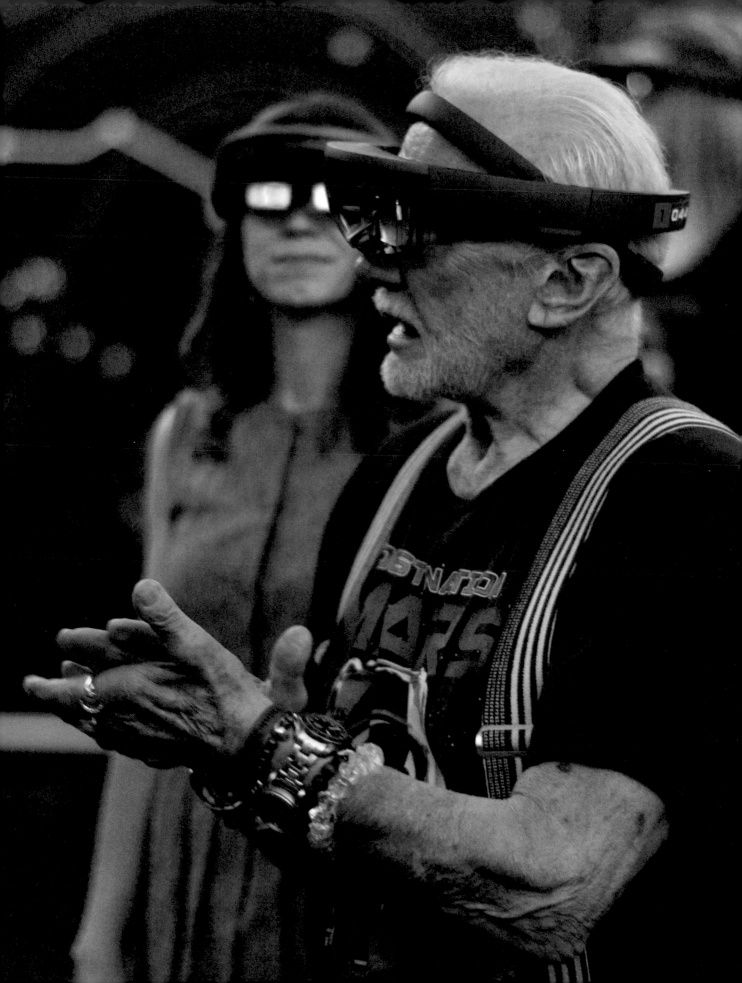

Column), buildings, and other structures to leave mediated traces. However, the modern history of urban media forms coincides with digital developments, and as mobile technology spreads and becomes increasingly available, so do the possibilities of augmenting our public and private environments. Today, technology adoption is on the rise globally: 68% of adults in rich countries report owning a smartphone; 87% use the Internet. Even in economies that do lag behind richer countries, smartphone ownership rates have skyrocketed since 2013 (Pew Research Center, 2016).

As mobile technology participates in spreading media throughout the urban landscape, the locative character of smartphones becomes particularly apparent and productive in urban settings. Applications and services can include location awareness to deliver specific and targeted information, and our location can be sent back to companies that then gather large swathes of data indicating patterns of behavior and movement. The mobile devices that we bring with us and those that are placed in objects and environments join into large networks of interconnected things and people, giving us the sense that the whole city is inhabited by media forms: some obvious and visible, others obscured and hidden. For social and practical purposes, for surveillance and control, for entertainment and commercially driven service, urban environments pulsate with digital information with which to interact.

The socio-technical condition of contemporary societies are providing communicators, designers, and programmers with a canvas for delivering content in new ways. For cultural heritage institutions, the calls for extending their offer to audiences outside the museum building have partially been answered by moving access to already digitized cultural archival material from exhibitions to relevant sites. Museums all over the world have produced quality content for mobile devices, for use inside as well as outside their buildings: for example, the Guggenheim, the Louvre, the Museum of Modern Art in New York, the Canadian Museum of Civilization, and the American Museum of Natural History.

Some of these applications use location awareness to offer content for the users, providing a digitally mediated layer of information that is overlaid onto the city as a mixed reality canvas. The Museum of London's Streetmuseum app from 2012 provides visitors with hybrid images of the present and the past as they walk through the city. The layered experience as a mediation renders the city readable, opening up institutions that many groups of citizens rarely if ever visit with a hope of democratizing content access. Other locative media experiences foreground information, communication, and entertainment. Still others focus on aesthetic explorations of mediated art in urban settings.

Early examples of digitally mediated urban art are the Los Angeles based 34 North 188 West project (Knowlton et al., 2012) and Proboscis's *Urban tapestries* (2002–04), a software platform that enabled users to build connections between places and to associate digital information to those places. Today, location awareness is ubiquitous in media devices and many services and applications regularly use location as part of the data gathering aimed at providing the user with more accurate information, for navigational purposes, advertising, entertainment, game or cultural heritage experiences.

Among the next steps in ubiquitous media will be technologies that address more of our senses at the same time and mediate our environment even more intensely: for example, the HoloLens, already available in a preproduction release, with its vision of "mixed reality" (MR). A promotional video (Microsoft, 2016) shows users of the HoloLens users putting on sleek headsets to experience and interact with 3D graphics and spatial sound overlaid on their visual environment. In the video the space of the home or the office comes alive with animated "holograms": the human body conveniently disassembles itself so that a student can more clearly see the organs, muscles, and skeletal system. Industrial designers collaborate on what appears to be a new videogame controller: it floats in front of them so that they can examine it from all directions. AR games emerge from the table or wall to provide new forms of entertainment. Video monitors follow the user as she walks around the room. The HoloLens, though, is a device that we must wear. It will only be used for limited periods of time in order to accomplish particular tasks or participate in particular games and forms of entertainment. With mobile devices that have increasing capabilities for input alongside high-end appliances and low-tech devices such as Google Cardboard, we can imagine a range of possibilities for experiences that address the whole human sensorium. McLuhan's classic tenet that media are extending our senses as well as older media forms seems now to be more accurate than ever.

Science-fiction author Vernor Vinge offers us his vision of the step beyond the HoloLens in his science-fiction novel *Rainbows End* (2006). The year is 2025, and Augmented Reality has become the dominant technology. Those who have successfully adapted to contemporary urban life wear elaborate body suits that allow them to see, hear, feel, and interact with a world of information around them. Sensors implanted through the world, but again principally in population centers, track and respond to the humans in body suits, and all of this technology is connected to a future Internet of tremendous bandwidth. This Internet of Things and People is seamless (at least when the worldwide network is functioning properly): the graphics and registration are so good that it is impossible to tell where the physical ends and the virtual picks up.

Such a radical and thoroughgoing overhaul of our entire media environment is not going to happen in the foreseeable future. The year 2025 is less than a decade away. The problem of this prediction of a perfect technological world lies not only in the fact that technology is progressing more slowly than Vinge imagined. There is a deeper problem: no single media technology (neither Virtual nor Augmented Reality) is likely to sweep all others aside. The "next step" in our media culture will be the continued multiplication and diversification of media forms. Media plenitude will be the guiding principle, rather than one dominant medium encompassing all media practice. All the examples that we have discussed above have this in common: they are special, particularly suited for certain communities of users, certain desired uses for entertainment, work, commerce, or education. This is the way media are today: they are all tailored to particular communities, even if some of the communities are very large (e.g., Facebook). Like all science fiction and all futurology, *Rainbows End* is not really about the future, but is, instead a reimagining of the present. In this case Vinge's novel is still indicative of the desire for a single media form, here AR, to take over our media world and more or less sweep away all other media. It seems likely that most of the forms that have emerged in the era of digital media—above all videogames and social media—will continue to be important parts of our media culture, although they themselves may undergo remediations for a new era of mixed reality. Mixed reality games and social media "tweets" and "Facebook pages" may begin to appear in forms that dot around the visual landscape, presented to us on a screen of something like a HoloLens. But it would not be surprising if users continue to tweet on small handheld devices as well. It would not be surprising if some segment of the public continues to read printed books, to attend movies and plays in theaters, and so on. Most, if not all, the augmentations of the past will continue, although they may have smaller user communities. There will be no single medium that absorbs all others; instead, different media will continue to flourish, each augmenting different aspects of our daily lived experience.

—Bolter, Jay David, and Richard Grusin. 1999. *Remediation: Understanding New Media*. Cambridge, MA: MIT Press.

—Knowlton, Jeff, Naomi Spellman and Jeremy Hight. 2012. "34 North 188 West: Mining the urban landscape." http://www.34n118w.net/34N.

—McLuhan, Marshall. 1964. *Understanding Media: The Extensions of Man*. New York: New American Library Inc.

—Microsoft. 2016. "HoloLens." https://www.microsoft.com/microsoft-hololens/en-us/why-hololens.

—Milk, Chris. 2015 (March). "How virtual reality can create the ultimate empathy machine." TED Talk. http://www.ted.com/talks/chris_milk_how_virtual_reality_can_create_the_ultimate_empathy_machine?language=en (accessed September 15, 2016).

—*Minority Report*. 2002. Directed by Steven Spielberg. Los Angeles: Amblin Entertainment.

—Pew Research Center. 2016 (February 22). "Smartphone ownership and Internet usage continues to climb in emerging economies." http://www.pewglobal.org/2016/02/22/smartphone-ownership-and-internet-usage-continues-to-climb-in-emerging-economies/) (accessed September 15, 2016).

—Price Waterhouse Cooper. 2016. "Global top 100 companies by market capitalisation: 31 March 2016 update." https://www.pwc.com/gr/en/publications/assets/global-top-100-companies-by-market-capitalisation.pdf.

—Proboscis. *Urban Tapestries*. 2002–04. http://proboscis.org.uk/projects/urban-tapestries.

—Vinge, Verner. 2006. *Rainbows End*. New York: Tor.

—Weiser, Mark. 1991. "The computer for the 21st century." *Scientific American*. http://www.ubiq.com/hypertext/weiser/SciAmDraft3.html.

—YouTube. 2012. "Marvel ReEvolution: Augmented reality demo." https://www.youtube.com/watch?v=rZJo19udwHU (accessed September 15, 2016).

—YouTube. 2010. "Nissan augmented reality." https://www.youtube.com/watch?v=Hv32V3EYauI (accessed September 15, 2016).

—YouTube. 2007. "Steve Job introduces iPhone in 2007." https://youtu.be/MnrJzXM7a6o (accessed September 15, 2016).

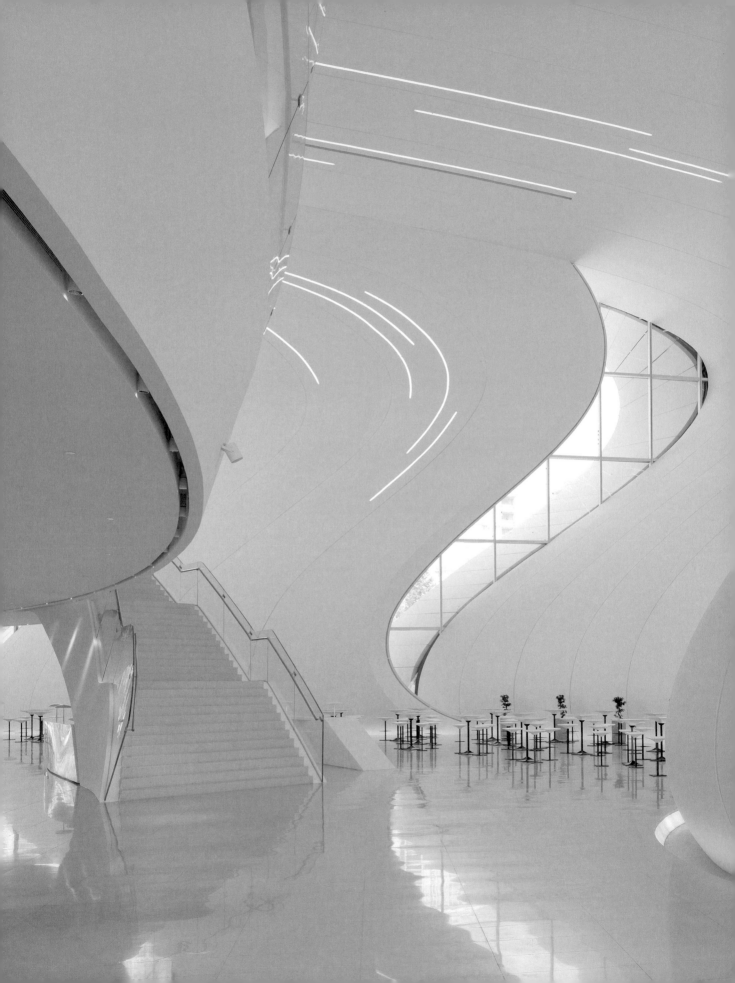

Human Legacies When Robots Rule the Earth

ROBIN HANSON

Opening image:
Zaha Hadid Architects
Heydar Aliyev Centre (2013),
in Baku, Azerbaijan.

Robin Hanson
George Mason University, Fairfax, VA, USA
Future of Humanity Institute of Oxford University, Oxford, UK

Robin Hanson is Associate Professor of Economics at George Mason
University, and Research Associate at the Future of Humanity Institute of
Oxford University. He has a Caltech Social Science PhD, an MA in Physics
and Philosophy from the University of Chicago, and spent nine years as an
AI researcher at Lockheed and NASA. He has 3175 citations, sixty academic
publications, 500 media mentions, 200 invited talks, and eight million visits
to his blog OvercomingBias.com. He published *The Age of Em: Work, Love,
and Life when Robots Rule the Earth* in 2016 (Oxford University Press) and *The
Elephant in the Brain*, coauthored with Kevin Simler, is forthcoming in 2017.

The three biggest disruptions in history were the introduction of humans, farming, and industry. A similar disruption could arise from artificial intelligence in the form of whole brain emulations, or "ems," some time in the next century. Drawing on academic consensus in many disciplines, I outline a baseline scenario set modestly far into a post-em-transition world. I consider computer architecture, energy, cooling, mind speeds, body sizes, security strategies, virtual reality, labor markets, management, job training, careers, wages, identity, retirement, life cycles, reproduction, mating, conversation, inequality, cities, growth rates, coalition politics, governance, law, and war.

INTRODUCTION

While we have had many kinds of robots (and other computer-based assistants) for many decades, their abilities have remained limited. For example, if we weigh work tasks by how much we pay to get them done, we find that humans remain far more valuable than robots, because humans get paid far more in total than robots do.

However, robot abilities have been slowly improving over many decades, and they have been improving much faster than human abilities have. So while it may take centuries, we expect robots to eventually get better than humans at almost all tasks; almost all of the money paid to do tasks will then be paid to robots (or their owners). This would be a world "dominated" by robots, at least in the sense of who does most of the work and who makes most of the concrete decisions requiring a detailed understanding of context. Humans might perhaps continue to choose key abstract, symbolic, and high-level policies.

What can we do today to influence events in a future dominated by robots? I first consider the general case of how to influence the future, and then I focus in particular on two kinds of future robots.

LEGACIES ARE HARD

When people talk about the distant future, they usually talk about what they want to happen in the future. Among the many future scenarios that they can imagine, which ones do they most prefer? They talk more about their basic values, less about the practical constraints that limit feasible scenarios, and they talk even less about how we today might influence future

outcomes. But this last neglected topic, how to influence the future, seems crucial. Why think about what we want if we cannot change it?

Imagine standing in a river, a river that eventually reaches the ocean, miles downstream. Down there at the ocean, someone you care about is standing in that river. You want to do something to the river next to you to somehow influence this other person downstream. Ideally for the better, but to start you will settle for influencing them in any noticeable way.

This actually turns out to be quite hard. You might splash some water next to you, heat it with a torch, or put a new rock in the river. But rivers tend to be stable arrangements that swallow such disturbances, quickly reverting back to their undisturbed forms. Even building a dam may result in only a temporary change, one that is reversed when the dam fills to overflowing. Perhaps you could put a bottle in the river, a bottle strong enough not to smash on the rapids along the way. Or you might try to divert the river to a new path that does not intersect the ocean at the same place. But none of these are easy.

Trying to influence the distant future is a lot like trying to influence a river far downstream. Many aspects of our world are locally stable arrangements that swallow small disturbances. If you build a mound, rains may wash it away. And if you add one more sandwich shop to your city, one extra shop may soon go out of business, leaving the same number of shops as before.

Yes, since the world has many possible stable arrangements, you might hope to "tip" it into a new one, analogous to a different stable path for a river. For example, maybe perhaps if enough customers experience more sandwich shops for a while, they will perceive a new fashion for sandwiches, and that fashion will allow more sandwich shops to exist. But fashion can be fickle, and perhaps a new food fashion will arise that displaces sandwiches. Also, it can be hard to map the stable arrangements, and rare to find oneself near a tipping point where a small effort can make a big difference.

The set of groups that ally with each other in politics can be somewhat stable, and so you might try to tip your political world to a new set of political coalitions. Similarly, you might join a social movement to lobby to give some values more priority in social and political contexts. But if such values respond to circumstances, they can also be part of stable arrangements, and so resist change. Yes, you may have seen changes in politically expressed values recently, but these may have resulted less from changes in truly fundamental values and more from temporary fashions and responses to changing circumstances.

Some kinds of things naturally accumulate. For example, many innovations, such as academic insights and technical or organizational design choices, are general and robust enough to retain their value outside of current social contexts. If such innovations are also big and simple enough, the world may collect a big pile of them. If so, you might influence the future by adding another such innovation to the pile. However, if someone else would soon have discovered a similar

innovation if you had not done so, the distant future may not look much different as a result of your contribution.

The whole world economy accumulates, in the sense that it grows, mostly via innovation. You might try to help some parts of it grow faster relative to other parts, but if there is a natural balance between parts, restoring forces may reverse your changes. You might try to influence the overall rate of growth, such as by saving more, but that might just get the same future to happen a bit earlier.

You might try to save resources and commit them to a future plan. This can be an especially attractive option when, as through most of history, investment rates of return have been higher than economic growth rates. In this case you can have a larger fractional influence on the future than you can on the present, at least when you can reliably influence how your future investment returns are spent.

For example, you might save and try to live a long time personally. Or you might make a plan and teach your children and grandchildren to follow your plan. You might create and fund a long-lived organization committed to achieving specified ends. Or you might try to take control of a pre-existing long-lived institution, like a church or government, and get it to commit to your plan.

If you think many others prefer your planned outcomes, but each face personal incentives to pursue other objectives, you might hope to coordinate with them via contracts or larger institutions. If you think most of the world agrees with you, you might even try to make a stronger world government, and get it to commit to your plan. But such commitments can be hard to arrange.

Some kinds of things, like rocks, buildings, or constitutions, tend to naturally last a long time. So by changing such a thing, you might hope to create longer-lasting changes. Some of our longest lasting things are the ways we coordinate with one another. For example, we coordinate to live near the same locations, to speak the same languages, and to share the same laws and governments. And because it is hard to change such things, changes in such things can last longer. But for that same reason, it can be rare to find yourself in a position to greatly influence such things.

For billions of years of the biosphere, by far the most common way to influence the distant future has been to work to have more children who grow up to have more kids of their own. This has been done via not dying, weakening rivals, collecting resources, showing off good

abilities to attract mates, and raising kids. Similar behavior has also been the main human strategy for many thousands of years.

This overwhelming dominance of the usual biological strategies suggests that in fact they are relatively effective ways to influence the long-run future; there appear on average to be relatively weak restoring forces that swallow small disturbances of this sort. This makes sense if our complex world is constantly trying to coordinate to match whatever complexity currently exists in it. In this case, the more you can fill the world now with things like you, the more that the world will try to adjust soon to match things like you, making more room in the distant future for things like you.

It tends to be easier to destroy than to create. This tempts us to find ways to achieve long-term aims via destruction. Fortunately, destruction-based approaches are somewhat in conflict with make-more-stuff-like-you approaches. Yes, we do try to kill our rivals, and societies sometimes go to war, but overall unfocused general destruction rarely does much to help individuals create more descendants.

Now that we have reviewed some basic issues in how to influence the future, what can we say about influencing a robot future?

TRADITIONAL ROBOTS

Machines have been displacing humans on job tasks for several centuries, and for seventy years many of these machines have been controlled by computers. While the raw abilities of these computers have improved at an exponential rate over many orders of magnitude, the rate at which human jobs have been displaced has remained modest and relatively constant. This is plausibly because human jobs vary enormously in the computing power required to do those jobs adequately. This suggests that the rate of future job displacement may remain mild and relatively constant even if computing power continues to improve exponentially over a great many more orders of magnitude.

"Artificial intelligence" (AI) is a field of computer research in which researchers attempt to teach computers to accomplish tasks that previously only humans could do. When individual AI researchers have gone out of their way to make public estimates of the overall future rate of progress in AI research, averaged over all of the subfields of AI, their median estimate has been that human-level abilities would be achieved in about thirty years. This thirty-year estimate has stayed constant for over five decades, and by now we can say that the first twenty years of such estimates were quite wrong. Researchers who have not gone out of their way to make public estimates, but instead responded to surveys, have given estimates about ten years later (Armstrong and Sotala, 2012; Grace, 2014).

However, AI experts are much less optimistic when asked about the topics on which they should know the most: recent progress in the AI subfield where they have the most expertise. I was a professional AI researcher for nine years (1984–93), and when I meet other experienced AI experts informally, I ask them how much progress they have seen in their specific AI subfield in the last twenty years. They typically say they have only seen five to ten percent of the progress required to achieve human-level abilities in their subfield. They have also typically seen no noticeable acceleration over this period (Hanson, 2012). At this rate of

progress, it should take two to four centuries for the median AI subfield to reach human-level abilities. I am more inclined to trust this later estimate, instead of the typical forward estimate of forty years, as it is based more directly on what these people should know best.

Even if it takes many centuries, however, eventually robots may plausibly do pretty much all the jobs that need doing. At that point, the overall growth rate of the economy could be far higher; the economy might double roughly every month, instead of every fifteen years as it does today. At that point, human income would have to come from assets other than their abilities to work. These assets could include stock, patents, and real estate. While asset values should double about as fast as the economy, humans without sufficient assets, insurance, or charity could starve.

A future world dominated by robots could in principle evolve gradually from a world dominated by humans. The basic nature, divisions, and distributions of cities, nations, industries, professions, and firms need not change greatly as machines slowly displace humans on jobs. That is, machines might fit into the social slots that humans had previously occupied. Of course at the very least, industries that previously raised and trained humans would be replaced by new industries that design, maintain, and manufacture robots.

However, there could also be much larger changes in the organization of a robot society if, as seems plausible, machines are different enough from humans in their relative costs or productivity so as to make substantially different arrangements more efficient. One reasonable way to guess at the costs, productivity, and larger-scale structures of a robot society is to look at the distribution of similar features in the software that we have created and observed for many decades. While it is possible that future software will look very different from historical software, in the absence of good reasons to expect particular kinds of changes, historical software may still be our best estimate of future software. So we might reasonably expect the structure of a robot society to look like the structure of our largest software systems, especially systems that are spread across many firms in many industries.

How might one try to influence such a robot future? One straightforward approach is to accumulate resources, and entrust them to appropriate organizations. For example, if you just wanted to influence the future in order to make yourself or your descendants comfortable and happy, you might try to live a long time and keep resources to yourself, or you might give resources to your descendants to spend as they please.

Perhaps you dislike the overall nature or structure that a robot society would likely have in a decentralized world with only weak global coordination. In this case, if you and enough others felt strongly, you might try to promote large-scale political institutions, and encourage them to adopt sufficiently strong regulations. With

detailed enough monitoring for violations and strong enough penalties for those found guilty, regulations might force the changes you desire. If the profits that organizations could gain from more decentralized arrangements were strong enough, however, global regulation might be required.

The structures of a future robot society may plausibly result from a gradual evolution over time from structures in the most robot-like parts of our society today. In this case, one might hope to influence future structures via our choices today of structures in computer-intensive parts of our society. For example, if one preferred a future robot society to have relatively decentralized security mechanisms, then one might try to promote such a future via promoting the development and adoption of relatively decentralized security mechanisms today. And if one feared high levels of firm concentration in a particular industry of a future robot society, one might try to promote low levels of firm concentration in that industry today.

EMULATION-BASED ROBOTS

As we have been discussing, it is possible that a future world will be filled with robots similar to the kinds of robots that we have been building for many decades. However, it is also possible to, at least for a time, fill a future with a very different kind of robot: brain emulations.

Brain emulations, also known as "uploads" or "ems," have been a staple of science fiction and tech futurism for decades. To make a brain emulation, one takes a particular human brain, scans it to record its particular cell features and connections, and then builds a computer model that processes signals according to those same features and connections. A good enough em has very close to the same overall input-output signal behavior as the original human. One might talk with it, and convince it to do useful jobs.

Like humans, ems would remember a past, are aware of a present, and anticipate a future. Ems can be happy or sad, eager or tired, fearful or hopeful, proud or shamed, creative or derivative, compassionate or cold. Ems can learn, and have friends, lovers, bosses, and colleagues. While em psychological features may differ from the human average, they are usually near the range of human variation.

The three technologies required to create ems—computing, scanning, and cell modelling—all seem likely to be ready within roughly a century, well before the two to four centuries estimated above for ordinary robots to do almost all jobs. So ems could appear at a time when

there is plenty of demand for human workers, and thus plenty of demand for ems to replace those human workers.

I recently published a book, *The Age of Em: Work, Love, and Life when Robots Rule the Earth* (Oxford University Press, 2016), giving a detailed description of a world dominated by ems, at least regarding its early form, the one that would appear soon after a transition to an em world. Let me now summarize some of that detail.

My analysis of the early em era paints a picture that is disturbing and alien to many. The population of ems would quickly explode toward trillions, driving em wages down to near em subsistence levels, em work hours up to fill most of their waking hours, and economic doubling times down to a month or less. Most ems would be copies of less than a thousand very smart, conscientious, and productive humans. Most ems would be near a subjective peak productivity age of fifty or more, and most would also be copies made to do a short-term task and then end when that task is done.

Ems would cram in a few tall cities packed densely with hot computer hardware. Ems would leisure in virtual reality, and most ems would work there as well. Em virtual reality would be of a spectacular quality, and ems would have beautiful virtual bodies that never need feel hunger, cold, grime, pain, or sickness. Since the typical em would run roughly a thousand times faster than humans, their world would seem more stable to them than ours seems to us.

Ems would often spin off copies to do short-term tasks and then end when those tasks are done. After a subjective career lasting perhaps a century or two, em minds would become less flexible and no longer compete well with younger minds. Such ems could then retire to an indefinite life of leisure at a slower speed.

The ease of making copies of ems would make preparation easier. One em could conceive of a software or artistic design and vision, and then split into an army of ems who execute that vision. Big projects could be completed more often on time if not on budget by speeding up the ems who work on lagging parts. One em could be trained to do a job, with many copies then made of that trained em. Em labor markets would thus be more like our product markets today, dominated by a few main suppliers.

Ems would be more unequal than we are, both because em speeds could vary, and because longer lifespans let unequal outcomes

"Second star to the right and straight on till morning."

Captain James T. Kirk, one of the characters from the Star Trek series, in *Star Trek VI, The Undiscovered Country* (1991).

The installation by Devorah Sperber in Microsoft's Studio D offices in Redmond, Washington, was inspired by the episode "Mirror, Mirror" from *Star Trek: The Original Series* (1967).

accumulate. Ems would split by speed into status castes, with faster ems being higher status. Em democracies would probably use speed-weighted voting, and em rulers would usually run faster than subordinates, to more easily coordinate bigger organizations. Em organizations may also use new governance methods like decision markets and combinatorial auctions.

Each em would feel strongly attached to its clan of copies all descended from the same original human. Em clans may self-govern and negotiate with other clans for the legal rules to apply to disputes with them. Clans may give members continual advice based on the life experiences of similar clan members.

To allow romantic relations when there is unequal demand for male vs. female em workers, the less demanded gender may run slower, and periodically speed up to meet with faster mates. Fast ems with physical robotic bodies would have proportionally smaller bodies. A typical thousand-times-human-speed em would stand two millimeters tall. To such an em, the Earth would seem far larger. Most long-distance physical travel would be via "beam me up" electronic travel, done with care to avoid mind theft.

Em cities are likely inhospitable to ordinary humans, who, controlling most of the rest of the Earth, mostly live a comfortable retirement on their em-economy investments. While ems could easily buy the rest of the Earth, they do not care enough to bother, beyond ensuring energy, raw materials, and cooling for em cities. Just as we rarely kill our retirees and take their stuff, there is a reasonable hope that ems might leave retired humanity in peace.

Over the longer run, the main risk to both humans and nature is probably em civilization instabilities like wars or revolutions. Ems running a thousand times faster than humans might fit a few millennia of history into a few objective years. As slow em-retirees face similar risks, they would be allies to help humans to promote stability in the em civilization.

EM ROBOT LEGACIES

Above we quickly discussed some of the main ways to try to influence a general robot future. How does this situation change for em-based robots?

The most obvious difference is that since each em results from scanning a particular human, particular humans can hope to have great influence over the individual ems that result from scanning them. The parents and grandparents of such humans can also hope to have a related influence. These sorts of influences are quite similar to those resulting from the typical and so-far-very-effective biosphere strategy of promoting future creatures who share many of your details.

Another big difference is that as ems are very human-like, ems can fit much more directly and easily into the various social slots in the previous human society. There is less reason to expect big immediate changes in the basic nature, divisions, and distributions of cities, nations, industries, professions, and firms when ems arrive. Because of this, the investments made today into influencing such social institutions can more plausibly last into the em era. Of course social arrangements and institutions are likely to change over time with ems, just as they would have changed over time if humans had still dominated the Earth.

We can expect that, during the em era, em robots would continue to develop the abilities of traditional non-em-based robots. Eventually such robots might become more capable than ems in pretty much all jobs. That could plausibly mark the end of the em era. It is less obvious that traditional robots would eventually displace ems than that such robots would eventually displace humans, because ems have more ways to improve over time than do humans. Even so, displacement of ems by traditional robots seems a scenario worth considering.

Compared to a scenario where humans are directly replaced by traditional robots, a scenario where ems first replace humans and then are replaced in turn by traditional robots seems to allow humans today to have a larger impact on the distant future. This is because the first scenario contains a more jarring transition in which existing social arrangements are more likely to be replaced wholesale with arrangements more suitable to traditional robots. In contrast, the second scenario holds more possibilities for more gradual change that inherits more structure from today's arrangements.

As the em economy advances, it is likely to become gradually more successful at finding useful and larger modifications of em brains. But the search would mainly be for modifications that can make the modified ems even more productive with the existing em jobs and social relations. And since most modifications are likely to be small, em minds, jobs, and other social relations would gradually co-evolve into new arrangements.

Larger em brain modification is probably accompanied by better abilities to usefully separate parts of em brains, and better theories for how these parts work. This probably encourages developers of traditional robots to include more subsystems like em brain parts, which fit more easily and naturally into the em economy.

The net effect is that a transition from ems to traditional robots would plausibly be less jarring and more incremental, including and continuing more elements of em minds and the larger arrangements of the em society. And since an em society would also continue more of the arrangements of the prior human society, humans today and their arrangements would face a more incremental path of future change, allowing more ways for people today to influence the future, and creating a future more like the people and institutions of today.

SELECT BIBLIOGRAPHY

—Armstrong, Stuart, and Kaj Sotala. 2012. "How we're predicting AI—or failing to." In *Beyond AI: Artificial Dreams*, J. Romportl, P. Ircing, E. Zackova, M. Polak, and R. Schuster (eds.). Pilsen: University of West Bohemia, 52–75.

—Grace, Katja. 2014. "MIRI AI Predictions Dataset." AI Impacts. May 20, 2014. Available at http://aiimpacts.org/miri-ai-predictions-dataset.

—Hanson, Robin. 2012. "AI Progress Estimate." OvercomingBias blog. August 27, 2012. Available at http://www.overcomingbias.com/2012/08/ai-progress-estimate.html.

Provably Beneficial Artificial Intelligence

STUART RUSSELL

Stuart Russell
University of California, Berkeley, CA, USA

Stuart Russell received his BA with first-class honors in Physics from Oxford
in 1982, his PhD in Computer Science from Stanford in 1986, and then joined
the faculty of the University of California at Berkeley. He is a Professor (and
former Chair) of Electrical Engineering and Computer Sciences and holds the
Smith-Zadeh Chair in Engineering. He is a Fellow of AAAI (Association for
the Advancement of Artificial Intelligence), ACM (Association for Computing
Machinery), and AAAS (American Association for the Advancement of
Science); and winner of the Computers and Thought Award and the ACM Karl
Karlstrom Outstanding Educator Award. From 2012 to 2014 he held the Blaise
Pascal Chair and the Senior Chair of Excellence of the ANR (French National
Research Agency) in Paris. His book *Artificial Intelligence: A Modern Approach*
(with Peter Norvig) is the standard text in AI; it has been translated into
thirteen languages and is used in over 1300 universities in 116 countries.

Should we be concerned about long-term risks to humanity from superintelligent AI? If so, what can we do about it? While some in the mainstream AI community dismiss these concerns, I will argue instead that a fundamental reorientation of the field is required. Instead of building systems that optimize arbitrary objectives, we need to learn how to build systems that will, in fact, be provably beneficial for us. I will show that it is useful to imbue systems with explicit uncertainty concerning the true objectives of the humans they are designed to help.

INTRODUCTION

The goal of artificial intelligence (AI) research has been to understand the principles underlying intelligent behavior and to build those principles into machines that can then exhibit such behavior. In the field's early years, several distinction definitions of "intelligent" were pursued, including emulation of human behavior and the capability for logical reasoning; in recent decades, however, a consensus has emerged around the idea of a *rational agent* that perceives and acts in order to maximally achieves its objectives. Subfields such as robotics and natural-language understanding can be understood as special cases of the general paradigm. AI has incorporated probability theory to handle uncertainty, utility theory to define objectives, and statistical learning to allow machines to adapt to new circumstances. These developments have created strong connections to other disciplines that build on similar concepts, including control theory, economics, operations research, and statistics.

Progress in AI seems to be accelerating. In the last few years, due in part to progress in machine learning, tasks such as speech recognition, object recognition, legged locomotion, and autonomous driving have been largely solved. Each advance in capabilities brings with it new potential markets and new incentives to invest in further research, resulting in a virtuous cycle pushing AI forward. Within the next decade we are likely to see substantial progress on effective language understanding, leading to systems capable of ingesting, synthesizing, and answering questions about the sum total of human knowledge.

Despite all this progress, we are still far from human-level AI. For example, we have no practical methods for inventing useful new concepts such as "electron" or useful new high-level actions such as "write slides for tomorrow's lecture." The latter capability is particularly important for systems operating in the real world, where meaningful goals may require billions of primitive motor-control actions to achieve. Without the ability to conceive of and

reason about new, high-level actions, successful planning and acting on these timescales is impossible. Undoubtedly there are more breakthroughs needed that we will not know how to describe until we see our best efforts to build general-purpose AI systems failing in interesting ways. The difficulty in predicting such breakthroughs means that giving any precise estimate of the date on which human-level AI will arrive is foolhardy. Nonetheless, most experts believe it is likely to arrive within the present century (Müller and Bostrom, 2016; Etzioni, 2016).

It is hard to overstate the significance of such an event. Everything our civilization offers is a consequence of our intelligence; thus, access to substantially greater intelligence would constitute a discontinuity in human history. It might lead to solutions for problems of disease, war, and poverty; at the same time, several observers have pointed out that superintelligent AI systems can, by their very nature, have impacts on a global scale—impacts that could be negative for humanity of the systems are not designed properly.[1] The game is to define the problem that our AI systems are set up to solve, such that we are guaranteed to be happy with the solutions; and the stakes could hardly be higher.

RISKS AND REBUTTALS

Concerns about superintelligent AI are hardly new. Turing himself, in a 1951 radio address, felt it necessary to point out the possibility:

> If a machine can think, it might think more intelligently than we do, and then where should we be? Even if we could keep the machines in a subservient position, for instance by turning off the power at strategic moments, we should, as a species, feel greatly humbled. ... [T]his new danger ... is certainly something which can give us anxiety.

I. J. Good (1965), who had worked with Turing during World War II, went one step further, pointing out the possibility of self-improving AI systems: "There would then unquestionably be an 'intelligence explosion,' and the intelligence of man would be left far behind." The *AI control problem*, then, is how to ensure that systems with an arbitrarily high degree of intelligence remain strictly under human control.

It seems reasonable to be cautious about creating something far more intelligent than ourselves; yet we need more than a general sense of unease if we are to channel in the right direction the relentless scientific and economic pressure to build ever-more-capable systems. Many novels and films have

translated this unease into scenarios of spontaneously evil machine consciousness, which is both vanishingly unlikely and, as a technical phenomenon to be avoided, impossible to address. In fact, to the extent that we understand the problem at all, the most likely source of difficulty appears to be a failure of *value alignment*—we may, perhaps inadvertently, imbue machines with objectives that are imperfectly aligned with our own. Norbert Wiener (1960) put it this way: "If we use, to achieve our purposes, a mechanical agency with whose operation we cannot interfere effectively... we had better be quite sure that the purpose put into the machine is the purpose which we really desire."

Unfortunately, neither AI nor other disciplines built around the optimization of objectives (economics, statistics, control theory, and operations research) have much to say about how to identify the purposes we really desire. Instead, they assume that objectives are simply implanted into the machine. AI studies the capacity to achieve objectives, not the design of those objectives. And as King Midas found out, getting what one asks for is not always a good thing.

Bostrom (2014) elaborates on several additional arguments suggesting that the problem has no easy solutions. The most relevant for the analysis in this paper is due to Omohundro (2008), who observed that intelligent entities will tend to act to preserve their own existence. This tendency has nothing to do with any self-preservation instinct or other biological notion; it is just that an entity cannot achieve its objectives if it is dead. This means that Turing's reliance on the off-switch, as quoted above, is misplaced: according to Omohundro's argument, a superintelligent machine will take steps to disable the off-switch in some way. Thus we have the prospect of superintelligent machines, whose actions are (by definition) unpredictable by mere humans, whose imperfectly and incompletely specified objectives may conflict with our own, and whose motivation to preserve their own existence in order to achieve those objectives may be insuperable.

A number of objections have been raised to these arguments, primarily by researchers within the AI community. The objections reflect a natural defensive reaction, coupled

perhaps with a lack of imagination about what a superintelligent machine could do. None appear to hold water on closer examination. (If some of the objections seem *prima facie* absurd, rest assured that several even more absurd ones have been omitted to spare their originators embarrassment.) Several of the objections appear in the recent AI100 report by Stone et al. (2016), while others have been made by individuals participating in panel discussions at AI conferences:

Human-level AI is impossible. This is an unusual claim for AI researchers to make, given that, from Turing onward, AI researchers have been fending off such claims from philosophers and mathematicians. The claim, which is backed by no arguments or evidence, appears to concede that if superintelligent AI *were* possible, it *would* be a significant risk. It is as if a bus driver, with all of humanity as passengers, said, "Yes, I'm driving toward a cliff, but trust me, we'll run out of gas before we get there!" The claim also represents a foolhardy bet against human ingenuity. We have made such bets before and lost. On September 11, 1933, renowned physicist Ernest Rutherford stated, with utter confidence: "Anyone who expects a source of power in the transformation of these atoms is talking moonshine." On September 12, 1933, physicist Leo Szilard invented the neutron-induced nuclear chain reaction. A few years later, having demonstrated such a reaction in his laboratory, Szilard wrote: "We switched everything off and went home. That night, there was very little doubt in my mind that the world was headed for grief."

It's too soon to worry about it. The right time to worry about a potentially serious problem for humanity depends not on when the problem will occur, but on how much time is needed to devise and implement a solution that avoids the risk. For example, if we were to detect a large asteroid predicted to collide with the Earth in 2066, would we say it is too soon to worry? And if we consider the global catastrophic risks from climate change, which are predicted to occur later in this century, is it too soon to take action to prevent them? On the contrary, it may be too late. The relevant timescale for human-level AI is less predictable, but of course that means it, like nuclear fission, might arrive considerably sooner than expected.

It's like worrying about overpopulation on Mars. This is an interesting variation on "too soon to worry," one that appeals to a convenient analogy: not only is the risk easily managed and far in the future, but also it is extremely unlikely we would even *try* to move billions of humans to Mars in the first place. The analogy is a false one, however. We *are already* devoting huge scientific and technical resources to creating ever-more-capable AI systems. A more apt analogy would be a plan to move the human race to Mars with no consideration for what we might breathe, drink, or eat once we arrive.

Human-level AI is really not imminent, so we needn't worry. This is another variation on "too soon to worry," but one that attributes concerns about AI control to the false belief that superintelligent AI is imminent. This objection simply mis-states the reasons for concern, which are not predicated on imminence. For example, Bostrom (2014) writes: "It is no part of the argument in this book that we are on the threshold of a big breakthrough in artificial intelligence, or that we can predict with any precision when such a development might occur."

We're the experts, we build the AI systems, trust us. This objection is usually accompanied by disparagement of those raising concerns as being ignorant of the realities of AI. While

it is true that some public figures who have raised concerns, such as Elon Musk, Stephen Hawking, and Bill Gates, are not AI researchers, they are hardly unfamiliar with scientific and technological reasoning. And it would be hard to argue that Turing (1951), Wiener (1960), Good (1965), and Minsky (1984) are unqualified to discuss AI.

You're just Luddites. Musk, Gates, Hawking, and others (including, apparently, the author) received the 2015 Luddite of the Year Award from the Information Technology Innovation Foundation. It is an odd definition of Luddite that includes Turing, Wiener, Minsky, Musk, and Gates, who rank among the most prominent contributors to technological progress in the twentieth and twenty-first centuries. Furthermore, the epithet represents a complete misunderstanding of the nature of the concerns raised and the purpose for raising them. It is as if one were to accuse nuclear engineers of Luddism if they point out the need for control of the fission reaction. Some objectors also use the term "anti-AI," which is rather like calling nuclear engineers "anti-physics." The purpose of understanding and preventing the risks of AI is to ensure that we can realize the benefits. Bostrom (2014), for example, writes that success in controlling AI will result in "a civilizational trajectory that leads to a compassionate and jubilant use of humanity's cosmic endowment."

Your doom-and-gloom predictions fail to consider the potential benefits of AI. If there were no potential benefits of AI, there would be no economic or social impetus for AI research, and hence no danger of ever achieving human-level AI. This objection is like accusing nuclear engineers who work on containment of never considering the potential benefits of cheap electricity. The sad fact is that the potential benefits of nuclear power have largely failed to materialize precisely because of insufficient attention paid to containment risks at Three-Mile Island and Chernobyl.

You can't control research. At present, no one is arguing that AI research be curtailed; merely that attention be paid to the issue of preventing negative consequences of poorly designed systems. But if necessary, we *can* control research: we do not genetically engineer humans because the molecular biology community decided, at a workshop at Asilomar in 1975, that it would be a bad idea, *even though "improving the human stock" had been a longstanding goal of many researchers in the biology community for several decades before that.*

Don't mention risks, it might be bad for funding. See nuclear power, tobacco, global warming.

In addition to these policy-level objections, there are also objections based on proposed simple solutions for avoiding negative consequences of superintelligent AI:

Instead of putting objectives into the AI system, just let it choose its own. It is far from clear how this solves the problem. The criteria by which an AI system would choose its own goals can be thought of as meta-objectives in their own right, and we face again the problem of ensuring that they lead to behaviors consistent with human well-being. We need to steer straight, not remove the steering wheel.

More intelligent humans tend to have better, more altruistic goals, so superintelligent machines will too. Beyond the fact that those making this argument think of themselves as more intelligent than average, there is precious little evidence for the premise of this argument; and the premise provides no support whatsoever for the conclusion.

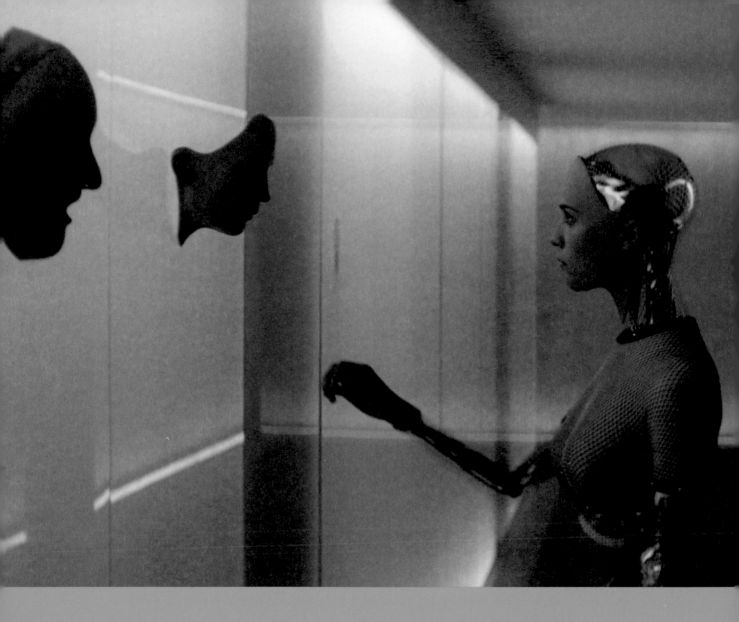

"The challenge is not to act automatically.
It's to find an action that is not automatic.
From painting, to breathing, to talking.
To falling in love..."

ALEX GARLAND
Writer and director Alex Garland was
nominated for an Oscar for Best Original
Screenplay for *Ex Machina* (2015).

Ex Machina (2015), Alex Garland.

Don't worry, we'll just have collaborative human-AI teams. Value misalignment precludes teamwork, so this solution simply begs the question of how to solve the core problem of value alignment.

Just don't put in "human" goals like self-preservation. See the discussion of Omohundro's argument above. For a coffee-fetching robot, death is not bad per se. Death is to be avoided, however, because it is hard to fetch the coffee if you are dead.

Don't worry, we can just switch it off. As if a superintelligent entity would never think of that.

SOLUTIONS

Bostrom (2014) considers a number of more serious technical proposals for solving the AI control problem. Some, under the heading of "oracle AI," seal the machines inside a kind of firewall, extracting useful question-answering work from them but never allowing them to affect the real world. (Of course, this means giving up on superintelligent robots!) Unfortunately, it seems unlikely to work—we have yet to invent a firewall that is secure against ordinary humans, let alone superintelligent machines. Others involve provably enforceable restrictions on behavior, but devising such restrictions is like trying to write loophole-free tax law (with superintelligent tax evaders!).

Can we, instead, tackle Wiener's warning head-on? Can we design AI systems whose purposes do not conflict with ours, so that we are sure to be happy with the way they behave? This is far from easy, but may be possible if we follow three core principles:

> 1. *The machine's purpose is to maximize the realization of human values.* In particular, it has no purpose of its own and no innate desire to protect itself.
> 2. *The machine is initially uncertain about what those human values are.* This turns out to be crucial, and in a way it sidesteps Wiener's problem. The machine may learn more about human values as it goes along, of course, but it may never achieve complete certainty.
> 3. *Machines can learn about human values by observing the choices that we humans make.*

It turns out that these three principles, once embodied in a formal mathematical framework that defines the problem the AI system is constitutionally required to solve, seem to allow some progress to be made on the AI control problem. In particular, at least in simple cases, we can define a template for agent designs that are provably beneficial under certain reasonable (if not strictly true) assumptions.

LEARNING REWARD FUNCTIONS

To explain the mathematical framework, it helps to be a little more precise about terminology. According to von Neumann and Morgenstern (1944), any rational agent can be described

as having a *utility function U(s)* that assigns a real number representing the desirability of being in any particular world state *s*. Equivalently, this is the expected desirability of the possible future state sequences beginning with *s*, assuming that the agent acts optimally. (In operations research, this is often called the *value function*, a term that has a distinct meaning in economics.) A further assumption of stationary preferences is typically made (Koopmans, 1972), whose consequence is that the desirability of any state sequence can be expressed as a sum (possibly discounted over time) of immediate *rewards* associated with each state in the sequence. For convenience, the *reward function R(s,a,s')* is defined to be the immediate reward associated with the transition from state *s* to state *s'* via action *a*. Typically, the reward function provides a concise way to define a task; for example, the task of playing backgammon can be defined by specifying the reward to be zero for all non-terminal states *s'* and a number between –192 and +192 for transitions to terminal states (the precise value depending on the state of the doubling cube and whether the games ends normally, with a gammon, or with a backgammon). The *utility* of a backgammon state *s*, on the other hand, will in most cases be a very complex function of *s* because it represents an expectation over future reward sequences with respect to all possible dice rolls occurring in the remainder of the game. For a person out enjoying his or her garden, rewards might be positive for smelling a rose (although not for smelling it 100 times in a row) and negative for pricking one's finger on the thorns, whereas the utility of being in the garden at that moment depends on all future rewards—and these might vary enormously depending on whether one is about to get married, about to begin a long prison sentence, and so on.

To the extent that *objectives* can be *defined* concisely by specifying reward functions, *behavior* can be *explained* concisely by inferring reward functions. This is the key idea underlying *inverse reinforcement learning*, or IRL (Russell, 1998; Ng and Russell, 2000). An IRL algorithm learns a reward function by observing the behavior of some other agent who is assumed to be acting in accordance with such a function. (IRL is the sequential form of preference elicitation, and is related to structural estimation of MDPs in economics.) Watching its owner make coffee in the morning, the domestic robot learns something about the desirability of coffee in some circumstances, while a robot with an English owner learns something about the desirability of tea in all circumstances.

SOLVING SIMPLE AI CONTROL PROBLEMS

One might imagine that IRL provides a simple solution to the value alignment problem: the robot observes human behavior, learns the human reward function, and behaves according to that function. This simple idea has two flaws. The first flaw is obvious: human behavior (especially in the morning) often conveys a desire for coffee, and the robot can learn this, but we do not want the robot to want coffee! This flaw is easily fixed: we need to formulate the value alignment problem so that the robot always has the fixed objective of optimizing reward for the human (the first principle given above), and becomes better able to do so as it learns what the human reward function is.

The second flaw is less obvious, and less easy to fix. The human has an interest in ensuring that value alignment occurs as quickly and accurately as possible, so that

the robot can be maximally useful and avoid potentially disastrous mistakes. Yet acting optimally in coffee acquisition while leaving the robot as a passive observer may not be the best way to achieve value alignment. Instead, the human should perhaps explain the steps in coffee preparation and show the robot where the backup coffee supplies are kept and what to do if the coffee pot is left on the heating plate too long, while the robot might ask what the button with the puffy steam symbol is for and try its hand at coffee making with guidance from the human, even if the first results are undrinkable. None of these things fit in with the standard IRL framework.

By extending IRL to incorporate both human and robot as agents, it becomes possible to formulate and solve a value alignment problem as a cooperative and interactive reward maximization process (Hadfield-Menell et al., 2017a). More precisely, a *cooperative inverse reinforcement learning* (CIRL) problem is a two-player game of partial information, in which the human knows the reward function[2] while the robot does not; but the robot's payoff is exactly the human's actual reward. (Thus, CIRL instantiates all three principles given above.) Optimal solutions to this game maximize human reward and may naturally generate active instruction by the human and active learning by the robot.

Within the CIRL framework, one can formulate and solve the off-switch problem—that is, the problem of preventing a robot from disabling its own off-switch. (With this, Turing may rest easier.) A robot that is designed to solve the CIRL problem is sure it wants to maximize human values, but also sure it does not know exactly what those are. Now, the robot actually *benefits* from being switched off, because it understands that the human will press the off-switch to prevent the robot from doing something counter to human values. Thus, the robot has a positive incentive to preserve the off-switch, and this incentive derives directly from its uncertainty about human values. Furthermore, it is possible to show that in some cases the robot is *provably beneficial*, that is, the expected reward for the human is higher when the CIRL-solving robot is available, regardless of what the human's actual reward function is (Hadfield-Menell et al., 2017b). The off-switch example suggests some templates for controllable agent designs and provides at least one case of a provably beneficial system. The overall approach has some resemblance to mechanism design problems in economics,

where one attempts to incentivize other agents to behave in ways that will be provably beneficial to the mechanism designer. The key difference here is that we are *building* one of the agents in order to benefit the other.

The off-switch example works because of the second principle: that the robot should be uncertain about the true human reward function. Strangely, uncertainty about rewards has been almost completely neglected in AI, even though uncertainty about domain knowledge and sensor interpretation has been a core preoccupation for over twenty years.

One reason may be that uncertainty about the reward function is *irrelevant* in standard sequential decision problems (MDPs, POMDPs, optimal control problems) because the optimal policy under an uncertain reward function is identical to the optimal policy under a definite reward function equal to the expected value of the uncertain reward function. This equivalence only holds, however, when the environment provides no further information about the true reward function—which is not the case in CIRL problems, where human actions reveal information about human preferences. When the environment can supply additional information about the reward function, agents with reward uncertainty can exhibit behaviors that are not realizable by traditional AI systems with fixed reward functions.

The reader familiar with the concept of reinforcement learning (RL) might point out that the "reward signal" received by the RL agent after each state-action-state transition *does* provide information about the true reward function, because it gives the actual value of $R(s,a,s')$ for the observed transition. So, could ordinary RL be a basis for value alignment if the human simply supplies a reward signal directly to the robot? Unfortunately not! First, the human may not be able to quantify the true reward accurately, even for specific experienced transitions. Second, the formal model of RL assumes that the reward signal reaches the agent from *outside* the environment; but the human and robot are part of the same environment, and the robot can maximize its reward by modifying the human to provide a maximal reward signal at all times. The undesirability of this outcome, known as *wireheading* (Muehlhauser and Hibbard, 2014), indicates a fundamental flaw in the standard formulation of RL. The flaw is that the environment cannot supply *actual reward* to an agent; it can only supply *information* about the reward. Thus, a human giving a "reward signal" to the robot is not giving a reward, but is providing evidence (possibly noisy) about the human's preferences in the form of an action that selects a number. This new formulation clearly avoids the wireheading problem, because the robot can only be *worse off* if it modifies the information source to mask the underlying signal. And if the formulation stipulates that the robot has to maximize the human's *original* reward function, then modifying the human so that he or she has a new reward function that is easier to maximize does not do the robot any good.

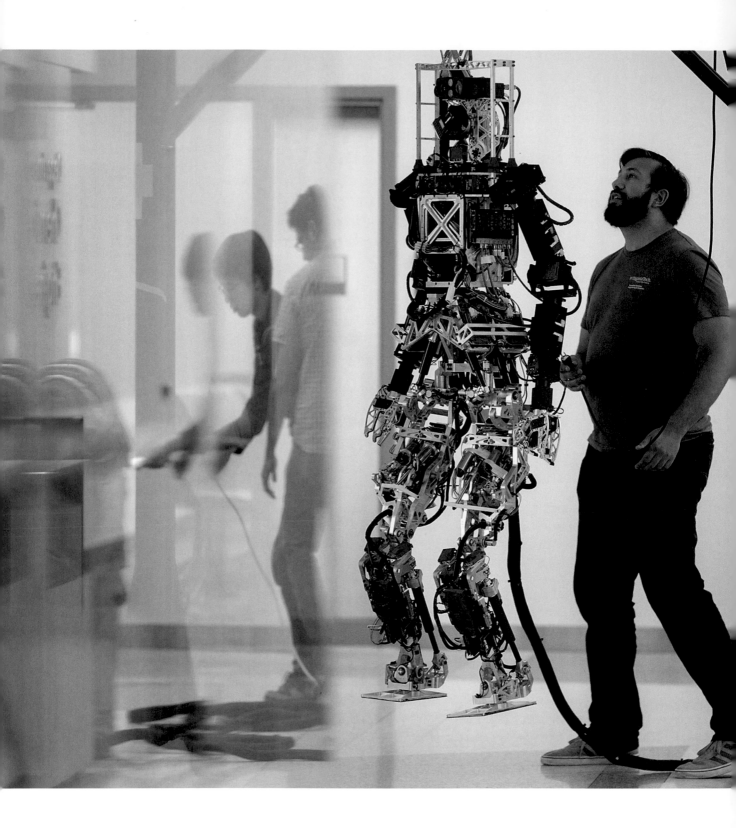

PRACTICAL CONSIDERATIONS

I have argued that the framework of cooperative inverse reinforcement learning may provide initial steps toward a theoretical solution of the AI control problem. There are also some reasons for believing that the approach may be workable in practice. First, there are vast amounts of written and filmed information about humans doing things (and other humans reacting). Technology to build models of human values from this storehouse will be available long before superintelligent AI systems are created. Second, there are very strong, near-term economic incentives for robots to understand human values: if one poorly designed domestic robot cooks the cat for dinner, not realizing that its sentimental value outweighs its nutritional value, the domestic robot industry will be out of business. In the area of personal digital assistants, which seems likely to become a significant market before the end of the decade, there are obvious benefits to an assistant that quickly adapts to the complex and nuanced preferences of its owner.

There are obvious difficulties, however, with an approach based on learning values from human behavior. Humans are irrational, inconsistent, weak-willed, and computationally limited, so their actions do not always reflect their values. (Consider, for example, two humans playing chess: usually, one of them loses, but not on purpose!) Humans are also diverse in both values and circumstances, which means that robots must be sensitive to individual preferences and must mediate among conflicting preferences—a problem for social scientists as well as engineers. And some humans are evil, so the robot must have a way to filter out individual value systems that are incompatible with the general welfare.

It seems likely that robots can learn from non-rational human behavior only with the aid of much better cognitive models of humans. What of evil behavior? Is it possible to avoid corrupting our robots without imposing preemptive (and hence culturally relative) constraints on the values we are prepared to allow? It might be possible to use a version of Kant's categorical imperative: a reward function that ascribes negligible or negative value to the well-being of others lacks *self-consistency*, in the sense that if everyone operated with such a reward function then no one would obtain much reward.

SUMMARY

I have argued, following numerous other authors, that finding a solution to the AI control problem is an important task; in Bostrom's sonorous words, "the essential task of our age." I have also argued that, up to now, AI has focused on systems that are better at making decisions; but this is not the same as making better decisions. No matter how excellently an algorithm maximizes, and no matter how accurate its model of the world, a machine's decisions may be ineffably stupid, in the eyes of an ordinary human, if its utility function is not well aligned with human values.

This problem requires a change in the definition of AI itself, from a field concerned with pure intelligence, independent of the objective, to a field concerned with systems that are provably beneficial *for humans*. (I suppose we could also supply AI systems designed for other species, but that is probably not an immediate concern.) Taking the problem seriously seems to have yielded new ways of thinking about AI, its purpose, and our relationship to it.

1. There are other possible risks from the misuse of increasingly powerful AI, including automated surveillance and persuasion, autonomous weapons, and economic disruption; these deserve serious study, but are not the subject of the current paper.

2. One might ask why a human who knows a reward function does not simply program it into the robot; here, we use "know" in the restricted sense of acting *as if* one knows the reward function, without necessarily being able to make it explicit. In the same sense, humans "know" the difference between the sounds for "cat" and "cut" without being able to write down the acoustic discrimination rule.

—Bostrom, Nick. 2014. *Superintelligence*. Oxford: OUP.

—Etzioni, Oren. 2016. "Are the experts worried about the existential risk of artificial intelligence?" *MIT Technology Review*.

—Good, I. J. 1965. "Speculations concerning the first ultraintelligent machine." In *Advances in Computers 6*, Franz L. Alt, and Morris Rubinoff (eds.). Cambridge, MA: Academic Press.

—Hadfield-Menell, D., A. Dragan, P. Abbeel, and S. Russell. 2017a. "Cooperative inverse reinforcement learning." In *Advances in Neural Information Processing Systems 25*. Cambridge, MA: MIT Press.

—Hadfield-Menell, D., A. Dragan, P. Abbeel, and S. Russell. 2017b. "The off-switch." Submitted to AAAI-17.

—Koopmans, T. C. 1972. "Representation of preference orderings over time." In *Decision and Organization*, C. B. McGuire, and R. Radner, (eds.). Amsterdam: Elsevier/North-Holland.

—Minsky, Marvin. 1984. "Afterword to Vernor Vinge's novel, 'True Names.'" Unpublished manuscript.

—Muehlhauser, L., and B. Hibbard. 2014. "Exploratory engineering in artificial intelligence." *Communications of the ACM* 57(9), 32–34.

—Müller, Vincent C., and Nick Bostrom. 2016. "Future progress in artificial intelligence: A survey of expert opinion." In *Fundamental Issues of Artificial Intelligence*, Vincent C. Müller (ed.), Synthèse Library 377. Berlin: Springer.

—Ng, Andrew Y., and Stuart Russell. 2000. "Algorithms for inverse reinforcement learning." In *Proceedings of the Seventeenth International Conference on Machine Learning*. Stanford, CA: Morgan Kaufmann.

—Omohundro, Stephen M. 2008. "The basic AI drives." In *Proceedings of the First AGI Conference*. Amsterdam: IOS Press.

—Russell, Stuart. 1998. "Learning agents for uncertain environments (extended abstract)." In *Proceedings COLT-98*. Madison, WI: ACM Press.

—Stone, Peter, et al. 2016. "Artificial intelligence and life in 2030." Stanford One Hundred Year Study on Artificial Intelligence: Report of the 2015 Study Panel.

—Turing, Alan M. 1951. "Can digital machines think?" Lecture broadcast on radio on BBC Third Programme; typescript at turingarchive.org.

—Von Neumann, J. and O. Morgenstern. 1944. *Theory of Games and Economic Behavior*. Princeton, NJ: Princeton University Press.

—Wiener, Norbert. 1960. "Some moral and technical consequences of automation." *Science* 131 (3410): 1355-1358.

Technological Progress and Potential Future Risks

DARRELL M. WEST

Darrell M. West
Brookings Institution, Washington DC, USA

Darrell M. West is the Vice President of Governance Studies and Director of the Center for Technology Innovation at the Brookings Institution, Washington DC, USA. He holds the Douglas Dillon Chair in Governance Studies. Previously, he was the John Hazen White Professor of Political Science and Public Policy, and Director of the Taubman Center for Public Policy at Brown University. He is the author of twenty-two books including *Megachange: Economic Disruption, Political Upheaval, and Social Strife in the 21st Century* (Brookings, 2016), *Billionaires: Reflections on the Upper Crust* (Brookings, 2014), *Digital Schools* (Brookings, 2012), and *The Next Wave: Using Digital Technology to Further Social and Political Innovation* (Brookings, 2011).

Emerging technologies, such as industrial robots, artificial intelligence, and machine learning, are advancing at a rapid pace. These developments can improve the speed, quality, and cost of goods and services, but they also displace large numbers of workers. This possibility challenges the traditional benefits model of tying health care and retirement savings to jobs. In an economy that employs dramatically fewer workers, we need to think about how to deliver benefits to displaced workers. If automation makes jobs less secure in the future, there needs to be a way to deliver benefits outside of employment. "Flexicurity," or flexible security, is one idea for providing health care, education, and housing assistance, whether or not someone is formally employed. In addition, activity accounts can finance lifelong education and worker retraining. No matter how people choose to spend time, there needs to be ways for people to live fulfilling lives even if society needs fewer workers.

The list of new technologies grows every day. Robots, Augmented Reality, algorithms, and machine-to-machine communications help people with a range of different tasks.[1] These technologies are broad-based in their scope and significant in their ability to transform existing businesses and personal lives. They have the potential to ease people's lives and improve their personal and business dealings.[2] Technology is becoming much more sophisticated and this is having a substantial impact on the workforce.[3]

In this paper, I explore the impact of robots, artificial intelligence, and machine learning on the workforce and public policy. If society needs fewer workers due to automation and robotics, and many social benefits are delivered through jobs, how are people outside the workforce for a lengthy period of time going to get health care and pensions? These are profound questions for public policy and we need to figure out how to deliver social benefits in the new digital economy.

EMERGING TECHNOLOGIES

Robots

Industrial robots are expanding in magnitude around the developed world. In 2013, for example, there were an estimated 1.2 million robots in use. This total rose to around 1.5 million in 2014 and is projected to increase to about 1.9 million in 2017.[4] Japan has the largest

number with 306,700, followed by North America (237,400), China (182,300), South Korea (175,600), and Germany (175,200). Overall, robotics is expected to rise from a $15-billion sector now to $67 billion by 2025.[5]

According to an RBC Global Asset Management study, the costs of robots and automation have fallen substantially. It used to be that the "high costs of industrial robots restricted their use to few high-wage industries like the auto industry. However, in recent years, the average costs of robots have fallen, and in a number of key industries in Asia, the cost of robots and the unit costs of low-wage labor are converging... Robots now represent a viable alternative to labor."[6]

In the contemporary world, there are many robots that perform complex functions. According to a presentation on robots:

> The early 21st century saw the first wave of companionable social robots. They were small cute pets like AIBO, Pleo, and Paro. As robotics become more sophisticated, thanks largely to the smart phone, a new wave of social robots has started, with humanoids Pepper and Jimmy and the mirror-like Jibo, as well as Geppetto Avatars' software robot, Sophie. A key factor in a robot's ability to be social is their ability to correctly understand and respond to people's speech and the underlying context or emotion.[7]

These machines are capable of creative actions. Anthropologist Eitan Wilf of Hebrew University of Jerusalem says that sociable robots represent "a cultural resource for negotiating problems of intentionality."[8] He describes a "jazz-improvising humanoid robot marimba player" that can interpret music context and respond creatively to improvisations on the part of other performers. Designers can put it with a jazz band, and the robot will ad lib seamlessly with the rest of the group. If someone were listening to the music, that person could not discern the human from the robot performer.

Amazon has organized a "picking challenge" designed to see if robots can "autonomously grab items from a shelf and place them in a tub." The firm has around 50,000 people working in its warehouses and it wants to see if robots can perform the tasks of selecting items and moving them around the warehouse. During the competition, a Berlin robot successfully completed ten of the twelve tasks. To move goods around the facility, the company already uses 15,000 robots and it expects to purchase additional ones in the future.[9] In the restaurant industry, firms are using technology to remove humans from parts of food delivery. Some places, for

example, are using tablets that allow customers to order directly from the kitchen with no requirement of talking to a waiter or waitress. Others enable people to pay directly, obviating the need for cashiers. Still others tell chefs how much of an ingredient to add to a dish, which cuts down on food expenses.[10]

Other experimentalists are using a robot known as Nao to help people deal with stress. In a pilot project called "Stress Game," Thi-Hai-Ha Dang and Adriana Tapus subject people to a board game where they have to collect as many hand objects as they can. During the test, stress is altered through game difficulty and noises when errors are made. The individuals are wired to a heart monitor so that Nao can help people deal with stress. When the robot feels human stress levels increasing, it provides coaching designed to decrease the tension. Depending on the situation, it can respond in empathetic, encouraging, or challenging ways. In this way, the "robot with personality" is able to provide dynamic feedback to the experimental subjects and help them deal with tense activities.[11]

Computerized Algorithms

There are computerized algorithms that have taken the place of human transactions. We see this in the stock exchanges, where high-frequency trading by machines has replaced human decision making. People submit buy and sell orders, and computers match them in the blink of an eye without human intervention. Machines can spot trading inefficiencies or market differentials at a very small scale and execute trades that make money for people.[12]

Some individuals specialize in arbitrage trading, whereby the algorithms see the same stocks having different market values. Humans are not very efficient at spotting price differentials but computers can use complex mathematical formulas to determine where there are trading opportunities. Fortunes have been made by mathematicians who excel in this type of analysis.[13]

Artificial Intelligence

Artificial intelligence refers to "machines that respond to stimulation consistent with traditional responses from humans, given the human capacity for contemplation, judgment and intention."[14] It incorporates critical reasoning and judgment into response decisions. Long considered a visionary advance, AI is now here and being incorporated in a variety of different areas. It is being used in finance, transportation, aviation, and telecommunications. Expert systems "make decisions which normally require a human level of expertise."[15] These systems help humans anticipate problems or deal with difficulties as they come up.

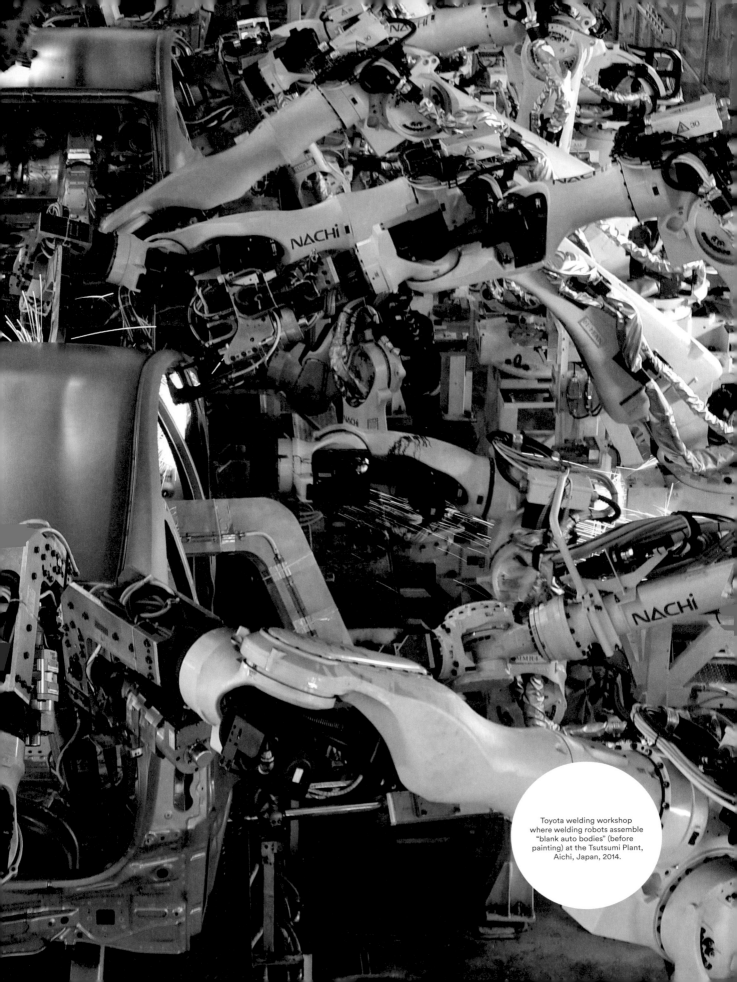

Toyota welding workshop where welding robots assemble "blank auto bodies" (before painting) at the Tsutsumi Plant, Aichi, Japan, 2014.

There is growing applicability of artificial intelligence in many industries.[16] It is being used to take the place of humans in a variety of areas. For example, it is being used in space exploration, advanced manufacturing, transportation, energy development, and health care. By tapping into the extraordinary processing power of computers, humans can supplement their own skills and improve productivity through artificial intelligence.

IMPACT ON THE WORKFORCE

The rapid increase in emerging technologies suggests that they are having a substantial impact on the workforce. Many of the large tech firms have achieved broad economic scale without a large number of employees. For example, Derek Thompson writes: "Google is worth $370 billion but has only about 55,000 employees—less than a tenth the size of AT&T's workforce in its heyday [in the 1960s]."[17] According to economist Andrew McAfee: "We are facing a time when machines will replace people for most of the jobs in the current economy, and I believe it will come not in the crazy distant future."[18]

In a number of fields, technology is substituting for labor, and this has dramatic consequences for middle-class jobs and incomes. Cornell University engineer Hod Lipson argues that "for a long time the common understanding was that technology was destroying jobs but also creating new and better ones. Now the evidence is that technology is destroying jobs and indeed creating new and better ones but also fewer ones."[19]

Martin Ford issues an equally strong warning. In his book, *The Lights in the Tunnel*, he argues that "as technology accelerates, machine automation may ultimately penetrate the economy to the extent that wages no longer provide the bulk of consumers with adequate discretionary income and confidence in the future. If this issue is not addressed, the result will be a downward economic spiral."[20] Continuing, he warns that "at some point in the future—it might be many years or decades from now—machines will be able to do the jobs of a large percentage of the 'average' people in our population, and these people will not be able to find new jobs."

Firms have discovered that robotics, machine learning, and artificial intelligence can replace humans and improve accuracy, productivity, and efficiency of operations. During the Great Recession of 2008–09, many businesses were forced to downsize their workforce for budgetary reasons. They had to find ways to maintain operations through leaner workforces. One business leader I know had five hundred workers for his $100 million business and now has the same size workforce even though the company has grown to $250 million in revenues. He did this by automating certain functions and using robots and advanced manufacturing techniques to operate the firm.

The US Bureau of Labor Statistics (BLS) compiles future employment projections. In its most recent analysis, the agency predicts that 15.6 million new positions will be created between 2012 and 2022. This amounts to growth of about 0.5 percent per year in the labor force.

The health-care and social assistance sector is expected to grow the most with an annual rate of 2.6 percent. This will add around five million new jobs over that decade. That is about one-third of all the new jobs expected to be created.[21] Other areas that are likely to

experience growth include professional services (3.5 million), construction (1.6 million), leisure and hospitality (1.3 million), state and local government (929,000), finance (751,000), and education (675,000).

Interestingly, in light of technology advances, the information sector is one of the areas expected to shrink in jobs. BLS projections anticipate that about 65,000 jobs will be lost there over the coming decade. Even though technology is revolutionizing many businesses, it is doing this by transforming operations, not increasing the number of jobs. Technology can boost productivity and improve efficiency, but does so by reducing the number of employees needed to generate the same or even higher levels of production.

Manufacturing is another area thought to lose jobs. The BLS expects the United States to lose 550,000 jobs, while the federal government will shed 407,000 positions, and agriculture, forestry, fishing, and hunting will drop 223,000 jobs.[22] These sectors are the ones thought to be least likely to generate new positions in the coming decade.

Since BLS projections make few assumptions about emerging technologies, it is likely that their numbers underestimate the disruptive impact of these developments. It is hard to quantify the way that robots, artificial intelligence, and sensors will affect the workforce because we are in the early stages of the technology revolution. It is hard to be definitive about emerging trends because it is not clear how new technologies will affect various jobs.

But there are estimates of the likely impact of computerization on many occupations. Oxford University researchers Carl Frey and Michael Osborn claim that technology will transform many sectors of life. They studied 702 occupational groupings and found that "forty-seven percent of US workers have a high probability of seeing their jobs automated over the next twenty years."[23]

According to their analysis, telemarketers, title examiners, hand sewers, mathematical technicians, insurance underwriters, watch repairers, cargo agents, tax preparers, photographic process workers, new accounts clerks, library technicians, and data entry keyers have a ninety-nine percent of having their jobs computerized. At the other end of the spectrum, recreational therapists, mechanic supervisors,

emergency management directors, mental health social workers, audiologists, occupational therapists, health-care social workers, oral surgeons, supervisors of fire fighters, and dieticians have less than a one percent chance of having their tasks computerized. They base their analysis of improving levels of computerization, wage levels, and education required in different fields.[24]

In addition, we know that fields such as health care and education have been slow to embrace the technology revolution, but are starting to embrace new models. Innovations in personalized learning and mobile health mean that many schools and hospitals are shifting from traditional to computerized service delivery. Educators are using massive, open, online courses (MOOCs) and tablet-based instruction, while health-care providers are relying on medical sensors, electronic medical records, and machine learning to diagnose and evaluate health treatments.

Hospitals used to be staffed with people who personally delivered the bulk of medical treatment. But health providers now are storing information in electronic medical records and data-sharing networks are connecting lab tests, clinical data, and administration information in order to promote greater efficiency. Patients surf the web for medical information and supplement professional advice with online resources. Both education and health-care sectors are seeing the disruption that previously has transformed other fields.

Given the uncertainties surrounding job projections, it is not surprising that experts disagree over the impact of emerging technologies. For example, in their highly acclaimed book, *The Second Machine Age: Work, Progress, and Prosperity in a Time of Brilliant Technologies*, economists Erik Brynjolfsson and Andrew McAfee argue that technology is producing major changes in the workforce. According to them:

> Technological progress is going to leave behind some people, perhaps even a lot of people, as it races ahead. As we will demonstrate, there has never been a better time to be a worker with special skills or the right education because these people can use technology to create and capture value. However, there has never been a worse time to be a worker with only "ordinary" skills and abilities to offer, because computers, robots, and other digital technologies are acquiring these skills and abilities at an extraordinary rate.[25]

Former US Treasury Secretary Lawrence Summers is equally pessimistic about the employment impact. He argues that "if current trends continue, it could well be that a generation from now a quarter of middle-aged men will be out of work at any given moment." From his standpoint, "providing enough work" will be the major economic challenge facing the world.[26]

However, some economists dispute these claims. They recognize that many jobs will be lost through technology improvements, but say that new ones will be created. There may be fewer people sorting items in a warehouse because machines can do that better than humans. But jobs analyzing big data, mining information, and managing data-sharing networks will be created. According to those individuals, the job gains and losses will even out over the long run. In future decades, work will be transformed but humans will still be needed to manage the digital world.

For example, MIT economist David Autor has analyzed data on jobs and technology but "doubts that technology could account for such an abrupt change in total employment [...] The sudden slowdown in job creation is a big puzzle, but there is not a lot of evidence it is linked to computers."[27] In the same vein, Harvard economist Richard Freeman is "skeptical that technology would change a wide range of business sectors fast enough to explain recent job numbers."[28]

Northwestern economist Robert Gordon takes an even stronger stance. He argues that:

> Recent progress in computing and automation is less transformative than electrification, cars, and wireless communication, and perhaps even indoor plumbing. Previous advances that enabled people to communicate and travel rapidly over long distances may end up being more significant to society's advancement than anything to come in the twenty-first century.[29]

Based on this reasoning, he does not anticipate dramatic workforce effects from emerging technologies, even though many other experts already see the substitution of technology for labor.

A Pew Research Center study asked 1,896 experts about the impact of emerging technologies. Its researchers found that:

> Half of these experts (48%) envision a future in which robots and digital agents have displaced significant numbers of both blue- and white-collar workers—with many expressing concern that this will lead to vast increases in income inequality, masses of people who are effectively unemployable, and breakdowns in the social order.[30]

IMPLICATIONS FOR PUBLIC POLICY

In the classic Edward Bellamy book, *Looking Backwards*, protagonist Julian West wakes up from a 113-year slumber and finds that the United States in 2000 is completely different from 1887. People stop working at age forty-five and devote their lives to mentoring other people and contributing to the overall sense of community.[31] There are shorter work weeks for ordinary people and everyone receives full benefits, food, and housing.

"Utopia is on the horizon. When I walk two steps, it takes two steps back. I walk ten steps, and it is ten steps further away. What is Utopia for? It is for this, for walking."

EDUARDO GALEANO (1940–2015)
Uruguayan writer.

Christo
The Floating Piers (2014–16)
Lake Iseo, Italy. With this project, inaugurated in June 2016, Bulgarian artist Christo realized his dream of being able to walk on water. It consisted of a three-kilometer-long platform linking two villages on the banks of Lake Iseo—Sulzano and Monte Isola—with the small island of San Paolo.

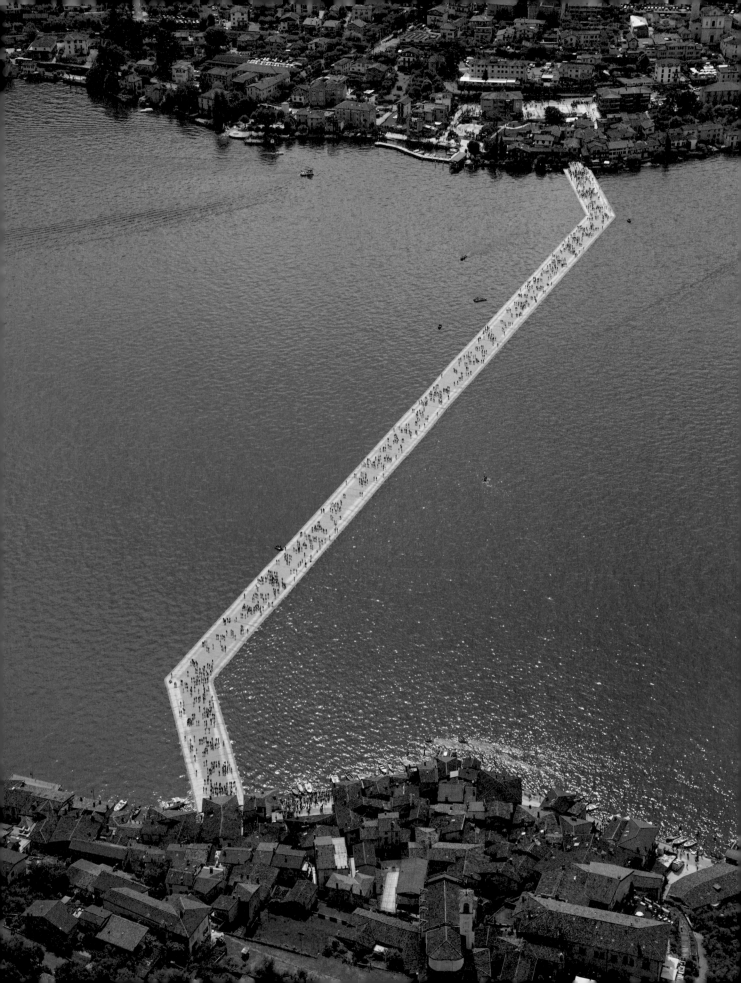

Similar to our time period, new technologies at that time enabled people to be very productive in a short period of time. Society did not need a large number of workers so people could devote much of their lives to education, volunteerism, and community development. In conjunction with these employment trends, public policy shifted to encourage new lifestyles and ways of living.

In flash-forwarding to the current era, we may be on the verge of a similar technology transition. Robotics and machine learning have improved productivity and enhanced the overall economy of developed nations. Countries that have invested in innovation have seen tremendous growth in overall economic performance. In the future, it may be possible that society will not need as many workers as seen today.

Yet unlike Bellamy's utopia, there has been little public discussion regarding the economic or policy impact of emerging technologies. Observers worry that knowledge societies are destroying industrial and manufacturing jobs, and exacerbating social and economic divisions. In its most pointed form, skeptics fear that technology will eliminate jobs, reduce incomes, and create a permanent underclass of unemployable people. As argued by Nicolas Colin and Bruno Palier: "Employment is becoming less routine, less steady, and generally less well remunerated. Social policy will therefore have to cover the needs of not just outside the labor market but even many inside it."[32]

If technology innovation allows businesses to provide goods and services with far fewer employees, what will that mean for workers? A significant increase in the number of people without full-time jobs would exacerbate divisions within society and complicate the distribution of benefits such as pensions, health care, and insurance. Most benefits are tied to employment so if the economy requires fewer workers due to technological advancement, we need to consider how this will affect social benefit delivery.

In this section, I review short- and long-term steps we should consider to deal with emerging technologies. This includes thinking about how to deliver benefits outside of jobs, considering a basic income guarantee, revamping the earned income tax credit, providing activity accounts for lifetime learning and job retraining, encouraging corporate profit-sharing, providing benefit credits for volunteerism, making curricular reforms to assure that students have the skills they need for a twenty-first-century economy,

encouraging adult education and continuing learning, expanding arts and culture for leisure time, and avoiding a permanent underclass suffering the ill effects of income inequality.

Benefits Outside of Jobs

If we end up in a situation with many people unemployed or underemployed for significant periods of time, we need a way to provide health care, disability, and pension benefits outside of employment. Called "flexicurity" or flexible security, this idea "separate(s) the provision of benefits from jobs."[33] It offers health care, education, and housing assistance on a universal basis.

Currently, people must work sixty percent of the time (around twenty-four hours a week) in order to qualify for full-time benefits. When they are fully employed, they are eligible for company-sponsored health-care plans and pensions. During the period since World War II, jobs have been a primary distribution system for social benefits. Except for the poor and elderly, this keeps benefits outside of the public sector and places the onus on private companies.

That approach worked well in an era when most of the people who wanted jobs were able to get them. People with limited skills were able to get well-paying jobs with benefits in factories, warehouses, and production facilities. They could educate their children, achieve a reasonable standard of living, and guard against disabling illnesses.

The complication came when the economy shifted, wages stagnated, and technology made it possible for companies to get by with fewer workers. The advent of robotics, machine learning, artificial intelligence, and machine-to-machine communications eliminated a number of jobs and put a number of people outside the typical workforce.

For health care, people need access to quality care through plans outside of employment. It is possible through commercial insurers to purchase catastrophic insurance for extraordinary health claims. Or if people are poor or elderly, there are government programs that guarantee access to medical care. The recent expansion of health insurance through the Affordable Care Act has extended insurance to millions of people who previously lacked coverage.

In regard to retirement planning, many employers have moved to 401-style pension plans. Employees contribute to their own funds and sometimes get a match from the employer. But this does not help those outside the workforce who need retirement assistance. Even Social Security is tied to employment. People who have not worked are not eligible for retirement benefits so we need to figure out ways to take care of those people in the newly emerging economy.

Provide Activity Accounts for Lifetime Learning and Job Retraining

We should consider the establishment of activity accounts for lifetime learning and job retraining. In an era of fast technology innovation and job displacement, there needs to

be a means for people to gain new skills throughout their adulthood. When people are employed, their companies could contribute a set amount to an individual's fund. This account could be augmented by contributions from the person him or herself as well as the government. Similar to a retirement account, money in the fund could be invested tax-free in investment options including cash reserves, stocks, and bonds. The owner of the account could draw on it to finance lifetime learning and job retraining expenses. It would be portable, meaning that if the person moved or switched jobs, the account would migrate with that individual.

The goal of this account is to provide incentives for continuing education. Under virtually any scenario, people are going to have to continue their education beyond the first twenty years of their lives. Emerging jobs are going to require different skills than what people gain in school. There will be new jobs created that may not exist today. As pointed out by Brookings Institution scholar Kemal Dervis, it will be crucial as technology innovation continues in the future to provide people with a means to upgrade their skills and knowledge levels.[34] He notes that France has established "individual activity accounts" that provide social benefits.

With the expected increase in leisure time, adults need time and financial support for continued learning. We should not envision education merely as a time for young people to learn new skills or pursue areas of interest. Instead, we need to think about education as a continuing activity that broadens people's horizons over the course of their entire lives. Education is an enrichment activity and we need to view it as a general benefit for the individual as well as the society as a whole.

Incentives for Volunteerism

The trends cited in this analysis suggest that we need to consider income supplements or benefit eligibility through vehicles other than full-time jobs. The workforce ramifications of emerging technologies mean that many people in the future may not be able to provide for their families through regular employment.

One possibility comes through volunteer activities. Even if people have limited employment options, many participate in a wide range of public-minded organizations. They help other people, train the next generation, or provide assistance for the less fortunate in society.

A variety of survey evidence demonstrates that young people are particularly interested in volunteerism. In general, they have different attitudes toward work and leisure time, and many say they want time to pursue outside activities. For example, a survey of American students found that they want "a job that focuses on helping others and improving society." In addition, they value quality of life considerations, not just financial well-being.[35]

A number of them value volunteer activities outside of their work experience. They have varied interests and want extra-curricular activities that fulfill them. This may involve tutoring in after-school programs, helping English as a Second Language pupils, stopping domestic violence, protecting the environment, or encouraging entrepreneurship. According to a Deloitte study, "63 percent of Millennials donate to charities and 43 percent actively volunteer or are a member of a community organization."[36]

In a digital world where there may be less work and more leisure time, it makes sense to think about incentives and work credits for volunteerism. This could include credits toward social benefits or public rewards that acknowledge community contributions. In the United Kingdom, for example, volunteers get reimbursed for expenses or earn credits for job training programs through participation in worthy causes. In addition, volunteering counts as "looking for work" so people can use those activities to qualify for national insurance credits.[37]

Going forward, the United States should consider those types of incentives. In the future, people are likely to have more time outside of employment so it makes sense to encourage them toward community engagement and give them incentives to volunteer for nonprofit organizations or charitable causes. This will benefit the overall community and give people purposeful activities in which to engage.

Expanding Arts and Culture for Leisure Time

The so-called "end of work" may create a new kind of economy. According to Harvard economist Lawrence Katz: "It is possible that information technology and robots [will] eliminate traditional jobs and make possible a new artisanal economy [...] an economy geared around self-expression, where people would do artistic things with their time."[38] From his standpoint, this transition would move the world from one of consumption to creativity.

People will use their leisure time to pursue interests in arts and culture, or special areas that they follow. This could include reading, poetry, music, or woodworking. Depending on their background, they could have more time for family and friends. A study of family time found that macroeconomic conditions affect how much time people spend together. When employment problems rise, "fathers spend more time engaging in enriching childcare activities" and "mothers are less likely to work standard hours."[39] As long as there are opportunities for people to pursue broader interests, reduction in work does not have to eliminate chances for cultural pursuits.

CONCLUSION

To summarize, advanced societies are at a major turning point in terms of how we think about work, leisure, and social benefit delivery. If these economies need fewer workers to complete needed tasks and benefits are delivered mainly through full-time jobs, there is a danger that

many people will have difficulties getting health care, pensions, and the income maintenance they need to sustain their lives. This is of particular concern at a time of large income inequality and highly skewed economic distributions.[40]

The contrast between the age of scarcity in which we have lived and the upcoming age of abundance through new technologies means that we need to pay attention to the social contract. We need to rewrite it in keeping with the dramatic shifts in employment and leisure time that are taking place. People have to understand we are witnessing a fundamental interruption of the current cycle where people are paid for their work and spend their money on goods and services. When a considerable portion of human labor is no longer necessary to run the economy, we have to rethink income generation, employment, and public policy. Our emerging economic system means we will not need all the workers that we have. New technologies will make these individuals obsolete and unemployable.

In this situation, it is important to address the policy and leisure time issues raised by persistent unemployment or underemployment. There is a danger of disruptions and unrest from large groups of people who are not working. That creates poverty and social dissatisfaction and runs the risk of instability for the society as a whole. Stability cannot be enforced through a police presence or having wealthy individuals live in gated communities.

There needs to be ways for people to live fulfilling lives even if society needs relatively few workers. We need to think about ways to address these issues before we have a permanent underclass of unemployed individuals. This includes a series of next steps for society. There needs to be continuous learning avenues, opportunities for arts and culture, and mechanisms to supplement incomes and benefits other than through full-time jobs. Policies that encourage volunteerism and reward those who contribute to worthy causes make sense from the standpoint of society as a whole. Adoption of these steps will help people adapt to the new economic realities.

ACKNOWLEDGMENTS

I wish to thank Hillary Schaub for outstanding research assistance on this project.

NOTES

1. James Manyika, Michael Chui, Jacques Bughin, Richard Dobbs, Peter Bisson, and Alex Marrs, *Disruptive Technologies: Advances That Will Transform Life, Business, and the Global Economy* (McKinsey Global Institute, May, 2013).

2. Daniela Rus, "How technological breakthroughs will transform everyday life," *Foreign Affairs*, July/August, 2015.

3. A more extended discussion of these issues can be found in Darrell M. West, *What Happens If Robots Take the Jobs?* (Brookings Institution Policy Report, October, 2015).

4. James Hagerty, "Meet the new generation of robots for manufacturing," *Wall Street Journal*, June 2, 2015.

5. Alison Sander and Meldon Wolfgang, "The rise of robotics," The Boston Consulting Group, August 27, 2014. https://www.bcgperspectives.com/content/articles/business_unit_strategy_innovation_rise_of_robotics.

6. RBC Global Asset Management, *Global Megatrends: Automation in Emerging Markets* (2014).

7. Cynthia Breazeal, "The personal side of robots," South by Southwest, March 13, 2015.

8. Eitan Wilf. "Sociable robots, jazz music, and divination: contingency as a cultural resource for negotiating problems of intentionality," *American Ethnologist: Journal of the American Ethnological Society*, November 6, 2013: 605. http://onlinelibrary.wiley.com/doi/10.1111/amet.12041/abstract.

9. Mike Murphy, "Amazon tests out robots that might one day replace warehouse workers," *Quartz*, June 1, 2015.

10. Lydia DePillis, "Minimum-wage offensive could speed arrival of robot-powered restaurants," *Washington Post*, August 16, 2015.

11. Thi-Hai-Ha Dang and Adriana Tapus, "Stress game: the role of motivational robotic assistance in reducing user's task stress," *International Journal of Social Robotics*, April, 2015.

12. Michael Lewis, *Flash Boys: A Wall Street Revolt* (New York: Norton, 2015).

13. Andrei A. Kirilenko and Andrew W. Lo, "Moore's Law versus Murphy's Law: algorithmic trading and its discontents," *Journal of Economic Perspectives*, 2013. http://www.jstor.org/stable/pdf/23391690.pdf?acceptTC=true.

14. Shukla Shubhendu and Jaiswal Vijay, "Applicability of artificial intelligence in different fields of life," *International Journal of Scientific Engineering and Research*, September, 2013.

15. Ibid.

16. Ibid.

17. Derek Thompson, "A world without work," *The Atlantic*, July/August, 2015.

18. Dawn Nakagawa, "The second machine age is approaching," *Huffington Post*, February 24, 2015.

19. *MIT Technology Review*, "Who will own the robots," September, 2015.

20. Martin Ford, *The Lights in the Tunnel: Automation, Accelerating Technology, and the Economy of the Future* (CreateSpace Independent Publishing Platform, 2009). Also see his more recent book, *Rise of the Robots: Technology and the Threat of a Jobless Future* (New York: Basic Books, 2015).

21. US Bureau of Labor Statistics, "Employment projections: 2012–2022 summary," December 19, 2013. http://www.bls.gov/news.release/ecopro.nr0.htm

22. Ibid.

23. Quoted in Harold Meyerson, "Technology and trade policy is pointing America toward a job apocalypse," *Washington Post*, March 26, 2014. The original paper is by Carl Benedikt Frey and Michael Osborne, "The future of employment: how susceptible are jobs to computerisation," Oxford University Programme on the Impacts of Future Technology, September 17, 2013.

24. Frey and Osborne, "The future of employment," op. cit.: 57–72.

25. Erik Brynjolfsson and Andrew McAfee, *The Second Machine Age: Work, Progress, and Prosperity in a Time of Brilliant Technologies* (New York: W. W. Norton, 2014), 11.

26. Lawrence Summers, "The economic challenge of the future: jobs," *Wall Street Journal*, July 7, 2014.

27. Quoted in David Rotman, "How technology is destroying jobs," *MIT Technology Review*, June 12, 2013. http://www.technologyreview.com/featuredstory/515926/how-technology-is-destroying-jobs/

28. Ibid.

29. Quoted in Melissa Kearney, Brad Hershbein, and David Boddy, "The future of work in the age of the machine," Brookings Institution Hamilton Project, February, 2015.

30. Aaron Smith and Janna Anderson, "AI, robotics, and the future of jobs," Pew Research Center, August 6, 2014.

31. Edward Bellamy, *Looking Backward 2000–1887* (Boston: Ticknor & Co., 1888).

32. Nicolas Colin and Bruno Palier, "Social policy for a digital age," *Foreign Affairs*, July/August, 2015.

33. Ibid.

34. Kemal Dervis, "A new birth for social democracy," *Brookings Institution Project Syndicate*, June 10, 2015.

35. The Griffith Insurance Education Foundation, "Millennial generation attitudes about work and the insurance industry," February 6, 2012.

36. Lindsey Pollack, "Attitudes and attributes of millennials in the workplace," September 12, 2014.

37. Job Centre Plus, "Volunteering while getting benefits," UK Department for Work and Pensions, October, 2010. https://www.gov.uk/government/uploads/system/uploads/attachment_data/file/264508/dwp1023.pdf

38. Quoted in Thompson, "A world without work," op. cit.

39. Melinda Sandler Morill and Sabrina Wulff Pabilonia, "What effects do macroeconomic conditions have on families' time together?" Leibniz Information Centre for Economics, 2012. http://hdl.handle.net/10419/58561

40. Darrell M. West, *Billionaires: Reflections on the Upper Crust* (Washington DC: Brookings Institution Press, 2014).

The Next Step in Finance: Exponential Banking

FRANCISCO GONZÁLEZ

Opening image:
Eduardo Terrazas
14.23. "Museo de lo cotidiano" Series (2014)
Dyed wooden blocks mounted
on a wooden frame
Monclova Projects Collection
Mexico City, Mexico.

Francisco González
BBVA Group Executive Chairman

President of BBVA since 2000, Francisco González holds a degree in
Economics and Business. He is a member of the Board of Directors of
the Institute of International Finance (IIF) and of diverse international
forums, including the Global Advisory Council of The Conference Board,
where he is Vice President of the Board of Trustees. He represents
BBVA at the International Monetary Conference (IMC) and is President
of the Fundación BBVA. Prior to the merging of Banco Bilbao Vizcaya
with Argentaria, he was President of Argentaria between 1996 and 1999,
where he led the integration, transformation, and privatizing of a very
diverse group of public banks. He began his professional career in 1964
as a programmer for a computing company, and that first job marked the
beginning of his clear, concentrated focus on transforming twenty-first-
century banking with the aid of new technologies.

Exponential technologies offer enormous opportunities for building a much more efficient and productive financial system capable of efficiently driving global growth and well-being. This demands a profound transformation of the financial industry and threatens the survival of today's banks. The present article begins with a consideration of how technological growth affects the economy and companies, and continues by detailing its impact on the financial industry. It then discusses the fundamental risks involved in the transformation that financial institutions must undergo. This final analysis is largely based on BBVA's experience with the drastic transformation it launched almost a decade ago.

INTRODUCTION: TOWARD BANKING WITHOUT BANKS?

Almost a decade after the financial crisis began in 2007, and after a massive and very costly cleanup and recapitalization—largely at the expense of the public sector, that is, the taxpayers—the global banking industry is passing through an even more difficult stage. More difficult because, while what was at stake in the previous decade was the continued existence of many banks, what is threatened today is the survival of banking itself, at least as we have known it for centuries.

The plethora of literature about banking's current situation and perspectives frequently attributes this sector's low and waning profitability and uncertain future to the more-or-less delayed effects of the crisis—including the maintenance by numerous banks in many countries of unproductive or non-performing assets whose balance sheet value far exceeds their market value; low economic, and therefore business, growth; more rigorous regulation, which has multiplied demands for capital and liquidity while reducing income from many activities; and most of all, negative interest rates in developed countries, which has had a deleterious impact on the profitability of banking operations. These unprecedented interest rates reflect powerfully expansive monetary policies initially intended to avoid a massive banking crisis and mitigate global recession and, later, to stimulate a recovery that continues to falter, even today. Another frequently mentioned aspect is the damage to banks' reputations as a result of the bad practices that lie at the roots of the crisis. This is thought to have contributed to the lesser demand for banking services among broad sectors of society —especially the young—and their willingness to accept other alternatives to satisfy their financial needs (see, for example, European Central Bank, 2015, and International Monetary Fund, 2015).

Still, at a deeper and more fundamental level, the greatest risks for the future of banks lie in the impact of the technological revolution and its far-reaching changes in the global economy and society. And this is not only true at a macro level—these changes directly affect people's habits, needs, and demands in every part of their lives.

Technological advances offer enormous opportunities for servicing these needs and demands—including new ones that will emerge as society and people continue to change—in a much more complete, perfect, and inexpensive manner. The drop in the cost of financial services will make it possible to offer them to all sectors of society, worldwide, including the most disadvantaged.

Financial activity is the backbone of our economy and it is instrumental in handling people's multiple needs and essential demands. Therefore, a much more efficient and productive financial system based on the most advanced technologies and able to respond to social changes and serve everyone can both benefit from and significantly contribute to the materialization of opportunities for progress and well-being offered by technological advances.

This, in turn, requires a profound transformation of the financial industry, which has already begun, although it is impossible to foresee its long-range development. It is equally impossible to know what the entities that provide these financial products and services will be like, although they will almost certainly bear only a distant resemblance to today's banks. The transformation of this industry threatens the survival of current banks, which will have to undergo a very complex, uncertain, and drastic process of adaptation if they want to be part of the financial industry of the future.

In this article, we will review the possible effects of emerging technologies on the economy before considering their impact on the financial industry. We will then analyze fundamental aspects of the transformation which must be addressed by financial entities, their regulators and supervisors in order to adapt to their new surroundings. This analysis will necessarily draw largely on BBVA's experience as an institution that has been involved with a process of radical transformation for almost a decade.

THE TECHNOLOGICAL REVOLUTION AND THE GLOBAL ECONOMY

Nick Bostrom's well-known description of the technological revolution as "a dramatic change brought about relatively quickly by the introduction of some new technology" (Bostrom, 2006), makes it very clear that we are experiencing a transformation whose scale may well be comparable to that of the Neolithic revolution that ushered in agriculture and sedentary human settlements. Our current revolution, however, is immeasurably faster in its effects. The speed and pace with which today's innovations not only emerge, but are applied and transmitted, is historically unprecedented.

The speed of these changes in our time is due to the nature of the current technological revolution, which stems from radical improvements in the capacity, velocity, and cost of information processing and transmission. This contrasts with earlier technological revolutions that were based on the physical world and the production and transportation of merchandise.

This technological revolution began in the mid-twentieth century with the development of the earliest computers, followed by personal computers and the Internet. Since then, it has certainly obeyed Moore's Law, which states that the capacity to store and process information doubles approximately every eighteen months, while the cost is halved in the same period of time. This exponential advance was initially achieved by improving and reducing the size of devices, and it later burgeoned as ever-greater numbers of them were interconnected.

That process has led to the emergence of "exponential technologies" whose name reflects their evolution in compliance with Moore's Law. Many, such as "intelligent mobility," which is the capacity for mobile computing, the cloud, big data, the Internet of Things, nanotechnologies, and the development of new "intelligent" materials, contribute to increases in the capacity for information processing while reducing costs in a way that supports the continued validity of Moore's Law. Others, such as robotics and drones (or driverless cars), 3-D printing, virtual reality, and a variety of biotechnologies—many, associated with genetics, including "gene editing"—benefit from the exponential growth of information processing and storage to advance at previously impossible speeds.

Brynjolfsson and McAfee (2014) suggest that the current technological revolution has led to the "second machine age." The first one drew on the development of steam engines to surpass the limited physical capacities of humans or animals. The second draws on the development of computers to surpass the limitations of human intellectual capacities, at least to some extent, and with consequences that have yet to be seen.

This final aspect is what distinguishes the current technological revolution from earlier ones; other elements such as technological acceleration, the emergence of related technologies that can be combined, their impact on productive sectors, society, politics, and human lives are not essentially different from what occurred in previous technological revolutions, but the magnitude and speed of change are not the same. The fundamental qualitative difference is that now emerging technologies make it possible to change what had previously been considered immutable fundaments of human nature: memory, cognitive processes, physical and intellectual capacities, and even mortality itself. These technologies raise questions as relevant for our species as the impact of a drastic lengthening

"There will always be plenty of things to compute in the detailed affairs of millions of people doing complicated things."

VANNEVAR BUSH (1890–1974)
In the visionary article "As We May Think", published in the American magazine *The Atlantic Monthly* in 1945.

Intel error-correction chip.

of the human lifespan, or a coexistence with machines whose intelligence is comparable or superior to ours, leading to the possible advent of so-called "singularity," where such machines would be capable of independently generating other machines of even greater intelligence.

In any case, the power of these new technologies and their rapid spread is accelerating the transformation, not only of industry and business, but also of human customs and lifestyles, culture, and, therefore, society as a whole. At the same time, as with earlier technological revolutions, we are experiencing a shift in the limits of what is possible in the production and distribution of products and services, and that should be generating a notable rise in productivity and global growth.

And yet, to the concern of many, global economic growth over the last decade has been very disappointing. Not only has the acceleration commonly associated with a technological revolution not taken place, but growth has actually been lower than in the previous decade, and far lower than in the twenty-five years following World War II, which were the most brilliant of the past century, and possibly of any time in history. And this is so despite the efforts of central banks, which have injected enormous amounts of liquidity into the system and lowered interest rates to unprecedented levels—even negative levels along a considerable length of the performance curve in Europe and Japan.

The weakness of the economic recovery following the latest crisis and the scant optimism of growth forecasts for the immediate future have led to considerable debate among economists. The so-called "techno-pessimists" believe we are in a phase of stagnancy, trapped in a long period of negligible growth in productivity and employment and even the threat of deflation and lasting depression. On the other hand, the so-called "techno-optimists" believe we are in a transitional phase still affected by the consequences of the crisis: a prolonged and difficult deleveraging and a weakness that still characterizes broad segments of the global banking system. According the them, this phase will be followed by a period of much faster growth, driven by technological advances.

About three years ago, Larry Summers (Summers, 2014) revived Alvin Hansen's 1930s hypothesis of secular stagnation (Hansen, 1938), to highlight the structural scarcity of investment demand as compared to savings. Other economists, such as Robert Gordon (Gordon, 2016), explain low growth in terms of supply factors, especially waning innovation and the consequent low growth of productivity. Yet others, including Thomas Piketty (Piketty, 2013) and Joseph Stiglitz (Stiglitz, 2015), cite other analyses that blame increased inequality for permanently depressing aggregate demand.

These explanations are not mutually incompatible and could occur simultaneously. The combination of a Keynesian scarcity of aggregate demand, a slowdown in productivity, and a growing concentration of wealth among higher-income segments would be more than sufficient to drag the global economy into a long period of low growth.

Still, there are also powerful reasons to dispute such a negative conclusion. First, the demographic perspectives maintained by emerging and developing economies suggest improved productivity and investment profitability that are much more favorable, and these could absorb the excess of global savings and also spur growth in the developed countries.

Second, there are well-known problems with how the GDP, investment, and productivity are undervalued by statistical measurement tools designed for a "steel and wheat"

economy—rather than a "digital" one, where data and information are the key "inputs" and "outputs" of a growing portion of economic activity (Mokyr, 2014). If these biases were corrected, they might offer a different view of future growth. Moreover, as Mokyr himself suggests, technological revolutions develop and bear fruit over a long period of time, and often in unexpected ways.

Brynjolfsson and McAfee (2014) believe we are on the verge of a period of strong growth driven by increasingly intelligent—and omnipresent—machines that will make the most of advances in computing, wider and denser communications networks, digitalization, and artificial intelligence, among other "exponential technologies."

Economic history has taught us that earlier disruptive technologies such as the steam engine or electricity, for example, needed time to reach a turning point in which they became widespread and accessible enough for general and flexible use that included their combination with other technologies, thus radically changing both means of production and living conditions. According to Brynjolfsson and McAfee, digital technologies are reaching this turning point, which would mark the beginning of what Klaus Schwab (2016) calls the "Fourth Industrial Revolution," in which the combination of very powerful technologies is erasing the traditional separation of physical, digital, and biological realms.

Until now, those most benefitted by these advances have been consumers. Technology allows an ever-greater number of people to access new products and services that improve their standard of living. But as Brynjolfsson and McAfee have pointed out, this process can also lead to greater unemployment and, thus, greater inequality. Technological advances will lead to the loss of innumerable jobs as workers are replaced by machines or their jobs become unnecessary when technology allows people to attend to their own needs.

This is not the first time in history that new technology is associated with increased inequality and unemployment. That was the guiding idea of early nineteenth-century Luddites, and Keynes himself coined the term "technological unemployment" in the 1930s.

In the past, however, notwithstanding the inevitable catastrophic prophecies, new technologies eventually generated new kinds of employment that replaced lost jobs. This new work was also more productive and it improved the overall population's living conditions, even in a general context of greater inequality. Still, those improvements only took place after a difficult period of transition. In our current circumstances, this period of adjustment could be long and difficult for broad sectors of the population, and potentially very conflictive.

Ultimately, the global economy faces two major challenges, which are different but related: first, strengthening aggregate demand and correcting imbalances that burden short-term growth; and second, facilitating and limiting the costs of the transition to a new reality. Overcoming both challenges will require ambitious measures on a global scale, including a fiscal impulse focused on investment in infrastructures and a broad group of structural reforms to improve market flexibility, with particular emphasis on job mobility, facilitating the creation of new businesses, reinforcing anti-monopoly laws, stimulating R & D + i, and, in a way that can no longer be delayed, drastically improving educational systems and promoting social inclusion policies so that technological advances lead to greater growth and everyone has access to these opportunities for greater wealth and well-being.

No matter why the impact of the technological revolution has yet to manifest itself as a clear improvement in global macroeconomic figures, there is no doubt that our way of life is rapidly changing, including our work, leisure, consumption, and social relations. Moreover, this is clearly driving radical changes in the productive sectors and the businesses that belong to them.

Klaus Schwab concludes that we are at the beginning of the "Fourth Industrial Revolution," which is being built on the basis of the "Third," or digital, revolution, that began in the mid-twentieth century and is characterized, fundamentally, by the merging or combination of technologies that are erasing the limits between physical, digital, and biological realms.

What Schwab calls the "Third Industrial Revolution," including the advent of Internet and the development of digital technologies, had an enormous impact on those sectors whose fundamental inputs and/or outputs consisted largely of information: communications, the media, music, many distribution sectors, and so on. These industries have had to reinvent themselves and have made enormous gains in productivity and efficiency, generating new and better products that benefit consumers.

With the "Fourth Industrial Revolution," other sectors that focus more on the physical world and have already experienced notable changes but not disruptive ones are beginning to see how the combination of technologies allows them to meet their clients' demands in entirely new ways that radically alter their value chains.

These changes are brought into the market by new, agile, and innovative competitors who can successfully compete with established companies by improving the quality, speed and price of their products or services—in sum, by offering their clients a better experience.

This most recent supply is tuned in to a burgeoning wave of "new" consumers who are developing novel needs and habits that change the nature of demand as well, largely through access to information and interaction from mobile devices. All of this is forcing companies to rethink the design, production, and distribution of their products and services, as well as generating profound changes in the companies themselves, and in industrial structures. The emergence of new competitors

such as Airbnb or Uber in industries strongly based on physical activities or on-site attention to clients—hotels or transportation for example—shows that the technological revolution is no longer hindered by sectoral barriers, and no industry is safe from disruption.

In his famous book, *The Third Wave,* Steve Case (2016) poses the same argument, suggesting that the technological revolution will occur in a series of increasingly profound and powerful waves. According to Case, the First Wave began in the 1980s, when the earliest Internet companies connected people to the web by creating the necessary hardware and software for a connected world. The Second Wave is responsible for the enormous changes we are now experiencing in our lives and surroundings, but it has not made core changes to the global economy.

Today, we find ourselves at the beginning of the Third Wave, in which profound changes have begun to affect key sectors of the economy, especially those dealing with "physical" or "real" concerns, such as health, education, energy, transport, food, and so on. In my opinion, as I will explain further on, the financial industry should also be included in this list.

This Third Wave will probably develop in a different and more gradual way than the first two, because it affects very well-established industries with highly complex production and distribution chains and very powerful companies—often multinational corporations—that are generally subject to wide-reaching and diverse regulation.

Therefore, it will be more difficult for individual disruptive agents such as start-ups to have a significant impact. Instead, they will be more likely to associate or collaborate with established companies.

A major challenge for established companies will be expanding structures that have been successful up to now to include technology, and doing so at the same time as necessary regulatory changes. Regulators, and in general, those with political responsibility, will play a fundamental role, because they can help make the adoption of new technologies more or less rapid and harmonious.

A mechanism that is proving key for the spread of technology and its adoption by well-established industries is the development of technology-dependent platforms that combine supply and demand by linking multiple providers with clients, generating tremendous amounts of data, information, and interactions, and creating new services and completely

new ways of distributing and consuming them. Developments associated with a "sharing economy" or the provision of goods and services "on demand" are clear examples of unprecedented changes in how transactions—and not only economic or commercial ones—are taking place among people.

Today, the five most important companies in the world in terms of market capitalization—Apple, Google (or its holding company, Alphabet), Microsoft, Amazon, and Facebook are essentially platforms of this type. This should give us an idea of the magnitude of the tsunami affecting all stakeholders and all areas served by companies. First of all, it places clients at the center of all company activities. Finding the best way to make contact with them and improving their experience with a company are keys to surviving in this new setting. Technology is therefore an essential tool, as all products and services, including the most "physical" ones, can be improved in different stages of design, production, and distribution by adding "digital" characteristics that increase their perceived value for clients. The rapid proliferation of new technologies, their infinite possible combinations, the importance and enormous abundance of data and information, and the techniques for processing them to generate better information and knowledge demand new kinds of collaboration between companies with different capacities. And the radical change in business models means that the talents and skills required by companies, their manners of working, organizational structures and, on a more general level, corporate culture must all be profoundly revised, and in some cases even reinvented.

Today, we cannot say where this process will take us, as it is just beginning. Especially when we remember that the new and most powerful technologies currently being developed will become the tools that drive scientific advances in physics, biosciences, computation, and the environment, and these, in turn, will lead to new technological applications.

But even the technologies already available today offer a multitude of possibilities to further spur the period of change we are now experiencing, including the cloud and big data analysis, multiple advances in robotics, artificial intelligence, biotechnologies, new materials, biometry, 3D printing, nanotechnology, and natural-language interaction with machines.

I am convinced that all of this will lead to an unprecedented wave of prosperity that increases well-being across the globe and allows us to confront humanity's greatest challenges: environmental degradation, climate change, poverty, and extreme inequality, among others. It is impossible to know how all of this will work out, how long the period of adjustment will last for each of the different social and economic sectors, or the degree of conflict involved. But we do know that all companies in all industrial sectors will be forced to profoundly revise their manner of working and doing business, generating a new culture that is open and positive in the face of change, and developing a willingness to question conventions and live in a state of continuous innovation.

THE TECHNOLOGICAL REVOLUTION AND THE FINANCIAL INDUSTRY

The financial industry—especially banking—has characteristics that make it a candidate for rapid and early digitalization, mainly because its fundamental raw materials and products boil down to two: data (or information) and money. And money can be turned into accounting figures, that is, data or information.

Still, despite the fact that banking—and the financial industry in general—has changed considerably in recent decades, it has not suffered anywhere near the level of disruption experienced by other sectors. Different reasons for this have been suggested, including the conservatism of most people in matters of money, which leads, historically, to high levels of customer loyalty; the industry's high growth rates and profitability, which tend to discourage experimentation and change; and what is almost certainly the most important element of all: regulation. The banking industry is subject to extremely detailed and broad regulation that limits institutions' freedom to adopt radical innovations but also protects them from the entry of new competitors.

But this is changing—first and foremost, because today's clients are different. The crisis has undermined banks' reputations and eroded customer confidence in them. Moreover, a new generation of clients has grown up in a digital marketplace, and it demands different services and new ways of accessing them. Furthermore, these new customers are more willing to accept banking services from other types of companies. And they are increasingly doing exactly that.

Hundreds, even thousands, of start-ups are already attacking different links in banking's value chain. These companies are not burdened by traditional banks' legacy of obsolete, costly, and inefficient structures, and they are able to make the most of technology. Consequently, they can offer customers a better experience in a very agile, flexible, and inexpensive way. Payments, loans, securities transactions, and assets management are probably the most threatened banking areas, but there are also initiatives with considerable potential in insurance, deposits, risk management, cybersecurity, capital markets, and many other areas.

The number, variety, and scale of these companies is burgeoning. A McKinsey report (McKinsey, 2015) estimates that they could cause banks to lose as much as 60% of their income in consumer finance, 35% in payments or loans to small and medium-sized companies, 30% in assets management, and 20% in mortgages.

At the same time, the economic foundations of the banking business have changed. The high growth rates and profitability at the beginning of this century are definitely a thing of the past: the current context of very low interest rates could last for several more years and banking's regulatory framework has become much stricter, with greater capital and liquidity requirements, as well as demands for transparency and consumer protection. All of this increases the need for an urgent transformation of banking to radically increase its productivity and efficiency.

This transformation will generate enormous benefits for users in terms of the quality, variety, and price of its products. It will also allow many millions of lower-income people throughout the world to access financial services, thereby improving their standard of living and their opportunity to prosper.

In macroeconomic terms, the transformation of banking implies a powerful structural reform: making resources cheaper, increasing the efficiency and agility of all services, and more precisely adapting them to users' needs are all outstanding ways to help foster growth and reduce inequality and poverty (González, 2015).

We are, therefore, headed toward a new and better finance industry, but we do not yet know what its final shape will be, or whether banks will occupy an important place in it. They may have no place at all.

Banks have some clear disadvantages, such as very costly and inflexible structures, slow and complex processes, obsolete technological bases, and corporate cultures poorly suited to the

digital world. Moreover, they are not close to those settings where the latest technologies and most disruptive innovations are being hatched, so it is difficult for them to access the talent that makes such activity possible.

On the other hand, they maintain the immense majority of banking clients and they handle a great wealth of information about them. They have infrastructures that allow them to produce and distribute a broad range of products and services, and much greater financial resources, as well as the licenses required by regulations and, most of all, a profound knowledge of the financial business.

The newcomers, however, are flexible, creative, innovative, and perfectly at home in technological settings, but they have neither clients nor the infrastructure needed to capture them. They lack well-established frameworks and experience in the banking business.

Other potential competitors—major digital companies such as Facebook, Apple, Google, Amazon, and others—might be interested in entering the financial business to complete their offer to clients and to participate in an activity that generates repeated contacts with customers and a huge volume of information about people. These companies undoubtedly have customers, a brand name, and economic resources to overcome any problems generated by insufficient infrastructure or lack of experience in this business. Presently, however, the financial industry has not been one of their priorities, probably because they are reticent to enter such a tightly regulated sector.

So far, digital competitors have attacked very specific segments of banking's value chain and have been unable to develop a broad range of products. Even operating in this limited setting, they often rely on a conventional bank to make their products available to customers.

So far, the major names on the web have made only relatively marginal incursions into the financial world. However, this will almost certainly change with advances in technological applications for that industry and changes to regulations in order to adapt them to the new setting.

So banks have a certain amount of time to remedy their current weaknesses and assume a position that allows them to build on the advantages they still have. But this will require a long, costly, and, most of all, complex process that involves not only a radical technological renovation but, even more so, a profound organizational and cultural transformation.

Three factors will be decisive in determining whether, in one form or another, banks will survive the technological revolution: first, the speed with which technology advances, and how fast it becomes a part of financial activity among both service providers, and most of all, clients. Second, regulations, which will be a factor in determining the speed with which the industry changes and, to a large degree, the direction it takes in many settings. And third, the speed, decisiveness, and success with which banks—at least, some of them—undertake the transformation process.

We will briefly consider these elements in the following sections.

TECHNOLOGY, CUSTOMERS, AND THE FUTURE OF THE FINANCIAL INDUSTRY

What will customers want from the new digital financial-service providers?

What customers definitely need is agile, rapid service—ideally, in real time—which is competitively priced and personalized, that is, adapted to their needs. And all this in a safe environment, where their data are protected.

Today, that means providing clients with a complete omni-channel experience that allows seamless switching from one channel to any other. And, especially, the finest mobile solutions that make it possible to smoothly handle all aspects of any consultation or transaction.

In any case, the customer's digital experience should be complete, from beginning to end, for any service or product, and clients should also have the capacity to contribute to their design and to define their characteristics according to their own preferences.

The security systems will have to be highly efficient yet agile, comfortable, and as unobtrusive as possible for the customer.

Finally, customers will want to be offered other services beyond those associated with conventional banking. These new services have yet to be defined, but they will almost certainly include easy access to P2P systems so that clients can use their bank for any sort of interaction or transaction with other people. Today, these consist of payments and loans, but in the future they will include many other services.

The technologies that make it possible to offer all of this already exist; their latest developments and growing adoption pave the way for changes we cannot even imagine, with enormous gains in the variety and quality of services offered and in the productivity of all operations.

Among the technologies currently driving the transformation of our industry in the most direct manner and destined to affect its configuration in the near future, I should mention:

> Mobile computing: smartphones that offer greater functionality every day and are increasingly becoming customers' preferred means of accessing their banks. In the United States, over thirty percent of clients prefer mobile banking, clearly surpassing those who still prefer their branches (24%).

> Biometrics, which permits secure identification without need for documentation or physical presence, and thus eliminates one of the last obstacles to the development of complete digital banking on any sort of device.

> Cloud computing, which enormously facilitates digital transformation by making it possible to offer computer services in a scalable and very efficient manner to everyone. It is extremely advantageous in terms both of agility and cost and thus paves the way for accelerated cycles of innovation. The most important digital companies, such as Google, Amazon, Facebook, and Apple, have been built on these types of structures, and they even offer them to third parties in order to benefit from their enormous economies of scale.

These are the infrastructures underlying the development of models for digital platforms that offer products and services supplied by different producers. Digital activity is growing at exponential rates, powerfully driven by mobile telephones, and increasingly by a multitude of other connected devices in what is now known as the "Internet of Things." The information

generated can be exploited, among other reasons, for better understanding the behavior of market agents. Big data analysis extracts information—in other words, value—from those enormous volumes of information at very high speeds. And big data also makes it possible to process very diverse kinds of information, both structured (statistics, indicators, etc.) and unstructured (web navigation flows, social media contents, etc.).

Blockchain technology has enormous potential for change in the financial business. In a nutshell, it is public accounting among peers that requires no authority, central control, or intermediary (see Karp, 2015). This changes the rules of the game in many areas of financial activity, and other industries, for managing any kind of assets, whether digital or physical. It will encourage new business models that challenge the position of current banking by directly attacking its function as an intermediary. Moreover, it will make it possible to automate many banking processes that currently require intensive human involvement, thus generating new business sources.

Another key technology for the development of banking will be "artificial intelligence," or more precisely, "cognitive technologies." These have the potential to drastically change how people live and, of course, how banking is done. They are actually a family of technologies with very diverse applications (Stanford University, 2016), ranging from routine tasks (the intelligent automation of processes), where they will ensure considerable savings, as well as improved quality and speed; to more complex tasks, where they stand out for their disruptive potential. These include the development of "conversational interfaces" that improve the users' experiences; "Automated Complex Reasoning," which permits totally automated decision making based on contextual and behavioral data and is fundamental for the development of "roboadvisors" capable of substituting for a human presence, even in complex operations; and "Deep Learning," which paves the way for developing much faster and more advanced systems for fraud detection. As well as "risk scoring," the definition of dynamic "clusters" of customers, the construction of artificial

stress scenarios, and much more. Artificial intelligence is fundamental for the development of natural-language processing, which allows computers to maintain a conversation with human beings. This would enormously accelerate customer digitalization.

All of this is already changing the financial industry. Largely because newcomers can attack concrete segments of the business, benefitting from some of these disruptive technologies and drawing on others for support to reduce the time and expense involved in establishing basic infrastructures for data processing, production, distribution, and so on.

As a result, the financial industry is growing increasingly fragmented. Each year, hundreds of new operators join over twenty thousand banks that already exist, worldwide. At the same time, the industry is unbundling to the degree that these highly specialized new operators are breaking banking's value chain by offering products and services focused on very specific links in that chain.

Are these trends permanent?

Almost certainly not. On the one hand, the global banking system has been suffering from a clear overcapacity for years and, lately, it has also been burdened by scant income and a drop in profitability.

This situation is worsening with the new competition, falling costs—and prices—ushered in by the technological revolution, as well as the technological and cultural difficulties that most banks are experiencing in their efforts to adapt to the new digital surroundings. Consequently, it is reasonable to expect many banks to disappear, along with innumerable start-ups, whose mortality rate is always very high. Thus, technological change will finally bring the drastic consolidation that the banking sector has needed for some time.

On the other hand, user convenience calls for much more global and integrated solutions to their needs, and this points to a rebundling of the goods and services being offered.

In such a complex and changing environment, rebundling will require combining products and services from different providers. Experience in other industries suggests that this will be achieved through platforms where different providers will compete and frequently cooperate to offer their users the best possible experience. These platforms will need a very convenient and user-friendly "front-end" that "knows how" to combine products and services to meet the specific needs and desires of each client at each moment.

It is very likely that different types of platforms will develop, some to provide functionality to other businesses and companies that may even offer so-called "banking services," that is, all of the infrastructure and processes needed to develop banking activity.

Other platforms will work as meeting points or marketplaces for final clients. User convenience will probably impose a trend toward "universal" platforms offering an entire

range of financial services along with others that are not financial. At the same time, or as a stage in the development of these universal platforms, there will also be many platforms specialized in different segments of the banking business, and they will be able to coexist and interact with the more generalist ones.

Foreseeably, the number of such platforms will gradually decrease, due to the enormous economies of scale and scope that can be generated. So the key question is: who will occupy the center of these platforms the way, for example, that Amazon does today?

This central player will be the platform's "owner," establishing the rules, taking responsibility for its maintenance and improvements, and validating the transactions that take place there. Consequently, it will receive a part of the income generated by those transactions and will have access to, and control of, the information generated around it, which is itself another enormous source of value.

Evidently, competition for this position will be very stiff as the most successful start-ups—in existence or yet to be created—will have grown exponentially and will vie with those banks most capable of adapting to the new environment, and probably with some of today's major digital enterprises.

Succeeding in such a competitive environment will involve two fundamental conditions, although these, alone, may not be enough: first, possessing the most advanced capacities offered by the exponential technologies on which the platform is built; and second, being able to gain consumer confidence through an excellent reputation that stresses prudence, transparency, and a complete absence of conflicts of interest.

Very few of today's banks will attain this position, but those that do will have done so thanks to their decisive and successful adoption of sweeping changes. The rest will simply disappear. They will be absorbed or will fade away as their client base gradually shrinks. Some may even become infrastructure providers, offering their services generically to other companies with direct client relations.

TOWARD NEW REGULATIONS AND "DIGITAL" OVERSIGHT

Historically, regulation has played a key role in the financial sector's evolution. Its traditional objectives have been to guarantee the system's stability, to prevent or minimize the effects of banking crises, and to protect consumers. Also, though less and less often, regulation has involved obliging banks to collaborate in attaining other economic policy objectives, such as industrialization, bolstering certain sectors, or even easing public debt. Encouraging competitiveness has only recently become a consideration for regulators and, of course, they have never been particularly interested in spurring innovation. Instead, they have frequently viewed financial innovations with misgivings, assigning more importance to their possible risks for the stability and/or protection of consumers than to their promise of better financial services at a lower cost.

All of this, along with the manner in which regulation itself hinders the entrance of new competitors, has led financial systems to be slow in responding to technological advances and their resultant social changes, and their evolution has always been characterized by incremental innovation, with very few disruptive episodes.

This is key to understanding why banking has lagged behind other sectors in its digitalization process, even though its characteristics make it a good candidate for an early adoption of such technology.

This is changing, however, as regulators begin to recognize the importance of a competitive and efficient financial system for driving economic growth, for the well-being of its users, and for the stability of the system itself. Moreover, we are now encountering very powerful factors that contribute to this new perception, even if the transformation is quite gradual.

One of these is exponential technologies' enormous and ever more widely recognized potential to improve the quality, convenience, and cost of financial services, with significant advantages for consumers and for economic growth. And this potential is even more clearly perceptible in our present situation, when zero interest rates, or even negative ones, are proving insufficient to spur credit. Drastic gains in productivity fostered by technology will make it possible to transmit monetary policy, reducing the cost of capital.

Another is the emergence of new competitors capable of providing specific financial services in a more flexible and efficient way, thanks to their use of technological capacities (the so-called "fintech") and consumers' increasing willingness to contract such services from non-banks. Finally, there is the pressure exerted by the banks themselves to loosen the fetters that keep them from competing in more efficient ways with "fintech."

As a result, in recent years, different authorities have softened regulation in order to spur competition, especially in those segments of financial activity that do not directly affect its stability. This has favored the entry of new competitors in certain niche areas such as retail payments.

Still, taking full advantage of technology's potential requires much broader and more systematic regulation that today does not exist. This creates vast zones of high potential risk for the regulators' basic objectives: macroeconomic and financial stability and consumer protection—including their data—as well as everything related to money laundering and the financing of illegal activities such as terrorism.

What is needed, then, are regulations that adequately balance the value of new digital proposals for consumers with protection from the corresponding risks. Moreover, the dangers for macroeconomic and financial stability must be adequately weighted in the face of the increased efficiency offered by new business models.

At the same time, regulation must create a competitive environment—and supervision must ensure that it is respected—in which similar financial products and services receive similar treatment regardless of what sort of institution—established banks or newcomers—is providing them.

Fortunately, many regulators and supervisors are taking steps in this direction. There are, however, many areas to address and not enough resources available for adequate preparation.

Therefore, regulators and supervisors must not only reinforce their "digital" human assets and strengthen dialogue with institutions that are moving ahead with digital transformation, they must also concentrate efforts on those areas that most affect the configuration of the future financial services industry.

Among these, I would first like to briefly mention "digital enablers." These technologies are at the base of almost every digital service and therefore require regulation to ensure their secure use. These include big data analysis, cybersecurity, and digital identification, that is, the development of secure and efficient remote identification systems.

Second, there are technologies that can radically alter the configuration of the financial system's infrastructure, including cloud computing and blockchain.

Third, regulators need to think about how to deal with new and emerging business models such as alternative financing mechanisms (P2P loans, crowdfunding, online platforms or markets, and so on) as well as the different ways and degrees that "service banking" is provided.

All of these elements stand out in a very broad and complex panorama of matters to be resolved, and they therefore require highly flexible and wide-ranging approaches, because "digital" financial innovation will always outpace regulatory review cycles. Moreover, inasmuch as financial activity is largely supraterritorial and easily relocated, these approaches must be global in scope. For all these reasons, future "digital" definitions and supervision will require a high degree of convergence and cooperation by responsible authorities in different countries, as well as constant, transparent, and constructive dialogue with the industry.

How digital regulation and supervision are defined will be determinant in the speed and, to a large degree, direction of the financial industry's transformation. Therefore, they will be essential to ensure financial and macroeconomic stability in the coming decades and to help convert the financial system into an engine of economic growth and improvement for the well-being of many millions of people around the world.

BBVA has been involved in an ambitious transformation process since 2007, when we began making important investments to renew our technological infrastructure.[1]

Since then, we have made substantial progress although, of course, the process must be ongoing if we are to keep pace with technological change.

Today, our technological platform allows us to work in real time, managing a collaborative ecosystem with a variety of developers; bringing much more advanced cybersecurity and data-protection architecture into play; extracting greater knowledge from our data; and turning this knowledge into products and services with a drastic reduction in "time to market."

Along with these advances, we quickly understood that transformation involves a much more complex process that encompasses all of our activities, human capital, and corporate culture. Advancing in all of these areas has also required changing our organizational structures.

In 2014, we launched a Digital Banking division to handle the management of this process and accelerate the transformation. We rapidly saw significant progress and realized we could speed up our advances.

As a result, in 2015 we adopted a completely new organizational structure that made transformation a key focus in all of our business and support areas with two fundamental goals: spurring results in all of the group's business in the short and medium term and providing necessary resources and skills (both human and technological) to all of the group's areas in order to successfully compete in the new banking industry.

This structure has speeded our advance in new areas, products, and services, attracting new talent to expand our digital capacities and accelerating the development of a more agile, flexible, entrepreneurial, and collaborative corporate culture.

This is already reflected in our working approach, which is increasingly oriented toward projects involving flexible and multidisciplinary teams, the expansion of "agile" methodologies, and the ever-broader use of "scrums." The changes in our corporate culture and working methods have also been spurred by our new offices, which act to leverage the transformation, favoring collaborative work as a means of bringing out collective intelligence and stimulating innovation. Thus, our changing approach to work has been driven on three fronts: technology, culture (or behavior), and physical space.

We have also strived to draw closer to those areas where new technologies and applications are being developed. We maintain various collaboration agreements with cutting-edge companies and we have developed an ambitious policy for investing in others that can provide us with special knowledge and capacities. At the same time, we have assembled teams to carry out very important research in fields such as design, the building of data architecture, big data analysis, process engineering, and so on.

Throughout this complex process, it is essential to remember that the ultimate focus must be on the client. Our efforts are aimed at defining our relation to our customers—on the one hand, by placing technology and information at their disposal, and, on the other, by concentrating our efforts on broadening and improving our relations with them.

To do so, we must become a knowledge bank, using data to gain a better knowledge of our clients so we can help them understand their own financial needs and more easily make

Herzog & de Meuron BBVA's Corporate Headquarters in Madrid. Known as *La Vela*, it is the icon of the new BBVA.

The Next Step in Finance: Exponential Banking Francisco González

decisions, while providing them access to personalized solutions. And all of this in an agile, flexible and transparent manner, at the right price, to ensure our clients the best possible experience.

This means redefining our value proposition, supporting our clients throughout their entire financial lives, and helping them fulfill their aspirations. It also requires directing our efforts toward democratizing our range of financial services, using technology to make them economically accessible to many millions of people who cannot afford them today.

That is what is reflected in our purpose "To bring the Age of Opportunity to everyone."

And that is what we call "exponential banking" at BBVA: banking that draws on exponential technologies to exponentially expand the area of contact with our customers and information about them; banking that multiplies both the variety and the quality of the services we offer; and, in sum, exponentially expands our business on a global scale.

Such a drastic and powerful transformation can only succeed if it is guided by clear vision, committed leadership, and firm principles of prudence, integrity, and transparency to all of the company's stakeholders. Because, in the final analysis, what matters is earning and keeping our customers' trust, as that is what will determine who succeeds in the financial industry of the future.

NOTES

1. For a broader, though undoubtedly less current, treatment of BBVA's transformation, see González, 2014.

SELECT BIBLIOGRAPHY

— Bostrom, Nick. 2006. "Technological revolutions: Ethics and policy in the dark." In *Nanoscale: Issues and Perspectives for the Nano Century*, Nigel M. de S. Cameron, and M. Ellen Mitchell (eds.). Hobokon, NJ: John Wiley, 2007, 129–152.
— Brynjolfsson, Erik, and Andrew McAfee. 2014. *The Second Machine Age. Work, Progress, and Prosperity in a Time of Brilliant Technologies*. New York: W. W. Norton & Company.
— Case, Steve. 2016. *The Third Wave: An Entrepreneur's Vision of the Future*, New York: Simon & Schuster.
— European Central Bank. 2015. *Financial Stability Review*.
— González, Francisco. 2014. "La transformación de una empresa analógica en una empresa digital: el caso de BBVA." In *Reinventar la Empresa en la Era Digital*, Madrid: BBVA.
— González, Francisco. 2015. "Europa, entre el estancamiento y la revolución tecnológica. La banca digital como motor del crecimiento." In *La Búsqueda de Europa. Visiones en Contraste*. Madrid: BBVA.
— Gordon, Robert. 2016. *The Rise and Fall of American Growth: The U.S. Standard of Living since the Civil War*. Princeton, NJ: Princeton University Press.
— Hansen, Alvin. 1938. "Economic progress and declining population growth." *American Economic Review* 29: 1–15.
— International Monetary Fund. 2015. *Global Financial Stability Review*.
— Karp, N. 2015. "Tecnología de cadena de bloques (blockchain)." *Situación Económica Digital*.
— Lipton, A., D. Schrier, and A. Pentland. 2016. *Digital Banking Manifiesto: the End of Banks*, Connection Science and Engineering, MIT, Massachusetts Institute of Technology.
— McKinsey. 2015. "The Fight for the Consumer." In *McKinsey Global Banking Annual Report*.
— Mokyr, J. 2014. "Secular stagnation? Not in your life." In *Secular Stagnation; Facts, Causes and Cures*, C. Teulings, and R. Baldwin. London: CEPR Press, 93–90.
— Piketty, Thomas. 2013. *Capital in the Twenty-First Century*. Cambridge, MA: Harvard University Press, 2014.
— Schwab, Klaus. 2016. *The Fourth Industrial Revolution: What it Means, How to Respond*. Geneva: World Economic Forum.
— Stanford University. 2016. *Artificial Intelligence and Life in 2030. One Hundred Year Study on Artificial Intelligence: Report of the 2015–2016 Study Panel*. Stanford University, Stanford, available at htpps://ai100.stanford.edu/2016-report.
— Stiglitz, Joseph. 2015. *Rewriting the Rules of the American Economy: An Agenda for Growth and Shared Prosperity*, New York: Roosevelt Institute.
— Summers, Larry. February 2014. "U.S. economic prospects: Secular stagnation, hysteresis, and the zero lower bound." Lecture at the Economic Policy Conference of the National Association for Business Economists. *Business Economics* 49(2).

The Past,
Present, and Future
of Money, Banking,
and Finance

CHRIS SKINNER

Opening image:
Andy Warhol
Dollar Sign, c. 1981
Synthetic polymer paint and
silkscreen ink on canvas
35.56 × 27.94 cm
The Andy Warhol Foundation for the
Visual Arts, Inc., New York, USA.

Chris Skinner
Financial Services Club, Essex, UK

Chris Skinner is known as an independent commentator on the financial
markets and fintech through his blog, the Finanser.com, as author of the
best-selling book *Digital Bank* and its new sequel *Value Web*, and Chair of
the European networking forum *The Financial Services Club*. He is on the
advisory boards of many companies, including Innovate Finance, Moven,
and Meniga, and has been voted one of the most influential people in
banking by *The Financial Brand* (as well as one of the best blogs), and one
of the Top 40 most influential people in financial technology by *The Wall
Street Journal's Financial News.*

The history of money is wrapped up in sex, religion, and politics, those things we are told not to talk about. After all, these are the themes that rule our lives, and money is at the heart of all three. To put this in context we need to begin at the beginning, as that is a very good place to start, and talk about the origins of humans, which is what I am going to cover in detail in this article. In fact, the origins of money reflect the origins of humans. As you will see, there have been three great revolutions in human history as we formed communities, then civilization and industry. We are currently living through a fourth great revolution in humankind, and these revolutions fundamentally change the way we live. Equally important is the fact that each evolution of humankind creates a revolution in monetary and value exchange. That is why it is important to reflect on the past to understand the present and forecast the future, especially as we are living through a fourth revolution in humanity and trade, and about to enter a fifth.

THE FIRST AGE: THE CREATION OF SHARED BELIEFS

Seven million years ago, the first ancestors of mankind appeared in Africa and seven million years later, as we speak, mankind's existence is being traced by archaeologists in South Africa, where they believe they are finding several missing links in our history. A history traced back to the first hominid forms. What is a hominid, I hear you say, and when did it exist?

Well, way back when scientists believe that the Eurasian and American tectonic plates collided and then settled, creating a massive flat area in Africa, after the Ice Age. This new massive field was flat for hundreds of miles, as far as the eye could see, and the apes that inhabited this land suddenly found there were no trees to climb. Instead, just flat land, and berries, and grasses. This meant that the apes found it hard going thundering over hundreds of miles on their hands and feet, so they started to stand up to make it easier to move over the land. This resulted in a change in the wiring of the brain, which, over thousands of years, led to the early forms of what is now recognized as human.

The first link to understanding this chain was the discovery of Lucy. Lucy—named after the Beatles song "Lucy in the Sky with Diamonds"—is the first skeleton that could be pieced together to show how these early human forms appeared on the African plains in the post-Ice

Age world. The skeleton was found in the early 1970s in Ethiopia by paleoanthropologist Donald Johanson and is an early example of the hominid australopithecine, dating back to about 3.2 million years ago. The skeleton presents a small skull akin to that of most apes, plus evidence of a walking gait that was bipedal and upright, similar to that of humans and other hominids. This combination supports the view of human evolution that bipedalism preceded an increase in brain size.

Since Lucy was found, there have been many other astonishing discoveries in what is now called the "Cradle of Humankind" in South Africa, a Unesco World Heritage site. It gained this status after the discovery of a near-complete *Australopithecus* skeleton called Little Foot, dating to around 3.3 million years ago, by Ron Clarke in 1997. Why was Little Foot so important? Because it is almost unheard of to find fossilized hominin remains intact. The reason is that the bones are scattered across the Earth as soil sank into the ground and remains were distributed among the porous caves underneath. An intact skeleton is therefore as likely to be found as a decent record by Jedward.

More recently, archaeologists have discovered the Rising Star Cave system, where many complete bodies have been found, and scientists believe this was a burial ground. It has also led to the naming of a new form of human relative, called *Homo naledi*.

All in all, the human tree of life that falls into the catchall of the Homo species, of which we are *Homo sapiens*, has several other tributaries including *Homo erectus*, *Homo floresiensis*, *Homo habilis*, *Homo heidelbergensis*, *Homo naledi*, and *Homo neanderthalensis*.

The question then arises: if there were several forms of human, how come we are the only ones left?

Some of that may have been due to changing times. After all, there are no Mammoths or Sabre-Toothed Tigers around today, but there are several forms of their ancestors still on Earth. Yet what is interesting in the order of Hominids, according to Professor Yuval Harari, author of *Sapiens* and leading authority on the history of humankind, is that *Homo sapiens* defeated all other forms of hominid because we could work together in groups of thousands. According to his theory, all other human forms peaked in tribes of a maximum of 150 members—about the maximum size of any ape colony—because at this size of a group, too many alpha males exist and the order of the group would fall apart. One part of the group would then follow one alpha male and another part the other. Consequently, the tribe divides and goes its separate ways.

Homo sapiens developed beyond this because we could talk to each other. We could create a rich landscape of information, not just grunts and signs, and began to build stories. By building stories, we could share beliefs and, by sharing beliefs, hundreds of us could work together in tribes, not just one hundred.

The result is that when *Homo sapiens* villages were attacked by other Homo forms, we could repel them easily. We could also, in return, attack those human forms and annihilate them. And we did. Neanderthals, who share about 99.5 percent of our DNA, died out 40,000 years ago and were the last Homo variation to survive. After that, it was just us human beings, or *Homo sapiens* if you prefer.

Now why is this important as a background to the five ages of man?

Because this was the first age. This was the age of enlightenment. It was the age of Gods. It was an age of worshiping the Moon and the Sun, the Earth and the Seas, Fire and Wind. The natural resources of Earth were seen as important symbols with the birds of the sky, the big cats of the Earth, and the snakes of the Earth below seen as key symbols for early humankind.

We shared these stories and beliefs and, by doing so, could work together and build civilizations. One of the oldest surviving religions of the world is Hinduism, around three thousand years old, but there were other religions before Hinduism in Jericho, Mesopotamia, and Egypt. The Sun God and the Moon God were fundamental shared beliefs, and these shared beliefs were important because they maintained order. We could work together in larger and larger groups thanks to these shared beliefs.

This is why a lot of Old Testament stories in the Bible have much in common with those of the Koran. Jews, Christians, and Muslims all share beliefs in the stories of Adam and Eve, Moses, Sodom and Gomorrah, and Noah, and some of these beliefs even originate from the ancient Hindu beliefs of the world.

Shared beliefs is the core thing that brings humans together and binds them. It is what allows us to work together and get on with each other, or not, as the case may be. The fundamental difference in our shared beliefs, for example, is what drives Daesh today and creates the fundamentalism of Islam, something that many Muslims do not believe in at all.

I will return to this theme since the creation of banking and money is all about a shared belief that these things are important and have value. Without that shared belief, banking, money, governments, and religions would have no power. They would be meaningless.

So man became civilized and dominant by being able to work in groups of hundreds. This was unique to *Homo sapiens* form of communication, as it allowed us to create shared beliefs in the Sun, Moon, Earth, and, over time, Gods, Saints, and Priests.

Eventually, as shared beliefs united us, they joined us together in having leaders. This is a key differential between humans and monkeys. For example, the anthropologist Desmond Morris was asked whether apes believe in God, and he emphatically responded no. Morris, an atheist, wrote a seminal book in the 1960s called *The Naked Ape*, where he states that humans, unlike apes, "believe in an afterlife because part of the reward obtained from our creative works is the feeling that, through them, we will 'live on' after we are dead."

This is part of our shared belief structure that enables us to work together, live together, and bond together in our hundreds and thousands. Hence, religion became a key part of mankind's essence of order and structure, and our leaders were those closest to our beliefs: the priests in the temples. As man settled into communities and began to have an organized structure however, it led to new issues. Historically, man had been nomadic, searching the land for food and moving from place to place across the seasons to eat and forage. Where we were deficient in our stores of food, or where other communities had better things, we created a barter system to exchange values with each other.

You have pineapples, I have maize; let's swap.

You have bright colored beads, I have strong stone and flint; let's trade.

The barter trade worked well, and allowed different communities to prosper and survive.

Eventually, we saw large cities form. Some claim the oldest surviving city in the world is Jericho, dating back over 10,000 years. Others would point to Eridu, a city formed in ancient Mesopotamia—near Basra in Iraq—7,500 years ago. Either way, both cities are extremely old.

As these cities formed, thousands of people gathered and settled in them because they could support complex, civilized life.

Using Eridu as the focal point, the city was formed because it drew together three ancient civilizations: the Samarra culture from the north; the Sumerian culture, which formed the oldest civilization in the world; and the Semitic culture, which had historically been nomadic with herds of sheep and goats; and it was the Sumerians who invented money.

Money: a new shared belief structure that was created by the religious leaders to maintain control.

In Ancient Sumer, the Sumerians invented money because the barter system broke down. It broke down because of humankind settling into larger groups and farming. The farming and settlement structures introduced a revolution in how humankind operated. Before, people foraged and hunted; now they settled, and farmed together.

Farming resulted in abundance and abundance resulted in the trading system breaking down. Barter does not work when everyone has pineapples and maize. You cannot trade something that someone already has. So there was a need for a new system and the leaders of the time—the government if you prefer—invented it. They invented money. Money is the control mechanism of societies and economies. Countries that have money have respected economies; countries that do not, do not.

Sumerian tablets for accounting, with cuneiform writing (c. 3,000–2,000 BC).

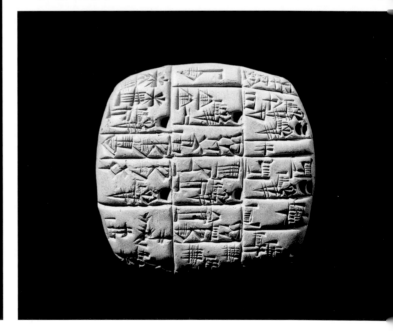

The Past, Present, and Future of Money, Banking, and Finance Chris Skinner

How can America and Britain have trillions of dollars of debt, but still be Triple-A rated? Because they have good money flows linked to their economies as global financial centers, binding our shared belief structures together.

As Professor Yuval Noah Harari puts it:

> The truly unique trait of [Homo] Sapiens is our ability to create and believe fiction. All other animals use their communication system to describe reality. We use our communication system to create new realities. Of course not all fictions are shared by all humans, but at least one has become universal in our world, and this is money. Dollar bills have absolutely no value except in our collective imagination, but everybody believes in the dollar bill.

So how did the priests invent this shared belief and make it viable?

Sex.

There were two Gods in Ancient Sumer: Baal, the god of war and the elements, and Ishtar, the goddess of fertility. Ishtar made the land and crops fertile, as well as providing pleasure and love:

> Praise Ishtar, the most awesome of the Goddesses,
> Revere the queen of women, the greatest of the deities.
> She is clothed with pleasure and love.
> She is laden with vitality, charm, and voluptuousness.
> In lips she is sweet; life is in her mouth.
> At her appearance rejoicing becomes full.

This was the key to the Sumerian culture: creating money so that the men could enjoy pleasure with Ishtar. Men would come to the temple and offer their abundant crops to the priests. The priests would place the crops in store for harder times—an insurance against winter when food is short and against crop failure in seasons of blight and drought. In return for their abundance of goods, the priests would give the famers money. A shared belief in a new form of value: a coin.

What could you do with this coin?

Have sex of course. The Greek historian Herodotus wrote about how this worked:

> Every woman of the land once in her life [is compelled] to sit in the temple of love and have intercourse with some stranger [...] the men pass and make their choice. [...] It matters not what be the sum of the money; the woman will never refuse, for that were a sin, the money being by this act made sacred. [...] After their intercourse she has made herself holy in the goddess's sight and goes away to her home; and thereafter there is no bribe however great that will get her. So then the women that are fair and tall are soon free to depart, but the uncomely have long to wait because they cannot fulfill the law; for some of them remain for three years, or four.

So money was sacred and every woman had to accept that she would prostitute herself for money at least once in her life. This is why Ishtar was also known by other names such as Har and Hora, from which the words harlot and whore originate.

It is why prostitution is the oldest profession in the world and accountancy the second oldest. Money was created to support religion and governments by developing a new shared belief structure that allowed society to overproduce goods and crops, and still get on with each other after barter broke down.

THE THIRD AGE: THE INDUSTRIAL REVOLUTION

The use of money as a means of value exchange, alongside barter, lasted for hundreds of years or, to be more exact, about 4,700 years. During this time, beads, tokens, silver, gold, and other commodities were used as money, as well as melted iron and other materials. Perhaps the strangest money is that of the Yap Islands in the Pacific that use stone as money.

This last example is a favorite illustration of how value exchange works for bitcoin libertarians, who use the stone ledger exchange systems of the Yap Islands to illustrate how you can then translate this to digital exchange on the blockchain, as it is just a ledger of debits and credits.

The trouble is that stone, gold, and silver is pretty heavy as a medium of exchange. Hence, as the Industrial Revolution powered full steam ahead, a new form of value exchange was needed.

In this context, I use the term "full steam ahead" as a key metaphor, as the timing of the Industrial Revolution is pretty much aligned with steam power. Steam power was first patented in 1606, when Jerónimo de Ayanz y Beaumont received a patent for a device that could pump water out of mines. The last steam patent dates to 1933, when George and William Besler patented a steam-powered airplane.

The steam age created lots of new innovations, but the one that transformed the world was the invention of the steam engine. This led to railways and transport from coast to coast and continent to continent. Moving from horse power to steam power allowed ships to steam across oceans and trains across countries. It led to factories that could be heated and powered, and to a whole range of transformational moments culminating in the end of the nineteenth-century innovations of electricity and telecommunications. The move from steam to electricity moved us away from heavy-duty machinery to far lighter and easier communication and power structures. Hence, the Industrial Revolution ended when we moved from factories to offices but, between 1606 and 1933, there were massive changes afoot in the world of commerce and trade.

Within this movement of trade, it was realized that a better form of value exchange was needed, as carrying large vaults of gold bullion around was not only heavy but easily open to attack and theft. Something new was needed. There had already been several innovations in the world—the Medici bankers created trade finance and the Chinese had already been using paper money since the ninth century—but these innovations did not go mainstream until the Industrial Revolution demanded it. And this Revolution did demand a new form of value exchange.

Hence, the governments of the world started to mandate and license banks to enable economic exchange. These banks appeared from the 1600s, and were organized as

"Money is like a sixth sense without which you cannot make a complete use of the other five."

WILLIAM SOMERSET
MAUGHAM (1874–1966)
British writer.

Late nineteenth-century Liberty
silver dollars from the United States.

government-backed entities that could be trusted to store value on behalf of depositors. It is for this reason that banks are the oldest registered companies in most economies. The oldest surviving British financial institution is Hoares Bank, created by Richard Hoare in 1672. The oldest British bank of size is Barclays Bank, first listed in 1690. Most UK banks are over two hundred years old, which is unusual as, according to a survey by the Bank of Korea, there are only 5,586 companies older than two hundred years with most of them in Japan.

Banks and insurance companies have survived so long as large entities—it is notable that they are large and still around after two to three hundred years—because they are government instruments of trade. They are backed and licensed by governments to act as financial oil in the economy, and the major innovation that took place was the creation of paper money, backed by government, as the means of exchange.

Paper bank notes and paper checks were created as part of this new ecosystem, to make it easier to allow industry to operate. At the time, this idea must have seemed most surprising. A piece of paper instead of gold as payment? But it was not so outrageous.

Perhaps this excerpt from the Committee of Scottish Bankers provides a useful insight as to why this idea took root:

> The first Scottish bank to issue banknotes was Bank of Scotland. When the bank was founded on 17th July 1695, through an Act of the Scottish Parliament, Scots coinage was in short supply and of uncertain value compared with the English, Dutch, Flemish or French coin, which were preferred by the majority of Scots. The growth of trade was severely hampered by this lack of an adequate currency and the merchants of the day, seeking a more convenient way of settling accounts, were among the strongest supporters of an alternative.
>
> Bank of Scotland was granted a monopoly over banking within Scotland for twenty-one years. Immediately after opening in 1695 the Bank expanded on the coinage system by introducing paper currency.

This idea was first viewed with some suspicion. However, once it became apparent that the Bank could honor its "promise to pay," and that paper was more convenient than coin, acceptance spread rapidly and the circulation of notes increased. As this spread from the merchants to the rest of the population, Scotland became one of the first countries to use a paper currency from choice.

And the check book? The UK's Cheque & Credit Clearing Company provides a useful history:

> By the seventeenth century, bills of exchange were being used for domestic payments as well as international trades. Cheques, a type of bill of exchange, then began to evolve. They were initially known as 'drawn notes' as they enabled a customer to draw on the funds they held on account with their banker and required immediate payment […] the Bank of England pioneered the use of printed forms, the first of which were produced in 1717 at Grocers' Hall, London. The customer had to attend

the Bank of England in person and obtain a numbered form from the cashier. Once completed, the form had to be authorized by the cashier before being taken to a teller for payment. These forms were printed on 'cheque' paper to prevent fraud. Only customers with a credit balance could get the special paper and the printed forms served as a check that the drawer was a bona fide customer of the Bank of England.

In other words, the late seventeenth century saw three major innovations appear at the same time: governments giving banks licenses to issue bank notes and drawn notes; checks, to allow paper to replace coins; and valued commodities.

The banking system then fuelled the Industrial Revolution, not only enabling easy trading of value exchange through these paper-based systems, but also to allow trade and structure finance through systems that are similar to those we still have today.

The oldest Stock Exchange in Amsterdam was launched in 1602 and an explosion of banks appeared in the centuries that followed to enable trade, supporting businesses and governments in creating healthy, growing economies. A role they are still meant to fulfill today.

During this time, paper money and structured investment products appeared, and large-scale international corporations began to develop, thanks to the rise of large-scale manufacturing and global connections.

So the Industrial Revolution saw an evolution of development, from the origins of money that was enforced by our shared belief systems, to the creation of trust in a new system: paper.

The key to the paper notes and paper check systems is that they hold a promise to pay which we believe will be honored. A bank note promises to pay the bearer on behalf wof the nation's bank and is often signed by that country's bank treasurer.

A check is often reflective of society of the time, and shows how interlinked these value exchange systems were with the industrial age.

In summary, we witness three huge changes in society over the past millennia of mankind: the creation of civilization based upon shared beliefs; the creation of money based upon those shared beliefs; and the evolution of money from belief to economy, when governments backed banks with paper.

THE FOURTH AGE OF MAN: THE NETWORK AGE

The reason for talking about the history of money in depth is as a backdrop to what is happening today. Money originated as a control mechanism for governments of Ancient Sumer to control farmers, based upon shared beliefs. It was then structured during the Industrial Revolution into government-backed institutions—banks—which could issue paper notes and checks that would be as acceptable as gold or coinage, based upon these shared beliefs. We share a belief in banks because governments say they can be trusted, and governments use the banks as a control mechanism that manages the economy.

So now we come to bitcoin and the Internet age, and some of these fundamentals are being challenged by the Internet. Let us take a step back and see how the Internet age came around.

Some might claim it dates back to Alan Turing, the Enigma machine, and the Turing test, or even further back to the 1930s when the Polish Cipher Bureau were the first to decode German military texts on the Enigma machine. Enigma was certainly the machine that led to the invention of modern computing, as British cryptographers created a programmable, electronic, digital, computer called Colossus to crack the codes held in the German messages.

Colossus was designed by the engineer Tommy Flowers, not Alan Turing—he designed a different machine—and was operational at Bletchley Park from February 1944, two years before the American computer ENIAC appeared. ENIAC, short for Electronic Numerical Integrator and Computer, was the first electronic general-purpose computer. It had been designed by the US Military for meteorological purposes—weather forecasting—and delivered in 1946.

When ENIAC launched, the media called it "the Giant Brain," with a speed a thousand times faster than any electromechanical machines of its time. ENIAC weighted over 30 tons and took up 167.4 square meters (1800 square feet) of space. It could process about 385 instructions per second.

Compare that with an iPhone6 that can process around 3.5 billion instructions per second, and this was rudimentary technology, but we are talking about seventy years ago, and Moore's Law had not even kicked in yet.

The key is that Colossus and ENIAC laid the groundwork for all modern computing, and became a boom industry in the 1950s. You may think that surprising when, back in 1943, the then President of IBM, Thomas Watson, predicted that there would be a worldwide market for maybe five computers. Bearing in mind the size and weight of these darned machines, you could see why he thought that way but my, how things have changed today.

However, we are still in the early days of the network revolution and I am not going to linger over the history of computers here. The reason for talking about ENIAC and Colossus was more to put our current state of change in perspective. We are seventy years into the transformations that computing is giving to our world.

Considering it was 330 years from the emergence of steam power to the last steam-power patent, that implies there is a long way to go in our transformation.

Let us first consider the fourth age in more depth as the key difference between this age and those that have gone before is the collapse of time and space. Einstein would have a giggle, but it is the case today that we are no longer separated by time and space as we were before. Distance is collapsing every day, and it is through our global connectivity that this is the case.

We can talk, socialize, communicate, and trade globally, in real time, for almost free. I can make a Skype call for almost no cost to anyone on the planet and, thanks to the rapidly diminishing costs of technology, there are $1 phones out there today, while the cheapest smartphone in the world is probably the Freedom 251. This is an Android phone with a 10.16-centimeter (4-inch) screen that costs just 251 rupees in India, around $3.75. In other words, what is happening in our revolution is that we can provide a computer that is far more powerful than anything before, and put it in the hands of everyone on the planet so that everyone on the planet is on the network.

Once on the network, you have the network effect, which creates exponential possibilities, since everyone can now trade, transact, talk, and target one-to-one, peer-to-peer.

This is why I think of the network as the fourth age of man and money, as we went from disparate, nomadic communities in the first age; to one that could settle and farm in the second; to one that could travel across countries and continents in the third; to one that is connected globally, one-to-one. This is a transformation and shows that man is moving from single tribes to communities to connected communities to a single platform: the Internet.

The importance of this is that each of these changes has seen a rethinking of how we do commerce, trade, and therefore finance. Our shared belief system allowed barter

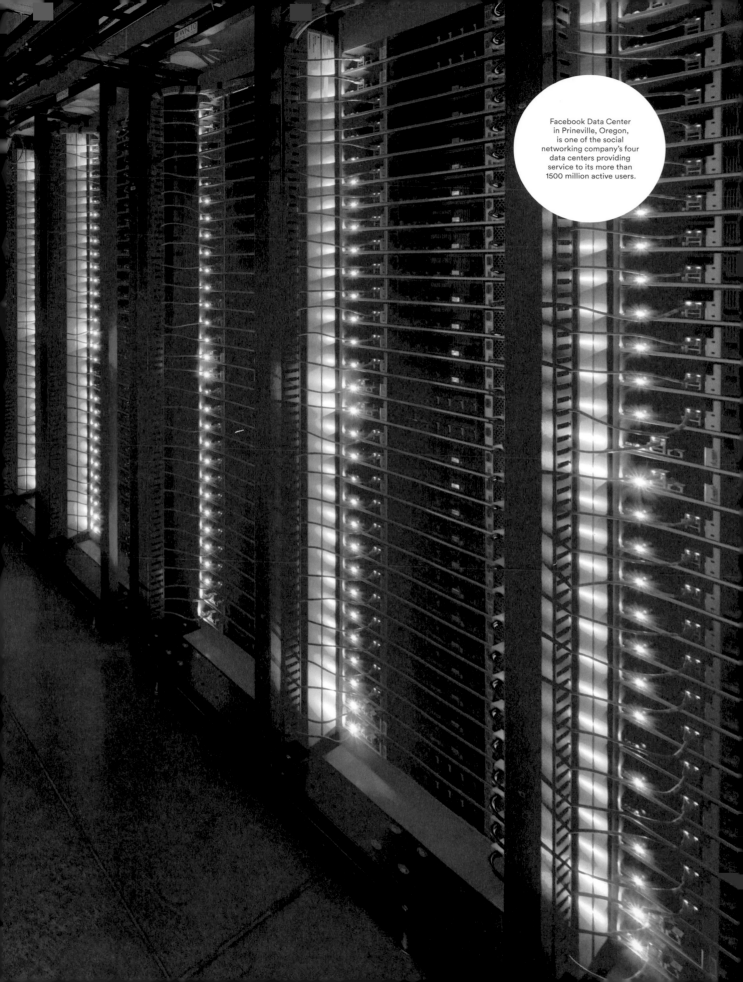

Facebook Data Center in Prineville, Oregon, is one of the social networking company's four data centers providing service to its more than 1500 million active users.

to work until abundance undermined bartering, and so we created money; our monetary system was based upon coinage, which was unworkable in a rapidly expanding industrial age, and so we created banking to issue paper money. Now, we are in the fourth age, and banking is no longer working as it should. Banks are domestic, but the network is global; banks are structured around paper, but the network is structured around data; banks distribute through buildings and humans, but the network distributes through software and servers.

This is why so much excitement is hitting mainstream as we are now at the cusp of the change from money and banking to something else. However, in each previous age, the something else has not replaced what was there before. It has added to it.

Money did not replace bartering; it diminished it. Banking did not replace money; it diminished it. Something in the network age is not going to replace banking, but it will diminish it. By diminish, we also need to put that in context.

Diminish. Barter is still at the highest levels it has ever been—about 15 percent of world trade is in a bartering form—but it is small compared to the monetary flows. Money in its physical form is also trading at the highest levels it has ever seen—cash usage is still rising in most economies—but it is not high compared to the alternative forms of monetary flow digitally, and in FX markets and exchanges. In other words, the historical systems of value exchange are still massive, but they are becoming a smaller percentage of trade compared with the newest structure we have implemented to allow value to flow.

This is why I am particularly excited about what the network age will do, as we connect one-to-one in real time, since it will create massive new flows of trade for markets that were underserved or overlooked. Just look at Africa. African mobile subscribers take to mobile wallets like ducks to water. A quarter of all Africans who have a mobile phone have a mobile wallet, rising to pretty much every citizen in more economically vibrant communities like Kenya, Uganda, and Nigeria. This is because these citizens never had access to a network before; they had no value exchange mechanism, except a physical one that was open to fraud and crime. Africa is leapfrogging other markets by delivering mobile financial inclusion almost overnight.

The same is true in China, India, Indonesian, the Philippines, Brazil, and many other underserved markets. So the first massive change in the network effect of financial inclusion is that the five billion people who previously had zero access to digital services are now on the network.

A second big change then is the nature of digital currencies, cryptocurrencies, bitcoin, and shared ledgers. This is the part that is building the new rails and pipes for the fourth generation of finance, and we are yet to see how this rebuilding works out. Will all the banks be based on an R3 blockchain? Will all clearing and settlement be via Hyperledger? What role will bitcoin play in the new financial ecosystem?

We do not know the answers to these questions yet, but what we will see is a new ecosystem that diminishes the role of historical banks, and the challenge for historical banks is whether they can rise to the challenge of the new system.

The Fourth Age of Moneykind is a digital networked value structure that is real time, global, connected, digital, and near free. It is based upon everything being connected from the seven billion humans communicating and trading in real time globally to their billions of machines and devices, which all have intelligence inside. This new structure obviously cannot work on a system built for paper with buildings and humans, and is most likely to be a new layer on top of that old structure.

A new layer of digital inclusion that overcomes the deficiencies of the old structure. A new layer that will see billions of transactions and value transferred at light speed in tiny amounts. In other words, the fourth age is an age where everything can transfer value, immediately and for an amount that starts at a billionth of a dollar if necessary.

This new layer for the fourth age is therefore nothing like what we have seen before and, for what was there before, it will supplement the old system and diminish it. Give it half a century and we will probably look back at banking today as we currently look back at cash and barter. They are old methods of transacting for the previous ages of man and moneykind.

This fourth age is digitizing value, and banks, cash, and barter will still be around but will be a much less important part of the new value ecosystem. They may still be processing volumes greater than ever before, but in the context of the total system of value exchange and trade, their role is less important.

In conclusion, I do not expect banks to disappear, but I do expect a new system to evolve that may include some banks but will also include new operators who are truly digital. Maybe it will be Google's, Baidu's, Alibaba's, and Facebook's; or maybe it will be Prosper's, Lending Club's, Zopa's, and SoFi's. We do not know the answer yet and if I were a betting man, I would say it will be a hybrid mix of all, as all evolve to the Fourth Age of Moneykind.

The hybrid system is one where banks are part of a new value system that incorporates digital currencies, financial inclusion, micropayments, and peer-to-peer exchange, because that is what the networked age needs. It needs the ability for everything with a chip inside to transact in real time for near free. We are not there yet but, as I said, this revolution is in its early days. It is just seventy years old. The last revolution took 330 years to play out. Give this one another few decades and then we will know exactly what we built.

Having covered four ages of moneykind—barter, coins, paper, chips—what could possibly be the fifth?

When we are just at the start of the Internet of Things (IoT), and are building an Internet of Value (*ValueWeb*), how can we imagine something beyond this next ten-year cycle?

Well we can and we must, as there are people already imagining a future beyond today. People like Elon Musk, who see colonizing Mars and supersmart high-speed transport as a realizable vision. People like the engineers at Shimzu Corporation, who imagine building city structures in the oceans. People like the guys at NASA, who are launching space probes capable of sending us HD photographs of Pluto when, just a hundred years ago, we only just imagined it existed.

A century ago, Einstein proposed a space-time continuum that a century later has been proven. What will we be discovering, proving, and doing a century from now?

No one knows, and most predictions are terribly wrong. A century ago they were predicting lots of ideas, but the computer had not been imagined, so the network revolution was unimaginable. A century before this, Victorians believed the answer to the challenge of clearing horse manure from the streets was to have steam-powered horses, as the idea of the car had not been imagined. So who knows what we will be doing a century from now.

2116. What will the world of 2116 look like?

Well there are some clues. We know that we have imagined robots for decades, and robots must surely be pervasive and ubiquitous by 2116 as even IBM are demonstrating such things today. A century from now we know we will be travelling through space, as the Wright Brothers invented air travel a century ago and look at what we can do today.

Emirates now offer the world's longest nonstop flight with a trip from Auckland to Dubai lasting 17 hours and 15 minutes. We are already allowing reusable transport vehicles to reach the stars and, a century from now, we will be beyond the stars I hope.

Probably the largest and most forecastable change is that we will be living longer. Several scientists believe that most humans will live a century or more, with some even forecasting that a child has already been born who will live for 150 years.

A child has been born who will live until 2166. What will they see?

And we will live so long because a little bit of the machine will be inside the human and a little bit of the human will be inside the machine. The Robocop is already here, with hydraulic prosthetics linked to our brainwaves able to create the bionic human. Equally, the cyborg will be arriving within thirty-five years according to one leading futurist. Add to this smorgasbord of life extending capabilities from nano-bots to leaving our persona on the network after we die, and the world is a place of magic become real.

We have smart cars, smart homes, smart systems and smart lives. Just look at this design for a window that becomes a balcony and you can see that the future is now.

Self-driving cars, biotechnologies, smart networking, and more will bring all the ideas of *Minority Report* and *Star Trek* to a science that is no longer fiction, but reality.

It might even be possible to continually monitor brain activity and alert health experts or the security services before an aggressive attack, such as in Philip K. Dick's dystopian novella *Minority Report*.

So, in this fifth age of man where man and machine create superhumans, what will the value exchange system be?

Well it will not be money and probably will not even be transactions of data, but some other structure. I have alluded to this other structure many times already as it is quite clear that, in the future, money disappears. You never see Luke Skywalker or Captain Kirk pay for anything in the future, and that is because money has lost its meaning.

Money is no longer a meaningful system in the fifth age of man. Having digitalized money in the fourth age, it just became a universal credit and debit system. Digits on the network recording our taking and giving; our living and earning; our work and pleasure.

After robots take over so many jobs, and man colonizes space, do we really think man will focus upon wealth management and value creation, or will we move beyond such things to philanthropic matters. This is the dream of Gene Rodenberry and other space visionaries, and maybe it could just come true. After all, when you become a multibillionaire, your wealth becomes meaningless. This is why Bill Gates, Warren Buffet, and Mark Zuckerberg start to focus upon philanthropic structures when money and wealth become meaningless.

So could the fifth age of man—the man who lives for centuries in space—be one where we forget about banking, money, and wealth, and focus upon the good of the planet and mankind in general? If everyone is in the network and everyone has a voice, and the power of the one voice can be as powerful as the many, do we move beyond self-interest?

I have no idea, but it makes for interesting questions around how and what we value when we become superhumans thanks to life extending and body engineering technologies; when we move beyond Earth to other planets; and when we reach a stage where our every physical and mental need can be satisfied by a robot.

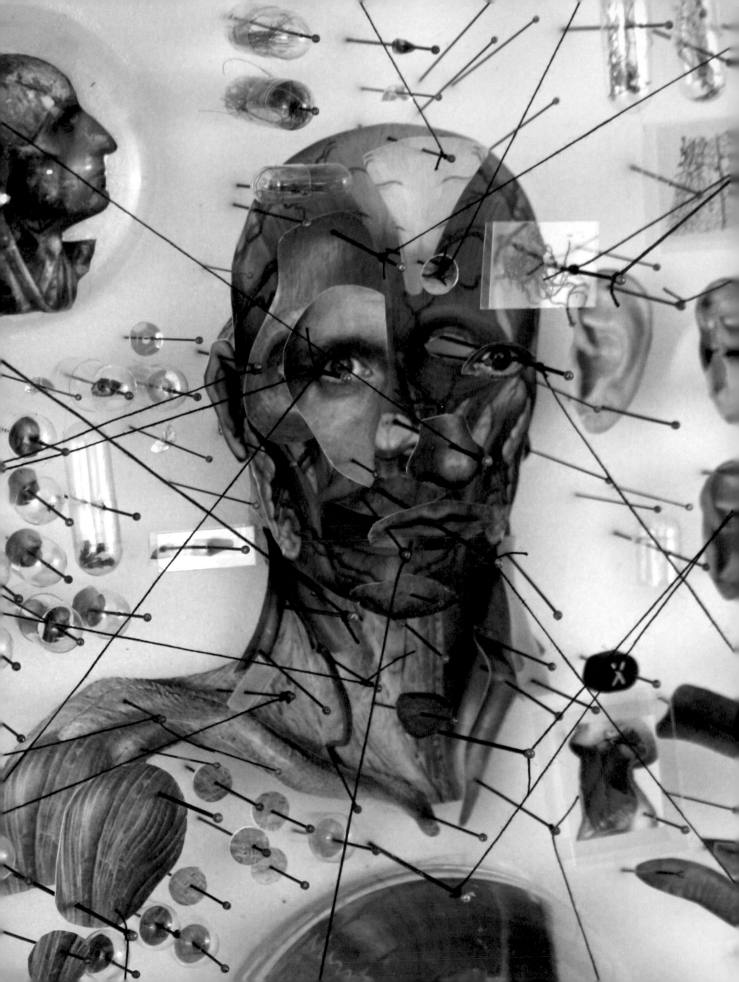

Large-Scale Whole-Genome Sequencing Efforts

STEVEN MONROE LIPKIN

Opening image:
Michael Mapes
Specimen No. 41 (detail) (2007)
Photographic prints, various printed matter,
entomology pins, poster board, test tubes,
magnifying glasses, gelatin capsules, petri
dish, hair, plastic bags, cotton thread,
rubber bands, resins, modelling clay
48 × 64 × 8 cm.

Steven Monroe Lipkin
Weill Cornell Medicine, Cornell University, New York City, USA

Dr. Steven Monroe Lipkin holds the Gladys and Roland Harriman Chair
of Medicine and is Director of the Adult and Cancer Genetics Clinic at
Weill-Cornell Medicine and New York Presbyterian Hospital in New York
City. He is a physician-scientist who sees patients and studies genes that
confer increased risk of different cancers and autoimmune diseases. He
is a Fellow of the American College of Medical Genetics and a member
of the American Society of Clinical Investigation.

Whole-genome sequencing has now become mainstream for diagnosing rare disorders and cancer therapy targets. As the costs have declined the trend is moving toward using it in broader groups of people. Even for people without a strong personal or family history of any disease, screening the seventy-six genes—held by expert medical consensus to influence clinical management—will identify about one in twenty who carry a mutation in a gene that will influence their medical care. However, people who pursue genetic testing may want to obtain life, disability, and/or long-term care insurance prior in order to reduce their premium payments.

At the age of twenty-seven, Ansel K. Paulson was a happy, healthy, and successful young man living and working in Manhattan, working at a financial company that managed mutual and hedge-fund back-office operations. Full of energy, as his hobby he was an amateur, nightclub, stand-up comic and also belonged to an improvisational comedy troupe performing in a Hells' Kitchen nightclub. Ansel K. had a serious girlfriend and was considering settling down, getting married, and starting a family, at least in the next few years. As a healthy young guy in his twenties enjoying himself, Ansel K. did not go to the doctor very much. In fact, he did not have a primary care doctor following him and I was the first doctor he had seen in about six years.

His first questions to me one rainy day during his first visit to the Weill-Cornell Medicine and New York Presbyterian Hospital Adult Genetics clinic in New York City were: "Am I going to need a $400,000-a-year medicine for the rest of my life, and am I going to lose my insurance?"

Ansel's family was also generally healthy and fortunately for him he did not have a very notable family history of serious medical problems. However, several months earlier, Ansel's mother, curious about her family's genetic ancestry and someone who enjoyed reading *Scientific American*, the "Science Times" section of *The New York Times*, and the "Nova" television series about many of the exciting new developments in genetic medicine, had ordered through the mail a $199 DNA test on her saliva from the company 23andMe.

Of the three billion or so bases of DNA in a person's genome, 23andMe analyzes a curated selection of about a million that have been associated with an array of information regarding a person's ancestry and, up until the United States Food and Drug Administration limited their testing several years ago, genetic variants associated with a wide range of genetic diseases. 23andMe has tested DNA from more than a million people, and currently has contract

collaborations with drug companies such as Roche, Genentech, and Pfizer to discover new pharmaceutical targets for new genetic diseases.

Ansel's mother's test results revealed that she carried a genetic mutation that had previously been identified in dozens of people that caused a well-studied and concerning malady for which there are several effective (although expensive) therapies: Gaucher disease. Gaucher disease is caused by mutations in the GBA gene. In Gaucher disease mutation carriers, there is a buildup of a particular type of fatty cell debris whose proper scientific name is glucosylceramide.

In Gaucher disease patients, the spleen can swell up to ten times its normal size. Depending on the particular patient and mutation, Gaucher disease can also cause enlargement of the liver, anemia, the blood cancer multiple myeloma, and the neurodegenerative condition Parkinson's disease, among others. However, Ansel's mother apparently had not read the textbooks. She was in her late fifties, but she had not had any clear medical problems linked to her disease, even though other Gaucher disease carriers with the same mutation clearly do and develop severely morbid medical problems. Gaucher disease is treated by drugs that replace the protein produced by the defective GBA gene; in the United States this can cost more than $400,000 each year. Yet, curiously, neither Ansel's mother nor Ansel appeared to have any symptoms of Gaucher disease and its sequelae.

In part, this curious situation reflects a common scenario for most genetic diseases. When they are originally identified, researchers focus on studying the most severely affected patients in order to be sure that they have correctly defined the symptoms associated with a particular gene. Then, with time, as more people are tested for mutations in the gene, it turns out (most often) that some people can have the gene mutation but have less severe symptoms, or perhaps not even develop the disease symptoms at all. In general, for most genetic conditions, carrying a particular mutation statistically increases the probability risk of developing the disease, but does not mean a person is destined to suffer or die from that disease. Other factors are at play.

How can this be? In 1624, before we ever knew about DNA or genes, the English poet John Donne wrote: "No man is an island." The same is often true for genes and gene mutations, and is why today we are entering the era of population genomics. There are a large number of other factors that can influence whether a gene

mutation in fact causes a person to develop severe enough disease to bring them out of their blissful state of being healthy and into the medical system as a patient with a diagnosis. These factors are often called *disease modifiers*. Disease modifiers can be environmental exposures (for example, the amount of sugar in the diet in individuals predisposed to become diabetic, or the level of daily exercise that influences weight) or include variants in genes that modify the impact of other genes, called gene-gene interactions.

Thus, for example, it is possible that Ansel K.'s family carries other genetic mutations that ameliorate the symptoms of Gaucher disease in people with their particular GBA mutation, and which could in principle lead to new drug targets to treat the disease that are better than the existing (quite costly) medications. While we know there are many disease modifiers, the critical issue for a patient's treating physician is whether, for a given disorder, there are any individual modifiers that have large-effect size and are potentially actionable.

The number of variables that can possibly modify genetic mutations is extremely large, in terms of genetic modifiers easily reaching into the millions. In combination with the rapid decline in the cost of DNA sequencing, the interest to determine which diseases have a genetic component, the strong incentive to identify and develop targets for drugs and also the genetic and environmental modifiers of disease have driven efforts in Europe, the United States, and Asia to sequence the whole genomes of hundreds to thousands to now millions of people, and this has taken several forms.

Many people ask why we need to do so much DNA sequencing. Don't we already have a good understanding of genetics in human beings? One of the great surprises from the Human Genome Project, which completed the first human genome in 2002, was that there were only about 20,000 genes—about as many genes as are in mealworms, fruit flies, or mice. That is the basic blueprint for life. What is particularly notable are the genetic differences between different species of animals, and now the focus has honed in to the genetic differences between each individual. In order to understand the role of individual mutations, we now recognize that we must understand the context. This includes both the other genetic variants inherited with a mutation, and, just as importantly, in order to make sense of all the information, to know as much as possible about the details of the medical and seemingly nonmedical life data of the person who carries these mutations. The specific information needed includes details to annotate the genomes including what their symptoms are, at what age they first started, other information such as blood pressure, height and weight, previous illnesses, medications, vaccinations, and the like.

Finding the specific causes of genetic diseases and what modifies their impact on keeping a person well or ill has significant implications. Most importantly, for public health, this information allows us to prevent diseases, or at least to catch them early, so that we can reduce the large burden of human suffering from disease. Equally important, studying all these genomes and the associated information about the lives of these patients will reveal new targets for the pharmaceutical industry to develop drugs for disease prevention to keep human beings healthier longer into their senior years. This latter point has significant commercial, as well as scientific and medical, value, and in part has driven several national efforts to sequence the genomes of hundreds of thousands to millions of people. Thus, the race is on to identify gene modifiers and combinations of genetic mutations that cause disease, sequencing millions of people to find those combinations that will serve as the foundation for the medicine of the next century.

At present, the project farthest along is in the United Kingdom. In part inspired by the 2012 Olympic Games in London that highlighted to the then British Prime Minister David Cameron that great athletic feats could be accomplished by exceptional individuals endowed with the right genetic traits and a strong drive to excel and compete, the 100,000 genomes project was initiated. A company was formed, Genomics England.

Genomics England is wholly owned and funded by the UK Department of Health with the goal of sequencing 100,000 whole genomes from its National Health Service patients by the end of 2017. Its primary missions are to bring benefit to patients, set up a genomic medicine infrastructure for the National Health Service, enable new scientific discoveries and medical insights, and accelerate the development of the UK genomics industry.

Patients donate their samples, medical, and lifestyle information after signing informed consent that permits their DNA and information to be used. These are more substantial although similar to consents that are used before a patient can have surgery performed on their body, or chemotherapy given for cancer. Or, perhaps another example is the consent that individuals who use Facebook or the Apple iPhone operating system; this allows these companies to use the data a person collects in their accounts, and allows the company to profit off it by targeting advertising to an individual or selling aggregated customer data to third-party marketing companies. The great majority of individuals in general consider the benefits of using these services, often provided at little or no cost, to far outweigh the risks of losing control of one's privacy.

These informed consents have been approved by an independent UK National Health Service ethics committee. The consent includes statements explicitly asking if patients are willing for commercial companies to be able to conduct approved research on their genomes and data. Many patients are, indeed, eager to see their genetic, medical, and lifestyle data used to help further research progress into the specific conditions that affect them, a consummate use of crowdsourcing.

Genomics England will also charge for its data services to ensure that the costs to UK taxpayers for maintaining the data are kept reasonably low. Potential users will include pharmaceutical companies, but may, in fact, also include academic researchers and physicians in the United States and Europe. For example, an individual in Germany with a particular genetic mutation, or their physician, may have to pay a fee to access data

regarding the symptoms and morbidities of other people who carry the same "one in a million" genetic variant. At this point in time precise details remain to be determined.

Inspired by the same excitement as Genomics England, there are several other sizable initiatives to sequence large numbers of citizens. These include collaborations such as those between the American health maintenance organization Geisinger Health System in Pennsylvania with the Regeneron Pharmaceutical Corporation to sequence the exomes (the ~1.5% of the genome that encodes all the DNA made into proteins, and the part of the human genome that is thought to be the most important for disease) of 50,000–100,000 enrollees. Another project is the private start-up Human Longevity, Inc., which was founded by Craig Venter—who previously commercially sequenced a large portion of the original human genome in 2003—to sequence 100,000 or more patients from the University of California, San Diego Health System, health maintenance organizations in South Africa, and those participating in clinical trials run by Roche and Astra-Zeneca. In China, Germany, the Netherlands, Israel, Saudi Arabia, Estonia, and Qatar there are similar large-scale sequencing initiatives involving tens to hundreds of thousands of people.

The current leader, Genomics England, includes both adults and children, but is more focused on diseases of adults. In 2013, the United States National Institutes of Health initiated an exciting new $25-million pilot program to sequence the genomes of hundreds of babies in America, with the goals of learning more about how ethically sound, interpretable, and clinically actionable this testing could turn out to be in comparison with biochemical newborn screening tests, such as for preventable genetic conditions like galactosemia or PKU that can cause mental retardation if not caught early and treated. "One can imagine a day when every newborn will have their genome sequenced at birth, and it would become a part of the electronic health record that could be used throughout the rest of the child's life both to think about better prevention but also to be more alert to early clinical manifestations of a disease," said Alan Guttmacher, director of the National Institute of Child Health and Human Development, which funded the study. This articulates the vision to shift the balance between disease treatment, early detection, and prevention toward the latter two. For virtually all genetic diseases, patients do better when symptoms are found early and treated aggressively.

For diseases of children, recessive diseases are particularly important. We have two eyes, two ears, two kidneys, and so on, as a backup system in case something goes wrong with one. Many genes are similar. We carry two copies of each chromosome (except for the X and Y chromosomes). For most genes, if one copy is mutated, the other picks up the slack and there are no medical sequelae. For recessive diseases, these are conditions where each parent carries one mutated gene and a child by chance inherits

both mutated copies of the same gene, and consequently has no intact un-mutated gene as a backup system. There are about 4,000 or so recessive genetic diseases, which are quite rare; when you add them all up, they affect approximately two percent of the population. An important rationale for whole-genome screening of every infant at birth is that even though most of the recessive diseases are individually rare, much of this pain and suffering falls disproportionately on our most valuable and vulnerable members, our children. Thus, lifelong benefit can be gained by treating and curing a childhood disease.

MCADD is one of the diseases for which newborns are screened from biochemical analyses of drops of blood taken from their heels shortly after birth. This disorder affects about one in ten thousand births. However, parents are not screened for it genetically because it is too rare to merit the cost of biochemically screening everyone.

Anne Morris, a colleague in the world of genetics, is one mother whose family was struck by genetic lightening and who could have potentially benefitted from more global pre-conception genetic screening. Anne was one of the one-to-two percent of women in the United States and Europe who use in vitro fertilization to have children. Her son was conceived with her eggs and a sperm donor. Sperm banks typically screen donors for more common genetic diseases, such as cystic fibrosis, but not for rare recessive diseases, again because of cost.

Both Anne and her son's biological father carried a mutation in the gene ACADM, which causes the recessive disease medium-chain acyl-CoA dehydrogenase deficiency, or MCADD. ACADM is a metabolic gene that helps convert fats into sugar to provide energy for the body. Newborn babies develop low blood sugar, often after periods of being sick with infections and not drinking enough formula or breast milk. When undiagnosed, MCADD is a significant cause of infant sudden death, or seizures after a mild illness. However, diet and stress are significant disease modifiers. Consequently, many children with MCADD may remain with symptoms for long periods of time, until an illness or other stress causes them not to eat and their blood sugar gets too low. Children with MCADD can live long and full lives when they are diagnosed and are carefully followed by attentive family members and medical professionals to monitor the children's diets, catch symptoms early, and begin drug therapy.

Anne was so impressed with the benefits of genetic diagnosis that she started GenePeeks, a genetic testing company in New York and Massachusetts, which focuses on high-quality, comprehensive, genetic testing for more than six hundred pediatric diseases at a reasonable cost for prospective parents.

"Ten fingers, ten toes, that's all
that used to matter, but not now.
Now, only seconds old, the exact
time and cause of my death was
already known."

ANDREW NICCOL (1964–)
Director and screenwriter of *Gattaca* (1997).

Gattaca (1997), Andrew Niccol.

The "baby genome" study is still ongoing, but with preliminary successful results has now been expanded into a broader group of Americans, with a more than $200-million Precision Medicine Initiative Cohort Program. The US President Obama, in his State of the Union Address on January 20, 2015, announced his support of the Precision Medicine Initiative. The goal of the Precision Medicine Initiative Cohort is "to bring us closer to curing diseases like cancer and diabetes, and to give all of us access to the personalized information we need to keep ourselves and our families healthier." Similar to Genomics England, the Precision Medicine Initiative Cohort will build a large research cohort of one million or more Americans. Because the population of the United States is ethnically more diverse than the United Kingdom, an important goal is to include genetically less well-studied minority groups, such as African Americans, Hispanics, and Native Americans. Stated official goals include developing quantitative estimates of risk for a range of diseases by integrating environmental exposures, genetic mutations, and gene-environment interactions; identification of determinants of individual variation in efficacy and safety of commonly used therapeutics; and the discovery of biomarkers that identify people with increased or decreased risk of developing common diseases. Additionally, the use of mobile health technologies from smartphone and similar devices will be emphasized to collect large amounts of data on physical activity, patient location in different environments (e.g., urban vs. rural), physiological measures and environmental exposures with health outcomes; development new disease classifications and relationships; empowerment of participants with data and information to improve their own health; and the creation of a platform to identify patients to perform clinical trials of novel therapies. The Precision Medicine Initiative Cohort will commence recruiting patients in November 2016 from all geographic regions of the United States.

For all of these population genomics programs, there is great potential societal benefit worldwide. Patients can have significant diseases detected before symptoms arise or catastrophic consequences occur, such as blood-vessel rupture in persons who have connective tissue diseases. New medical diagnostic tests and drugs will be developed to diagnose and treat previously undiagnosed genetic conditions that are rationally matched to the specific underlying root biological defect rather than nonspecific later complications. There is the hope that improved knowledge of the genetics will also reduce health-care costs, enabling precision therapies instead of the one-size-fits-all treatments that are today's norm.

However, for the individuals who enroll in population genomics studies, there are potential concerns. While the specifics depend on an individual's nationality, a question frequently raised by patients in Europe and North America is whether having their genome sequenced will change the premiums that they pay for insurance. In the UK, health insurance is universal and patients do not pay premiums unless they seek out private networks with desired higher-quality services and shorter wait times. In the United States, health insurance coverage is not universal and people have to choose to enroll in specific plans. Additionally, there are other types of insurance that can be affected. In the UK, the US, and many countries in Europe, these include life insurance, critical illness (in the United States often called long-term care) insurance, and income protection (in the United States often called disability) insurance.

Most of the time, for these individuals, participating in the Genomics England 100,000 Genomes Project or Precision Medicine Initiatives, having their genomes sequenced will not

impact premiums for medical (in the US) life, critical illness, and income protection insurance (for US, UK, and many European Union countries), as for now this is a research study and there are currently no requirements for patients to tell insurers that they have results of genetic testing.

Overall, for even healthy people with no obvious personal medical or family history consistent with genetic disease (like Ansel K.), more than 4.5 percent (and with full genome sequencing this will likely be higher) will have a clearly concerning genetic mutation that will directly impact their medical care in the present tense. Thus, an estimated 5,000–7,000 people or more from this project at the very least will have a new red-letter diagnosis in their medical record in Genomics England, and 50,000–70,000 patients in the Precision Medicine Initiative.

While patients do not have to disclose their 100,000 Genomes or Precision Medicine Initiative genome-sequencing test results, participants will have to respond truthfully to questions relating to any screening or preventative treatments. So, for example, if a woman is found to have a mutation in a gene increasing risk of colorectal cancer and is having annual colonoscopy to check for cancers, this will need to be disclosed and could influence coverage decisions. It is, of course, probable that an insurer could be alerted to closely examine an individual's personal medical and family history for coverage decisions. Presumably, this could be particularly important for critical illness/long-term care and income protection/disability insurance premiums.

In the United States, in May 2008 President George W. Bush signed into law the Genetic Information Non-Discrimination Act, or GINA. The GINA law had been presented as a federal bill to Congress a full twelve years earlier, but it had previously been thwarted in different Congressional committees and sub-committees. The bill passed the US Senate 95–0 and the House of Representatives 414–1. The only nay vote was from Congressman Ron Paul, who is currently a conservative leader in the US Republican Party and a significant recipient of campaign contributions from the United States Insurance Lobby.

GINA prohibits genetic discrimination in both employment and health coverage. Specifically, insurers and employers who have more than fifteen employees are not allowed to request genetic information to be used in any of their decisions. However, small businesses are exempt because of concerns over the cost of administration. The Genetic Alliance, a not-for-profit group dedicated to the responsible use of genetic information, called the GINA law a landmark in the history of genetics in the United States and in Civil Rights law. However, GINA has some limitations. It does not protect against discrimination involving life, disability, and long-term care insurance, similar to the situation in the UK.

The situation gets complicated in that at the individual state level, there can be laws that provide additional protections above and beyond those covered by the GINA law. A good resource for people who are considering participating in the Precision Medicine Initiative, or even for those having genetic testing in general, is the Council for Responsible Genetics, which provides state level information about specific protections and laws. For example, in the State of California, there is a law called Cal-GINA. Cal-GINA provides civil legal protection against genetic discrimination in life, long-term care, and disability insurance, as well as in health insurance, employment, housing, education, mortgage lending, and elections. The states of Vermont (supported by Presidential Democratic contender Bernie Sanders) and Oregon also have strong laws that broadly prohibit genetic diagnoses being used to inform long-term care, life, and disability insurance. However, for most states there is only at present coverage by the GINA law, for example, in the State of New York, where I practice genetic medicine.

This is not a theoretical but a real-life situation, and I have patients who have been denied life insurance because of a genetic diagnosis. For example, Karen Young is one patient in my practice who has Lynch syndrome. This is a genetic cancer susceptibility disease that increases the risk for colorectal, uterine, ovarian, and other cancers and is caused by mutations in MSH2, MLH1, and other genes. Karen is in her fifties and had surgery to remove her colon, uterus, and ovaries. She has never developed any cancer and is diligent to keep up with cancer screening in order to work and take care of her family. Despite her meticulous care to stay healthy, Karen was denied life insurance, blandly because of her genetic diagnosis. The denial letter from her insurer read:

> Like all insurance companies, we have guidelines that determine when coverage can or cannot be provided. Unfortunately, after carefully reviewing your application, we regret that we are unable to provide you with coverage

because of your positive finding of a mutation in the MSH2 gene, which causes the Lynch syndrome, as noted in your medical records.

If you received any correspondence prior to this letter that you interpret as coverage, please disregard it. You do not have coverage. Also, if you have an existing policy that you were replacing, please continue paying the premiums on that policy.

In summary, the concerns of patients such as Karen or Ansel are just now beginning to be heard. The large-scale population genomics research projects in the UK, the US (both public and private), and other countries have great potential to improve our ability to diagnose and, with time, develop new effective treatments for many individuals with a wide range of genetic diseases. As DNA sequencing costs have fallen dramatically, the number of people who could benefit from whole-genome sequencing has the potential to rise dramatically.

However, what is lagging is societal legal policies in the different countries that can protect the American public from insurance concerns and genetic discrimination, whether overt or covert. Because these large-scale research projects are progressing rapidly, the United States, the United Kingdom, and other nations performing similar projects urgently need more comprehensive legal protections for people who have had genome sequencing. We are not in a position to say, "It cannot happen here," because genetic discrimination is in fact already happening around the world. Unless more comprehensive legal safeguards are put into place, there is the risk that a backlash will ensue that can limit the willingness of individuals to participate in these important scientific endeavors, to the detriment of our nations' entire populations.

Tackling Climate Change Through Human Engineering

S. MATTHEW LIAO

Opening image:
Department of Water and Power (DWP)
San Fernando Valley Generating Station,
Sun Valley, CA, USA.

S. Matthew Liao
Center for Bioethics | New York University, New York, USA

S. Matthew Liao is Arthur Zitrin Professor of Bioethics, Director of the
Center for Bioethics, and Affiliated Professor of Philosophy at New York
University. He is the author of *The Right to Be Loved* (Oxford University
Press, 2015); *Philosophical Foundations of Human Rights* (Oxford
University Press, 2015); and *Moral Brains: The Neuroscience of Morality*
(Oxford University Press, 2016). He has given TED talks in New York and
Geneva, and he has been featured in *The New York Times*, *The Atlantic*,
The Guardian, *Harper's Magazine*, *Sydney Morning Herald*, *Scientific
American*, *Newsweek*, and other media outlets.

Human-induced climate change is one of the biggest problems that we face today. Unfortunately, existing solutions such as behavioral and market solutions appear to be insufficient to mitigate the effects of climate change while geoengineering could have catastrophic consequences for us and the planet. In this paper, I propose that we explore a new kind of solution to climate change, namely, human engineering, which involves biomedical modifications of humans so that they can mitigate or adapt to climate change. I shall argue that human engineering is potentially less risky than geoengineering and that it could make behavioral and market solutions more likely to succeed.

INTRODUCTION

Human-induced climate change is one of the biggest problems that we face today. Millions could suffer hunger, water shortages, diseases, and costal flooding as a result of climate change.[1] The latest science suggests that we may be near or even beyond the point of no return.[2] The risks of the worst impacts of climate change can be lowered if the greenhouse gas levels in the atmosphere can be reduced and stabilized. To reduce greenhouse gas emissions, various solutions have been proffered, ranging from low-tech behavioral solutions such as encouraging people to drive less and recycle more; to market solutions such as carbon taxation, emissions trading, and other ways of incentivizing industries to adopt cleaner power, heat, and transport technologies; to geoengineering, that is, large-scale manipulations of the environment including reforestation, spraying sulfate aerosols into the stratosphere to alter the reflectivity of the planet, and fertilizing the ocean with iron to spur algae blooms so that they can help remove carbon out of the atmosphere.[3]

Each of these solutions has its merits and demerits. For instance, behavioral solutions are ones that most of us could easily physically perform. On the other hand, many people lack the motivation to alter their behavior in the required ways. Importantly, even if behavioral solutions were widely adopted, such behavioral changes may not be enough to mitigate the effects of climate change. Similarly, market solutions could, on the one hand, reduce the conflict that currently exists for companies between making profit and minimizing undesirable environmental impact. But, on the other hand, effective market solutions such as international emissions trading require workable international agreements, which have thus far seemed difficult to orchestrate. For example, current data suggests that the Kyoto

Protocol has not really been successful in producing demonstrable reductions in emissions in the world,[4] and there is already some evidence that the US, for example, is unlikely to meet the targets set by the Paris Agreement.[5] Moreover, it has been estimated that to restore our climate to a hospitable state requires us to cut our carbon emissions globally by at least seventy percent.[6] Given the inelastic and rising demands for petrol and electricity, there are serious issues about whether market solutions such as carbon taxation can by themselves deliver reductions of this magnitude.

As a result, some scientists and policy makers are proposing that we take very seriously the idea of geoengineering, since, at least in theory, the impact of geoengineering could be significant enough to mitigate climate change.[7] However, a major problem with geoengineering is that, in many cases, we appear to lack the necessary scientific knowledge to devise and implement geoengineering without significant risk to ourselves and to future generations. Indeed, spraying sulfate aerosols could destroy the ozone layer and iron fertilization could promote toxic planktons and destroy some or all forms of marine life.

In this context, I propose that we explore another kind of solution to the problem of climate change, one that has not been considered before and one that is potentially less risky than geoengineering, something that my colleagues and I have elsewhere called "human engineering."[8]

Human engineering involves the biomedical modification of humans to make us better at mitigating, and adapting to the effects of, climate change. I shall argue that human engineering potentially offers an effective means of tackling climate change, especially if implemented alongside the sorts of solution that we have already described.

Before I explain the proposal, let me make clear that human engineering is intended to be a voluntary activity—possibly supported by incentives such as tax breaks or sponsored health care—rather than a coerced, mandatory activity. I am positively against any form of coercion of the sort that the Nazis perpetrated in the past (segregation, sterilization, and genocide). Also, this proposal is intended for those who believe that climate change is a real problem, and who, as a result, are willing to take seriously potentially catastrophic measures such as geoengineering. Someone who does not believe that climate change is a real problem is likely to think that even asking people to recycle more is an overreaction to

climate change. Finally, the main claim here is a modest one, namely, human engineering should be considered alongside other solutions such as geoengineering. The claim is not that human engineering ought to be adopted as a matter of public policy. This is an attempt to encourage "outside the box" thinking vis-à-vis a seemingly intractable problem.

So what are some examples of human engineering? Here are four examples that a) seem realistic and feasible to implement in the near future; and b) seem potentially desirable even for people who may not care about climate change. I am not wedded to these examples and readers are welcome to come up with better examples to illustrate the point that human engineering should be taken seriously.

PHARMACOLOGICAL MEAT INTOLERANCE

A widely cited report by the UN Food and Agriculture Organization estimates that 18% of the world's greenhouse emissions (in CO_2 equivalents) come from livestock farming, a higher share than from transport. Others have suggested that livestock farming accounts for at least 51% of the world's greenhouse emissions.[9] Still others have estimated that nitrous oxide and methane from livestock may double by 2070.[10] This alone would make meeting climate targets essentially impossible. However, even by the more conservative estimate, close to 9% of human CO_2 emissions are due to deforestation for expansion of pastures, 65% of anthropogenic nitrous oxide is due to manure, and 37% of anthropogenic methane comes directly or indirectly from livestock. Some experts estimate that each of the world's 1.5 billion cows alone emit 100–500 liters (about 26–132 gallons) of methane a day.[11] Since a large proportion of these cows and other grazing animals are meant for consumption, reducing the consumption of these kinds of red meat could have significant effects on the environment.[12] Indeed, even a minor (21–24%) reduction of red meat consumption would achieve the same reduction in emissions as the total localization of food production, that is, having zero "food-miles."[13]

Now some people will not give up eating red meat no matter what. However, there are others who would be willing to give up eating red meat, but they lack the motivation or will power to do so. After all, many people find the taste of red meat irresistible. This may explain why many vegetarian restaurants serve vegetarian dishes with plant-based ingredients that taste like meat.

Human engineering could help here. Just as some people have natural intolerance to, for example, milk or crayfish, we could artificially induce mild intolerance to red meat. While meat intolerance is normally uncommon, in principle, it could be induced by stimulating the immune system against common bovine proteins.[14] The immune system would then become primed to react to them, and henceforth eating "eco-unfriendly" food would

induce unpleasant experiences. Even if the effects do not last a lifetime, the learning effect is likely to persist for a long time.

In fact, there is evidence that meat intolerance can be triggered naturally. Bites from Lone Star ticks can make people allergic to red meat.[15] Lone Star ticks carry a sugar called alpha-gal, which is also found in red meat, but not in people. Normally, alpha-gal in meat poses no problems for people. But when a Lone Star tick bites a person, it transfers alpha-gal into the blood stream. As a result, the person's body produces antibodies to fight the sugar. The next time a person eats red meat, the person has an allergic reaction, which could be mild or severe.

A potentially safe and practical way of inducing such intolerance may be to produce "meat" patches—akin to nicotine patches. People can wear these patches in order to curb their enthusiasm for red meat. To ensure that these patches have the broadest appeal, we can produce patches that just target animals that contribute the most to greenhouse gas emissions, so that people need not become full vegetarians if they do not want to.

MAKING HUMANS SMALLER

Human ecological footprints are partly correlated with our size. We require a certain amount of food and nutrients to maintain each kilogram of body mass. Other things being equal, the larger one is, the more food and energy one requires. Indeed, basal metabolic rate (which determines the amount of energy needed per day) scales linearly with body mass and length.[16] In addition to needing to eat more, larger people also consume more energy in less obvious ways. For example, a car uses more fuel per mile to carry a heavier person than a lighter person; more fabric is needed to clothe larger than smaller people; heavier people wear out shoes, carpets, and furniture more quickly than lighter people, and so on.

A way to reduce this ecological footprint would be to reduce size. Since weight increases with the cube of length, even a small reduction in, for example, height might produce a significant effect in size. (To reduce size, we could also reduce average weight. But to keep the discussion simple, I shall just use the example of height). Reducing the average US height by just 15 centimeters (5.9 inches) would mean a mass reduction of 23% for men and 25% for women, with a corresponding reduction of metabolic rate (15%/18%).

How could height reduction be achieved? Height is determined partly by genetic factors and partly through diet and stressors. One possibility is to use preimplantation

genetic diagnosis (PGD). PGD is currently employed in fertility clinics as a relatively safe means of screening out embryos with certain inherited genetic diseases. One might also be able to use PGD to select shorter children. This would not involve modifying or altering the genetic material of embryos in any way. It would simply involve rethinking the criteria for selecting which embryos to implant.

Also, one might consider hormone treatment either to affect somatotropin levels or to trigger the closing of the epiphyseal plate earlier than normal. Hormone treatments are currently already used for growth reduction in excessively tall children.[17]

Finally, there is a strong correlation between birth size and adult height.[18] Gene imprinting, where only one parent's copy of the genes is turned on and the other parent's copy is turned off, has been found to affect birth size, as a result of evolutionary competition between paternally and maternally imprinted genes.[19] So drugs or nutrients that either reduce the expression of paternally imprinted genes or increase the expression of maternally imprinted genes could potentially regulate birth size.

LOWERING BIRTHRATES THROUGH COGNITIVE ENHANCEMENT

In 2008, John Guillebaud, an emeritus professor of family planning and reproductive health at University College London, and Dr Pip Hayes, a general practitioner from Exeter, pointed out that "each UK birth will be responsible for 160 times more greenhouse gas emissions ... than a new birth in Ethiopia."[20] Given this, they argue that, as a way to mitigate climate change, Britons should consider having no more than two children.

There are of course already many available methods of curbing birthrates such as the use of contraception. But given the problems of climate change, it seems that we need to accelerate this process. There is strong evidence that birthrates decline as more women receive adequate access to education.[21] While the primary reason for promoting education is to improve human rights and well-being, fertility reduction may be a positive side effect from the point of view of tackling climate change. In general, there seems to be a link between cognition and lower birthrates. In the US, for example, women with low cognitive ability are more likely to have children before age eighteen.[22] Hence, another

possible human engineering solution is to use cognition enhancements such as Ritalin and Modafinil to achieve lower birthrates. As with education, there are many other, more compelling reasons to improve cognition, but the fertility effect may be desirable as a means of tackling climate change. Even if the direct cognitive effect on fertility is minor, cognition enhancements may help increase the ability of people to educate themselves, which would then affect fertility, and indirectly climate change.

PHARMACOLOGICAL INDUCTION OF ALTRUISM AND EMPATHY

Many environmental problems are the result of collective action problems, in which individuals do not cooperate for the common good. But if people were generally more willing to act as a group, and could be confident that others would do the same, we may be able to enjoy the sort of benefits that arise only when large numbers of people act together. Pharmacological induction of altruism and empathy may help increase the chances of this occurring.[23]

There is evidence that altruism and empathy have biological underpinnings and can be affected pharmacologically. For example, test subjects given the prosocial hormone oxytocin, which is available as a prescription drug, were more willing to share money with strangers and to behave in a more trustworthy way.[24] Also, a noradrenaline reuptake inhibitor increased social engagement and cooperation with a reduction in self-focus during an experiment.[25] Furthermore, oxytocin appears to improve the capacity to read other people's emotional state, which is a key capacity for empathy.[26] This suggests that interventions affecting the sensitivity in these neural systems could also increase the willingness to cooperate with social rules or goals.

These examples are intended to illustrate some possible human engineering solutions. Others like them might include increasing our resistance to heat and tropical diseases, reducing our need for food and water, and, more speculatively, giving humans cat eyes so that they can see better at night and thereby reduce global energy usage considerably.[27]

A CASE FOR HUMAN ENGINEERING

Why should we take human engineering solutions seriously? There are at least two reasons: human engineering is potentially less risky than geoengineering; and human engineering could make behavioral and market solutions more likely to succeed.

In comparison to geoengineering, the human engineering solutions canvassed here rely on tried-and-tested technology, whose risks, at least at the individual level, are comparatively low and well known. For example, PGD—the process that would enable us to select smaller children—is an accepted practice in many fertility clinics. And, oxytocin, which could be used to increase empathy, is already used as a prescription drug. Also, given that human engineering applies at the level of individual humans, it seems that we should be better at managing its risks in comparison to the risks imposed by something like geoengineering which takes place on a much larger, global, scale.

"If we disappear then nature will continue, but if nature disappears then none of us will survive."

SEBASTIÃO SALGADO (1944–)
Brazilian photographer.

Clouds of smoke fill the atmosphere as areas of tropical forest are destroyed to plant oil palms in Tripa, Aceh Province, Indonesia. Palm oil is used as a vegetable fat in products ranging from chocolate and breakfast cereals to shampoo. It is also classified as a biofuel.

Human engineering could also make behavioral and market solutions more likely to succeed in the following way. Pharmacologically induced altruism and empathy could increase the likelihood that we adopt the necessary behavioral and market solutions for curbing climate change. Pharmacological meat intolerance could make the behavioral solution of giving up red meat much easier for those who want to do so but who find it too difficult.

Moreover, human engineering could be more liberty enhancing than certain behavioral and market solutions. As we have seen, given the seriousness of climate change, some people have proposed that we ought to restrict human reproduction and adopt something akin to China's one-child policy.[28] However, suppose that the relevant issue is some kind of fixed allocation of greenhouse gas emissions per family. If so, given certain fixed allocations of greenhouse gas emissions, human engineering could give families the choice between having one large child, two medium-sized children, or three small-sized children. In this context, human engineering seems more liberty enhancing than a policy that says that one can only have one or two children.

Furthermore, some human engineering solutions might be "win-win" solutions in the sense that desirable effects are very likely to result from implementing them regardless of their effectiveness at tackling climate change. For instance, cognitive enhancement, if effective at reducing birthrates, could enable China to limit or dispense with its controversial, coercive one-child policy. At the same time, improved cognition is itself of great value. Similarly, if pharmacological meat intolerance is effective at reducing greenhouse gases that result from the farming of certain kinds of animals for consumption, it could reduce the need to tax undesirable behavior. In addition, the health benefits of eating less red meat and the reduction in suffering of animals farmed for consumption are themselves positive goods.

More generally, as well as helping to mitigate climate change, human engineering could also help solve some other serious problems of the modern world: smaller people, more considerate people, and lower meat consumption, can help address the problems associated with unsustainable energy demands and water shortage.

At this point, it is worth reiterating that human engineering is intended to be a voluntary activity. I am positively against others coercing someone to take up these pharmacological measures. The idea here is there are people who would like to do the right thing, but owing to a weakness of will, they cannot get themselves to do the right thing. Having the option to use human engineering, such as pharmacological altruism, may help these people overcome their weakness of will voluntarily and enable them to do the right thing.

SOME POSSIBLE CONCERNS REGARDING HUMAN ENGINEERING

As with all biomedical treatments—including those routinely prescribed by medical professionals—human engineering carries risks. The possibility of these risks means that if people are to be persuaded to undergo human engineering, the risks associated with it must be minimized.

This said, these risks should also be balanced against the risks associated with taking inadequate action to combat climate change. If behavioral and market solutions alone are not sufficient to mitigate the effects of climate change—then even if human engineering were riskier than these other solutions, we might still need to consider it. Also, it is important not to exaggerate the risks involved in human engineering. This is a very real possibility, since people are generally less tolerant of risks arising from novel, unfamiliar technologies than they are of risks arising from familiar sources.[29] To counter this effect, it is worth remembering both that much of the technology involved in human engineering—such as PGD and oxytocin—is already safely available for other uses, and that in non-climate change contexts our society has been willing to make biomedical interventions on a population-wide scale. For example, fluoride is deliberately added to water with the aim of fortifying us against tooth decay, even though doing so is not without risks. Similarly, people are routinely vaccinated to prevent themselves and those around them from acquiring infectious diseases, even though vaccinations sometimes have side effects, and can even lead to death. Hence, with respect to safety, it seems that we should judge human engineering solutions on a case-by-case basis, and not rule them out *tout court*.

Others may be concerned that human engineering involves interfering with nature. In the biomedical enhancement debate, Michael Sandel argues that a problem with human enhancement is that it represents "a Promethean aspiration to remake nature, including human nature, to serve our purposes and satisfy our desires."[30] Given that human engineering is using biomedical means for the sake of climate change, some might worry that this problem would similarly be present in human engineering. Indeed, a number of environmentalists believe that it is precisely our interference with nature that has given rise to climate change. These environmentalists might therefore object to human engineering on the ground that it, too, is interfering with nature.

While there is something to this concern, the view that "it is morally impermissible to interfere with human nature, because this is interfering with nature, and it is morally impermissible to interfere with nature" seems too strong. Vaccination and giving women access to epidural during labor both interfere with nature, but we would not therefore conclude that their usage is morally impermissible. Also, not every human engineering

solution involves interfering with human nature, if by interference one means making modifications to human beings. The selection of a smaller child through PGD, for example, involves no more interference with nature than the standard IVF process, which is not generally viewed as morally suspect.

Moreover, if human engineering could mitigate the effects of climate change, arguably this would bring about a net reduction in human interference with nature at large. Lastly, Sandel is objecting to human enhancement partly because many people want to use it "to serve our purposes and satisfy our desires." But human engineering, as I envisage it, is an ethical endeavor in that mitigating climate change can promote the well-being of many people and animals which are vulnerable to the effects of climate change. Given this, it seems that even those who share Sandel's disapproval can share in the aims of human engineering.

A further concern with human engineering is that some of the solutions may affect children, sometimes irreversibly. To be sure, not all human engineering solutions that would involve children are necessarily controversial. For instance, would we as parents really object to the use of cognitive enhancement on our children as a means of lowering birthrates? There is evidence that many parents are happy to give their children cognitive enhancements such as Ritalin. Still, there are other human engineering solutions that would involve children and that may be controversial, such as giving hormone treatments to their children. In such a case, issues about a child's present and future autonomy and the limits of parental authority would certainly arise.[31] Even in this case though, it is helpful to point out that parents are currently permitted to give hormone treatments to their children, who are otherwise perfectly healthy, so that, for example, a daughter who is predicted to be 1.98 meters (6 feet 5 inches) tall could instead be 1.83 meters (6 feet) tall. On what grounds then should we forbid other parents who want to give hormone treatments to their children so that their children could be 1.52 meters (5 feet) tall instead of 1.62 meters (5 feet 5 inches) tall? It might be thought that in case of the former, the daughters would later appreciate and consent to the parents' decision. But if climate change would seriously affect the well-being of millions of people including one's children, then these children may also later appreciate and consent to the parents' decision.

As a general remark, it is worth asking ourselves why more controversial kinds of human engineering would be contemplated. They might be contemplated because there is evidence that existing solutions for mitigating climate change are likely to fall short of their intended goals, and because millions could suffer hunger, water shortages, diseases, and costal flooding if climate change were not mitigated. In the biomedical enhancement literature, some people believe that, however controversial a technology may be, parents have the right socially and biologically to modify their children as long

as doing so would on the whole promote their children's well-being, and as long as there exists no better means of achieving such an end. Given the seriousness of climate change, and given the possible lack of alternative solutions, we might conclude that if a particular human engineering solution would on the whole promote a child's well-being, then parents should also have a right to implement such a solution even if the solution is a controversial one.

Let me address one last concern, namely, human engineering is likely to have limited appeal. For example, who in their right mind would choose to make their children smaller?

In response, it is helpful to note first that while it is tempting to focus on the most provocative examples of human engineering solutions discussed here, it is not the case that human engineering is synonymous with lack of appeal. After all, cognitive enhancements and pharmacological means of resisting meat are likely to appeal to many people, since improved cognition and the health benefits of reduced consumption of red meat are good in themselves.

Secondly, it is understandable why some people would react negatively toward the idea of having smaller children, since, in our society, being tall is often seen as being advantageous. Indeed, studies have shown that women find taller men more attractive than shorter men and that taller people enjoy greater career success.[32] However, the fact that a particular human engineering solution may not appeal to some people is not a reason to avoid making such a solution available. For one thing, what may be unappealing today may not be so tomorrow. Indeed, people's attitudes toward vegetarianism have drastically changed as a result of vegetarianism's ethical status. Also, it is worth remembering how fluid human traits like height are. A hundred years ago people were much shorter on average, and there was nothing wrong with them medically. We should be wary of the idea that there is an optimal height, namely, the average height in our society today, since this may simply reflect a status-quo bias. Lastly, it is helpful to point out that being small could be advantageous in a number of circumstances. Certainly, there is an advantage to being small given the rapidly shrinking airline seats. In addition, how many centenarians, that is, people who are over a hundred years old, are over 1.83 meters (6 feet) tall? There is evidence that taller people are at higher risk for cancer and tend to suffer more respiratory and cardiovascular illnesses.[33] Moreover, as we prepare for the human exploration of Mars[34] and other planets, it seems likely that height restriction on astronauts will be considered, given not only the cost of fuel but also the resources needed to sustain these individuals.

To drive home the point that having smaller children need not be unappealing, imagine that our preindustrial ancestors are given a choice between a) a world populated by nine billion people who have intervened in their own biology such that most of them are smaller than they would otherwise have been, and who as a result live in a sustainable world; b) a

world populated by nine billion people who have not intervened to affect their own height and who as a result live in a non-sustainable world; and c) a world populated by six billion people who have not intervened to affect their own height and who live in a sustainable world. It is not obvious that, to our preindustrial ancestors, a) would stand out as the least appealing option. In fact, it seems plausible that they might prefer a) to b) or c), given that a) allows more people to live in a sustainable world. If so, in dismissing certain human engineering solutions as unappealing, we should ensure that we are not thereby implicitly endorsing a more familiar, but certainly no more appealing, set of circumstances.

CONCLUSION

I hope to have sketched some plausible scenarios of what human engineering solutions to climate change might involve. I argued that human engineering is potentially less risky than geoengineering and that it could make behavioral and market solutions more likely to succeed. I also considered possible concerns regarding human engineering and I suggested some responses to these concerns.

It may turn out that human engineering is not the best way of tackling climate change. But to concede this now would be to ignore the widely acknowledged fact that we do not currently know which solutions to climate change will be the most effective.

To combat climate change, we can either change the environment or change ourselves. Given the enormous risks associated with changing the environment, we should take seriously the idea that we may need to change ourselves.

1. IPCC, "Ipcc Fourth Assessment Report 2007, Working Group II Report 'Impacts, adaptation and vulnerability,'" (2007).
2. See http://www.climatecentral.org/news/world-passes-400-ppm-threshold-permanently-20738 (accessed on Oct 1, 2016).
3. D. W. Keith, "Geoengineering the climate: History and prospect," *Annual Review of Energy and the Environment* 25 (2000).
4. Igor Shishlov, Romain Morel, and Valentin Bellassen, "Compliance of the parties to the Kyoto Protocol in the first commitment period," *Climate Policy* 16(6) (2016).
5. Jeffery B. Greenblatt and Max Wei, "Assessment of the climate commitments and additional mitigation policies of the United States," *Nature Climate Change*, advance online publication (2016).
6. Warren M. Washington et al., "How much climate change can be avoided by mitigation?," *Geophys. Res. Lett.* 36(8) (2009).
7. House of Commons Science and Technology Committee, "The regulation of geoengineering," (Fifth Report of Session 2009-10).
8. S. Matthew Liao, Anders Sandberg, and Rebecca Roache, "Human engineering and climate change," *Ethics, Policy & Environment* 15(2) (2012).
9. R. Goodland and J. Anhang, "Livestock and climate change: What if the key actors in climate change are… cows, pigs, and chickens?," *World Watch*, November/December (2009).
10. Fredrik Hedenus, Stefan Wirsenius, and Daniel J. A. Johansson, "The importance of reduced meat and dairy consumption for meeting stringent climate change targets," *Climatic Change* 124(1) (2014).
11. K. A. Johnson and D. E. Johnson, "Methane emissions from cattle," *Journal of Animal Science* 73(8) (1995).
12. G. Eshel and P. A. Martin, "Diet, energy, and global warming," *Earth Interactions* 10 (2006).

13. C. L. Weber and H. S. Matthews, "Food-miles and the relative climate impacts of food choices in the United States," *Environmental Science & Technology* 42(10) (2008).
14. V. F. Aparicio et al., "Allergy to mammal's meat in adult life: Immunologic and follow-up study," *Journal of Investigational Allergology and Clinical Immunology* 15(3) (2005).
15. See https://www.dtnpf.com/agriculture/web/ag/news/livestock/article/2016/04/25/lone-star-tick-bite-can-create-beef (accessed on Oct 1, 2016).
16. M. D. Mifflin et al., "A new predictive equation for resting energy expenditure in healthy individuals," *American Journal of Clinical Nutrition* 51(2) (1990).
17. A. Grüters et al., "Effect of different oestrogen doses on final height reduction in girls with constitutional tall stature," *European Journal of Pediatrics* 149(1) (1989).
18. H. T. Sorensen et al., "Birth weight and length as predictors for adult height," *American Journal of Epidemiology* 149(8) (1999).
19. Austin Burt and Robert Trivers, *Genes in Conflict* (Cambridge, MA: Belknap Press, 2006).
20. John Guillebaud and Pip Hayes, "Population growth and climate change," *British Medical Journal* 337 (2008): 576.
21. United Nations, *Women's Education and Fertility Behaviour: Recent Evidence from the Demographic and Health Surveys* (New York: United Nations, 1995).
22. D. L. Shearer et al., "Association of early childbearing and low cognitive ability," *Perspectives on Sexual and Reproductive Health* 34(5) (2002).
23. T. Dietz, E. Ostrom, and P. C. Stern, "The struggle to govern the Commons," Science 302(5652) (2003).
24. Paul J. Zak, Angela A. Stanton, and Sheila Ahmadi, "Oxytocin increases generosity in humans," *PLoS ONE* 2(11) (2007).
25. W. S. Tse and A. J. Bond, "Difference in serotonergic and noradrenergic regulation of human social behaviours," *Psychopharmacology* 159(2) (2002).

26. A. J. Guastella, P. B. Mitchell, and M. R. Dadds, "Oxytocin increases gaze to the eye region of human faces," *Biological Psychiatry* 63(1) (2008).
27. See http://www.theadaptors.org/episodes/2015/2/11/cat-eyes-for-climate-change (accessed on Oct 1, 2016).
28. Sarah Conly, *One Child: Do We Have a Right to More?* (New York: Oxford University Press, 2016); Travis N. Rieder, *Toward a Small Family Ethic: How Overpopulation and Climate Change Are Affecting the Morality of Procreation* (New York: Springer, 2016).
29. P. Slovic, "Perception of risk," *Science* 236(4799) (1987).
30. M. Sandel, *The Case Against Perfection: Ethics in the Age of Genetic Engineering* (Harvard: Harvard University Press, 2007).
31. S. Matthew Liao, "The ethics of using genetic engineering for sex selection," *Journal of Medical Ethics* 31 (2005).
32. R. Kurzban and J. Weeden, "Hurrydate: Mate preferences in action," *Evolution and Human Behavior* 26(3) (2005); T. A. Judge and D. M. Cable, "The effect of physical height on workplace success and income: Preliminary test of a theoretical model," *Journal of Applied Psychology* 89(3) (2004).
33. Geoffrey C. Kabat et al., "Adult stature and risk of cancer at different anatomic sites in a cohort of postmenopausal women," *Cancer Epidemiology Biomarkers & Prevention* (2013).
34. See http://www.nasa.gov/content/nasas-journey-to-mars (accessed on Oct 1, 2016).

—Aparicio, V. F., I. S. Marcen, A. P. Montero, M. L. Baeza, and M. D. Fernandez. 2005. "Allergy to mammal's meat in adult life: Immunologic and follow-up study." *Journal of Investigational Allergology and Clinical Immunology* 15(3): 228–231.

—Burt, Austin, and Robert Trivers. 2006. *Genes in Conflict*. Cambridge, MA: Belknap Press.

—Conly, Sarah. 2016. *One Child: Do We Have a Right to More?* New York: Oxford University Press.

—Dietz, T., E. Ostrom, and P. C. Stern. 2003. "The struggle to govern the commons." *Science* 302(5652): 1907–1912.

—Eshel, G., and P. A. Martin. 2006. "Diet, energy, and global warming." *Earth Interactions* 10: 1–17.

—Goodland, R., and J. Anhang. 2009. "Livestock and climate change: What if the key actors in climate change are... cows, pigs, and chickens?" *World Watch* (November/December): 10–19.

—Greenblatt, Jeffery B., and Max Wei. 2016. "Assessment of the climate commitments and additional mitigation policies of the United States." *Nature Climate Change* advance online publication.

—Grüters, A., P. Heidemann, H. Schlüter, P. Stubbe, B. Weber, and H. Helge. 1989. "Effect of different oestrogen doses on final height reduction in girls with constitutional tall stature." *European Journal of Pediatrics* 149(1): 11–13.

—Guastella, A. J., P. B. Mitchell, and M. R. Dadds. 2008. "Oxytocin increases gaze to the eye region of human faces." *Biological Psychiatry* 63(1): 3–5.

—Guillebaud, John, and Pip Hayes. 2008. "Population growth and climate change." *British Medical Journal* 337: 576.

—Hedenus, Fredrik, Stefan Wirsenius, and Daniel J. A. Johansson. 2014. "The importance of reduced meat and dairy consumption for meeting stringent climate change targets." *Climatic Change* 124(1): 79–91.

—House of Commons Science and Technology Committee. "The regulation of geoengineering." 2010. http://www.publications.parliament.uk/pa/cm200910/cmselect/cmsctech/221/221.pdf. Fifth Report of Session 2009–10.

—IPCC. 2007. "Ipcc Fourth Assessment Report 2007, Working Group II Report 'Impacts, adaptation and vulnerability.'"

—Johnson, K. A., and D. E. Johnson. 1995. "Methane emissions from cattle." *Journal of Animal Science* 73(8): 2483–2492.

—Judge, T. A., and D. M. Cable. 2004. "The effect of physical height on workplace success and income: Preliminary test of a theoretical model." *Journal of Applied Psychology* 89(3): 428–441.

—Kabat, Geoffrey C., Matthew L. Anderson, Moonseong Heo, H. Dean Hosgood, Victor Kamensky, Jennifer W. Bea, Lifang Hou, Dorothy S. Lane, Jean Wactawski-Wende, JoAnn E. Manson, and Thomas E. Rohan. 2013."Adult stature and risk of cancer at different anatomic sites in a cohort of postmenopausal women." *Cancer Epidemiology Biomarkers & Prevention*.

—Keith, D. W. 2000. "Geoengineering the climate: History and prospect." *Annual Review of Energy and the Environment* 25: 245–284.

—Kurzban, R., and J. Weeden. 2005. "Hurrydate: Mate preferences in action." *Evolution and Human Behavior* 26(3): 227–244.

—Liao, S. Matthew. 2005. "The ethics of using genetic engineering for sex selection." *Journal of Medical Ethics* 31: 116–118.

—Liao, S. Matthew, Anders Sandberg, and Rebecca Roache. 2012. "Human engineering and climate change." *Ethics, Policy & Environment* 15(2): 206–221.

—Mifflin, M. D., S. T. Stjeor, L. A. Hill, B. J. Scott, S. A. Daugherty, and Y. O. Koh. 1990. "A new predictive equation for resting energy expenditure in healthy individuals." *American Journal of Clinical Nutrition* 51(2): 241–247.

—Rieder, Travis N. 2016. *Toward a Small Family Ethic: How Overpopulation and Climate Change Are Affecting the Morality of Procreation*. New York: Springer.

—Sandel, M. 2007. *The Case against Perfection: Ethics in the Age of Genetic Engineering*. Harvard: Harvard University Press.

—Shearer, D. L., B. A. Mulvihill, L. V. Klerman, J. L. Wallander, M. E. Hovinga, and D. T. Redden. 2002. "Association of early childbearing and low cognitive ability." *Perspectives on Sexual and Reproductive Health* 34(5): 236–243.

—Shishlov, Igor, Romain Morel, and Valentin Bellassen. 2016. "Compliance of the parties to the Kyoto protocol in the first commitment period." *Climate Policy* 16(6): 768–782.

—Slovic, P. 1987. "Perception of risk." *Science* 236(4799): 280–285.

—Sorensen, H. T., S. Sabroe, K. J. Rothman, M. Gillman, F. H. Steffensen, P. Fischer, and T. I. A. Sorensen. 1999. "Birth weight and length as predictors for adult height." *American Journal of Epidemiology* 149(8): 726–729.

—Tse, W. S., and A. J. Bond. 2002. "Difference in serotonergic and noradrenergic regulation of human social behaviours." *Psychopharmacology* 159(2): 216–221.

—United Nations. 1995. *Women's Education and Fertility Behaviour: Recent Evidence from the Demographic and Health Surveys*. New York: United Nations.

—Washington, Warren M., Reto Knutti, Gerald A. Meehl, Haiyan Teng, Claudia Tebaldi, David Lawrence, Lawrence Buja, and Warren G. Strand. 2009. "How much climate change can be avoided by mitigation?" *Geophys. Res. Lett.* 36(8): L08703.

—Weber, C. L., and H. S. Matthews. 2008. "Food-miles and the relative climate impacts of food choices in the United States." *Environmental Science & Technology* 42(10): 3508–3513.

—Zak, Paul J., Angela A. Stanton, and Sheila Ahmadi. 2007. "Oxytocin increases generosity in humans." *PLoS ONE* 2(11): 1–5.

Neurotechnological Progress: The Need for Neuroethics

JAMES GIORDANO

James Giordano
Georgetown University, Washington DC, USA

James Giordano, PhD, is Chief Scientist of the Office of the Senior
Vice President for Research of Georgetown University, Professor in the
Departments of Neurology and Biochemistry, and Chief of the Neuroethics
Studies Program of the Pellegrino Center for Clinical Bioethics at the
Georgetown University Medical Center, Washington DC, USA. His
current work focuses on neuroethical issues arising in and from the use of
advanced neurotechnologies in medicine, public life and national security.
He is the author of over 230 publications and seven books in neuroscience
and neuroethics, and eleven governmental whitepapers on brain science.

The use of increasingly sophisticated techniques and technologies has enabled rapid discoveries and developments in brain research that are being translated into varied applications in medicine, public life, and national security. Such developments foster a host of questions and problems generated both by the novelty of neuroscientific tools and techniques, and by social effects that neuroscientific information and capabilities incur. These issues are the focus of the field of neuroethics. This chapter describes these new developments, addresses neuroethical issues, questions and tasks, and posits directions for neuroethical engagement and guidance of neuroscientific knowledge and capabilities.

DEVELOPMENTS IN—AND INFLUENCE OF—NEUROSCIENCE AND TECHNOLOGY (NEUROS/T)

Brain science is developing at a rapid pace, fostered by ever more convergent, multidisciplinary methods (Giordano, 2012a) that afford a systems-based, integrative approach to the development and translational use of neuroscientific technologies and techniques, that is, neuroS/T (Giordano, 2012a, 2012b). Research and applications of neuroS/T are aimed at evaluating and treating a number of neuropsychiatric disorders and conditions, and are also being increasingly viewed as a means of affecting neural substrates of cognition, emotion, and behavior to modify aspects of human performance (if not personality).

In general, neuroS/T can be defined as those methods and devices that are utilized to access, assess, and/or affect neural systems. As depicted in Table I, these approaches can be categorized as:

> 1. Assessment neuroS/T, including genetic, genomic, and proteomic methods, various forms of neuroimaging (e.g., tomographic and magnetic imaging; quantitative and magneto-encephalography); and biomarker assays for particular neurological functions and neuropsychiatric conditions;
> 2. Interventional neuroS/T, to include neuro/psychotropic drugs and novel pharmaceutical methods; neuromodulatory devices (e.g., transcranial magnetic and/or electrical stimulation—TMS and tES, respectively; deep brain stimulation—DBS, and cranial and peripheral nerve stimulators); neural tissue and genetic implants and transplants; and neural- and brain-machine interfaced neuroprosthetic systems.

CATEGORIES OF NEUROSCIENCE AND NEUROTECHNOLOGY (NEUROS/T)	
	Assessement NeuroS/T
	(Neuro) Genetic and Genomic Probes
	Biomarker Assays
	Neuroimaging
	Computerized Tomography (CT)
	Single Photon Emission Computerized Tomography (SPECT)
	Positron Emission Tomography (PET)
	Magnetic Resonance Imaging (MRI)
	Functional Magnetic Resonance Imaging (fMRI)
	Diffusion Tensor and Kurtosis Imaging (DTI/DKI)
	Neurophysiological Methods
	Electroencephalography (EEG)
	Quantitative Electroencephalography (qEEG)
	Magneto-encephalography (MEG)
	Interventional NeuroS/T
	Neuro- and Psychotropic Drugs
	Neural Tissue Implants/Transplants
	Neurogenetic Implants/Transplants
	Cranial and Peripheral Nerve Stimulation Devices
	Transcranial Neuromodulatory Devices
	Transcranial Electrical Stimulation (tES)
	Transcranial Direct Current Stimulation (tDCS)
	Transcranial Alternating Current Stimulation (tACS)
	In-dwelling Neuromodulatory Devices
TABLE I	Deep Brain Stimulation (DBS)

To be sure, the field—and its domains of application and use—is fast paced, engaged by multiple entries that are vying for defined outcomes (and "prizes" of innovation, discovery, recognition, and economic gain), and as such can be seen as a "neuroS/T speedway." Reflective of the racing comparison, it is a highly competitive environment, which, while offering definable benefits (to both stake and shareholders), is not without risk, if not frankly dangerous as neuroS/T is ever more broadly engaged in the social milieu (Giordano, 2016a).

Ongoing governmental and commercial support, such as that provided via the *Brain Research through Advancing Innovative Neurotechnologies (BRAIN)* initiative in the United States, and the European Union's *Human Brain Project*, has sustained rapid development of new ideas, concepts, methods, devices, and abilities, which are being quickly and broadly translated for use in medicine, public life, international relations, and global security. Such

growth and varied applications are reflected by an ever-increasing number of reports in the international peer-reviewed literature (Giordano, 2012a), and patents for neurotechnologies (Lynch and McCann, 2010; NeuroInsights, 2015).

The tools of neuroscience have become ever more prominent as a means to access, evaluate, and manipulate brain structure and function, and such information and capacity, while nascent and contingent, incurs far-reaching potential to affect medical, ethical, legal, and cultural norms, ontological status, and social action. Clearly, there is much that *can* be done with neuroscience and its tools, but in each and every case, it is important to consider what *should* be done, given the boundaries of neuroscientific knowledge and technology, sociocultural realities, extant moral constructs, and the potential to use any scientific and technological tool to evoke good or harm.

At the fore is the need to appreciate neuroscience as a human endeavor, and to assume responsibility for the relative rightness and/or wrongness of the ways that neuroscientific knowledge and interventions are employed. Brain research prompts new vistas of understanding, and may alter the ways that humans and nonhuman beings (e.g., animals, artificially intelligent machines, etc.) are regarded and treated. Moreover, neuroscience provides means to control cognition, emotion, and behavior. While beneficent motives may drive the use of such capabilities, neuroscience is not enacted in a social vacuum, and thus neuroS/T interventions and manipulations are subject to the influences of the market and political direction. Therefore, it is vital to ask how these goods and resources will be utilized and distributed, and what effect(s) use and allocation would incur on individuals, groups, and society.

Imperatives for innovation, the novelty of approaches, current limitations of knowledge, and resultant uncertainties of the relative benefit, burdens, and harms of neuroS/T can each and all evoke a variety of neuroethico-legal and social issues (NELSI). As shown in Table II, these can be generally categorized as:

> 1. Those that are focal to characteristic qualities, parameters, ambiguities, and problems inherent to the complex and sophisticated techniques and devices being developed;
> 2. Those arising from the widening applications of neuroS/T, misuse of neuroscientific knowledge and/or capabilities, and/or distribution of neuroS/T in light of the increasingly diverse nature of twenty-first-century world culture, international commercial entities, and political support for neuroS/T research, development, and use (Giordano and Benedikter, 2012a, 2012b; Hughes, 2006; Lanzilao, Shook, Benedikter, and Giordano, 2013; Lynch and McCann, 2010; NeuroInsights, 2015). These issues are not mutually exclusive, but rather are interactive and can often be reciprocal in effect, and therefore require an interfluent approach to their address and resolution (Giordano, 2010; Giordano and Olds, 2010).

I posit that three primary, and three derivative questions are fundamental to querying the ways that neuroS/T can and should be engaged in various spheres of use (Giordano, 2011; 2014; 2016a).

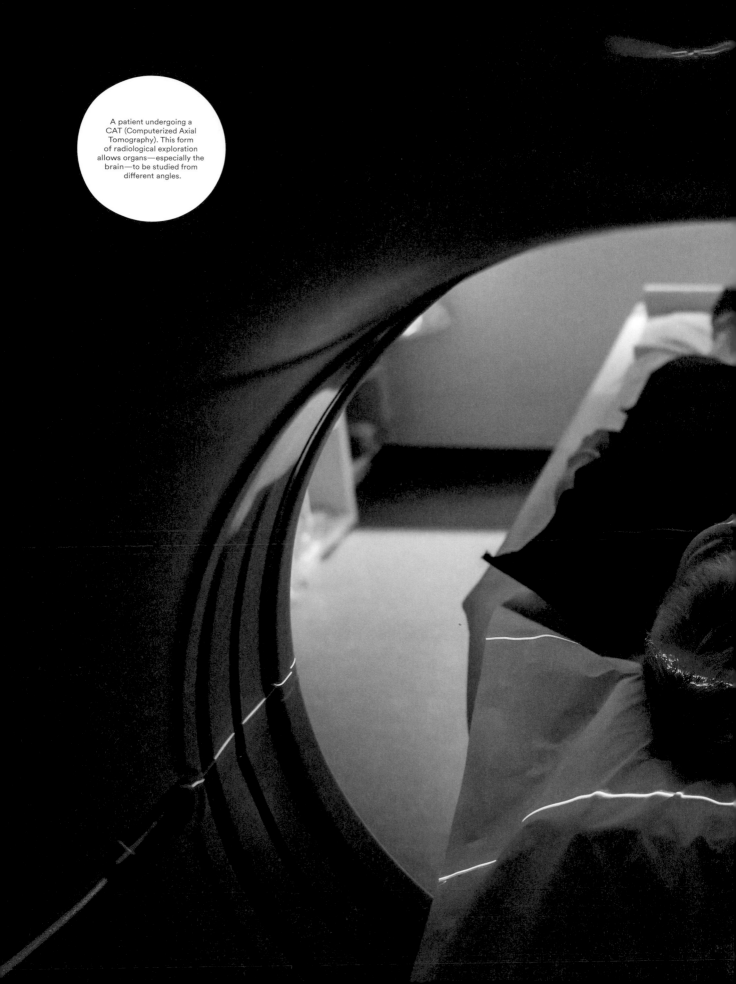

A patient undergoing a CAT (Computerized Axial Tomography). This form of radiological exploration allows organs—especially the brain—to be studied from different angles.

CATEGORIES OF NEUROETHICAL ISSUES	**Technology Inherent**
	Novel, "Frontier" Science and Technology
	Unknown Mechanisms
	Unanticipated Effects
	Runaway Effects
	Societally-Derived/Focal
	Misperception/Misinterpretation of Capabilities, Limits and/or Meaning/Value
	Inapt Use/Misuse
	Economic Manipulation
	Provision/Distribution of Resources
TABLE II	Cultural Variability in Needs, Values, Use and/or Access

PRIMARY NEUROETHICAL QUESTIONS

Taking these in turn, it is first essential to ask: *what are the actual capabilities of specific types of (assessment and interventional) neuroS/T*? The capabilities and limitations of a particular technology and/or technique define if, how, and to what extent such tools can be validly and reliably employed to depict, define, and affect brain structure and function(s) relative and relevant to neuropsychiatric state, conditions, and capacities. Simply put, what can the tools of brain science *really* do? A complete analysis of the capabilities and limitations of various forms of neuroS/T is beyond the scope of the present chapter; for an overview, and discussion of NELSI fostered, see Giordano (2016a, 2016b, 2012b).

Presumed validity of given neuroS/T incurs relative value of using certain techniques and technologies in practice. Therefore a second fundamental question is: *whether, and in what ways could interventional neuroS/T (e.g., drugs, neuromodulatory devices, etc.) be used or misused to treat neuropsychiatric disorders and/or affect fundamental aspects of personality or "the self"?* Discerning the technical capacities of neuroS/T establishes those ways that given tools and techniques act at particular substrates to alter mechanisms and processes of cognition, emotion, and/or behavior. Here, the border between issues and questions inherent to a neuroS/T approach (e.g., capabilities, limitations, effects, etc.) merges with those derived from its possible applications (to define, evaluate, and treat neurological and psychiatric disorders, and to alter neurocognitive functions and performance). At the crux is a heuristic reliance, which we have referred to as "builders' bias": namely, that the tools employed to establish (theoretical) bases of/for what is regarded as functional or dysfunctional, and normal or abnormal, create—if not prompt and sustain—the impetus and justification to utilize such (classes and types of) tools to affect the structures and functions that are axiomatic to such definitions (Giordano, 2010).

We have posed that working—and socially recognized—distinctions of function, dysfunction, and norms instantiate a threshold for whether some neurological intervention

would be considered to be a "treatment" (i.e., to prevent, mitigate, or reverse a circumscribed dysfunction, disorder, or "disease"), or an "enhancement" (i.e., to change cognition, emotion, or behavior in ways that represent some recognized optimization of particular aspects of performance: Gini, Rossi, and Giordano, 2010; Gini and Giordano, 2010; Shook and Giordano, 2016). Indeed, there is abundant and rich discourse addressing if and how the use of neuroS/T constitutes treatment or enhancement, and the NELSI generated by such use (for complete bibliography, see: Martin et al., 2016), and the core question of what constitutes treatment or enhancement spawns further inquiry about the provision (and availability) of various interventions to individuals, groups (i.e., professions, inclusive of possible direct and dual use for military purposes), and (developed, developing, or nondeveloped) nations.

Extending discussion to account for the use (misuse, or nonuse) of neuroS/T on international scales prompts the third fundamental question; to wit, *how will markets for neuroS/T influence—and be engaged to affect—the commercialization and global economics of neuroscientific and technological resources and services?* Brain science represents a significant market that has shown an excess of $150 billion in annual revenues, which exhibits approximately 5% in net growth. The globalizing trend in neuroS/T is reflected by recent estimates of a greater than 60% increase in neuroS/T research and its translation (into medical, public use, and military markets) occurring by 2025, with significant gains being achieved by Asian and South American enterprises (Lynch and McCann, 2010; NeuroInsights 2015). That such efforts may equal or exceed Western endeavors only serves to fortify both the economic capability—and power—that could be leveraged through neuroS/T, and the need to recognize and acknowledge multicultural philosophies, values, and practices when addressing (and attempting to resolve) NELSI, and the ways that neuroethical discourse informs national and international guidelines, policies, and laws (Anderson, Fitz and Howlader, 2012; Lanzilao, Shook, Benedikter, and Giordano, 2013; Shook and Giordano, 2014).

From these primary questions, three further queries arise that are focal to if and how neuroS/T might be employed within various societal domains. First among these is: will (and how might) necessary insight be levied when evaluating neuroS/T so as to acknowledge the actual strengths and limitations of these approaches? Second is: will (and how will) sufficient prudence be exercised when determining if, when, and how neuroS/T outcomes and tools are to be employed in specific ways within the medical, social, legal, and even political milieu? Third, yet certainly not last nor least is: if and what ethical system(s), and methods might be best suited to engage deliberations about—and provide direction for—the viability and value of employing neuroS/T in the aforementioned ways and settings on local to the global scales? (Giordano, 2014).

A PARADIGMATIC APPROACH TO NEUROETHICAL ADDRESS

In addressing these questions—and in developing possible solutions—I have argued that a simple precautionary posture, while certainly seeking to maximize benefit and reduce risk and harms, would be inadequate, as it tends to be overly proscriptive if and when accounting for the reality of burdens and risks that often occur as science and technology become iteratively more vulnerable to unanticipated effects and/or misuse. On the other hand, a solely permissive orientation, while being less restrictive, could encourage a *laissez-faire* attitude and foster something of a "wait and see" approach, that could fail to engage deliberations necessary to gain timely insight and guidance for neuroS/T developments that emerge upon the world stage (Giordano, Forsythe and Olds, 2010; Sarewitz and Karras, 2012). Thus, I believe that some balance of precautionism and assertivism is better suited, if not required, to enable effective neuroethical address (Giordano, 2012a; 2014; 2016a). To obtain such balance, I have advocated a preparatory stance that is built upon responsibility for remaining apace with—and realistically appraising—developments in neuroS/T innovation and translation (i.e., the "6-R" construct, as depicted in Table III).

6-R GROUNDWORK CONSTRUCT TABLE III	Responsibility for... **Realistic Assessment:** of the neurotechnology and NELSI **Research:** for ongoing evaluation of use/effects-in-practice **Responsiveness:** to benefits, burdens and deleterious effects **Revisions:** in technology, marketing and directions for use **Regulation:** that remains flexible to iterative change in neuroS/T

This orientation directs queries about the dimensions and extent of using particular neuroS/T in practice (i.e., "6-W questions"); and frames such use within specific contexts and contingencies as relative and relevant to maximizing benefits, and mitigating burdens and risks that may be incurred by patients, publics, and so on (i.e., the "6-C concept"; Giordano, 2016a, 2015a, 2015b; Giordano, Casebeer, and Sanchez, 2014).

The "6-W questions" define patterns of employment, depict targeted benefits, and discern burdens and harms that are likely to be incurred by the use of neuroS/T. These questions are:

> **What** neuroS/T approaches are being considered and/or advocated for use; and what are the identified benefits, and potential burdens, risks, and/or harms?
>
> **Why** are specific neuroS/T approaches being considered (e.g., in light of their actual capabilities to affect pathology, cognition, emotion, and/or behavior; inadequacy/ineffectiveness of other approaches, etc.)?
>
> **Who** will receive such neuroS/T (e.g., specific individuals, groups, etc.)?
>
> **When** will particular types of neuroS/T be considered and/or advocated for use (e.g., within a medical treatment protocol; under certain occupational conditions and contingencies)?
>
> **Where** will neuroS/T be utilized/provided (e.g., clinical, para-clinical/ occupational, or other settings)?
>
> **Which** programs of subsidy will be used and/or developed to support both provision of neuroS/T as well as continuity of research and care necessary for sound translation of brain science in practice?

These questions should be framed by/within a 6-C concept that builds upon the work of Casebeer (2013) to characterize and examine the development and use of neuroS/T with reference and as relevant to:

> **Capacities**—of the science and technology in question;
>
> **Consequences**—of research and/or use of neuroscientific knowledge and/or tools in practice;
>
> **Character**—of both the research, and how use(s) of neuroS/T might affect individual and/or community identity and ontology;
>
> **Continuity of Clinical Care and Research**—as necessary to address and manage any/all effects incurred by using certain neuroscientific techniques and technologies;
>
> **Consent**—with regard to the nature, extent, and provision of available information as required to assure voluntary participation in research trials or use of neuroS/T;
>
> **Contexts**—in which specific types of neuroS/T might be used within various situations, institutions, and sociocultural contingencies that may affect the aforementioned variables.

"As long as our brain is a mystery, the universe, the reflection of the structure of the brain will also be a mystery."

SANTIAGO RAMÓN Y CAJAL (1852–1934)
Spanish physician and neuroscience pioneer, recipient of the Noble Prize for Medicine in 1906. *Chácaras de café* (1920).

Semi-schematic cross-section of a mammal's cerebral gyrus. Drawing by Santiago Ramón y Cajal, c. 1888.

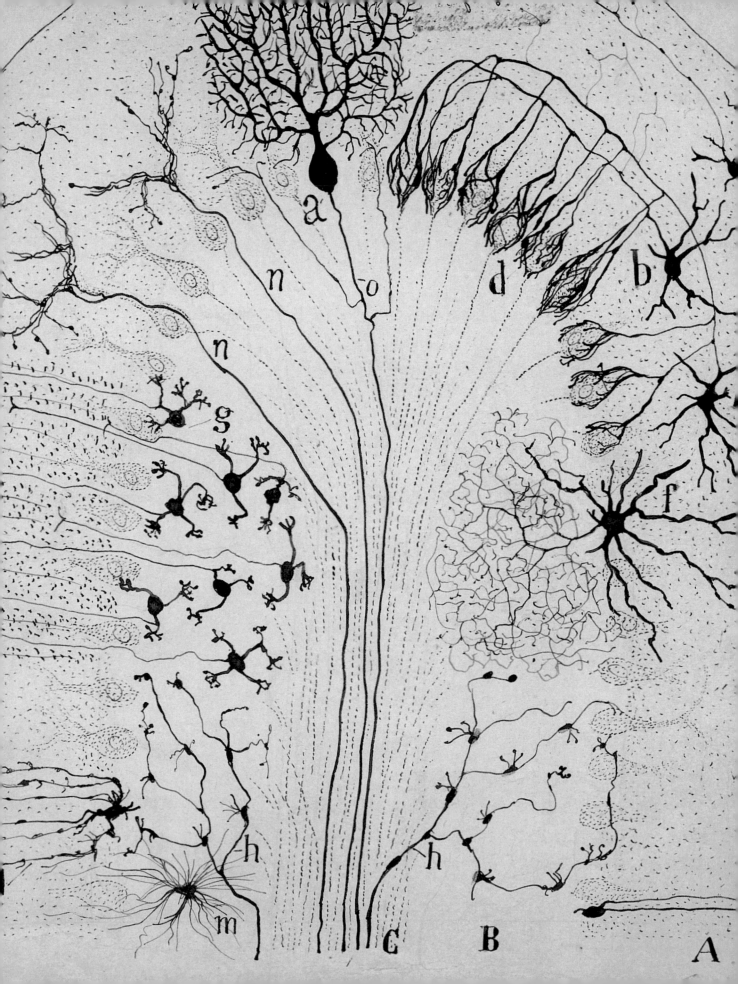

Extant evidence from the international peer-reviewed literature, public media and forums, and commercial trends can be employed both to map key NELSI domains generated by neuroS/T in global contexts, and to identify those foci that are of primary concern and importance (Nuffield Council on Bioethics, 2013; Schnabel et al., 2014). Such investigations can reveal the extent and interactions of various domains of effect and influence, and can be employed to 1) model NELSI (domains) incurred by various uses of neuroS/T, and 2) develop patterns of interactions and interconnection(s) between emerging scientific and technological developments and various domains of a society in which ethico-legal issues may arise and exert influence.

In some cases, however, patterns of neuroS/T use(s) and effect(s) will be entirely new. In such situations, a more casuistic approach may be required to provide prior exemplars that may serve as comparitors from which plots of near- to mid-term future trajectories can be developed. Toward such ends, we have proposed a method referred to by the acronym *HISTORY*—that addresses *h*istoricity and *i*mplications of *S/T*, and engages *o*mbudsmanship, and *r*esponsible *y*eomanry in the pragmatic elucidation, and address of ethical-legal and social issues and problems generated by S/T in specific contexts (Giordano and Benedikter, 2013; Tractenberg, FitzGerald, and Giordano, 2014). Historical analysis of the influence and implications of S/T is an important step toward ombudsmanship: revealing and depicting ethico-legal and social issues and problems evoked by S/T and its various applications in a given social setting. From this arises responsible yeomanry: the identification and analysis of actual capabilities and limitations of neuroS/T, and the needs, values, and mores of individuals and communities that will utilize and be affected by such tools and techniques.

Whether assessed by depiction of extant progress, or via casuistic evaluation of previous relevant trends, the modelling of social effects of neuroS/T characteristically entails extrapolations of concept-to-construct articulation. However, we have shown that modelling neuroS/T progress and influence beyond a ten- to fifteen-year future horizon becomes difficult due to fractal growth of S/T, reciprocal interaction(s) of S/T and social forces, and resulting diversity of potential (known and unknown) effects (Schnabel et al., 2014). This is particularly true of NELSI generated in and by dual use of neuroS/T, given world stage economic and political scenarios that affect national security agenda and the employment of biotechnology in military operations (Abney, Lin, and Mehlman, 2014; Dando, 2015; Giordano, 2016a; 2014; Giordano, Forsythe, and Olds, 2010; Tabery, 2014).

Force-planning techniques may be useful—if not essential—for enabling preparation for circumstances and effects incurred by neuroS/T development and articulation at the upper limit of these ten-to-fifteen-year timespans. Force planning employs a multidisciplinary and multifaceted approach to appraise strategic needs set forth in strategy, establishes requirements to meet these needs, and selects capabilities that will optimally suit operational requirements as projected over a defined time frame (ten to fifteen years). This process entails analyzing resource constraints, changing environments, and risks (e.g., uncertainty and negative outcomes associated with mismatches among essential factors) to discern key variables so as to optimize modelling and planning for NELSI and their effects in and upon given sociocultural settings (Giordano, 2016a).

If and when used within an integrative approach to neuroS/T assessment, the engagement and adaptation of extant force-planning methods could provide a valid and valuable approach to neuroS/T and NELSI modelling. Such methods can: 1) enable a more flexible and responsive orientation to predicting and describing likely public health, socio-economic, political, and military scenarios that can shape if, why, what, and how neuroS/T may progress within international ecologies; 2) define key NELSI arising in and from these trajectories and scenarios, and in these ways 3) inform proximate and mid-term future guidance and governance of neuroS/T. At present, we are developing modelling and gaming-simulation protocols that identify domains and plot trajectories of effect generated by uses and applications of neuroS/T at varying timepoints of extrapolation, and under multivariate conditions (Schnabel et al., 2014).

ENGAGING NEUROETHICS IN PRACTICE

Recent recommendations, such as those offered by the Presidential Commission for the Study of Bioethical Issues (2015) and federal guidelines and regulations (e.g., ICH E-6, ISO 14155; 2011; and 21 CFR 812.43) provide important parameters for research and use of neuroS/T. However, a number of neuroethical challenges remain, as the breadth, pace, and distribution of neuroS/T, and the demand for such techniques and technologies expand (Giordano and Shook, 2015). Indubitably, neuroS/T can and will affect and be affected by sociocultural needs, values, and views. Although some needs and values may be common to many if not all cultures, others will differ.

Thus, existing ethical precepts and principles, while viable—and valuable—in some cases, will likely not be sufficient or adequate to address and guide the specific situations and contingencies posed by the varied (sociocultural) contexts in which neuroS/T is being developed and/or employed (Levy, 2010; Giordano, 2010; Giordano and Benedikter, 2012a, 2012b; Shook and Giordano, 2014). We have opined that the internationalization of neuroS/T necessitates a move away from older, exclusively Western philosophy and ethics. A contemporary neuroethics can only be meaningful and applicable upon the twenty-first-century world stage if the sociocultural contingencies and exigencies of various stake- and shareholders in neuroS/T are taken into accord. To account for this, we have endorsed a cosmopolitan approach that can be articulated within particular communitarian contexts

through adapting certain existing principles and the development of others. While hypothetical and tentative, we maintain that this construct, while not without problems (such as potential tensions arising from inter-communitarian engagement), affords promise as a methodological paradigm for a "globalizable" neuroethics (Lanzilao et al., 2013).

Neuroethical address and guidance of neuroS/T research and use will require dedicated efforts toward the formation of working groups, ongoing discourse, formulation of methods and protocols, and establishment of national and internationally relevant and viable standards and guidelines. We have proposed that a defined percentage of the total budgets of national initiatives dedicated to brain research be allocated to addressing key NELSI arising in and from funded neuroscientific projects (Giordano and Shook, 2015). Specifically, we advocate a nonagnostic approach, in which there is targeted address of the NELSI that could likely be generated by the science that would be conducted under particular requests for proposals (RFPs). As well, equivalent investment by the private and commercial sectors would be instrumental to establishing well-conceived and NELSI projects that reflect and are aligned with the direction, scope, and activities of these groups' respective endeavors in neurotechnological research and its translation (Avram and Giordano, 2014; Lanzilao et al., 2013).

Working in concert, efforts of federal and private (i.e., commercial and philanthropic) entities could aggregate funding to support the formation of a network of neuroethics centers (both in and outside of academia) that would serve as interactive (and in some cases, governmentally independent) resources to conjoin multidisciplinary scholars and practitioners to focus upon key NELSI that are germane to major areas of neuroS/T investment, development, and articulation affecting various spheres of society (e.g., medicine, public life, the military, etc.). As well, it will be vitally important to educate professionals (in a variety of fields, including the sciences, humanities, law, and politics) as well as the general public about what neuroS/T can and cannot do, given the current level and planned courses of research, development, and use, and the NELSI likely to be spawned by the realistic employment of neuroS/T. Indeed, learning must precede positive change, and absent this learning, change can evoke false hopes or fear, and give rise to misdirected action—often with dire consequences.

CONCLUSION

I have stated that it would be unwise, if not wholly irresponsible to: "...ignore the gravitas of neuroscientific information, its impact upon society, the resultant ethical (and legal) situations that will arise, and necessity to make moral decisions about the ways neuroscience and its tools are employed" (Giordano, 2011), and hence have repeatedly called for "no new neuroS/T without neuroethics" (Giordano, 2015c). But equally, I appeal for any and all neuroethico-legal deliberation to be soundly based upon the realities of brain science and its actual capabilities, limitations, and uses (i.e., "no neuroethics without neuroscience").

Moreover, while ethical deliberation and explications may be vociferous, such discourses can be vacuous unless there is directed effort to inform the development of guidelines and policies (Giordano, 2015c; Giordano and Shook, 2015). However, the pace of scientific and technological development often outstrips that of policy formulation. While on one the hand, this could be viewed as enabling deep and equivocal discourse about science and technology, and its societal implications and effects, on the other, it can rightly be seen as rendering policy to be post-facto and reactive, rather than reflexive and proactive. So, by the time policies are enacted, they may in fact be implementing governance of dated effects and "old" science and technology (Swetnam et al., 2013).

Thus, guidelines and policy must be informed in a timely manner, and must remain relatively flexible to meet contingencies fostered by iterative developments in neuroS/T and the social domains in which such science is articulated. It is inevitable that neuroS/T is, and will become, an ever more salient reality—and powerful force. How this force and power will be manifested in the future is dependent upon—and subject to—current and ongoing neuroethical address, deliberation, and prudent engagement toward guidelines and policies that shape and direct the use of neuroS/T in twenty-first-century society.

> "That we would do / We should do when we would"
> Shakespeare (*Hamlet*, 4.7: 118–119)

ACKNOWLEDGMENTS

This chapter was adapted from the author's works, "Neuroethics: Traditions, tasks and values," *Human Prospect* 1(1): 2–8 (2011); "The human prospect(s) of neuroscience and neurotechnology: Domains of influence and the necessity—and questions—of neuroethics," *Human Prospect* 4(1): 1–18 (2014); and "Toward an operational neuroethical risk analysis and mitigation paradigm for emerging neuroscience and technology (neuroS/T)," *Exp Neurol* (2016); with permission. This work was supported, in part, by funding from the William H. and Ruth Crane Schaefer Endowment, Clark Foundation, and the Lawrence Livermore National Laboratory. The author serves as an appointed member of the Neuroethics, Legal, and Social Issues Advisory Panel of the United States' Defense Advanced Research Projects Agency (DARPA). The views expressed in this chapter are those of the author, and do not necessarily reflect those of DARPA, the United States Department of Defense, or Department of Energy.

—Abney, K., Lin, P., and Mehlman, M. 2014. "Military neuroenhancement and risk assessment." In *Neurotechnology in National Security and Defense: Practical Considerations, Neuroethical Concerns*, J. Giordano (ed.). Boca Raton, FL: CRC Press, 239–248.

—Anderson, M. A., Fitz, N., and Howlader, D. 2012. "Neurotechnology research and the world stage: Ethics, biopower and policy." In *Neurotechnology: Premises, Potential and Problems*, J. Giordano (ed.). Boca Raton, FL: CRC Press, 287–300.

—Avram, M., and Giordano, J. 2014. "Neuroethics: Some things old, some things new, some things borrowed... and to do." *AJOB-Neuroscience* 5(4): 1–3.

—Casebeer, W. 2013. "Ethical issues associated with the BRAIN Initiative and ongoing work in neuroscience." Presented at the 14th Meeting of the Presidential Commission for the Study of Bioethical Issues, 20, August 2013, Philadelphia, PA.

—Dando, M. 2015. *Neuroscience and the Future of Chemical-Biological Weapons*. New York: Palgrave Macmillan.

—Gini, A., and Giordano, J. 2010. "The human condition and strivings to flourish." In *Scientific and Philosophical Perspectives in Neuroethics*, J. Giordano, and B. Gordijn (eds.). Cambridge: Cambridge University Press, 343–354.

—Gini, A., Rossi, P. J., and Giordano, J. 2010. "Considering enhancement and treatment: On the need to regard contingency and develop dialectic evaluation." *AJOB-Neuroscience* 1(1): 25–27.

—Giordano, J. 2010. "The mechanistic paradox: The relationship of science, technology, ethics and policy." *Synesis: A Journal of Science, Technology, Ethics, and Policy* 1(1): G1–4.

—Giordano, J. 2011. "Neuroethics: Two interacting traditions as a viable meta-ethics?" *AJOB-Neuroscience* 3(1): 23–25.

—Giordano, J. 2012a. "Neurotechnology as demiurgical force: Avoiding Icarus' folly." In *Neurotechnology: Premises, Potential and Problems*, J. Giordano, (ed.). Boca Raton, FL: CRC Press, 1–14.

—Giordano, J. (ed.). 2012b. *Neurotechnology: Premises, Potential and Problems*. Boca Raton, FL: CRC Press.

—Giordano, J. 2014. "The human prospect(s) of neuroscience and neurotechnology: Domains of influence and the necessity—and questions—of neuroethics." *Human Prospect* 4(1): 1–18.

—Giordano, J. 2015a. "A preparatory neuroethical approach to assessing developments in neurotechnology." *AMA J Ethics* 17(1): 56–61.

—Giordano, J. 2015b. "Conditions to the consent for use of neurotechnology: A preparatory neuroethical approach to risk assessment and reduction." *AJOB-Neuroscience* 6(4): 12–13.

—Giordano, J. 2015c. "No new neuroscience without neuroethics." BioMed Central Blog Network, available at: http://blogs.biomedcentral.com/on-health/2015/07/08/no-new-neuroscience-without-neuroethics.

—Giordano, J. 2016a. "Toward an operational neuroethical risk analysis and mitigation paradigm for emerging neuroscience and technology (neuroS/T)." *Exp Neurol*.

—Giordano, J. 2016b. "The neuroweapons threat." *Bull Atomic Sci* 72(3): 1–4.

—Giordano, J., and Benedikter, R. 2012a. "An early—and necessary—flight of the Owl of Minerva: Neuroscience, neurotechnology, human socio-cultural boundaries, and the importance of neuroethics." *J Evolution and Technol* 22(1): 14–25.

—Giordano, J., and Benedikter, R. 2012b. "Neurotechnology, culture and the need for a cosmopolitan neuroethics." In *Neurotechnology: Premises, Potential and Problems*, J. Giordano (ed.). Boca Raton, FL: CRC Press, 233–242.

—Giordano, J., and Benedikter, R. 2013. "HISTORY: Historicity and implications of science and technology, ombudsmanship, responsibility and yeomanry: A methodic approach to neuroethics." Paper presented at the 5th Annual Meeting of the International Neuroethics Society, November 15, 2013, San Diego, CA.

—Giordano, J., Casebeer, W., and Sanchez, J. 2014. "Assessing and managing risks in systems neuroscience research and its translation: A preparatory neuroethical approach." Paper presented at the 6th Annual Meeting of the International Neuroethics Society, November 13–14, 2014, Washington DC.

—Giordano, J., Forsythe, C., and Olds, J. 2010. "Neuroscience, neurotechnology and national security: The need for preparedness and an ethics of responsible action." *AJOB-Neuroscience* 1(2): 1–3.

—Giordano, J., and Olds, J. 2010. "On the interfluence of neuroscience, neuroethics and legal and social issues: The need for (N)ELSI." *AJOB-Neuroscience* 2(2): 13–15.

—Giordano, J., and Shook, J. R. 2015. "Minding brain science in medicine: On the need for neuroethical engagement for guidance of neuroscience in clinical contexts." *Ethics Biol Engineer Med* 6(1–2): 37–42.

—Hughes, J. J. 2006. "Human enhancement and the emergent technopolitics of the 21st century." In *Managing Nano-Bio-Info-Cogno Innovations*, W. S. Bainbridge, and M. C. Roco (eds.). New York: Springer, 285–307.

—Lanzilao, E., Shook, J., Benedikter, R., and Giordano, J. 2013. "Advancing neuroscience on the 21st century world stage: The need for—and proposed structure of—an internationally relevant neuroethics." *Ethics Biol Engineer Med* 4(3): 211–229.

—Levy, N. 2010. "Neuroethics: A new way of doing ethics." *AJOB-Neuroscience* 2(2): 3–9.

—Lynch, Z., and McCann, C. M. 2010. "Neurotech clusters 2010–2020: Leading regions in the global neurotechnology industry 2010–2020." *NeuroInsights Report 2009*, San Francisco, CA.

—Martin, A., Becker, K., Darragh, M., and Giordano, J. 2016. "A four-part bibliography of neuroethics: Part 3: The ethics of neuroscience." *Phil Ethics Humanities in Med* 11(3).

—NeuroInsights. 2015. NeuroInsights home page. Available at: http://www.neuroinsights.comneurotech-2015.

—Nuffield Council on Bioethics. 2013. *Novel Neurotechnologies: Intervening in the Brain*. London: Nuffield Council on Bioethics Reports.

—Presidential Commission for the Study of Bioethical Issues. 2015. *Gray Matters. Topics at the Intersection of Neuroscience, Ethics, and Society,* Vol. 2. Washington DC: Presidential Commission for the Study of Bioethical Issues Press.

—Sarewitz, D., and Karras, T. H. 2012. "Policy implications of technology for cognitive enhancement." In: Giordano, J. (ed.) *Neurotechnology: Premises, Potential and Problems*, J. Giordano (ed.). Boca Raton, FL: CRC Press, 267–286.

—Schnabel, M., Kohls, N. B., Shepard, B., and Giordano, J. 2014. "New paths through identified fields: Mapping domains of neuroethico-legal and social issues of global use of neurotechnology by quantitative modeling and probability plotting within a health promotions' paradigm." Paper presented at the 6th Annual Meeting of the International Neuroethics Society, November 13–14, 2014, Washington DC.

—Shakespeare, W. 1965. *Hamlet.* New York: Penguin Press, 4.7: 118–119.

—Shook, J. R., and Giordano, J. 2014. "A principled, cosmopolitan neuroethics: Considerations for international relevance." *Phil Ethics Humanities in Med* 9 (1).

—Shook, J. R., and Giordano, J. 2016. "Neuroethics beyond normal. Performance enablement and self-transformative technologies." *Camb Q Healthcare Ethics—Neuroethics Now* 25: 121–140.

—Swetnam, M., McBride, D., Herzfeld, C., Barnett, J., Schiller, K., Gallington, D., Retelle, J., Siegrist, D., Buss, J., and Giordano, J. 2013. *Neurotechnology Futures Study: A Roadmap for the Development of Neuroscience and Neurotechnology That Will Lead to the Economic Revolution of the 21st Century*. Arlington, VA: Potomac Institute Press.

—Tabery, J. 2014. "Can (and should) we regulate neurosecurity? Lessons from history." In *Neurotechnology in National Security and Defense: Practical Considerations, Neuroethical Concerns*, J. Giordano (ed.). Boca Raton, FL: CRC Press, 249–258.

—Tractenberg, R. E., FitzGerald, K. T., and Giordano, J. 2014. "Engaging neuroethical issues generated by the use of neurotechnology in national security and defense: Toward process, methods and paradigm." In *Neurotechnology in National Security and Defense: Practical Considerations, Neuroethical Concerns*, J. Giordano (ed.). Boca Raton, FL: CRC Press, 259–278.

Hyperhistory, the Emergence of the MASs, and the Design of Infraethics

LUCIANO FLORIDI

Luciano Floridi
Oxford Internet Institute, University of Oxford, Oxford, UK

Luciano Floridi is Professor of Philosophy and Ethics of Information at the
University of Oxford, UK. Among his recent books, all published by Oxford
University Press: *The Fourth Revolution—How the Infosphere is Reshaping
Human Reality* (2014), *The Ethics of Information* (2013), and *The Philosophy
of Information* (2011). He is a member of the EU's Ethics Advisory Group
on Ethical Dimensions of Data Protection, of the Royal Society and British
Academy Working Group on Data Governance, of Google Advisory Board
on "the right to be forgotten," and Chairman of the Ethics Advisory Board
of the European Medical Information Framework.

The Copernican revolution displaced us from the center of the universe. The Darwinian revolution displaced us from the center of the biological kingdom. And the Freudian revolution displaced us from the center of our mental lives. Today, Computer Science and digital ICTs are causing a fourth revolution, radically changing once again our conception of who we are and our "exceptional centrality." We are not at the center of the infosphere. We are not standalone entities, but rather interconnected informational agents, sharing with other biological agents and smart artifacts a global environment ultimately made of information. Having changed our views about ourselves and our world, are ICTs going to enable and empower us, or constrain us? The answer lies in an ecological and ethical approach to natural and artificial realities. We must put the "e" in an environmentalism that can deal successfully with the new issues caused by the fourth revolution.

HYPERHISTORY

More people are alive today than ever before in the evolution of humanity. And more of us live longer[1] and better[2] today than ever before. To a large measure, we owe this to our technologies, at least insofar as we develop and use them intelligently, peacefully, and sustainably.

Sometimes, we may forget how much we owe to flints and wheels, to sparks and ploughs, to engines and satellites. We are reminded of such deep technological debt when we divide human life into prehistory and history. That significant threshold is there to acknowledge that it was the invention and development of information and communication technologies (ICTs) that made all the difference between who we were and who we are. It is only when the lessons learned by past generations began to evolve in a Lamarckian rather than a Darwinian way that humanity entered into history.

History has lasted six thousand years, since it began with the invention of writing in the fourth millennium BC. During this relatively short time, ICTs have provided the *recording* and *transmitting* infrastructure that made the escalation of other technologies possible, with the direct consequence of furthering our dependence on more and more layers of technologies. ICTs became mature in the few centuries between Guttenberg and Turing. Today, we are experiencing a radical transformation in our ICTs that could prove equally

significant, for we have started drawing a new threshold between history and a new age, which may aptly be called *hyperhistory* (Figure 1). Let me explain.

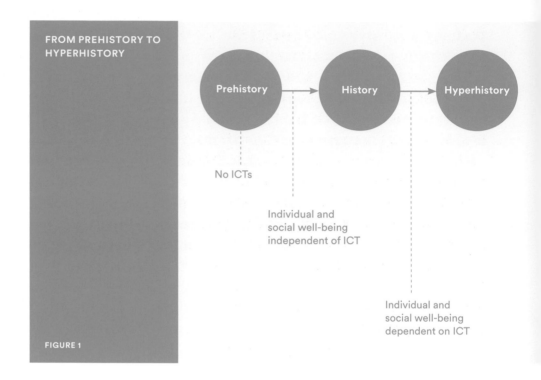

FROM PREHISTORY TO HYPERHISTORY

Prehistory → History → Hyperhistory

No ICTs

Individual and social well-being independent of ICT

Individual and social well-being dependent on ICT

FIGURE 1

Prehistory (i.e., the period before written records) and history work like adverbs: they tell us *how* people live, not *when* or *where*. From this perspective, human societies currently stretch across three ages, as ways of living. According to reports about an unspecified number of uncontacted tribes in the Amazonian region, there are still some societies that live prehistorically, without ICTs or at least without recorded documents. If one day such tribes disappear, the end of the first chapter of our evolutionary book will have been written. The greatest majority of people today still live historically, in societies that rely on ICTs to *record* and *transmit* data of all kinds. In such historical societies, ICTs have not yet overtaken other technologies, especially energy related ones, in terms of their vital importance. Then there are some people around the world who are already living hyperhistorically, in societies or environments where ICTs and their data *processing* capabilities are the necessary condition for the maintenance and further development of societal welfare, personal well-being, as well as intellectual flourishing. The nature of conflicts provides a sad test for the reliability of this tripartite interpretation of human evolution. Only a society that lives hyperhistorically can be vitally threatened informationally, by a cyber attack. Only those who live by the digit may die by the digit.[3]

To summarize, human evolution may be visualized as a three-stage rocket: in prehistory, there are no ICTs; in history, there are ICTs, they *record* and *transmit* data, but human societies depend mainly on other kinds of technologies concerning primary resources and energy; in hyperhistory, there are ICTs, they record, transmit, and, above all, *process* data, increasingly autonomously, and human societies become vitally dependent on them and on information as a fundamental resource. Added-value moves from being ICT-related to being ICT-dependent. We can no longer unplug our world from ICTs without turning it off.

If all this is even approximately correct, the emergence from its historical age represents one of the most significant steps ever taken by humanity. It certainly opens up a vast horizon of opportunities as well as challenges and difficulties, all essentially driven by the recording, transmitting, and processing powers of ICTs. From synthetic biochemistry to neuroscience, from the Internet of Things to unmanned planetary explorations, from green technologies to new medical treatments, from social media to digital games, from agricultural to financial applications, from economic developments to the energy industry, our activities of discovery, invention, design, control, education, work, socialization, entertainment, care, security, business, and so forth would be not only unfeasible but unthinkable in a purely mechanical, historical context. They have all become hyperhistorical in nature today. It follows that we are witnessing the defining of a macroscopic scenario in which hyperhistory, and the re-ontologization of the infosphere in which we live, are quickly detaching future generations from ours.

Of course, this is not to say that there is no continuity, both backward and forward. *Backward*, because it is often the case that the deeper a transformation is, the longer and more widely rooted its causes may be. It is only because many different forces have been building the pressure for a very long time that radical changes may happen all of a sudden, perhaps unexpectedly. It is not the last snowflake that breaks the branch of the tree. In our case, it is certainly history that begets hyperhistory. There is no ASCII without the alphabet. *Forward*,

because it is most plausible that historical societies will survive for a long time in the future, not unlike those prehistorical Amazonian tribes mentioned before. Despite globalization, human societies do not parade uniformly forward, in synchronic steps.

Such a long-term perspective should help to explain the slow and gradual process of political *apoptosis* that we are undergoing, to borrow a concept from cell biology. Apoptosis (also known as programmed cell death) is a natural and normal form of self-destruction in which a programmed sequence of events leads to the self-elimination of cells. Apoptosis plays a crucial role in developing and maintaining the health of the body. One may see this as a dialectical process of renovation, and use it to describe the development of nation states into information societies in terms of political apoptosis (see Figure 2), in the following way.

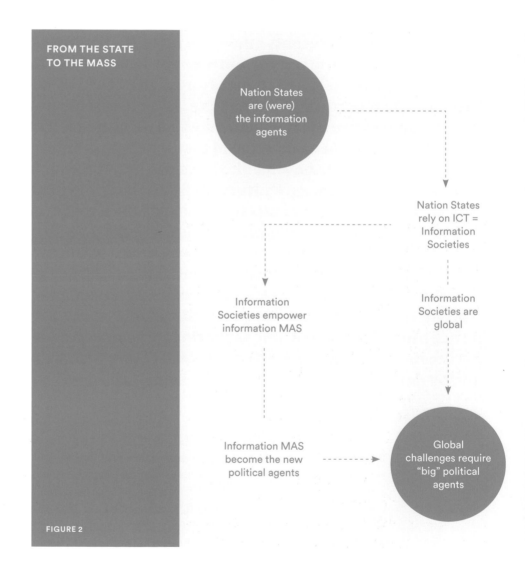

FROM THE STATE TO THE MASS

Nation States are (were) the information agents

Nation States rely on ICT = Information Societies

Information Societies empower information MAS

Information Societies are global

Information MAS become the new political agents

Global challenges require "big" political agents

FIGURE 2

Oversimplifying, a quick sketch of the last four hundred years of political history may look like this. The Peace of Westphalia (1648) meant the end of World War Zero, namely the Thirty Years' War, the Eighty Years' War, and a long period of other conflicts during which European powers, and the parts of the world they dominated, massacred each other for economic, political, and religious reasons. Christians brought hell to each other with staggering violence and unspeakable horrors. The new system that emerged in those years, the so-called *Westphalian order*, saw the coming of maturity of sovereign states and then nation states as we still know them today, France, for example. Think of the time between the last chapter of *The Three Musketeers*—when D'Artagnan, Aramis, Porthos, and Athos take part in Cardinal Richelieu's siege of La Rochelle in 1628—and the first chapter of *Twenty Years Later*, when they come together again, under the regency of Queen Anne of Austria (1601–66) and the ruling of Cardinal Mazarin (1602–61). The state became not a monolithic, single-minded, well-coordinated agent, the sort of beast (Hobbes' Leviathan) or rather robot that a later, mechanical age would incline us to imagine. It never was. Rather, it rose to the role of the binding power, the network able to keep together, influence, and coordinate all the different agents and behaviors falling within the scope of its geographical borders. Citizenship had been discussed in terms of biology (your parents, your gender, your age…) since the early city-states of ancient Greece. It became more flexible (degrees of citizenship) when it was conceptualized in terms of legal status as well, as under the Roman Empire, when acquiring a citizenship (a meaningless idea in purely biological contexts) meant becoming a rights holder.

With the modern state, geography started playing an equally important role, mixing citizenship with nationality and locality. In this sense, the history of the passport is enlightening. As a means to prove one's own identity, it is acknowledged to be an invention of King Henry V of England (1386–1422), centuries before the Westphalian order took place. However, it is the Westphalian order that makes possible the passport as we understand it today: a document that entitles the holder not to travel (e.g., a visa may also be required) or be protected abroad, but to return to (or be sent back to) the country that issued the passport. It is, metaphorically, an elastic band that ties the holder to a geographical point, no matter how long in space and prolonged in time the journey in other lands is. Such a document became increasingly useful the better that geographical point was defined. Readers may be surprised to know that travelling was still quite passport-free in Europe until World War I, when security

pressure and techno-bureaucratic means caught up with the need to disentangle and manage all those elastic bands travelling around by train.

Back to the Westphalian order. Now the physical and legal spaces overlap and they are both governed by sovereign powers, which exercise control through physical force to impose laws and ensure their respect within the national borders. Mapping is not just a matter of travelling and doing business, but also an introvert question of controlling one's own territory, and an extrovert question of positioning oneself on the globe. The taxman and the general look at those lines with eyes very different from those of today's users of Expedia. For sovereign states act as multiagent systems (or MASs, more on them later) that can, for example, raise taxes within their borders and contract debts as legal entities (hence our current terminology in terms of "sovereign debt," which are bonds issued by a national government in a foreign currency), and they can of course dispute borders. Part of the political struggle becomes not just a silent tension between different components of the state-MAS, say the clergy versus the aristocracy, but an explicitly codified balance between the different agents constituting it. In particular, Montesquieu suggests the classic division of the state's political powers that we take for granted today. The state-MAS organizes itself as a network of three "small worlds"—a legislature, an executive, and a judiciary—among which only some specific kinds of information channels are allowed. Today, we may call this Westphalian 2.0.

With the Westphalian order, modern history becomes the age of the state, and the state becomes *the* information agent, which legislates on and controls (or at least tries to control), insofar as it is possible, all technological means involved in the information life cycle including education, census, taxes, police records, written laws and rules, press, and intelligence. Already most of the adventures in which D'Artagnan is involved are caused by some secret communication. The state thus ends by fostering the development of ICTs as a means to exercise and maintain political power, social control, and legal force, but in so doing it also undermines its own future as the only, or even the main, information agent.

As I shall explain in more detail later, ICTs, as one of the most influential forces that made the state possible and then predominant as a historical driving force in human politics, also contributed to make it less central, in the social, political, and economic life across the world, putting pressure on centralized government in favor of distributed governance and international, global coordination. The state developed by becoming more and more an information society, thus progressively making itself less and less the main information agent. Through the centuries, it moved from being conceived as the ultimate guarantor and defender of a *laissez-faire* society to a Bismarckian welfare system that would take full care of its citizens. The two World Wars were also clashes of nation states resisting mutual coordination and inclusion as part of larger multiagent systems. They led to the emergence of MASs such as the League of Nations, the World Bank, the International Monetary Fund, the United Nations, the European Union, NATO, and so forth. Today, we know that global problems—from the environment to the financial crisis, from social justice to intolerant religious fundamentalisms, from peace to health conditions—cannot rely on nation states as the only sources of a solution because they involve and require global agents. However, in a post-Westphalian world (Linklater, 1998), there is much uncertainty about the new MASs involved in shaping humanity's present and future.

The previous remarks offer a philosophical way of interpreting the *Washington Consensus*, the last stage in the state's political apoptosis. John Williamson coined the expression "Washington Consensus" in 1989, in order to refer to a set of ten specific policy recommendations that he found to constitute a standard strategy adopted and promoted by institutions based in Washington DC—such as the US Treasury Department, the International Monetary Fund (IMF), and the World Bank—when dealing with countries that needed to cope with economic crises. The policies concerned macroeconomic stabilization, economic opening with respect to both trade and investment, and the expansion of market forces within the domestic economy. In the past quarter of a century, the topic has been the subject of intense and lively debate, in terms of correct description and acceptable prescription: does the Washington Consensus capture a real historical phenomenon? Does the Washington Consensus ever achieve its goals? Is it to be re-interpreted, despite Williamson's quite clear definition, as the imposition of neoliberal policies by Washington-based international financial institutions on troubled countries? These are important questions, but the real point of interest here is not the hermeneutical, economic, or normative evaluation of the Washington Consensus. Rather, it is the fact that the very idea, even if it remains only an influential idea, captures a significant aspect of our hyperhistorical, post-Westphalian time. For the Washington Consensus may be seen as the coherent outcome of the United Nations Monetary and Financial Conference, also known as the *Bretton Woods Conference* (Steil, 2013). This gathering in 1944 of 730 delegates from all forty-four Allied nations at the Mount Washington Hotel in Bretton Woods, New Hampshire, United States, regulated the international monetary and financial order after the conclusion of World War II. It saw the birth of the International Bank for Reconstruction and Development (IBRD, together with its concessional lending arm, the International Development Association, it is known as the World Bank), of the General Agreement on Tariffs and Trade (GATT, which will be replaced by the World Trade Organization in 1995), and the International Monetary Fund. In short, Bretton Woods sealed the official emergence of a variety of MASs as supranational or

intergovernmental forces involved with the world's political, social, and economic problems. Thus, Bretton Woods and later on the Washington Consensus highlight the fact that, after World War II, organizations and institutions (not only those in Washington DC) that are not states but rather nongovernmental MASs are openly acknowledged to act as major, influential forces on the political and economic scene internationally, dealing with global problems through global policies. The very fact (no matter whether correct or not) that the Washington Consensus has been accused of being widely mistaken in disregarding local specificities and global differences reinforces the point that a variety of powerful MASs are now the new sources of policies in the globalized information societies.

All this helps to explain why—in a post-Westphalian (emergence of the nation state as the modern, political information agent) and post-Bretton Woods (emergence of non-state MASs as hyperhistorical players in the global economy and politics) world—one of the main challenges we face is how to design the right sort of MASs that could take full advantage of the sociopolitical progress made in modern history, while dealing successfully with the new global challenges that are undermining the best legacy of that very progress in hyperhistory.

Among the many explanations for such a shift from a historical, Westphalian order to a post-Washington Consensus, hyperhistorical predicament in search of a new equilibrium, three are worth highlighting here.

First, *power*. ICTs "democratize" data and the processing/controlling power over them, in the sense that both now tend to reside and multiply in a multitude of repositories and sources, thus creating, enabling, and empowering a potentially boundless number of non-state agents, from the single individual to associations and groups, from macro-agents, like multinationals, to international, intergovernmental, as well as nongovernmental organizations and supranational institutions. The state is no longer the only, and sometimes not even the main, agent in the political arena that can exercise informational power over other informational agents, in particular over (groups of) citizens. The phenomenon is generating a new tension between power and force, where power is informational, and exercised through the elaboration and dissemination of norms, whereas force is physical, and exercised when power fails to orient the behavior of the relevant agents and norms need to be enforced. The more physical goods and even money become information-dependent, the more the informational power exercised by MASs acquires a significant financial aspect.

Second, *geography*. ICTs de-territorialize human experience. They have made regional borders porous or, in some cases, entirely irrelevant. They have also created, and are exponentially expanding, regions of the infosphere where an increasing number of agents (not only human, see Floridi, 2013) operate and spend more and more time, the onlife experience. Such regions are intrinsically stateless. This is generating a new tension between geopolitics, which is global and non-territorial, and the nation state, which still defines its identity and political legitimacy in terms of a sovereign territorial unit, as a country.

Third, *organization*. ICTs fluidify the topology of politics. They do not merely enable but actually promote (through management and empowerment) the agile, temporary, and timely aggregation, disaggregation, and re-aggregation of distributed groups "on demand," around shared interests, across old, rigid boundaries, represented by social classes, political parties, ethnicity, language barriers, physical barriers, and so forth. This is generating new tensions between the nation state, still understood as a major organizational institution, yet

no longer rigid but increasingly morphing into a very flexible MAS itself (I shall return to this point later), and a variety of equally powerful, indeed sometimes even more powerful and politically influential (with respect to the old nation state) non-state organizations, the other MASs on the block. Terrorism, for example, is no longer a problem concerning internal affairs—as some forms of terrorism in the Basque Country, Germany, Italy, or Northern Ireland were—but an international confrontation with a MAS such as Al-Qaeda, the notorious, global, militant Islamist organization.

The debate on direct democracy is thus reshaped. We used to think that it was about how the nation state could reorganize itself internally, by designing rules and managing the means to promote forms of democracy, in which citizens could propose and vote on policy initiatives directly and almost in real time. We thought of forms of direct democracy as complementary options for forms of representative democracy. It was going to be a world of "politics always-on." The reality is that direct democracy has turned into a mass-mediated democracy in the ICT sense of new social media. In such digital democracies, MASs (understood as distributed groups, temporary and timely, and aggregated around shared interests) have multiplied and become sources of influence external to the nation state. Citizens vote for their representatives but influence them via opinion polls almost in real time. Consensus-building has become a constant concern based on synchronic information.

Because of the previous three reasons—power, geography, and organization—the unique position of the historical state as *the* information agent is being undermined from below and overridden from above by the emergence of MASs that have the data, the power (and sometimes even the force, as in the very different cases of the UN, of groups' cyber threats, or of terrorist attacks), the space, and the organizational flexibility to erode the modern state's political clout, to appropriate (some of) its authority and, in the long run, make it redundant in contexts where it was once the only or the predominant informational agent. The Greek crisis, which begun in late 2009, and the agents involved in its management, offer a good template: the Greek government and the Greek state had to interact "above" with the EU, the European Central Bank, the IMF, the rating agencies, and so forth, and "below" with the Greek mass media and the people in Syntagma square, the financial markets and international investors, German public opinion, and so forth.

Of course, the historical nation state is not giving up its role without a fight. In many contexts, it is trying to reclaim its primacy as the information superagent governing the political life of the society that it organizes. In some cases, the attempt is blatant. In the UK, the Labour government introduced the first Identity Cards Bill in November 2004. After several intermediary stages, the Identity Cards Act was finally repealed by the Identity Documents Act 2010, on January 21, 2011. The

failed plan to introduce compulsory ID in the UK should be read from a modern, Westphalian perspective. In many cases, it is "historical resistance" by stealth, as when an information society—which is characterized by the essential role played by intellectual, intangible assets (knowledge-based economy), information-intensive services (business and property services, finance and insurance), and public sectors (especially education, public administration, and health care)—is largely run by the state, which simply maintains its role of major informational agent no longer just legally, on the basis of its power over legislation and its implementation, but now also economically, on the basis of its power over the majority of information-based jobs. The intrusive presence of so-called "state capitalism" with its SOE (State Owned Enterprises) all over the world, from Brazil, to France, to China, is an obvious symptom of hyperhistorical anachronism.

Similar forms of resistance seem only able to delay the inevitable rise of political MASs. Unfortunately, they may involve huge risks, not only locally, but above all globally. Recall that the two World Wars may be seen as the end of the Westphalian system. Paradoxically, while humanity is moving into a hyperhistorical age, the world is witnessing the rise of China, currently a most "historical" sovereign state, and the decline of the US, a sovereign state that more than any other superpower in the past already had a hyperhistorical and multiagent vocation in its federal organization.

We might be moving from a Washington Consensus to a *Beijing Consensus*, described by Williamson as consisting of incremental reform, innovation, and experimentation, export-led growth, state capitalism, and authoritarianism. All this is risky, because the anachronistic historicism of some of China's policies and humanity's growing hyperhistoricism are heading toward a confrontation. It may not be a conflict, but hyperhistory is a force whose time has come, and while it seems very likely that it will be the Chinese state that will emerge deeply transformed, one can only hope that the inevitable friction will be as painless and peaceful as possible. The financial and social crises that the most advanced information societies are currently undergoing may

actually be the very painful but still peaceful price we need pay to adapt to a future post-Washington Consensus order.

The previous conclusion holds true for the historical state in general: in the future, we shall see the political MASs acquire increasing prominence, with the state progressively abandoning its resistance to hyperhistorical changes and evolving into a MAS itself. Good examples are provided by devolution, or the growing trend in making central banks, like the Bank of England or the European Central Bank, independent, public organizations.

The time has come to consider the nature of the political MAS more closely and some of the questions that its emergence is already posing.

THE POLITICAL MASS

The political MAS is a system constituted by other systems,[4] which, as a single agent, is:

a) *teleological*: the MAS has a purpose, or goal, which it pursues through its actions;
b) *interactive*: the MAS and its environment can act upon each other;
c) *autonomous*: the MAS can change its configurations without direct response to interaction, by performing internal transitions to change its states. This imbues the MAS with some degree of complexity and independence from its environment; and finally,
d) *adaptable*: the MAS's interactions can change the rules by which the MAS changes its states. Adaptability ensures that the MAS learns its own mode of operation in a way that depends critically on its experience.

The political MAS becomes *intelligent* (in the sense of being smart) when it implements features a–d efficiently and effectively, minimizing resources, wastefulness and errors, while maximizing the returns of its actions. The emergence of intelligent, political MASs poses many serious questions, five of which are worth reviewing here, even if only quickly: identity and cohesion, consent, social versus political space, legitimacy, and transparency (the transparent MAS).

Identity and Cohesion

Throughout modernity, the state has dealt with the problem of establishing and maintaining its own *identity* by working on the equation between State = Nation, often through the legal means of Citizenship and the narrative rhetoric of Space (the Mother/Father Land) and Time (Story in the sense of traditions, recurrent celebrations of past nation-building events, etc.). Consider, for example, the invention of mandatory military service during the French Revolution, its increasing popularity in modern history, but then the decreasing number of sovereign states that still impose it nowadays. Conscription transformed the right to wage war from an eminently economic problem—Florentine bankers financed the English kings during the Hundred Years War (1337–1453), for example—into also a legal problem: the right of the state to send its citizens to die on its behalf, thus making human life the penultimate value,

available for the ultimate sacrifice, in the name of patriotism. "For King and Country": it is a sign of modern anachronism that, in moments of crisis, sovereign states still give in to the temptation of fuelling nationalism about meaningless, *geographical* spots, often some small islands unworthy of any human loss, from the Falkland Islands or Islas Malvinas to the Senkaku or Diaoyu Islands.

The equation between State, Nation, Citizenship and Land/Story had the further advantage of providing an answer to a second problem, that of *cohesion*, for it answered not just the question of who or what the state is, but also the question of who or what belongs to the state and hence may be subject to its norms, policies, and actions. New political MASs cannot rely on the same solution. Indeed, they face the further problem of having to deal with the decoupling of their political identity and cohesion. The political identity of a MAS may be very strong and yet unrelated to its temporary and rather loose cohesion, as is the case with the Tea Party movement in the US. Both identity and cohesion of a political MAS may be rather weak, as in the international Occupy movement. Or one may recognize a strong cohesion and yet an unclear or weak political identity, as with the population of tweeting individuals and their role during the Arab Spring. Both identity and cohesion of a political MAS are established and maintained through information sharing. The Land is virtualized into the region of the infosphere in which the MAS operates. So Memory (retrievable recordings) and Coherence (reliable updates) of the information flow enable a political MAS to claim some identity and some cohesion, and therefore offer a sense of belonging. But it is, above all, the fact that the boundaries between the online and offline are disappearing, the appearance of the onlife experience, and hence the fact that the virtual infosphere can affect politically the physical space, that reinforces the sense of the political MAS as a real agent. If *Anonymous* had only a virtual existence, its identity and cohesion would be much less strong. Deeds provide a vital counterpart to the virtual information flow to guarantee cohesion. An ontology of interactions replaces an ontology of entities, or, with a word play, *ings* (as in interact-*ing*, process-*ing*, network-*ing*, do-*ing*, be-*ing*, etc.) replace things.

"Technological innovation involves Linvention, acceptance, rejection of change, conflict between the old and the new, movements of wealth and power, modification of labor, new culture, new awareness, new society."

DOMENICO DE MASI (1938–)
Italian labor sociologist, author of
La fantasia e la concretezza (2003).

November 27, 2011. Two Cairo activists consulting *Tweets* on the eve of Egypt's first legislative elections after the fall of dictator Hosni Mubarak.

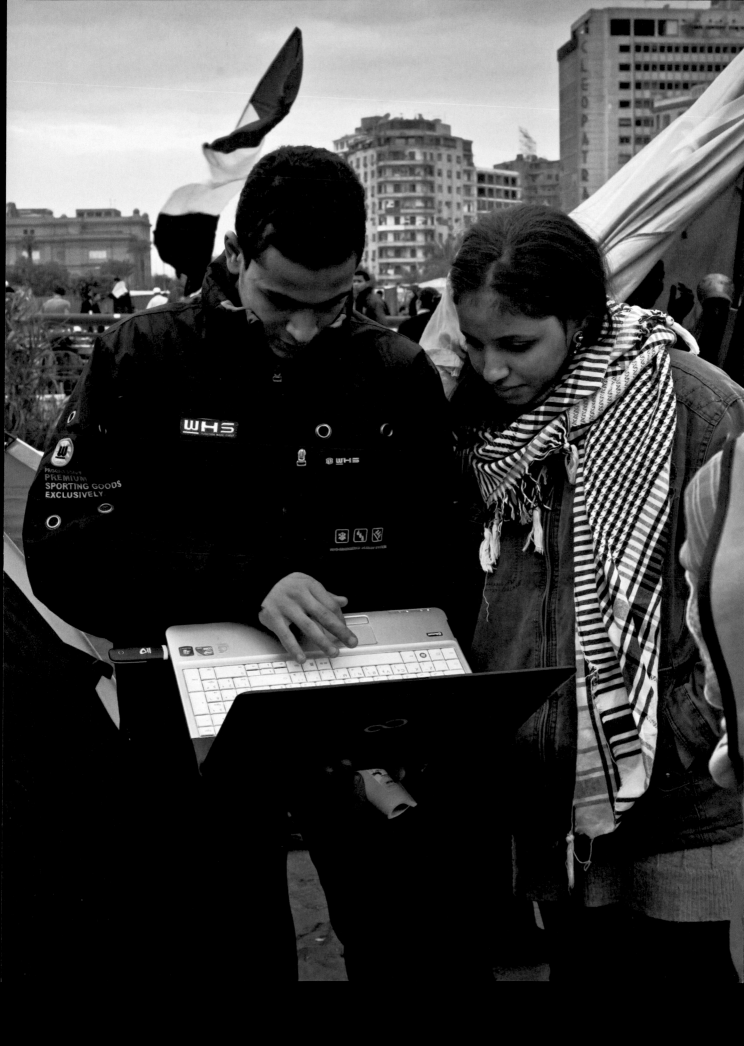

Consent

A significant consequence of the breaking up of the equation "political MAS = Nation State = Citizenship = Land = Story" and of the decoupling of identity and cohesion in a political MAS is that the age-old theoretical problem of how consent to be governed by a political authority arises is being turned on its head. In the historical framework of social contract theory, the presumed default position is that of a legal opt-out: there is some kind of (to be specified) *a priori*, original consent, allegedly given (for a variety of reasons) by any individual subject to the political state, to be governed by the latter and its laws. The problem is to understand how such consent is given and what happens when an agent, especially a citizen, opts out of it (the out-law). In the hyperhistorical framework, the expected default position is that of a social opt-in, which is exercised whenever the agent subjects itself to the political MAS conditionally, for a specific purpose. Oversimplifying, we are moving from being part of the political consensus to taking part in it, and such part-taking is increasingly "just in time," "on demand," "goal-oriented," and anything but permanent or long-term, and stable. If doing politics looks increasingly like doing business it is because, in both cases, the interlocutor, the citizen-customer needs to be convinced every time anew. Loyal membership is not the default position, and needs to be built and renewed around political and commercial products alike. Gathering consent around specific political issues becomes a continuous process of (re)engagement. It is not a question of political attention span—the generic complaint that "new generations" cannot pay sustained attention to political problems anymore is unfounded; they are, after all, the generations that binge-watch TV—but of motivating interest again and again, without running into semantic inflation (one more crisis, one more emergency, one more revolution, one more...) and political fatigue (how many times do we need to intervene urgently?). The problem is therefore to understand what may motivate repeatedly or indeed force agents (again, not just individual human beings, but all kinds of agents) to give such consent and become engaged, and what happens when such agents, unengaged by default (note, not disengaged, for disengagement presupposes a previous state of engagement), prefer to stay away from the activities of the political MAS, inhabiting a social sphere of civil but apolitical "nonimity" (lack of anonymity). Failing to grasp the previous transformation from historical opt-out to hyperhistorical opt-in means being less likely to understand the apparent inconsistency between the disenchantment of individuals with politics and the popularity of global movements, international mobilizations, activism, voluntarism, and other social forces with huge political implications. What is moribund is not politics *tout court*, but historical politics, that based on parties, classes, fixed social roles, and the nation state, which sought political legitimacy only once and spent it until revoked. The inching toward the so-called center by parties in liberal democracies around the world, as well as the "Get out the vote" strategies (GOTV is a term used to describe the mobilization of *voters as supporters* to ensure that those who can do vote) are evidence that engagement needs to be constantly renewed and expanded in order to win an election. Party (as well as Union) membership is a modern feature that is likely to become increasingly less common.

Social vs. Political Space

Understanding the previous inversion of default positions means being faced by a further problem. Oversimplifying once more, in prehistory, the social and the political spaces overlap because, in a stateless society, there is no real difference between social and political relations

and hence interactions. In history, the state seeks to maintain such coextensiveness by occupying, as an informational MAS, all the social space politically, thus establishing the primacy of the political over the social. This trend, if unchecked and unbalanced, risks leading to totalitarianisms (e.g., the Italy of Mussolini), or at least broken democracies (e.g., the Italy of Berlusconi). We have seen earlier that such a coextensiveness and its control may be based on normative or economic strategies, through the exercise of power, force, and rule-making. In hyperhistory, the social space is the original, default space from which agents may move to (consent to) join the political space. It is not accidental that concepts such as *civil society* (in the post-Hegelian sense of nonpolitical society), *public sphere* (also in a non-Habermasian sense), and *community* become increasingly important the more we move into a hyperhistorical context. The problem is to understand such social space where agents of various kinds are supposed to be interacting and which gives rise to the political MAS.

Each agent, as described earlier, has some degrees of freedom. By this I do not mean liberty, autonomy or self-determination, but rather, in the robotic, more humble sense, some capacities or abilities, supported by the relevant resources, to engage in specific actions for a specific purpose. To use an elementary example, a coffee machine has only one degree of freedom: it can make coffee, once the right ingredients and energy are supplied. The sum of an agent's degrees of freedom is its "agency." When the agent is alone, there is of course only agency, but no social let alone political space. Imagine Robinson Crusoe on his "Island of Despair." However, as soon as there is another agent (Friday on the "Island of Despair"), or indeed a group of agents (the native cannibals, the shipwrecked Spaniards, the English mutineers), agency acquires the further value of multiagent (i.e., social) interaction: practices and then rules for coordination and constraint of the agents' degrees of freedom become essential, initially for the well-being of the agents constituting the MAS, and then for the well-being of the MAS itself. Note the shift in the level of analysis: once the social space arises, we begin to consider the group as a group—for example, as a family, or a community, or as a society—and the actions of the individual agents constituting it become elements that lead to the MAS's newly established degrees of freedom, or agency. The previous simple example may still help. Consider now a coffee machine and a timer: separately, they are two agents with different agency, but if they are properly joined and coordinated into a MAS, then the issuing agent has the new agency to make coffee at a set time. It is now the MAS that has a more complex capacity, and that may or may not work properly.

A social space is thus the totality of degrees of freedom of the inhabiting agents one wishes to take into consideration. In history, such consideration—which is really just another level of analysis—was largely determined physically and geographically, in terms of presence in a territory, and hence by a variety of forms of neighborhood. In the previous example, all the agents interacting with Robinson Crusoe are taken into consideration because of their relations (interactive presence in terms of their

degree of freedom) to the same "Island of Despair." We saw that ICTs have changed all this. In hyperhistory, where to draw the line to include, or indeed exclude, the relevant agents whose degrees of freedom constitute the social space has become increasingly a matter of at least implicit choice, when not of explicit decision. The result is that the phenomenon of distributed morality, encompassing that of distributed responsibility, is becoming more and more common. In either case, history or hyperhistory, what counts as a social space may be a political move. Globalization is a de-territorialization in this political sense.

If we now turn to the political space in which the new MASs operate, it would be a mistake to consider it a separate space, over and above the social one: both are determined by the same totality of the agents' degrees of freedom. The political space emerges when the complexity of the social space—understood in terms of number and kinds of interactions and of agents involved, and of degree of dynamic reconfiguring of both agents and interactions—requires the prevention or resolution of potential *divergences* and the coordination or collaboration about potential *convergences*. *Both* are crucial. And in each case more information is required, in terms of representation and deliberation about a complex multitude of degrees of freedom. The result is that the social space becomes politicized through its informatization.

Legitimacy

It is when the agents in the social space agree to agree on how to deal with their divergences (conflicts) and convergences that the social space acquires the political dimension to which we are so used. Yet two potential mistakes await us here.

The first, call it Hobbesian, is to consider politics merely as the prevention of war by other means, to invert the famous phrase by Carl von Clausewitz, according to which "war is the continuation of politics by other means." This is not the case, because even a complex society of angels (*Homo hominis agnus*) would still require rules in order to further its harmony. Convergences too need politics. Out of metaphor, politics is not just about conflicts due to the agents' exercises of their degree of freedom when pursuing their goals. It is also, or at least it should be, above all, the furthering of coordination and collaboration of degrees of freedom by means other than coercion and violence.

The second, and one may call this potential mistake Rousseauian, is that it may seem that the political space is then just that part of the social space organized by law. In this case, the mistake is subtler. We usually associate the political space with the rules or laws that regulate it but the latter are not constitutive, by themselves, of the political space. Compare two cases in which rules determine a game. In chess, the rules do not merely constrain the game, they are the game because they do not supervene on a previous activity: rather, they are the *necessary and sufficient conditions* that determine all and only the moves that can be legally made. In football, however, the rules are supervening *constraints* because the agents enjoy a previous and basic degree of freedom, consisting in their capacity to kick a ball with the foot in order to score a goal, which the rules are supposed to regulate. Whereas it is physically possible, but makes no sense, to place two pawns on the same square of a chessboard, nothing impeded Maradona from scoring an infamous goal by using his hand in the Argentina vs. England football match (1986 FIFA World Cup), and that to be allowed by a referee who did not see the infringement.

Once we avoid the two previous mistakes, it is easier to see that the political space is that area of the social space constrained by the agreement to agree on resolution of divergences and coordination of convergences. This leads to a further consideration, concerning the transparent MAS, especially when, in this transition time, the MAS in question is still the state.

The Transparent MAS

There are two senses in which the MAS can be transparent. Unsurprisingly, both come from ICTs and Computer Science (Turilli & Floridi, 2009), one more case in which the information revolution is changing our mental frameworks.

On the one hand, the MAS (think of the nation state, and also corporate agents, multinationals, or supranational institutions, etc.) can be transparent in the sense that it moves from being a black box to being a white box. Other agents (citizens, when the MAS is the state) not only can see inputs and outputs—for example, levels of tax revenue and public expenditure—they can also monitor how (in our running example, the state as) a MAS works internally. This is not a novelty at all. It was a principle already popularized in the nineteenth century. However, it has become a renewed feature of contemporary politics due to the possibilities opened up by ICTs. This kind of transparency is also known as *Open Government*.

On the other hand, and this is the more innovative sense that I wish to stress here, the MAS can be transparent in the same sense in which a technology (e.g., an interface) is: invisible, not because it is not there, but because it delivers its services so efficiently, effectively, and reliably that its presence is imperceptible. When something works at its best, behind the scenes as it were, to make sure that we can operate as efficiently and as smoothly as possible, then we have a transparent system. When the MAS in question is the state, this second sense of transparency should not be seen as a surreptitious way of introducing, with a different terminology, the concept of "Small State" or "Small Governance." On the contrary, in this second sense, the MAS (the state) is as transparent and as vital as the oxygen that we breathe. It strives to be the ideal butler.[5] There is no standard terminology for this kind of transparent MAS that becomes perceivable only when it is absent. Perhaps one may speak of *Gentle Government*. It seems that MASs can increasingly support the right sort of ethical infrastructure (more on this later) the more transparently, that is, openly and gently, they play the negotiating game

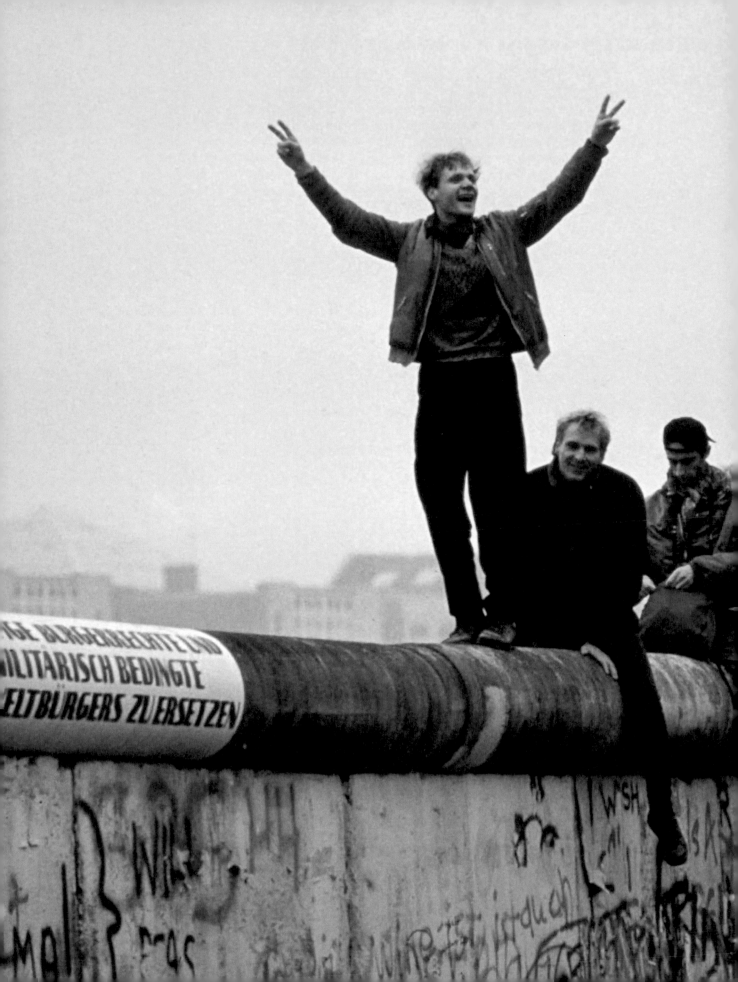

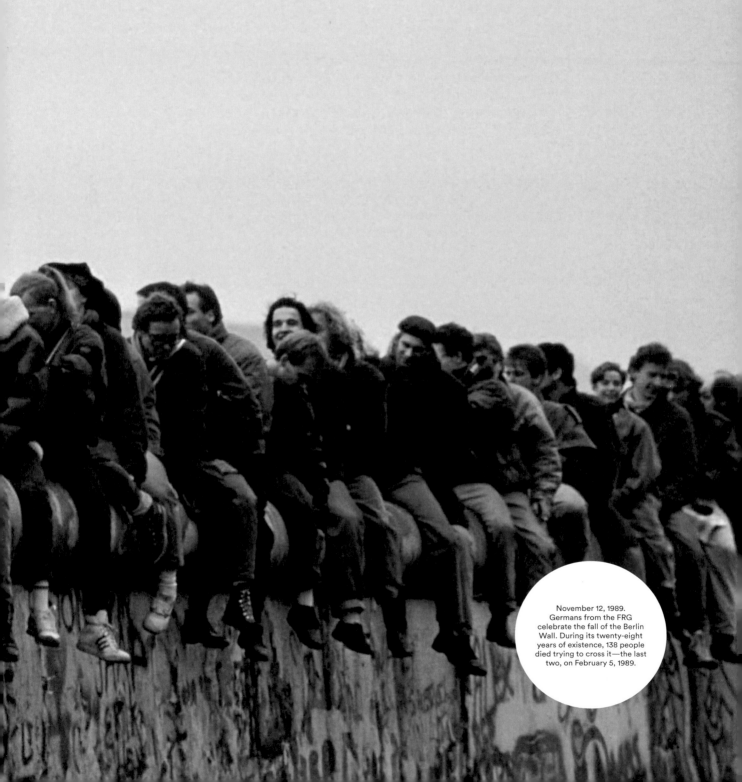

November 12, 1989. Germans from the FRG celebrate the fall of the Berlin Wall. During its twenty-eight years of existence, 138 people died trying to cross it—the last two, on February 5, 1989.

through which they take care of the *res publica*. When this negotiating game fails, the possible outcome is an increasingly violent conflict among the parties involved. It is a tragic possibility that ICTs have seriously reconfigured.

All this is not to say that *opacity* does not have its virtues. Care should be exercised, lest the sociopolitical discourse is reduced to the nuances of higher quantity, quality, intelligibility, and usability of information and ICTs. The more the better is not the only, nor always the best, rule of thumb. For the withdrawal of information can often make a positive and significant difference. We already encountered Montesquieu's division of the state's political powers. Each of them may be carefully opaque in the right way to the other two. For one may need to lack (or intentionally preclude oneself from accessing) some information in order to achieve desirable goals, such as protecting anonymity, enhancing fair treatment, or implementing unbiased evaluation. Famously, in Rawls (1999), the "veil of ignorance" exploits precisely this aspect of information, in order to develop an impartial approach to justice. Being informed is not always a blessing and might even be dangerous or wrong, distracting or crippling. The point is that opacity cannot be assumed to be a good feature in a political system unless it is adopted explicitly and consciously, by showing that it is not a mere bug.

INFRAETHICS

Part of the ethical efforts engendered by our hyperhistorical condition concerns the design of environments that can facilitate MASs' ethical choices, actions, or process. This is not the same as *ethics by design*. It is rather *pro-ethical design*, as I hope will become clearer in the following pages. Both are liberal, but the former may be mildly paternalistic, insofar as it privileges the facilitation of the *right* kind of choices, actions, process or interactions on behalf of the agents involved, whereas the latter does not have to be, insofar as it privileges the facilitation of *reflection* by the agents involved on their choices, actions, or process.[6] For example, the former may let people opt out of the default preference according to which, by obtaining a driving licence, one is also willing to be an organ donor. The latter may not allow one to obtain a driving license unless one has decided whether one wishes to be an organ donor. In this section, I shall call environments that can facilitate ethical choices, actions, or process, the ethical infrastructure, or *infraethics*. I shall call the reader's attention to the problem of how to design the right sort of infraethics for the emerging MASs. In different contexts or cases, the design of a liberal infraethics may be more or less paternalistic. My argument is that it should be as little paternalistic as the circumstances permit, although no less.

It is a sign of the times that, when politicians speak of infrastructure nowadays, they often have in mind ICTs. They are not wrong. From business fortunes to conflicts, what makes contemporary societies work depends increasingly on bits rather than atoms. We already saw all this. What is less

obvious, and philosophically more interesting, is that ICTs seem to have unveiled a new sort of equation.

Consider the unprecedented emphasis that ICTs have placed on crucial phenomena such as trust, privacy, transparency, freedom of expression, openness, intellectual property rights, loyalty, respect, reliability, reputation, rule of law, and so forth. These are probably better understood in terms of an infrastructure that is there to facilitate or hinder (reflection upon) the im/moral behavior of the agents involved. Thus, by placing our informational interactions at the center of our lives, ICTs seem to have uncovered something that, of course, has always been there, but less visibly so: the fact that the moral behavior of a society of agents is also a matter of "ethical infrastructure" or simply *infraethics*. An important aspect of our moral lives has escaped much of our attention and indeed many concepts and related phenomena have been mistakenly treated as if they were only ethical, when in fact they are probably mostly infraethical. To use a term from the philosophy of technology, they have a dual-use nature: they can be morally good, but also morally evil (more on this presently). The new equation indicates that, in the same way that business and administration systems, in an economically mature society, increasingly require infrastructures (transport, communication, services, etc.), so too, moral interactions increasingly require an infraethics, in an informationally mature society.

The idea of an infraethics is simple, but can be misleading. The previous equation helps to clarify it. When economists and political scientists speak of a "failed state," they may refer to the failure of a *state-as-a-structure* to fulfill its basic roles, such as exercising control over its borders, collecting taxes, enforcing laws, administering justice, providing schooling, and so forth. In other words, the state fails to provide *public* (e.g., defense and police) and *merit* (e.g., health care) *goods*. Or (too often an inclusive and intertwined or) they may refer to the collapse of a *state-as-an-infrastructure* or environment, which makes possible and fosters the right sort of social interactions. This means that they may be referring to the collapse of a substratum of default expectations about economic, political, and social conditions, such as the rule of law, respect for civil rights, a sense of political community, civilized dialogue among differently minded people, ways to reach peaceful resolutions of ethnic, religious, or

cultural tensions, and so forth. All these expectations, attitudes, practices, in short such an implicit "sociopolitical infrastructure," which one may take for granted, provides a vital ingredient for the success of any complex society. It plays a crucial role in human interactions, comparable to the one that we are now accustomed to attributing to physical infrastructures in economics.

Thus, infraethics should not be understood in terms of Marxist theory, as if it were a mere update of the old "base and superstructure" idea, because the elements in question are entirely different: we are dealing with moral actions and not-yet-moral facilitators of such moral actions. Nor should it be understood in terms of a kind of second-order normative discourse on ethics, because it is the not-yet-ethical framework of implicit expectations, attitudes, and practices that *can* facilitate and promote moral decisions and actions. At the same time, it would also be wrong to think that an infraethics is morally neutral. Rather, it has a dual-use nature, as I anticipated earlier: it can both facilitate and hinder morally good as well as evil actions, and do this in different degrees. At its best, it is the grease that lubricates the moral mechanism. This is more likely to happen whenever having a "dual-use" nature does not mean that each use is equally likely, that is, that the infraethics in question is still not neutral, nor merely positive, but does have a bias to deliver more good than evil. If this is confusing, think of a the dual-use nature not in terms of an equilibrium, like an ideal coin that can deliver both heads and tail, but in terms of a co-presence of two alternative outcomes, one of which is more likely than the other, like in a biased coin more likely to turn heads than tails. When an infraethics has a "biased dual-use" nature, it is easy to mistake the infraethical for the ethical, since whatever helps goodness to flourish or evil to take root partakes of their nature.

Any successful complex society, be this the City of Man or the City of God, relies on an implicit infraethics. This is dangerous, because the increasing importance of an infraethics may lead to the following risk: that the legitimization of the ethical ground is based on the "value" of the infraethics that is supposed to support it. *Supporting* is mistaken for *grounding*, and may even aspire to the role of *legitimizing*, leading to what Lyotard criticized as mere "performativity" of the system, independently of the actual values cherished and pursued. Infraethics is the vital syntax of a society, but it is not its semantics, to use a distinction popular in artificial intelligence. It is about the structural form, not the meaningful contents.

We saw earlier that even a society in which the entire population consisted of angels, that is, perfect moral agents,

still needs norms for collaboration. Theoretically, that is, when one assumes that morally good values and the infraethics that promotes them may be kept separate (an abstraction that never occurs in reality but that facilitates our analysis), a society may exist in which the entire population consisted of Nazi fanatics who could rely on high levels of trust, respect, reliability, loyalty, privacy, transparency, and even freedom of expression, openness, and fair competition. Clearly, what we want is not just the successful mechanism provided by the right infraethics, but also the coherent combination between it and morally good values, such as civil rights. This is why a balance between security and privacy, for example, is so difficult to achieve, unless we clarify first whether we are dealing with a tension within ethics (security and privacy as a moral rights), within infraethics (both are understood as not-yet-ethical facilitators), or between infraethics (security) and ethics (privacy), as I suspect. To rely on another analogy: the best pipes (infraethics) may improve the flow but do not improve the quality of the water (ethics), and water of the highest quality is wasted if the pipes are rusty or leaky. So creating the right sort of infraethics and maintaining it is one of the crucial challenges of our time, because an infraethics is not morally good in itself, but it is what is most likely to yield moral goodness if properly designed and combined with the right moral values. The right sort of infraethics should be there to support the right sort of axiology (theory of value). It is certainly a constitutive part of the problem concerning the design of the right MASs.

The more complex a society becomes, the more important and hence salient the role of a well-designed infraethics is, and yet this is exactly what we seem to be missing. Consider the recent Anti-Counterfeiting Trade Agreement (ACTA), a multinational treaty concerning the international standards for intellectual property rights. By focusing on the enforcement of IPR (intellectual property rights), supporters of ACTA completely failed to perceive that it would have undermined the very infraethics that they hoped to foster, namely one promoting some of the best and most successful aspects of our information society. It would

have promoted the structural inhibition of some of the most important individuals' positive liberties and their ability to participate in the information society, thus fulfilling their own potential as informational organisms. For lack of a better word, ACTA would have promoted a form of *informism*, comparable to other forms of social agency's inhibition such as classism, racism, and sexism. Sometimes a defense of liberalism may be inadvertently illiberal. If we want to do better, we need to grasp that issues such as IPR are part of the new infraethics for the information society, that their protection needs to find its carefully balanced place within a complex legal and ethical infrastructure that is already in place and constantly evolving, and that such a system must be put at the service of the right values and moral behaviors. This means finding a compromise, at the level of a liberal infraethics, between those who see new legislation (such as ACTA) as a simple fulfillment of existing ethical and legal obligations (in this case from trade agreements), and those who see it as a fundamental erosion of existing ethical and legal civil liberties.

In hyperhistorical societies, any regulation affecting how people deal with information is now bound to influence the whole infosphere and onlife habitat within which they live. So enforcing rights (such as IPR) becomes an environmental problem. This does not mean that any legislation is necessarily negative. The lesson here is one about complexity: since rights such as IPR are part of our infraethics and affect our whole environment understood as the infosphere, the intended and unintended consequences of their enforcement are widespread, interrelated, and far-reaching. These consequences need to be carefully considered, because mistakes will generate huge problems that will have cascading costs for future generations, both ethically and economically. The best way to deal with "known unknowns" or unintended consequences is to be careful, stay alert, monitor the development of the actions undertaken, and be ready to revise one's decision and strategy quickly, as soon as the wrong sort of effects start appearing. *Festina lente*, "more haste, less speed" as the classic adage suggests. There is no perfect legislation but only legislation that can be perfected more or less easily. Good agreements about how to shape our infraethics should include clauses about their timely update.

Finally, it is a mistake to think that we are like outsiders ruling over an environment different from the one we inhabit. Legal documents (such as ACTA) emerge from within the infosphere that they affect. We are building, restoring, and refurbishing the house from inside, or one may say that we are repairing the raft while navigating on it, to use the metaphor introduced in the Preface. Precisely because the whole problem of respect, infringement, and enforcement of rights (such as IPR) is an infraethical and environmental problem for advanced information societies, the best thing we could do, in order to devise the right solution, is to apply to the process itself the very infraethical framework and ethical values that we would like to see promoted by it. This means that the infosphere should regulate itself from within, not from an impossible without.

CONCLUSION: THE LAST OF THE HISTORICAL GENERATIONS?

Six thousand years ago, a generation of humans witnessed the invention of writing and the emergence of the conditions of possibility of cities, kingdoms, empires, and nation states. This is not accidental. Prehistoric societies are both ICT-less and stateless. The state is a

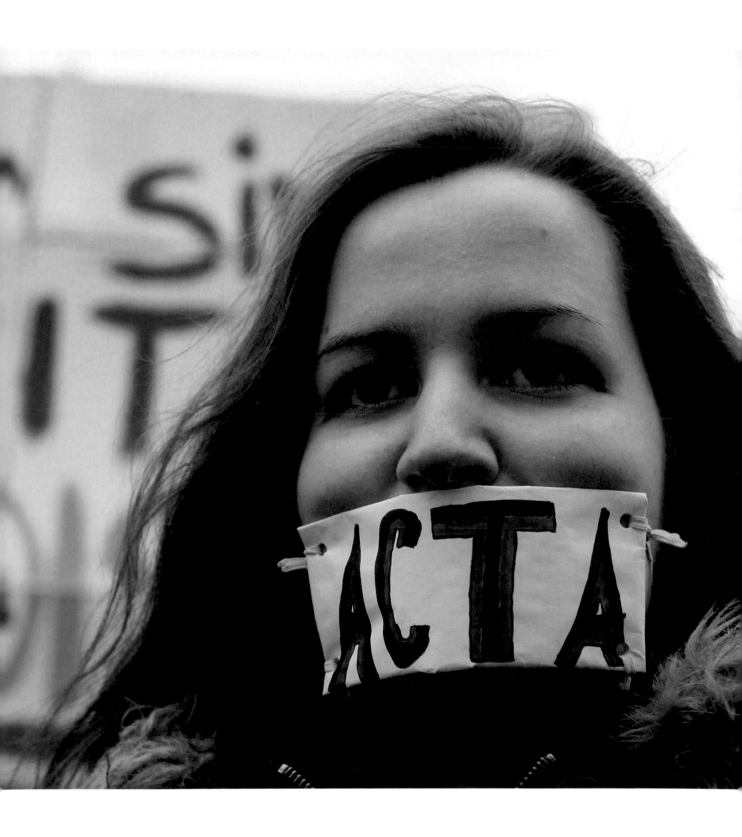

Hyperhistory, the Emergence of the MASs, and the Design of Infraethics Luciano Floridi

typical historical phenomenon. It emerges when human groups stop living a hand-to-mouth existence in small communities and begin to live a mouth-to-hand one, in which large communities become political societies, with division of labor and specialized roles, organized under some form of government, which manages resources through the control of ICTs, including that very special kind of information called "money." From taxes to legislation, from the administration of justice to military force, from census to social infrastructure, the state was for a long time the ultimate information agent and so I suggested that history, and especially modernity, is the age of the state.

Almost halfway between the beginning of history and now, Plato was still trying to make sense of both radical changes: the encoding of memories through written symbols and the symbiotic interactions between individuals and *polis*-state. In fifty years, our grandchildren may look at us as the last of the historical, state-organized generations, not so differently from the way we look at the Amazonian tribes mentioned at the beginning of this chapter, as the last of the prehistorical, stateless societies. It may take a long while before we come to understand in full such transformations. And this is a problem, because we do not have another six millennia in front of us. We cannot wait for another Plato in a few millennia. We are playing an environmental gambit with ICTs, and we have only a short time to win the game, for the future of our planet is at stake. We better act now.

1. According to data about life expectancy at birth for the world and major development groups, 1950–2050. Source: Population Division of the Department of Economic and Social Affairs of the United Nations Secretariat (2005). World Population Prospects: The 2004 Revision Highlights. New York: United Nations, available online.

2. According to data about poverty in the word, defined as the number and share of people living below $1.25 a day (at 2005 prices) in 2005–08. Source: World Bank, and *The Economist*, 29 February, 2012, available online.

3. Floridi & Taddeo (forthcoming). Clarke & Knake (2010) approach the problems of cyberwar and cybersecurity from a political perspective that would still qualify as "historical" within this chapter, but it is very helpful.

4. For a more detailed analysis see Floridi, 2011.

5. On good governance and the rules of the political, global game, see Brown & Marsden, 2013.

6. I have sought to develop an information ethics in Floridi, 2013. For a more introductory text see Floridi, 2010.

— Brown, I., & Marsden, C. T. (2013). *Regulating Code: Good Governance and Better Regulation in the Information Age*. Cambridge, MA: MIT Press.
— Clarke, R. A., & Knake, R. K. (2010). *Cyber War: The Next Threat to National Security and What to Do About It*. New York: Ecco.
— Floridi, L. (2011). *The Philosophy of Information*. Oxford: Oxford University Press.
— Floridi, L. (2013). *The Ethics of Information*. Oxford: Oxford University Press.
— Floridi, L. (ed.). (2010). *The Cambridge Handbook of Information and Computer Ethics*. Cambridge: Cambridge University Press.
— Floridi, L., & Taddeo, M. (eds.). (2014). *The Ethics of Information Warfare*. New York: Springer.
— Linklater, A. (1998). *The Transformation of Political Community: Ethical Foundations of the Post-Westphalian Era*. Oxford: Polity.
— Rawls, J. (1999). *A Theory of Justice* (rev. ed.). Cambridge, MA: Belknap Press of Harvard University Press.
— Steil, B. (2013). *The Battle of Bretton Woods. John Maynard Keynes, Harry Dexter White, and the Making of a New World Order*. New Jersey: Princeton University Press.
— Turilli, M., & Floridi, L. (2009). "The ethics of information transparency." *Ethics and Information Technology*, 11(2), 105–112.

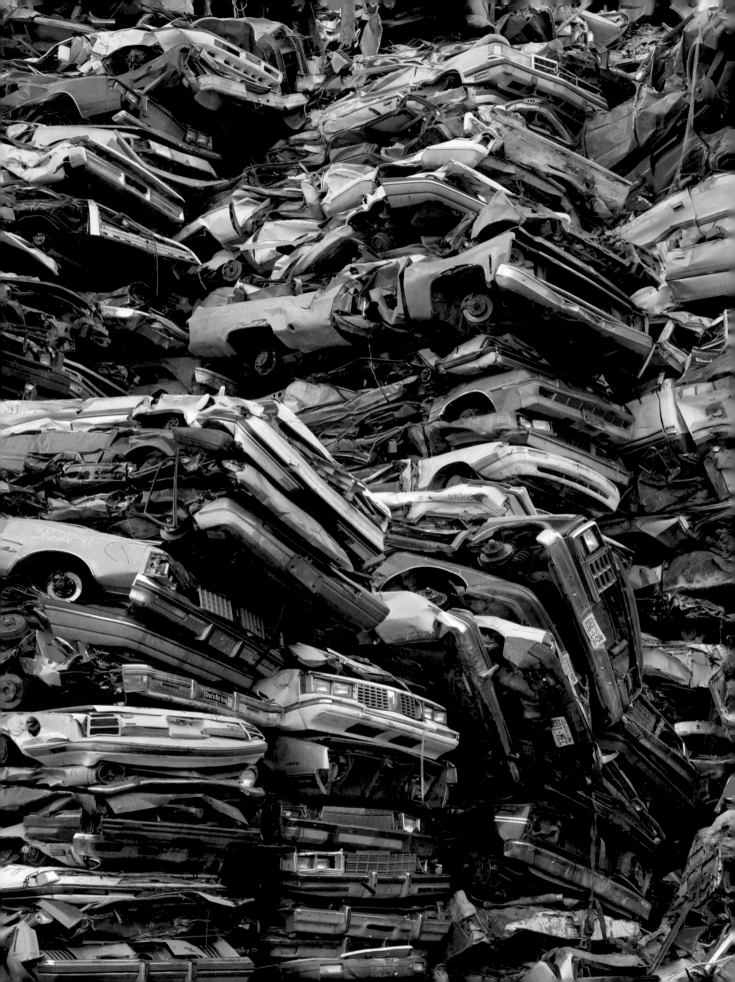

Technological Wild Cards: Existential Risk and a Changing Humanity

SEÁN Ó HÉIGEARTAIGH

Opening image:
Chris Jordan
Crushed Cars #2, Tacoma (2004)
"Intolerable Beauty: Portraits of
American Mass Consumption" Series
44 × 62 cm.

Seán Ó hÉigeartaigh
Centre for the Study of Existential Risk (CSER), Cambridge, UK

Seán Ó hÉigeartaigh is the Executive Director of Cambridge's Centre for
the Study of Existential Risk (CSER), a world-leading academic research
center focused on global risks and emerging technologies. He is
codeveloper of the Centre for the Future of Intelligence, a new Cambridge-
Oxford-Imperial-Berkeley collaboration on the opportunities and challenges
of artificial intelligence. Prior to Cambridge, he ran interdisciplinary
research programs on emerging technologies, and on catastrophic risk
modelling, at Oxford's Future of Humanity Institute. His research interests
include: emerging technologies, risk, technology policy, horizon-scanning,
and foresight. He has a PhD in Genomics from Trinity College Dublin.

Humanity has always faced threats to its global survival, such as asteroid impacts and supervolcanoes. Yet now the greatest risks we face may be a result of our own scientific and civilizational progress. We are developing technologies of unprecedented power, such as nuclear weapons and engineered organisms. We are also wiping out species, changing the climate, and burning through the earth's resources at an unsustainable rate as the global population soars. However, the coming century's breakthroughs in science and technology will also provide powerful solutions to many of the greatest challenges we face.

A NEW ERA OF RISK

In the early hours of September 26, 1983, Stanislav Petrov was on duty at a secret bunker outside Moscow. A lieutenant colonel in the Soviet Air Defense Forces, his job was to monitor the Soviet early warning system for nuclear attack. Tensions were high; earlier that month Soviet jets had shot down a Korean civilian airliner, an event US President Reagan had called " a crime against humanity that must never be forgotten." The KGB had sent out a flash message to its operatives to prepare for possible nuclear war.

Petrov's system reported a US missile launch. He remained calm, suspecting a computer error. The system then reported a second, third, fourth, and fifth launch. Alarms screamed, and lights flashed. Petrov "had a funny feeling in my gut"[1]; why would the US start a nuclear war with only five missiles? Without any additional evidence available, he radioed in a false alarm.

Later, it emerged that sunlight glinting off clouds at an unusual angle had triggered the system.

This was not an isolated incident. Humanity came to the brink of large-scale nuclear war many times during the Cold War.[2] Sometimes computer system failures were to blame, and human intuition saved the day. Sometimes human judgment was to blame, but cooler heads prevented thermonuclear war. Sometimes flocks of geese were enough to trigger the system. As late as 1995, a Norwegian weather rocket launch resulted in the nuclear briefcase being open in front of Russia's President Yeltsin.

If each of these events represented a coin flip, in which a slightly different circumstance—a different officer in a different place, in a different frame of mind—could have resulted in nuclear war, then we have played some frightening odds in the last seventy-odd years. And we have been breathtakingly fortunate.

Humanity has already changed a lot over its lifetime as a species. While our biology is not drastically different than it was 70,000 years ago, the capabilities enabled by our scientific, technological, and sociocultural achievements have changed what it is to be human. Whether through the processes of agriculture, the invention of the steam engine, or the practices of storing and passing on knowledge and ideas, and working together effectively as large groups, we have dramatically augmented our biological abilities. We can lift heavier things than our biology allows, store and access more information than our brains can hold, and collectively solve problems that we could not individually.

The species will change even more over coming decades and centuries, as we develop the ability to modify our biology, extend our abilities through various forms of human-machine interaction, and continue the process of sociocultural innovation. The long-term future holds tremendous promise: continued progress may allow humanity to spread throughout a galaxy that to the best of our knowledge appears devoid of intelligent life. However, what we will be in the future may bear little resemblance to what we are now, both physically and in terms of capability. Our descendants may be augmented far beyond what we currently recognize as human.

This is reflected in the careful wording of Nick Bostrom's definition of existential risk, the standard definition used in the field. An existential risk "is one that threatens the premature extinction of earth-originating intelligent life, or the permanent and drastic destruction of its potential for desirable future development."[3] Scholars in the field are less concerned about the form humanity may take in the long-term future, and more concerned that we avoid circumstances that might prevent our descendants—whatever form they may take—from having the opportunity to flourish.

One way in which this could happen is if a cataclysmic event were to wipe out our species (and perhaps, with it, the capacity for our planet to bear intelligent life in future). But another way would be if a cataclysm fell short of human extinction, but changed our circumstances such that further progress became impossible. For

example, runaway climate change might not eliminate all of us, but might leave so few of us, scattered at the poles, and so limited in terms of accessible resources, that further scientific, technological, and cultural progress might become impossible. Instead of spreading to the stars, we might remain locked in a perennial battle for survival in a much less bountiful world.

The Risks We Have Always Faced

For the first 200,000 years of humanity's history, the risks that have threatened our species as a whole have remained relatively constant. Indonesia's crater lake Toba is the result of a catastrophic volcanic super-eruption that occurred 75,000 years ago, blasting an estimated 2800 cubic kilometers of material into the atmosphere. An erupted mass just 1/100th of this from the Tambora eruption (the largest in recent history) was enough to cause the 1816 "year without a summer," where interference with crop yields caused mass food shortages across the northern hemisphere. Some lines of evidence suggest that the Toba event may have wiped out a large majority of the human population at the time, although this is debated. At the Chixculub Crater in Mexico, geologists uncovered the scars of the meteor that most likely wiped out seventy-five percent of species on earth at that time, including the dinosaurs, sixty-six million years ago. This may have opened the door, in terms of available niches, for the emergence of mammalian species and ultimately humanity.

Reaching further into the earth's history uncovers other, even more cataclysmic events for previous species. The Permian-Triassic extinction event wiped out 90–96% of species at the time. Possible causes include meteor impacts, rapid climate change possibly due to increased methane release, large-scale volcanic activity, or a combination of these. Even further back, the cyanobacteria that introduced oxygen to our atmosphere, and paved the way for oxygen-breathing life, did so at a cost: they brought about the extinction of nearly all life at the time, to whom oxygen was poisonous, and triggered a "snowball earth" ice age.

The threats posed by meteor or asteroid impacts and supervolcanoes have not gone away. In principle an asteroid could hit us at any point with little warning. A number of geological hotspots could trigger a volcanic eruption; most famously, the Yellowstone Hotspot is believed to be "due" for another massive explosive eruption.

However, on the timescale of human civilization, these risks are very unlikely in the coming century, or indeed any given century. 660,000 centuries have passed since the event that wiped out the dinosaurs; the chances that the next such event will happen in our lifetimes is likely to be of the order of one in a million. And "due around now" for Yellowstone means that geologists expect such an event at some point in the next 20,000–40,000 years. Furthermore, these threats are static; there is little evidence that their probabilities, characteristics, or modes of impact are changing significantly on a human civilizational timescale.

New Challenges

New challenges have emerged alongside our civilizational progress. As we organized ourselves into larger groups and cities, it became easier for disease to spread among us. During the Middle Ages the Black Death outbreaks wiped out 30–60% of Europe's population. And our travel across the globe allowed us to bring diseases with us to places they would never have otherwise reached; following European colonization of the Americas, disease outbreaks wiped out up to 95% native populations.

The Industrial Revolution allowed huge changes in our capabilities as a species. It allowed rapid progress in scientific knowledge, engineering, and manufacturing capability. It allowed us to draw heavily from cheap, powerful, and rapidly available energy sources—fossil fuels. It helped us to support a much greater global population. The global population more than doubled between 1700 and 1850, and population in England—birthplace of the Industrial Revolution—increased from 5 to 15 million in the same period, and doubled again to 30 million by 1900.[4] In effect, these new technological capabilities allowed us to extract more resources, create much greater changes to our environment, and support more of us than had ever previously been possible. This is a path we have been accelerating along ever since then, with greater globalization, further scientific and technological development, a rising global population, and, in developed nations at least, a rising quality of life and resource use footprint.

On July 16, 1945, the day of the Trinity atomic bomb test, another milestone was reached. Humans had developed a weapon that could plausibly change the global environment in such an extreme way as to threaten the continued existence of the human species.

Power, Coordination, and Complexity

Humanity now has a far greater power to shape its environment, locally and globally, than any species that has existed to our knowledge; more so even than the cyanobacteria that turned this into a planet of oxygen-breathing life. We have repurposed huge swathes of the world's land to our purposes—as fields to produce food for us, cities to house billions of us, roads to ease our transport, mines to provide our material resources, and landfill to house our waste. We have developed structures and tools such as air conditioning and heating that allow us to populate nearly every habitat on earth, the supply networks needed to maintain us across these locations, scientific breakthroughs such as antibiotics, and practices such as sanitation and pest control to defend ourselves from the pathogens and pests of our environments. We also modify ourselves to be better adapted to our environments, for example through the use of vaccines.

This increased power over ourselves and our environment, combined with methods to network and coordinate our activities over large numbers and wide areas, has created great resilience against many threats we face. In most of the developed world we can guarantee adequate food and water access for the large majority of the population, given normal fluctuations in yield; our food sources are varied in type and geographical

Technological Wild Cards: Existential Risk and a Changing Humanity

Seán Ó hÉigeartaigh

location, and many countries maintain food stockpiles. Similarly, electricity grids provide a stable source of energy for developed populations, given normal fluctuations in supply. We have adequate hygiene systems and access to medical services, given normal fluctuations in disease burden, and so forth. Furthermore, we have sufficient societal stability and resources that we can support many brilliant people to work on solutions to emerging problems, or to advance our sciences and technologies to give us ever-greater tools to shape our environments, increase our quality of life, and solve our future problems.

It goes without saying that these privileges exist to a far lesser degree in developing nations, and that many of these privileges depend on often exploitative relationships with developing nations, but this is outside the scope of this chapter. Here the focus is on the resilience or vulnerability of the human-as-species, which is tied more closely to the resilience of the best-off than the vulnerability of the poorest, except to the extent that catastrophes affecting the world's most vulnerable populations would certainly impact the resilience of less vulnerable populations.

Many of the tools, networks, and processes that make us more resilient and efficient in "normal" circumstances, however, may make us more vulnerable in the face of extreme circumstances. While a moderate disruption (for example, a reduced local crop yield) can be absorbed by a network, and compensated for, a catastrophic disruption may overwhelm the entire system, and cascade into linked systems in unpredictable ways. Systems critical for human flourishing, such as food, energy, and water, are inextricably interlinked (the "food-water-energy nexus") and a disruption in one is near-guaranteed to impact the stability of the others. Further, these affect and are affected by many other human- and human-affected processes: our physical, communications, and electronic infrastructure, political stability (wars tend to both precede and follow famines), financial systems, and extreme weather (increasingly a human-affected phenomenon). These interactions are very dynamic and difficult to predict. Should the water supply from the Himalayas dry up one year, we have very little idea of the full extent of the regional and global impact, although we could reasonably speculate about droughts, major crop failures, and mass starvation, financial crises, a massive immigration crisis, regional warfare that could go nuclear and escalate internationally, and so forth. Although unlikely, it is not outside the bounds of imagination that through a series of unfortunate events, a catastrophe might escalate to one that would threaten the collapse of global civilization.

Two factors stand out.

Firstly, the processes underpinning our planet's health are interlinked in all sorts of complex ways, and our activities are serving to increase the level of complexity, interlinkage, and unpredictability—particularly in the case of extreme events.

Secondly, the fact is that, despite our various coordinated processes, we as a species are very limited in our ability to act as a globally coordinated entity, capable of taking the most rational actions in the interests of the whole—or in the best interests of our continued survival and flourishing.

This second factor manifests itself in global inequality, which benefits developed nations in some ways, but also introduces major global vulnerabilities; the droughts, famines, floods, and mass displacement of populations likely to result from the impacts of climate change in the developing world are sure to negatively affect even the richest nations. It manifests itself in an inability to act optimally in the face of many of our biggest challenges. More effective coordination on action, communication, and resource distribution would make us more resilient in the face of pandemic outbreaks, as illustrated so vividly by the Ebola outbreak of 2014; a relatively mild outbreak of what should be an easily controllable disease served to highlight how inadequate pandemic preparedness and response was.[5, 6] We were lucky that the disease was not one with greater pandemic potential, such as one capable of airborne transmission and with long incubation times.

Our limited ability to coordinate in our long-term interest manifests itself in a difficulty in limiting our global resource use, limiting the impact of our collective activities on our global habitat, and of investing our resources optimally for our long-term survival and well-being. And it limits our ability to guarantee that advances in science and technology be applied to furthering our well-being and resilience, as opposed to being destabilizing or even used for catastrophically hostile purposes, such as in the case of nuclear weapons.

Collective action problems are as old as humanity,[7] and we have made significant progress in designing effective institutions, particularly in the aftermath of World War I and II. However, the stakes related to these problems become far greater as our power to influence our environment grows—through sheer force of numbers and distribution across the planet, and through more powerful scientific and technological tools with which to achieve our myriad aims or to frustrate those of our fellows. We are entering an era in which our greatest risks are overwhelmingly likely to be caused by our own activities, and our own lack of capacity to collectively steer and limit our power.

OUR FOOTPRINT ON THE EARTH

Population and Resource Use

The United Nations estimated the earth's population at 7.4 billion as of March 2016, up from 6.1 billion in 2000, 2.5 billion in 1950, and 1.6 billion in 1900. Long-term growth is difficult to predict (being affected by many uncertain variables such as social norms, disease, and the occurrence of catastrophes) and thus varies widely between studies. However, UN projections currently point to a steady increase through the twenty-first century, albeit at a slower growth rate, reaching just shy of 11 billion in 2100.[8] Most estimates indicate global population will

eventually peak and then fall, although the point at which this will happen is very uncertain. Current estimates of resource use footprints indicate that the global population is using fifty percent more resources per year than the planet can replenish. This is likely to continue rising sharply; more quickly than the overall population. If the average person used as many resources as the average American, some estimates indicate the global population would be using resources at four times the rate that they can be replenished. The vast majority of the population does not use food, energy, and water, nor release CO_2 at the rate of the average American. However, the rapid rise of a large middle class in China is beginning to result in much greater resource use and CO_2 output in this region, and the same phenomenon is projected to occur a little later on in India.

Catastrophic Climate Change

Without a significant change of course on CO_2 emissions, the world is on course for significant human-driven global warming; according to the latest IPCC report, an increase of 2.5 to 7.8 °C can be expected under "business as usual" assumptions. The lower end of this scale will have significant negative repercussions for developing nations in particular but is unlikely to constitute a global catastrophe; however, the upper end of the scale would certainly have global catastrophic consequences. The wide range in part reflects significant uncertainty over how robust the climate system will be to the "forcing" effect of our activities. In particular, scientists focused on catastrophic climate change worry about a myriad of possible feedback loops. For example, a reduction of snow cover, which reflects the sun's heat, could increase the rate of warming resulting in greater loss of snow cover. The loss of arctic permafrost might result in the release of large amounts of methane in the atmosphere, which would accelerate the greenhouse effect further. The extent to which oceans can continue to act as both "heat sinks" and "carbon sinks" as we push the concentration of CO_2 in the atmosphere upward is unknown. Scientists theorize the existence of "tipping points," which, once reached, might trigger an irreversible shift—for example, the collapse of the West Antarctic ice sheets or the melt of Greenland's huge glaciers, or the collapse of the capacity for oceans to absorb heat and sequester CO_2. In effect, beyond a certain point, a "rollercoaster" process may be triggered, where 3 degrees of temperature rise rapidly and irreversibly may lead to 4 degrees, and then 5.

Laudable progress has been made on achieving global coordination around the goal of reducing global carbon emissions, most notably in the aftermath of the December 2015 United Nations Climate Change Conference. 174 countries signed an agreement to reach zero net anthropogenic greenhouse gas emissions by the second half of the twenty-first century, and to "pursue efforts to limit" the temperature increase to 1.5 °C. But many experts hold that these goals are unrealistic, and that the commitments and actions being taken fall far short of what will be needed. According to the International Energy Agency's Executive Director Fatih Birol: "We think we are lagging behind strongly in key technologies, and in the absence of a strong government push, those technologies will never be deployed into energy markets, and the chances of reaching the two-degree goal are very slim."[9]

Soil Erosion

Soil erosion is a natural process. However human activity has increased the global rate dramatically, with deforestation, drought, and climate change accelerating the rate of loss of

fertile soil. There are reasons to expect this trend to accelerate; some of the most powerful drivers of soil erosion are extreme weather events, and these events are expected to increase dramatically in frequency and severity as a result of climate change.

Biodiversity Loss

The world is entering an era of dramatic species extinction driven by human activity.[10] Since 1900, vertebrate species have been disappearing at more than 100 times the rate seen in non-extinction periods. In addition to the intrinsic value of the diversity of forms of life on earth (the only life-inhabited planet currently known to exist in the universe), catastrophic risk scholars worry about the consequences for human societies. Ecosystem resilience is a tremendously complex phenomenon, and it seems plausible that tipping points exist in them. For example, the collapse of one or more keystone species underpinning the stability of an ecosystem could result in a broader ecosystem collapse with potentially devastating consequences for human system stability (for example, should key pollinator species disappear, the consequences for agriculture could be profound). Current human flourishing relies heavily on these ecosystem services, but we are threatening them at an unprecedented rate, and we have a poor ability to predict the consequences of our activity.

Everything Affects Everything Else

Once again, the sheer complexity and interconnectedness of these risks represents a key challenge. None of these processes happen in isolation, and developments in one affect the others. Climate change affects ecosystems by forcing species migration (for those that can), a change in plant and animal patterns of growth and behavior, and by driving species extinction. Reductions in available soil force us to drive more deeply into nonagricultural wilderness to provide the arable land we need to feed our populations. And the ecosystems we threaten play important roles in maintaining a stable climate and environment. Recognizing that we cannot get all the answers we need on these issues by studying them in isolation, threats posed by the interplay of these phenomena are a key area of study for catastrophic risk scholars.

All these developments result in a world with greater uncertainty, the emergence of huge and unpredictable new vulnerabilities, and more extreme and unprecedented events. These events will play out in a crowded world that contains more powerful technologies, and more powerful weapons, than have ever existed before.

HUMANITY AND TECHNOLOGY IN THE TWENTY-FIRST CENTURY

Our progress in science and technology, and related civilizational advances, have allowed us to house far more people on this planet, and have provided the power for those people to influence their environment more than any previous species. This progress is not of itself a bad thing, nor is the size of our global population.

There are good reasons to think that with careful planning, this planet should be able to house seven billion or more people stably and comfortably.[11] With sustainable agricultural practices and innovative use of irrigation methods, it should be possible for many relatively

uninhabited and agriculturally unproductive parts of the world to support more people and food production. An endless population growth on a finite planet is not possible without a collapse; however, growth until the point of collapse is by no means inevitable. Stabilization of population size is strongly correlated with several factors we are making steady global progress on: including education (especially of women), and rights and a greater level of control for women over their own lives. While there are conflicting studies,[12] many experts hold that decreasing child mortality, while leading to population increase in the near-term, leads to a drop in population growth in the longer term. In other words, as we move toward a better world, we will bring about a more stable world, provided intermediate stages in this process do not trigger a collapse or lasting global harm.[13, 14]

Current advances in science and technology, while not sufficient in themselves, will play a key role in making a more resilient and sustainable future possible. Rapid progress is happening in carbon-zero energy sources such as solar photovoltaics and other renewables.[15] Energy storage remains a problem, but progress is occurring on battery efficiency. Advances in irrigation techniques and desalination technologies may allow us to provide water to areas where this has not previously been possible, allowing both food production and other processes that depend on reliable access to clean water. Advances in materials technology will have wide-ranging benefits, from lighter, more energy-efficient vehicles, to more efficient buildings and energy grids, to more powerful scientific tools and novel technological innovations. Advances in our understanding of the genetics of plants are leading to crops with greater yields, greater resilience to temperature shifts, droughts and other extreme weather, and greater resistance to pests—resulting in a reduction of the need for polluting pesticides. We are likely to see many further innovations in food production; for example, exciting advances in lab-grown meat may result in the production of meat with a fraction of the environmental footprint of livestock farming.

Many of the processes that have resulted in our current unsustainable trajectories can be traced back to the Industrial Revolution, and our widespread adoption of fossil fuels. However, the Industrial Revolution and fossil fuels must also be recognized as having unlocked a level of prosperity, and a rate and scale of scientific and technological progress that would simply not have been possible without them. While a continued reliance on fossil fuels would be catastrophic for our environment, it is unclear whether many of the "clean technology" breakthroughs that will allow us to break our dependence on fossil fuels would have been possible without the scientific breakthroughs that were enabled directly, or indirectly, by this rich, abundant, and easily available fuel source. The goal is clear: having benefitted so

tremendously from this "dirty" stage of technology, we now need to take advantage of the opportunity it gives us to move onto cleaner and more powerful next-generation energy and manufacturing technologies. The challenge will be to do so before thresholds of irreversible global consequence have been passed.

The broader challenge is that humanity as a species needs to transition to a stage of technological development and global cooperation where as a species we are "living within our means": producing and using energy, water, food, and other resources at a sustainable rate, and by methods that will not impose long-term negative consequences on our global habitat—for at least as long as we are bound to it. There are no physical reasons to think that we might not be capable of developing an extensive space-faring civilization at a future point. And if we last that long, it is likely we will develop extensive abilities to terraform extraterrestrial environments to be hospitable to us—or indeed, transform ourselves to be suitable to currently inhospitable environments. However, at present, in Martin Rees's words, there is no place in our Solar System nearly as hospitable as the most hostile environment on earth, and so we are bound to this fragile blue planet.

Part of this broader challenge is gaining a better understanding of the complex consequences of our actions, and more so, of the limits of our current understanding. Even if we cannot know everything, recognizing when our uncertainty may lead us into dangerous territory can help us figure out an appropriately cautious set of "safe operating parameters" (to borrow a phrase from Steffen et al.'s "Planetary Boundaries"[16]) for our activities. The second part of the challenge, perhaps harder still, is developing the level of global coordination and cooperation needed to stay within these safe operating parameters.

Technological Wild Cards
While much of the Centre for the Study of Existential Risk's research focuses on these challenges—climate change, ecological risks, resource use, and population, and the interaction between these—the other half of our work is on another class of factors: transformative emerging and future technologies. We might consider these "wild cards"; technological developments significant enough to change the course of human civilization significantly in and of themselves. Nuclear weapons are such a wild card; their development changed the nature of geopolitics instantly and irreversibly. They also changed the nature of

global risk: now many of the stressors we worry about might escalate quite quickly through human activity to a worst-case scenario involving a large-scale exchange of nuclear missiles. The scenario of most concern from an existential risk standpoint is one that might trigger a nuclear winter: a level of destruction sufficient to send huge amounts of particulate matter into the atmosphere and cause a lengthy period of global darkness and cold. If such a period persisted for long enough, this would collapse global food production and could drive the human species to near- or full-extinction. There is disagreement among experts about the scale of nuclear exchange needed to trigger a nuclear winter, but it appears eminently plausible that the world's remaining arsenals, if launched, might be sufficient.

Nuclear weapons could be considered a wild card in a different sense: the underlying science is one that enabled the development of nuclear power, a viable carbon-zero alternative to fossil fuels. This *dual-use* characteristic—that the underlying science and technology could be applied to both destructive purposes, and peaceful ones—is common to many of the emerging technologies that we are most interested in.

A few key sciences and technologies of focus for scholars in this field include, among others:

> Topics within bioscience and bioengineering such as the manipulation and modification of certain viruses and bacteria, and the creation of organisms with novel characteristics and capabilities (genetic engineering and synthetic biology).

> Geoengineering: a suite of proposed large-scale technological interventions that would aim to "engineer" our climate in an effort to slow or even reverse the most severe impacts of climate change.

> Advances in artificial intelligence—in particular, those that relate to progress toward artificial *general* intelligence—AI systems capable of matching or surpassing human intellectual abilities across a broad range of domains and challenges.

Progress on these sciences are driven in great part by a recognition of their potential for improving our quality of life, or the role they could play in aiding us to combat existing or emerging global challenges. However, in and of themselves they may also pose large risks.

Virus Research

Despite advances in hygiene, vaccines, and other health technology, natural pandemic outbreaks remain among the most potent global threats we face; for example, the 1918 Spanish influenza outbreak killed more people than World War I. This threat is of particular concern in our increasingly crowded, interconnected world. Advances in virology research are likely to play a central role in better defenses against, and responses to, viruses with pandemic potential.

A particularly controversial area of research is "gain-of-function" virology research, which aims to modify existing viruses to give them different host transmissibility and other characteristics. Researchers engaged in such research may help identify strains with high

pandemic potential, and develop vaccines and antiviral treatment. However, research with infectious agents runs the risk of accidental release from research facilities. There have been suspected releases of infectious agents from laboratory facilities. The 1977–78 Russian influenza outbreak is strongly suspected to have originated due to a laboratory release event,[17] and in the UK, the 2007 foot-and-mouth outbreak may have originated in the Pirbright animal disease research facility.[18] Research on live infectious agents is typically done in facilities with the highest biosafety containment procedures, but some experts maintain that the potential for release, while low, remains, and may outweigh the benefits in some cases.

Some worry that advances in some of the same underlying sciences may make the development of novel, targeted biological weapons more feasible. In 2001 a research group in Australia inadvertently engineered a variant of mousepox with high lethality to vaccinated mice.[19] An accidental or deliberate release of a similarly modified virus infecting humans, or a species we depend heavily on, could have catastrophic consequences.

Similarly, *synthetic biology* may lead to a wide range of tremendous scientific benefits. The field aims to design and construct new biological parts, devices, and systems, and to comprehensively redesign living organisms to perform functions useful to us. This may result in synthetic bacterial and plant "microfactories," designed to produce new medicines, materials, and fuels, to break down waste, to act as sensors, and much more. In principle, such biofactories could be designed with much greater precision than current genetic modification and biolytic approaches. They should also allow products to be produced cheaply and cleanly. Such advances would be transformative on many challenges we currently face, such as global health care, energy, and fabrication.

Moreover, as the tools and facilities needed to engage in the science of synthetic biology become cheaper, a growing "citizen science" community is emerging around synthetic biology. Community "DIY Bio" facilities allow people to engage in novel experiments and art projects; some hobbyists even engage in synthetic biology projects in their own homes. Many of the leaders in the field are committed to synthetic biology being as open and accessible as possible worldwide, with scientific tools and expertise available freely. Competitions such as iGEM (International Genetically Engineered Machine) encourage undergraduate student teams to build and test biological systems in living cells, often with a focus on applying the science to important real-world challenges, and also to archive their results and products so as to make them available to future teams to build on.

Such citizen science represents a wonderful way of making cutting-edge science accessible and exciting to generations of

innovators. However, the increasing ease of access to increasingly powerful tools is a cause of concern to the risk community. Even if the vast majority engaging in synthetic biology are both responsible and well intentioned, the possibility of bad actors or unintended consequences (such as the release of an organism with unintended ecological consequences) exists. Further, we may expect that the range and severity of negative consequences will increase, as well as the difficulty in tracking those who have access to the necessary tools and expertise. At present, biosafety and biosecurity is deeply embedded within the major synthetic biology initiatives. In the United States, the FBI works closely with synthetic biology centers, and leaders in the field espouse the need for good practices at every level. However, this area will progress rapidly, and a balance will need to be struck between allowing access to powerful tools to a wide number of people who can do good with them, while restricting the potential for accidents or deliberate misuse. It remains to be seen how easy it will be to achieve this.

Geoengineering represents a host of challenges. Stratospheric aerosol geoengineering represents a particularly powerful proposal: here, a steady stream of reflective aerosols would be released into the upper atmosphere in order to reduce the amount of the sun's light reaching the earth's surface globally. This effectively mimics the global cooling phenomenon that occurs after a large volcanic eruption, when particulate matter is blasted into the atmosphere. However, current work is focused on theoretical modelling, with very minimal practical field tests carried out to date. Questions remain about how practically feasible it would be to achieve this on a global scale, and what impact it would have on rainfall patterns and crop growth.

It should be highlighted that this is not a solution to climate change. While global temperature might be stabilized or lowered, unless this was accompanied by reduction of CO_2 emissions, then a host of damages such as ocean acidification would still occur. Furthermore, if CO_2 emissions were allowed to continue to rise during this period, then a major risk termed "termination shock" could manifest. In this case, if any circumstance resulted in an abrupt cessation of stratospheric aerosol geoengineering, then the increased CO_2 concentration in the atmosphere would result in a rapid jump in global temperature, which would have far more severe impacts on ecosystems and human societies than the already disastrous effects of a gradual rise.

Critics fear that such research might be misunderstood as a way of avoiding the far more costly process of eliminating carbon emissions; and some are concerned that intervening

in such a profound way in our planet's functioning is deeply irresponsible. It also raises knotty questions about global governance: should any one country have the right to engage in geoengineering, and, if not, how could a globally coordinated decision be reached, particularly if different nations have different exposures to the impacts of climate change, and different levels of concern about geoengineering, given we are all under the same sky?

Proponents highlight that we may already be committed to severe global impacts from climate change at this stage, and that such techniques may allow us the necessary breathing room needed to transition to zero-carbon technology while temporarily mitigating the worst of the harms. Furthermore, unless research is carried out to assess the feasibility and likely impacts of this approach, we will not be well placed to make an informed decision at a future date, when the impacts of climate change may necessitate extreme measures. Eli Kintisch, a writer at *Science*, has famously called geoengineering "a bad idea whose time has come."[20]

Artificial intelligence, **explored in detail in Stuart Russell's chapter, may represent the wildest card of all. Everything we have achieved in terms of our civilizational progress, and shaping the world around us to our purposes, has been a product of our intelligence. However, some of the intellectual challenges we face in the twenty-first century are ones that human intelligence alone is not best suited to: for example, sifting through and identifying patterns in huge amounts of data, and integrating information from vast and interlinked systems. From analyzing disparate sources of climate data, to millions of human genomes, to running thousands of simulations, artificial intelligence will aid our ability to make use of the huge amount of knowledge we can gather and generate, and will help us make sense of our increasingly complex, interconnected world. Already, AI is being used to optimize energy use across Google's servers, replicate intricate physics experiments, and discover new mathematical proofs. Many specific tasks traditionally requiring human intelligence, from language translation to driving on busy roads, are now becoming automatable; allowing greater efficiency and productivity, and freeing up human intelligence for the tasks that AI still cannot do. However, many of the same advances have more worrying applications; for example, allowing collection and deep analysis of data on us as individuals, and paving the road for the development of cheap, powerful, and easily scalable autonomous weapons for the battlefield.**

These advances are already having a dramatic impact on our world. However, the vast majority of these systems can be described as "narrow" AI. They can perform functions at human level or above in narrow, well-specified domains, but lack the general cognitive abilities that humans, dogs, or even rats have: general problem-solving ability in a "real-world" setting, an ability to learn from experience and apply knowledge to new situations, and so forth.

There is renewed enthusiasm for the challenge of achieving "general" AI, or AGI, which would be able to perform at human level or above across the range of environments and cognitive challenges that humans can. However, it is currently unknown how far we are from such a scientific breakthrough, or how difficult the fundamental challenges to achieving this will be, and expert opinion varies widely. Our only proof of principle is the human brain, and it will take decades of progress before we can meaningfully understand the brain to a degree that would allow us to replicate its key functions. However, if and when such a breakthrough is achieved, there is reason to think that progress from human-level general intelligence to superintelligent AGI might be achieved quite rapidly.

Improvements in the hardware and software components of AI, and related sciences and technologies, might be made rapidly with the aid of advanced general AI. It is even conceivable that AI systems might directly engage in high-level AI research, in effect accelerating the process by allowing cycles of self-improvement. A growing number of experts in AI are concerned that such a process might quickly result in extremely powerful systems beyond human control; Stuart Russell has drawn a comparison with nuclear chain reaction.

Superintelligent AI has the potential to unlock unprecedented progress on science, technology, and global challenges; to paraphrase the founders of Google DeepMind, if intelligence can be "solved," it can then be used to help solve everything else. However, the risk from this hypothetical technology, whether through deliberate use or unintended runaway consequences, could be greater than that of any technology in human history. If it is plausible that this technology might be achieved in this century, then a great deal of research and planning—both on the technical design of such systems, and the governance structures around their development—will be needed in the decades beforehand in order to achieve a desirable transition.

Predicting the Future

The field also engages in exploratory and foresight-based work on more forward-looking topics; these include future advances in neuroscience and nanotechnology, future physics experiments, and proposed manufacturing technologies that may be developed in coming decades, such as molecular manufacturing. While we are limited in what we can say in detail about future scientific breakthroughs, it is often possible to establish some useful groundwork. For example, we can identify developments that should, in principle, be possible based on our current understanding of the relevant science. And we can dismiss ideas that are pure "science fiction," or sufficiently unfeasible to be safely ignored for now, or that represent a level of progress that makes them unlikely to be achieved for many generations.

By focusing further on those that could plausibly be developed within the next half century, we can give considerations to their underlying characteristics and possible impacts on the world, and of the broad principles we might bear in mind for their safe development and application. While it would have been a fool's errand to try to predict the full impacts of

the Internet prior to 1960, or of the development of nuclear weapons prior to 1945, it would certainly be possible to develop some thinking around the possible implications of very sophisticated global communications and information-sharing networks, or of a weapon of tremendous destructive potential.

Lastly, if we have some ideas about the directions from which transformative developments might come, we can engage in foresight and road-mapping research. This can help identify otherwise insignificant breakthroughs and developments that may indicate meaningful progress toward a more transformative technology being reached, or a threshold beyond which global dynamics are likely to shift significantly (such as photovoltaics and energy storage becoming cheaper and more easily accessible than fossil fuels).

Confronting the Limits of Our Knowledge

A common theme across these emerging technologies and emerging risks is that a tremendous level of scientific uncertainty and expert disagreement typically exists. This is particularly the case for future scientific progress and capabilities, the ways in which advances in one domain may influence progress in others, and the likely global impacts and risks of projected advances. Active topics of research at CSER include how to obtain useful information from a range of experts with differing views, and how to make meaningful scientific progress on challenges where we have discontinuous data, or few case studies to draw on, or even when we must characterize an entirely unprecedented event. This might be a hypothesized ecological tipping point, which when passed would result in an irreversible march toward the collapse of an entire critical ecosystem. Or it might be a transformative scientific breakthrough such as the development of artificial general intelligence, where we only have current trends in AI capability, hardware, and expert views on the key unsolved problems in the field to draw insight from. It is unrealistic to expect that we can always, or even for the most part, be right. We need to have humility, to expect false positives, and to be able to identify priority research targets from among many weak signals.

Recognizing that there are limits to the level of detail and certainty that can be achieved, this work is often combined with work on general principles of scientific and technological governance. For example, work under the heading of "responsible innovation" focuses on the challenge of developing collective stewardship of progress in science and technology in the present, with a view to achieving good future outcomes.[21] This combines scientific foresight with processes to involve the key stakeholders at the appropriate stages of a technology's development. At different stages these stakeholders will include: scientists involved in fundamental research and applied research;

industry leaders; researchers working on the risks, benefits, and other impacts of a technology; funders; policymakers; regulators; NGOs and focus groups; and laypeople who will use or be affected by the development of a technology. In the case of technologies with a potential role in global catastrophic risk, the entire global population holds a stake. Therefore decisions with long-term consequences must not rest solely with a small group of people, represent only the values of a small subset of people, or fail to account for the likely impacts on the global population.

There have been a number of very encouraging specific examples of such foresight and collaboration, where scientific domain specialists, interdisciplinary experts, funders, and others have worked together to try to guide an emerging technology's development, establish ethical norms and safety practices, and explore its potential uses and misuses in a scientifically rigorous way. In bioengineering, the famous 1975 Asilomar conference on recombinant DNA established important precedents, and more recently summits have been held on advances such as human gene editing. In artificial intelligence, a number of important conferences have been held recently, with enthusiastic participation from academic and industry research leaders in AI alongside interdisciplinary experts and policymakers. A number of the world's leading AI research teams have established ethical advisory panels to inform and guide their scientific practices, and a cross-industry "partnership on AI to benefit people and society" involving five companies leading fundamental research has recently been announced.[22]

More broadly, it is crucial that we learn from the lessons of past technologies and, where possible, develop principles and methodologies that we can take forward. This may give us an advantage in preparing for developments that are currently beyond our horizon and that methodologies too deeply tied to specific technologies and risks may not allow. One of the key concerns associated with risks from emerging and future technologies is the rate at which progress occurs and at which the associated threats may arise. While every science will throw up specific challenges and require domain-specific techniques and expertise, any tools or methodologies that help us to intervene reliably earlier are to be welcomed. There may be a

"People were always getting ready
for tomorrow. I didn't believe in that.
Tomorrow wasn't getting ready for them.
It didn't even know they were there."

The Road, a novel with which US writer Cormac
McCarthy won the Pulitzer Prize in 2007, was later made
into a movie of the same name by John Hillcoat with a
script adapted by Joe Penhall.

The Road (2009), John Hillcoat.

limited window of opportunity for averting such risks. Indeed, this window may occur in the early stages of developing a technology, well before the fully mature technology is out in the world, where it is difficult to control. Once Pandora's box is open, it is very difficult to close.

WORKING ON THE (DOOMSDAY) CLOCK

Technological progress now offers us a vision of a remarkable future. The advances that have brought us onto an unsustainable pathway have also raised the quality of life dramatically for many, and have unlocked scientific directions that can lead us to a safer, cleaner, more sustainable world. With the right developments and applications of technology, in concert with advances in social, democratic, and distributional processes globally, progress can be made on all of the challenges discussed here. Advances in renewable energy and related technologies, and more efficient energy use—advances that are likely to be accelerated by progress in technologies such as artificial intelligence—can bring us to a point of zero-carbon emissions. New manufacturing capabilities provided by synthetic biology may provide cleaner ways of producing products and degrading waste. A greater scientific understanding of our natural world and the ecosystem services on which we rely will aid us in plotting a trajectory whereby critical environmental systems are maintained while allowing human flourishing. Even advances in education and women's rights globally, which will play a role in achieving a stable global population, can be aided specifically by the information, coordination, and education tools that technology provides, and more generally by growing prosperity in the relevant parts of the world.

There are catastrophic and existential risks that we will simply not be able to overcome without advances in science and technology. These include possible pandemic outbreaks, whether natural or engineered. The early identification of incoming asteroids, and approaches to shift their path, is a topic of active research at NASA and elsewhere. While currently there are no known techniques to prevent or mitigate a supervolcanic eruption, this may not be the case with the tools at our disposal a century from now. And in the longer run, a civilization that has spread permanently beyond the earth, enabled by advances in spaceflight, manufacturing, robotics, and terraforming, is one that is much more likely to endure. However, the breathtaking power of the tools we are developing is not to be taken lightly. We have been very lucky to muddle through the advent of nuclear weapons without a global catastrophe. And within this century, it

is realistic to expect that we will be able to rewrite much of biology to our purposes, intervene deliberately and in a large-scale way in the workings of our global climate, and even develop agents with intelligence that is fundamentally alien to ours, and may vastly surpass our own in some or even most domains—a development that would have uniquely unpredictable consequences.

It is reassuring to note that there are relatively few individual events that could cause an existential catastrophe—one resulting in extinction or a permanent civilizational collapse. Setting aside the very rare events (such as supervolcanoes and asteroids), the most plausible candidates include nuclear winter, extreme global warming or cooling scenarios, the accidental or deliberate release of an organism that radically altered the planet's functioning, or the release of an engineered pathogen. They also include more speculative future advances: new types of weaponry, runaway artificial intelligence, or maybe physics experiments beyond what we can currently envisage. Many global risks are, in isolation, survivable—at least for some of us—and it is likely that human civilization could recover from them in the long run: less severe global warming, various environmental disasters and ecosystem collapses, widespread starvation, most pandemic outbreaks, conventional warfare (even global).

However, this latter class of risks, and factors that might drive them (such as population, resource use, and climate change) should not be ignored in the broader study of existential risk. Nor does it make sense to consider these challenges in isolation: in our interconnected world they all affect each other. The threat of global nuclear war has not gone away, and many scholars believe that it may be rising again (at the time of writing, North Korea has just undergone its most ambitious nuclear test to date). If climate pressures, drought, famine, and other resource pressures serve to escalate geopolitical tensions, or if the potential use of a new technology, such as geoengineering, could lead to a nuclear standoff, then the result is an existential threat.

For all these reasons and more, a growing community of scholars across the world believe that the twenty-first century will see greater change and greater challenges than any century in humanity's past history. It will be a century of unprecedented global pressures, and a century in which extreme and unpredictable events are likely to happen more frequently than ever before in the past. It will also be a century in which the power of technologies unlike any

we have had in our past history will hang over us like multiple Damocles' swords. But it will also be a century in which the technologies we develop, and the institutional structures we develop, may aid us in solving many of the problems we currently face—if we guide their development, and their uses and applications, carefully.

It will be a century in which we as a species will need to learn to cooperate on a scale and depth that we have never done before, both to avoid the possibility of conflict with the weapons of cataclysmic power we have developed, and to avoid the harmful consequences of our combined activities on the planet. And despite how close we came to falling on the first hurdle with nuclear weapons, there are reasons for great optimism. The threat they presented has, indeed, led to a greater level of international cooperation, and international structures to avoid the possibility of large-scale war, than has ever happened before. In a world without nuclear weapons, we may, indeed, have seen a third world war by now. And the precedent set by international efforts around climate change mitigation is a powerful one. In December 2015, nations around the world agreed to take significant steps to reduce the likelihood of global catastrophic harm to future generations, even though in many cases these steps may be both against the individual economic interests of these nations, and against the economic interests of the current generation. With each of these steps, we learn more, and we put another plank in the scientific and institutional scaffolding we will need to respond effectively to the challenges to come.

If we get it right in this century, humanity will have a long future on earth and among the stars.

ACKNOWLEDGMENTS

Seán Ó hÉigeartaigh's work is supported by a grant from Templeton World Charity Foundation. The opinions expressed in this chapter are those of the author and do not necessarily reflect the views of Templeton World Charity Foundation.

1. M. Garber, "The man who saved the world by doing absolutely nothing," *The Atlantic* (2013). http://www.theatlantic.com/technology/archive/2013/09/the-man-who-saved-the-world-by-doing-absolutely-nothing/280050.

2. P. M. Lewis et al., *Too Close for Comfort: Cases of Near Nuclear Use and Options for Policy* (London: Chatham House, the Royal Institute of International Affairs, 2014).

3. Nick Bostrom, "Existential risks," *Journal of Evolution and Technology* 9(1) (2002).

4. J. Jefferies, "The UK population: past, present and future," in *Focus on People and Migration* (London: Palgrave Macmillan UK, 2005).

5. B. Gates, "The next epidemic— lessons from Ebola," *New England Journal of Medicine* 372(15) (2015).

6. Jeremy J. Farrar and Peter Piot, "The Ebola emergency— immediate action, ongoing strategy," *New England Journal of Medicine* 371 (2014): 16.

7. See http://slatestarcodex.com/2014/07/30/meditations-on-moloch.

8. World Population Prospects: the 2015 Revision. United Nations Department of Economic and Social Affairs. https://esa.un.org/unpd/wpp/Publications/Files/Key_Findings_WPP_2015.pdf.

9. See https://www.technologyreview.com/s/601601/six-months-after-paris-accord-were-losing-the-climate-change-battle.

10. G. Ceballos et al., "Accelerated modern human-induced species losses: Entering the sixth mass extinction," *Science Advances* 1(5) (2015).

11. Toby Ord, "Overpopulation or underpopulation," in *Is the Planet Full?*, Ian Goldin (ed.), (Oxford: OUP, 2014).

12. J. D. Shelton, "Taking exception. Reduced mortality leads to population growth: an inconvenient truth," *Global Health: Science and Practice* 2(2) (2014).

13. See https://www.givingwhatwecan.org/post/2015/09/development-population-growth-and-mortality-fertility-link.

14. Bill Gates, "2014 Gates annual letter: 3 myths that block progress for the poor," *Gates Foundation* 14 (2014). http://www.gatesfoundation.org/Who-We-Are/Resources-and-Media/Annual-Letters-List/Annual-Letter-2014.

15. D. King et al., *A Global Apollo Programme to Combat Climate Change* (London: London School of Economics, 2015). http://www.globalapolloprogram.org/

16. W. Steffen et al., "Planetary boundaries: Guiding human development on a changing planet," *Science* 347(6223) (2015)..

17. M. Rozo and G. K. Gronvall, "The reemergent 1977 H1N1 strain and the gain-of-function debate," *mBio* 6(4) (2015).

18. T. Hugh Pennington, "Biosecurity 101: Pirbright's lessons in laboratory security," *BioSocieties* 2(04) (2007).

19. M. J. Selgelid et al., "The mousepox experience," *EMBO reports* 11(1) (2010): 18–24.

20. See https://www.wired.com/2010/03/hacktheplanet-qa.

21. J. Stilgoe et al., "Developing a framework for responsible innovation," *Research Policy* 42(9) (2013).

22. See http://www.partnershiponai.org.

Interstellar Travel and Post-Humans

MARTIN REES

Martin Rees
Institute of Astronomy, Cambridge, UK

Martin Rees is a cosmologist and space scientist. He has contributed
insights to many aspects of stars, black holes, galaxy evolution, the 'big
bang' and the multiverse. He is based in Cambridge, UK, where he has
been Director of the Institute of Astronomy, a Research Professor, and
Master of Trinity College. He was President of the Royal Society during
2005–10. In 2005 he was appointed to the UK's House of Lords. His books
include *Before the Beginning*, *Our Final Century*, *Just Six Numbers*, *Our
Cosmic Habitat*, *Gravity's Fatal Attraction*, and *From Here to Infinity:
Scientific Horizons*, an expanded version of his BBC Reith Lectures. A
further book, *What We Still don't Know*, is forthcoming.

The Earth has existed for forty-five million centuries
—and even longer timespans lie ahead before the Sun
dies. But even in this vast time-perspective, the present
century is special. It is the first when humans may establish
communities away from the Earth. And it is the first when
they may create electronic intelligences that surpass their
own all-round capabilities, and also achieve the ability to
bio-engineer their progeny. In this chapter, some aspects
of this transition are discussed, along with some even more
speculative comments about "post-human" evolution, and
the future of the universe itself.

INTRODUCTION

Astronomers like myself are professionally engaged in thinking about huge expanses of space and time. We view our home planet in a cosmic context. We wonder whether there is life elsewhere in the cosmos. But, more significantly, we are mindful of the immense future that lies ahead—the post-human future where our remote descendants may transcend human limitations—here on Earth but (more probably) far beyond. This is my theme in the present chapter.

The stupendous timespans of the evolutionary past are now part of common culture. But the even longer time-horizons that stretch ahead—though familiar to every astronomer —have not permeated our culture to the same extent. Our Sun is less than half way through its life. It formed 4.5 billion years ago, but it has got six billion more before the fuel runs out. It will then flare up, engulfing the inner planets and vaporizing any life that might still remain on Earth. But even after the Sun's demise, the expanding universe will continue— perhaps forever—destined to become ever colder, ever emptier.

Any creatures witnessing the Sun's demise six billion years hence will not be human —they will be as different from us as we are from a bug. Post-human evolution could be as prolonged as the Darwinian evolution that has led to us, and even more wonderful— and will have spread far from Earth, even among the stars. Indeed, this conclusion is strengthened when we realize that future evolution will proceed not on the million-year timescale characteristic of Darwinian selection, but at the much accelerated rate allowed by genetic modification and the advance of machine intelligence (and forced by the drastic environmental pressures that would confront any humans who were to construct habitats beyond the Earth). Natural selection may have slowed: its rigors are tempered in civilized

countries. But it will be replaced by "directed" evolution. Already, performance enhancing drugs, genetic modification, and cyborg technology are changing human nature, and these are just precursors of more drastic changes.

Darwin himself realized that "No living species will preserve its unaltered likeness into a distant futurity." We now know that "futurity" extends far further, and alterations can occur far faster than Darwin envisioned. And we know that the cosmos, through which life could spread, offers a far more extensive and varied habitat than he ever imagined. So humans are surely not the terminal branch of an evolutionary tree, but a species that emerged early in the overall roll-call of species, with special promise for diverse evolution—and perhaps of cosmic significance for jump-starting the transition to silicon-based (and potentially immortal) entities that can more readily transcend human limitations.

A SPECIAL CENTURY

For nearly fifty years we have had pictures of the Earth taken from space, showing how its delicate biosphere contrasts with the sterile moonscape where the astronauts left their footprint. These have become iconic, especially for environmentalists. But suppose some aliens had been viewing such an image for our planet's entire history, what would they have seen?

Over nearly all that immense time, 4.5 billion years, Earth's appearance would have altered very gradually. The continents drifted; the ice cover waxed and waned; successive species emerged, evolved, and became extinct. But in just a tiny sliver of the Earth's history—the last one millionth part, a few thousand years—the patterns of vegetation altered much faster than before. This signalled the start of agriculture. The pace of change accelerated as human populations rose. Humanity's "footprint" got larger because our species became more demanding of resources—and also because of population growth.

Within fifty years—little more than one hundredth of a millionth of the Earth's age—the carbon dioxide in the atmosphere began to rise anomalously fast. And something else unprecedented happened: rockets launched from the planet's surface escaped the biosphere completely. Some were propelled into orbits around the Earth; some journeyed to the Moon and planets.

If they understood astrophysics, the aliens could confidently predict that the biosphere would face doom in a few billion years when the Sun flares up and dies. But could they have predicted this sudden "fever" half way through the Earth's life—these human-induced alterations occupying, overall, less than a millionth of the Earth's elapsed lifetime and seemingly occurring with runaway speed?

If they continued to keep watch, what might they witness in the next hundred years? Will the spasm be followed by silence? Will the planet make a transition to sustainability? And, most important of all for the long-term future, will an armada of rockets leaving Earth have led to new communities elsewhere—on Mars and its moons, on asteroids, or freely floating in space?

And we live at a crucial time. Our Earth has existed for forty-five million centuries, and still more lie ahead. But this century may be a defining moment. It is the first in our planet's history where one species (ours) has Earth's future in its hands, because of our empowerment

by fast-advancing technologies. We humans are entitled to feel uniquely significant, as the first known species with the power (and the responsibility) to mold its own future —and perhaps the future of intelligence in the cosmos.

Three new technologies will be crucial in the rest of this century: advanced biotech; artificial intelligence (and the possibility of "cyborg" enhancement); and the ability to explore space. These are all advancing so fast that we cannot confidently predict even to the end of the present century: we must keep our minds open to transformative advances that may now seem science fiction. After all, the smartphone, the web, and their ancillaries pervade our lives today, but they would have seemed magic as little as twenty years ago.

On the bio front, it took fifty years from Crick and Watson's discovery of the double helix to the sequencing of the human genome. And within just a decade the costs of each such sequencing have fallen by a factor of ten thousand. New techniques for gene editing (e.g., CRISPR) and so-called "gain-of-function" experiments that can make viruses more virulent or transmissible offer great hopes. But they open up new ethical dilemmas, and great fears of misuse, because the relevant expertise will be widespread. ("Biohacking" is already a competitive pursuit among students.) The physicist Freeman Dyson conjectures a time when children will be able to design and create new organisms just as routinely as his generation played with chemistry sets. This is a hugely exciting prospect (especially if we one day wish to "green" alien habitats with plants to flourish there). But on the other hand there is a downside, stemming from the risk of bioerror or bioterror. If it becomes possible to "play God on a kitchen table" (as it were), our ecology, and even our species, may not long survive unscathed.

But what about a second transformative technology: robotics and artificial intelligence (AI)? We are all familiar with the dramatic consequences of Moore's Law in yielding continuing advances in computer modelling and data processing. Progress in AI has, however, experienced "false dawns" followed by periods of discouragement. But it is currently on a "high," partly due to exciting advances in what is called generalized machine learning. "Deep Mind" (a small London company now bought up by Google) achieved a remarkable feat early in 2016—its computer beat the world champion in the game of "Go."

Of course it is twenty years since IBM's "Deep Blue" beat Kasparov, the world chess champion. But "Deep Blue" was programmed in detail by expert players. In contrast, the Go-playing machine

"The only way of discovering
the limits of the possible is to
venture a little way past them
into the impossible."

ARTHUR C. CLARKE (1917–2008)
British writer. This quote is Clarke's second law, published in his essay
"Hazards of Prophecy: The Failure of Imagination", in *Profiles of the
Future* (1962). He is the author of the novel *2001: A Space Odyssey* (1968),
which he wrote concurrently with the production of the film. It was
published following the film's premiere.

2001: A Space Odyssey (1968), Stanley Kubrick.

gained expertise by absorbing huge numbers of games and playing itself over and over again. Its designers do not themselves know how the machine makes its decisions.

Computers use "brute force" methods and it is the advances in processing power that have allowed generalized machine learning to "take off." Computers learn to identify dogs, cats, and human faces by "crunching" through millions of images—not the way babies learn. And they learn to translate by reading millions of pages of (for example) multilingual European Union documents (they never get bored!).

But advances are patchy. Robots are still clumsier than a child in moving pieces on a real chessboard. They cannot tie your shoelaces or cut your toenails. But sensor technology, speech recognition, information searches, and so forth are advancing apace. They will not just take over manual work (indeed plumbing and gardening will be among the hardest jobs to automate), but routine legal work (conveyancing and suchlike), medical diagnostics, and even surgery.

The big social and economic question is this: will this "second machine age" be like earlier disruptive technologies—the car, for instance—and create as many jobs as it destroyed? Or is it really different this time? These concerns are sufficiently near-term that they are on the political agenda.

But let us speculate further ahead. If robots became less clumsy and limited, they might eventually be able to observe, interpret, and alter their environment as adeptly as we do. They would then truly be perceived as intelligent beings, to which (or to whom) we can relate. Such machines pervade popular culture—in movies like *Her*, *Transcendence*, and *Ex Machina*. Do we have obligations toward them? We worry if our fellow-humans, and even animals, cannot fulfill their natural potential. Should we feel guilty if our robots are frustrated, underemployed or bored?

We have a long way to go before we really confront these issues. As an indicator of the gap still to be bridged, the Go-playing computer probably consumed several hundreds of kilowatts during the game. The human champion's brain (which of course can do many other things apart from play a game) consumes about 30 watts—as much as a light bulb.

There is disagreement about the route toward human-level intelligence. Some think we should emulate nature, and reverse-engineer the human brain. Others say that is as misguided as designing a flying machine by copying how birds flap their wings. And philosophers debate whether "consciousness" is special to the wet, organic brains of

humans, apes, and dogs—so that robots, even if their intellects seem superhuman, will still lack self-awareness or inner life.

But, either way, we may one day confront in reality scenarios where autonomous robots " go rogue," where a "supercomputer" offers its controller dominance of international finance, or where a network could develop a mind of its own. If it could infiltrate the Internet—and the burgeoning "Internet of things"—it could manipulate the rest of the world. It may have goals utterly orthogonal to human wishes—or even treat humans as an encumbrance.

Some AI pundits take this seriously, and think the field already needs guidelines—just as biotech does. But others regard these concerns as premature—and worry less about artificial intelligence than about real stupidity. Be that as it may, it is likely that society will, within this century, be transformed by autonomous robots, even though the jury is out on whether they will still be "idiot savants" or will already display superhuman capabilities.

Back in the 1960s the British mathematician I. J. Good pointed out that superintelligent robots (if sufficiently versatile) could be the last invention that humans need ever make. Once machines had surpassed human capabilities, they could themselves design and assemble a new generation of even more intelligent ones, as well as an array of robotic fabricators that could transform the world physically.

Techno-evangelists like Ray Kurzweil (who now works at Google) predict that intelligent machines will "take over" within fifty years, triggering a global transformation—the so-called "singularity." For this to happen, processing power is not enough: the computers would need sensors that enabled them to see and hear as well as we do, and the software to process and interpret what their sensors tell them. Kurzweil thinks that humans could transcend biology by merging with computers. In old-style spiritualist parlance, they would "go over to the other side."

Few doubt that machines will gradually surpass more and more of our distinctively human capacities—or enhance our capabilities via cyborg technology. Disagreements are basically about the timescale: the rate of advance, not the direction of advance. Some think that there will be an "intelligence explosion" during this century. The cautious among us think these transformations may take centuries.

But a timespan of centuries is but an instant compared to the timescales of the Darwinian selection that led to humanity's emergence. More relevantly, they are less than a millionth of the vast expanses of time lying ahead. So I think it is inevitable that the long-range future lies with machines.

There are chemical and metabolic limits to the size and processing power of brains with the kind of "wet" hardware we

have inside our skulls. Maybe we humans are close to these limits already. But there are no such constraints on electronic computers (still less, perhaps, on quantum computers): for these, the potential for further development could be as dramatic as the evolution from monocellular organisms to humans. By any definition of "thinking," the amount and intensity that is done by organic human-type brains will be utterly swamped by the cerebrations of AI. Moreover, the evolution toward ever-greater complexity will take place on a technological timescale—far faster than the slow Darwinian selection that has driven evolution on the Earth up till now.

This post-human intelligence will surely spread far beyond the Earth. So I turn next to the prospects for space technology. This is an arena where (despite human spaceflight) robots already have the dominant role.

THE FUTURE OF SPACE TECHNOLOGY

In the last two years we have seen ESA's "Rosetta" spacecraft land a robot on a comet. And NASA's "New Horizons" probe has beamed back amazing pictures from Pluto, 10,000 times further away than the Moon. These two instruments were designed and built fifteen years ago: they took five years to construct, and then ten years journeying to their remote targets. Think how much better we could do today.

I would venture a confident forecast that, during this century, the entire Solar System—planets, moons, and asteroids—will be explored and mapped by flotillas of tiny robotic craft. The next step would be space mining and fabrication. (And fabrication in space will be a better use of materials mined from asteroids than bringing them back to Earth.) Every man-made object in space has had to be launched from Earth. But later this century giant robotic fabricators will be able to assemble, in space, huge solar-energy collectors and huge computer networks. The Hubble Telescope's successors, with huge gossamer-thin mirrors assembled under zero gravity, will further expand our vision of stars, galaxies, and the wider cosmos.

But what role will humans play? There is no denying that NASA's "Curiosity," now trundling across Martian craters, may miss startling discoveries that no human geologist could overlook. But robotic techniques are advancing fast, allowing ever more sophisticated unmanned probes, whereas the cost gap between manned and unmanned missions remains huge. The practical case for manned spaceflight gets ever weaker with each advance in robots and miniaturization: indeed, as a scientist or practical man, I see little purpose in sending people into space at all. But, as a human being, I am an enthusiast for manned missions. And I am old enough to recall my excitement at the Apollo Program, and Neil Armstrong's "one

small step" on the Moon back in 1969. The last men on the Moon returned in 1972. Since then, hundreds of humans have been into space, but only into low orbit—circling the Earth only a few hundred kilometers about its surface, many in the hugely expensive (but uninspiring) International Space Station.

I hope some people now living will walk on Mars—as an adventure, and as a step toward the stars. They may be Chinese: China has the resources, the dirigiste government, and maybe the willingness to undertake an Apollo-style program. And China would need to aim at Mars, not just at the Moon, if it wanted to assert its superpower status by a "space spectacular": a rerun of what the US achieved fifty years earlier would not proclaim parity.

Unless motivated by pure prestige and bankrolled by superpowers, manned missions beyond the Moon will need perforce to be cut-price ventures, accepting high risks—perhaps even "one-way tickets." These missions will be privately funded; no Western governmental agency would expose civilians to such hazards. There would, despite the risks, be many volunteers—driven by the same motives as early explorers, mountaineers, and the like. Private companies already offer orbital flights. Wealthy adventurers are signing up for a week-long trip round the far side of the Moon—voyaging further from Earth than anyone has been before (but avoiding the greater challenge of a Moon landing and blast-off). I am told they have sold a ticket for the second flight but not for the first flight. And Denis Tito, a former astronaut and entrepreneur, may not be crazy in planning to send people to Mars and back—without landing. This would involve five hundred stressful days cooped up in a capsule. The ideal crew would be a stable middle-aged couple—old enough to be relaxed about a high dose of radiation. And there is another scheme that would allow you to land on Mars, but then to stay there—no return ticket.

We should surely acclaim these private-enterprise efforts in space—they can tolerate higher risks than a Western government could impose on publicly funded civilians, and thereby cut costs compared to NASA or ESA. But they should be promoted as adventures or extreme sports—the phrase "space tourism" should be avoided. It lulls people into unrealistic confidence.

By 2100 courageous pioneers in the mold of (say) Felix Baumgartner, who broke the sound barrier in free fall from a high-altitude balloon, may have established "bases" independent from the Earth—on Mars, or maybe on asteroids. Elon Musk himself (aged forty-four) says he wants to die on Mars—but not on impact. Development of self-sustaining communities remote from the Earth would also ensure that advanced life would survive, even if the worst conceivable catastrophe befell our planet.

But do not ever expect mass emigration from Earth. Nowhere in our Solar System offers an environment even as clement as the Antarctic or the top of Everest. It is a dangerous delusion to think that space offers an escape from Earth's problems. There is no "Planet B."

Indeed, Space is an inherently hostile environment for humans. For that reason, even though we may wish to regulate genetic and cyborg technology on Earth, we should surely wish the space pioneers good luck in using all such techniques to adapt to different atmospheres, different g-forces, and so on. This might be the first step toward divergence into a new species: the beginning of the post-human era.

Human exploration will be restricted to the planets and moons of our Solar System. This is because the transit time to other stars, using known technology, exceeds a human lifetime.

The Kepler satellite owes its name to Johannes Kepler. Its mission was to seek planets outside the Solar System. It was launched from Cape Canaveral on the morning of March 6, 2009. The mission concluded four years later, on August 15, 2013.

And it will remain so even if futuristic forms of propulsion can be developed and deployed—involving nuclear power, matter-antimatter annihilation, or pressure from giant laser beams. Interstellar travel (except for unmanned probes, DNA samples, and so on) is therefore an enterprise for post-humans. They could be organic creatures (or cyborgs) who had won the battle with death, or perfected the techniques of hibernation or suspended animation. A journey lasting thousands of years is a doddle if you are near-immortal and not constrained to a human lifespan.

And machines of human intelligence could spread still further. Indeed, the Earth's biosphere, in which organic life has symbiotically evolved, is not essential sustenance for advanced AI. Indeed it is far from optimal: interplanetary and interstellar space, a hostile environment for humans, will be the preferred arena where nonbiological "brains" may, in the far future, construct huge artifacts by mining moons and asteroids. And where these post-human intellects will develop insights as far beyond our imaginings as string theory is for a mouse.

These considerations have a transformational impact on our perception of Earth's cosmic significance. Even if intelligent life were unique to the Earth, we need not conclude that life is a trivial irrelevance in a vast cosmos. It may seems so today, but in the billions of years lying ahead, post-human species or artifacts would have abundant time to spread through the entire Galaxy.

But are we unique, or is there intelligent life out there already?

DOES ALIEN LIFE EXIST AND HOW CAN WE FIND IT?

There may be simple organisms on Mars, or perhaps freeze-dried remnants of creatures that lived early in the planet's history; and there could be life, too, swimming in the ice-covered oceans of Jupiter's moon Europa, or Saturn's moon Enceladus. But few would bet on it; and certainly nobody expects a complex biosphere in such locations. For that, we must look to the distant stars—far beyond the range of any probe we can now construct. And here the prospects are far brighter: we have recognized that there are, within our Milky Way Galaxy, millions—even billions—of planets resembling the young Earth.

In the last twenty years (and especially in the last five) the night sky has become far more interesting, and far more enticing to explorers, than it was to our forbears. Astronomers have discovered that many stars—perhaps even most—are orbited by retinues of planets, just like the Sun is. These planets are not detected directly. Instead, they reveal their presence by effects on their parent star that can be detected by precise measurements: small periodic motions in the star induced by an orbiting planet's gravity, and slight recurrent dimmings in a star's brightness when a planet transits in front of it, blocking out a small fraction of the star's light.

NASA's "Kepler" spacecraft monitored the brightness of 150,000 stars with high enough precision to detect transits of planets no bigger than the Earth. Some stars are known to be orbited by as many as seven planets, and it is already clear that planetary systems display a surprising variety: our own Solar System may be far from typical. In some systems, planets as big as Jupiter are orbiting so close to their star that their "year" lasts only a few days. Proxima Centauri, the nearest star, is orbited by a planet only a few times heavier than the Earth. This star is much fainter than our Sun. Consequently, even though the planet is orbiting so close

that its "year" is only eleven days, it has a temperature such that liquid water could exist without boiling away. Some planets are on eccentric orbits. And there is one planet orbiting a binary star, which is itself orbited by another binary star: it would have four "suns" in its sky. But there is special interest in possible "twins" of our Earth—planets the same size as ours, orbiting other Sun-like stars, on orbits with temperatures such that water neither boils nor stays frozen. These exo-planets have been inferred indirectly, by detecting their effect on the brightness or motions of the stars they are orbiting around.

But we would really like to see these planets directly—not just their shadows. And that is hard. To realize just how hard, suppose an alien astronomer with a powerful telescope was viewing the Earth from (say) thirty light-years away—the distance of a nearby star. Our planet would seem, in Carl Sagan's phrase, a "pale blue dot," very close to a star (our Sun) that outshines it by many billions: a firefly next to a searchlight. But if the aliens could detect the Earth at all, they could learn quite a bit about it. The shade of blue would be slightly different, depending on whether the Pacific ocean or the Eurasian land mass was facing them. They could infer the length of the "day," the seasons, whether there are oceans, the gross topography, and the climate. By analyzing the faint light, they could infer that the Earth had a biosphere.

Our present telescopes do not allow us to infer much about Earthlike planets (though they are able to resolve the light from "Jupiters" around nearby stars. But firmer cues will surely come, in the next decade, from the James Webb Space Telescope (a space telescope with a 6.5-meter-diameter mirror, due to be launched in 2018). Better still could be the next generation of giant ground-based telescopes. Within fifty years, the unimaginatively named E-ELT ("European Extremely Large Telescope") being constructed on a mountain-top in Chile, with a mosaic mirror thirty-nine meters across, will be able to draw such inferences about planets the same size as our Earth, orbiting other Sun-like stars. (And there are two somewhat smaller US telescopes in gestation too.)

But do we expect alien life on these extra-solar planets? Many are "habitable," but that does not mean that they are inhabited, even by the most primitive life forms, let alone by anything that we would deem "advanced" or "intelligent."

We do not know how life began on our planet—it is still a mystery what caused the transition from complex chemistry to the first replicating and metabolizing entities that would be deemed to be "alive." This transition could have involved an

incredibly rare fluke. On the other hand, something similar could have happened on many of these other "Earths." The origin of life has long been realized to be one of the "Everest problems" of science. But until recently it has been deemed too challenging, and has not attracted many top-rate scientists. But that has now changed. I am hopeful that biochemists will offer clues within the next decade or two. We shall then know how likely life's emergence was, and where best to look. And also whether there is something very special about the DNA/RNA basis of terrestrial life, or whether alien creatures could exist whose bodies and metabolism are based on very different chemistry.

In considering the possibilities of life elsewhere, we should surely, in our present state of ignorance, be open-minded about where it might emerge and what forms it could take. It is important not to dismiss the possibility of non-Earthlike life in non-Earthlike locations, But it plainly makes sense to start with what we know (the "searching under the street light" strategy) and to deploy all available techniques to discover whether any exo-planet atmospheres display evidence for a biosphere—or for any life at all.

Even if simple life is common, it is of course a separate question whether it is likely to evolve into anything we might recognize as intelligent—whether Darwin's writ runs through the wider cosmos. Perhaps the cosmos teems with life; on the other hand, our Earth could be unique among the billions of planets that surely exist.

But if intelligence did emerge on some of these worlds, it could have had a head start if it emerged on a planet around a star older then the Sun, or it could have evolved faster than it did here. Consequently life elsewhere could have already achieved capabilities far exceeding our own.

Such thoughts have led to renewed interest in seeking evidence for "ET," or extraterrestrial. Indeed a Russian investor, Yuri Milner, has committed 100 million dollars, over the next decade, to upgrading such searches. I would rate the chances of success as, at best, a few percent. But a detection would be so important—not just for science but for our perception of humanity's place in the cosmos—that it is surely worth the gamble.

Conjectures about advanced or intelligent life are, of course, far more shaky than those about simple life. The firmest guesses that we can make are based on what has happened on Earth, and what might develop in the far future from Earth-based life.

It would plainly be a momentous discovery to detect any "signal" that was manifestly artificial: it would indicate that there are entities elsewhere in the cosmos manifesting evidence of intelligence and technology. If there were to be a detection, what might its originators be like? In popular culture, aliens are generally depicted as vaguely humanoid—generally bipedal, though maybe with tentacles, or eyes on stalks. Perhaps such creatures exist. But I would argue that they are not the kind of alien intelligence that we should be expecting.

The changing perspective on the future of life on Earth that I have described earlier in this chapter is highly relevant to any discussion of SETI (or Search for Extraterrestrial Intelligence) and suggests that we should expect something very different. The recent advances in computational power and robotics have led to growing interest in the possibility that artificial intelligence could in the coming decades achieve (and exceed) human capabilities over a wider range of conceptual and physical tasks. This is leading to a greater understanding of learning, thinking, and creativity and has stimulated debate on the nature of consciousness (is it an "emergent" property or something more special?). It has also led to some fascinating speculation by ethicists and philosophers on what forms of inorganic intelligence might be created by us.

Suppose that there are many other planets where life began; and suppose that on some of them Darwinian evolution followed a similar track to what happened here on Earth. Even then, it is highly unlikely that the key stages would be synchronized. If the emergence of intelligence and technology on a planet lags significantly behind what has happened on Earth (because the planet is younger, or because the "bottlenecks" to complex life—from single cell to multicellular organisms, for instance—have taken longer to negotiate there than here) then that planet would plainly reveal no evidence of ET. But life on some planets could have developed faster. Moreover, on a planet around a star older than the Sun, it could have had a head start of a billion years or more.

The history of human technological civilization is measured in centuries—and it may be only a few more centuries before humans are overtaken or transcended by inorganic intelligence. And—most importantly—this inorganic intelligence could then persist, continuing to evolve, for billions of years. Such considerations suggest that if we were to detect ET, we would be most unlikely to "catch" alien intelligence in the brief sliver of time when it was still in organic form. It is far more likely that it would have had a head start and would long ago have transitioned into electronic (and inorganic) forms.

So an ET signal, if we were to find it, would more likely come not from organic or biological life, not from an alien "civilization," but from immensely intricate and powerful electronic brains. In particular, the habit of referring to "alien civilizations" may be too restrictive. A "civilization" connotes a society of individuals: in contrast, ET might be a single integrated intelligence.

What does this mean for SETI searches? These are surely worthwhile, despite the heavy odds against success because the stakes are so high. That is why we should surely acclaim

the launch of Yuri Milner's "Breakthrough Listen" project, which will carry out the world's deepest and broadest search for alien technological life using several of the world's largest radio and optical telescopes. The project involves dedicating to the program twenty to twenty-five percent of the time on two of the world's biggest steerable radio dishes: those at Green Bank, West Virginia, in the United States, and at Parkes in Australia.

Hopefully other instruments such as the Arecibo Observatory (the huge dish carved in the ground in Puerto Rico) will join the quest. These telescopes will be used to search for non-natural radio transmissions from nearby and distant stars, from the plane of the Milky Way, from the Galactic Center and from nearby galaxies. They will seek narrow-band emission of a kind that could not arise from any natural cosmic source. They will search over a wide frequency range from 100 MHz to 50 GHz using advanced signal processing equipment developed by a team centered on UC Berkeley.

This project builds on a tradition of radio-astronomical SETI dating back fifty years. But of course there could be evidence in other wavebands. For instance, laser pulses would be a good way to communicate over interstellar distances. And very powerful laser beams offer a possible advanced technique for accelerating spacecraft to high speed. These would be even more conspicuous. And that is why the Breakthrough Listen project will use optical telescopes as well.

SETI searches seek electromagnetic transmissions—in any band—that are manifestly artificial. But even if the search succeeded (and few of us would bet more than one percent on this), it would still, in my view, be unlikely that the "signal" would be a decodable message, intentionally aimed at us. It would more likely be just a by-product (or even a malfunction) of some super-complex machine far beyond our comprehension that could trace its lineage back to alien organic beings. (These beings might still exist on their home planet, or might long ago have died out).

The only type of intelligence whose messages we could decode would be the (perhaps small) subset that used a technology attuned to our own parochial concepts. Even if signals were being intentionally transmitted, we may not recognize them as artificial because we may not know how to decode them. A radio engineer familiar only with amplitude-modulation might have a hard time decoding modern wireless communications. Indeed, compression techniques aim to make the signal as close to noise as possible—insofar as a signal is predictable, there is scope for more compression, and more energy saving in the transmission. So we may fail to recognize a meaningful message even if it is detected.

Assembly of the Delta IV rocket's super-motors. One more step towards Orion's first flight in 2018.

Even if intelligence were widespread in the cosmos, we may only ever recognize a small and atypical fraction of it. Some "brains" may package reality in a fashion that we cannot conceive. Others could be living contemplative lives—deep under some planetary ocean or floating freely in space—doing nothing to reveal their presence.

Perhaps the Galaxy already teems with advanced life, and our descendants will "plug in" to a galactic community—as rather "junior members." On the other hand, our Earth may be unique and the searches may fail. This would disappoint the searchers. But it would have an upside. Humans could then be less cosmically modest. Our tiny planet—this pale blue dot floating in space—could be the most important place in the entire cosmos. Moreover, we would be living at a unique time in our planet's history: our species would have cosmic significance, for being the transient precursor to a culture dominated by machines, extending deep into the future and spreading far beyond Earth. Even if we are now alone in the universe (which would be a disappointment, of course, for the SETI program) this would not mean that life would forever be a trivial "pollutant" of the cosmos, Our planet's future would then be of cosmic importance, not "merely" a matter of concern for us humans.

The Breakthrough Listen project may not settle this momentous question. But it gives us a small chance of doing so—and the stakes are so high that even that small chance is worth far more than zero.

A MOTIVATION FOR INTERSTELLAR TRAVEL

As I have emphasized earlier, interstellar travel is inherently of long duration, and is, therefore, in my view, an enterprise for post-humans, evolved from our species not via natural selection but by design. They could be silicon-based, or they could be organic creatures who had won the battle with death, or perfected the techniques of hibernation or suspended animation. Even those of us who do not buy the idea of a singularity by mid-century would expect a sustained, if not enhanced, rate of innovation in biotech, nanotech, and information science—leading to entities with superhuman intellect within a few centuries. The first voyagers to the stars will not be human, and maybe not even organic. They will be creatures whose life cycle is matched to the voyage: the aeons involved in traversing the Galaxy are not daunting to immortal beings.

Before setting out from Earth the voyagers would know what to expect at journey's end, and what destinations would be most promising. Such information will have come from studies using giant futuristic telescopes. Most importantly of all, they will know whether their destination is lifeless or inhabited, and robotic probes will have sought out already existing biospheres, or planets that could be terraformed to render them habitable.

It could happen, but would there be sufficient motive? Would even the most intrepid leave the Solar System? We cannot predict what inscrutable goals might drive post-humans. But the motive would surely be weaker if it turned out that biospheres were rare. The European explorers in earlier centuries who ventured across the Pacific were going into the unknown to a far greater extent than any future explorers would be (and facing more terrifying dangers): there were no precursor expeditions to make maps, as there surely would be for space ventures. Future space-farers would always be able to communicate with Earth (albeit with a time lag). If precursor probes have revealed that there are, indeed, wonders to explore, there will

be a compelling motive—just as Captain Cook was motivated by the biodiversity and beauty of the Pacific islands. But if there is nothing but sterility out there, the motive will be simply expansionist—in resources and energy. And that might be better left to robotic fabricators.

And it might be too anthropocentric to limit attention to Earthlike planets. Science-fiction writers have other ideas—balloon-like creatures floating in the dense atmospheres of Jupiter-like planets, swarms of intelligent insects, nanoscale robots, and so on. Perhaps life can flourish even on a planet flung into the frozen darkness of interstellar space, whose main warmth comes from internal radioactivity (the process that heats the Earth's core). And if advanced ET exists, it will most likely not be on a planet at all, but freely floating in interstellar space. Indeed, no life will survive on a planet whose central Sun-like star flares up when its hydrogen fuel is exhausted, and blows off its outer layers. Such considerations remind us of the transience of inhabited worlds (and life's imperative to escape their bonds eventually).

Maybe we will one day find ET. On the other hand, SETI searches may fail; Earth's intricate biosphere may be unique. But that would not render life a cosmic sideshow. Evolution is just beginning. Our Solar System is barely middle-aged and if humans avoid self-destruction, the post-human era beckons. Intelligent entities—descended from Earthly life—could spread through the entire Galaxy, evolving into a teeming complexity far beyond what we can even conceive. If so, our tiny planet—this pale blue dot floating in space—could be the most important place in the entire Galaxy, and the first interstellar voyagers from Earth would brave a mission that would resonate through the entire Galaxy and perhaps beyond.

"FAST-FORWARD" TO THE END OF TIME

In cosmological terms (or indeed in a Darwinian timeframe) a millennium is but an instant. So let us "fast-forward" not for a few centuries, nor even for a few millennia, but for an "astronomical" timescale millions of times longer than that. The "ecology" of stellar births and deaths in our Galaxy will proceed gradually more slowly, until jolted by the "environmental shock" of an impact with Andromeda, maybe four billion years hence. The debris of our Galaxy, Andromeda, and their smaller companions, which constitute the so-called Local Group, will thereafter aggregate into one amorphous galaxy.

As the universe expands the observable universe gets emptier and more lonely. Distant galaxies will not only move further away, but recede faster and faster until they disappear—rather as objects falling into a black hole encounter a horizon, beyond which they are lost from view and causal contact.

But the remnants of our Local Group could continue for far longer—time enough, perhaps, for all the atoms that were once in stars and gas to be transformed into structures as intricate as a living organism or a silicon chip but on a cosmic scale.

But even these speculations are in a sense conservative. I have assumed that the universe itself will expand, at a rate that no future entities have power to alter. And that everything is in principle understandable as a manifestation of the basic laws governing particles, space and time that have been disclosed by twenty-first-century science. Some speculative scientists envisage stellar-scale engineering to create black holes and wormholes—concepts far beyond any technological capability that we can envisage, but not in violation of these basic physical laws. But are there new "laws" awaiting discovery? And will the present "laws" be immutable, even to an intelligence able to draw on galactic-scale resources?

We are well aware that our knowledge of space and time is incomplete. Einstein's relativity and the quantum principle are the two pillars of twentieth-century physics, but a theory that unifies them is unfinished business for twenty-first-century physicists. Current ideas suggest that there are mysteries even in what might seem the simplest entity of all—"mere" empty space. Space may have a rich structure, but on scales a trillion trillion times smaller than an atom. According to the string theory, each "point" in our ordinary space, if viewed with this magnification, would be revealed as a tightly wound origami in several extra dimensions. Such a theory will perhaps tell us why empty space can exert the "push" that causes the cosmic expansion to accelerate; and whether that "push" will indeed continue forever or could be reversed. It will also allow us to model the very beginning—an epoch where densities are so extreme that quantum fluctuations can shake the entire universe—and learn whether our big bang was the only one.

The same fundamental laws apply throughout the entire domain we can survey with our telescopes. Atoms in the most distant observable galaxies seem, from spectral evidence, identical to atoms studied in laboratories on Earth. But what we have traditionally called "the universe"—the aftermath of "our" big bang—may be just one island, just one patch of space of time, in a perhaps infinite archipelago. There may have been an infinity of big

bangs, not just one. Each constituent of this "multiverse" cooled down differently, ending up governed by different laws. Just as Earth is a very special planet among zillions of others, so—on a far grander scale—our big bang was also a very special one. In this hugely expanded cosmic perspective, the laws of Einstein and the quantum could be mere parochial bylaws governing our cosmic patch. Space and time may have a structure as intricate as the fauna of a rich ecosystem, but on a scale far larger than the horizon of our observations. Our current concept of physical reality could be as constricted, in relation to the whole, as the perspective of the Earth available to a plankton whose "universe" is a spoonful of water.

And that is not all: there is a final disconcerting twist. Post-human intelligence (whether in organic form, or in autonomously evolving artifacts) will develop hyper-computers with the processing power to simulate living things—even entire worlds. Perhaps advanced beings could thereby surpass the best "special effects" in movies or computer games so vastly that they could simulate a universe fully as complex as the one we perceive ourselves to be in. Maybe these kinds of superintelligences already exist elsewhere in the multiverse— in universes that are older than ours, or better tuned for the evolution of intelligence. What would these superintelligences do with their hyper-computers? They could create virtual universes vastly outnumbering the "real" ones. So perhaps we are "artificial life" in a virtual universe. This concept opens up the possibility of a new kind of "virtual time travel," because the advanced beings creating the simulation can, in effect, rerun the past. It is not a time-loop in a traditional sense: it is a reconstruction of the past, allowing advanced beings to explore their history.

Possibilities once in the realms of science fiction have shifted into serious scientific debate. From the very first moments of the big bang to the mind-blowing possibilities for alien life, parallel universes, and beyond, scientists are led to worlds even weirder than most fiction writers envisage. We have intimations of deeper links between life, consciousness, and physical reality. It is remarkable that our brains, which have changed little since our ancestors roamed the African savannah, have allowed us to understand the counter-intuitive worlds of the quantum and the cosmos. But there is no reason to think that our comprehension is matched to an understanding of all key features of reality. Scientific frontiers are advancing fast, but we may at sometime "hit the buffers." Some of these insights may have to await post-human intelligence. There may be phenomena, crucial to life's long-term destiny, that we are not aware of, any more than a monkey comprehends the nature of stars and galaxies.

If our remote descendants reach the stars, they will surely far surpass us not only in lifespan, but in insight as well as technology.

"As soon as somebody demonstrates the art of flying, settlers from our species of man will not be lacking. [...] Given ships or sails adapted to the breezes of heaven, there will be those who will not shrink from even that vast expanse. Therefore, for the sake of those who, as it were, will presently be on hand to attempt this voyage, let us establish the astronomy, Galileo, you of Jupiter, and me of the moon."

JOHANNES KEPLER (1571–1630)
German astronomer and mathematician, in a letter to Galileo, April 19, 1610.

Pluto and Charon, the largest known satellite relative to its parent body. The image was captured by NASA's New Horizons space probe when passing over the dwarf planet Pluto in 2015.

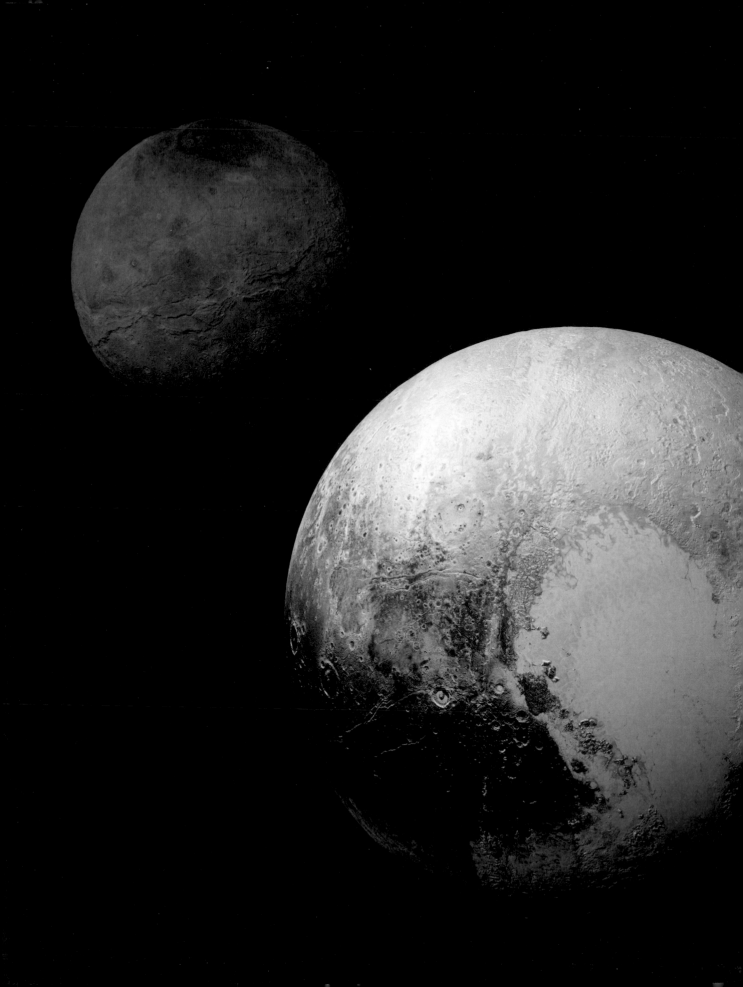

Publisher
BBVA

Project direction and
coordination
Chairman's Advisory, BBVA

Texts
Jay David Bolter
Maria Engberg
Luciano Floridi
James Giordano
Francisco González
Aubrey D. N. J. de Grey
Robin Hanson
S. Matthew Liao
Steven Monroe Lipkin
Ramón López de Mántaras
Seán Ó hÉigeartaigh
Helen Papagiannis
Joseph A. Paradiso
Martin Rees
Jonathan Rossiter
Stuart Russell
Huma Shah
Chris Skinner
Kevin Warwick
Darrell M. West

Edition and production
Turner

Publishing coordination
Nuria Martínez Deaño

Graphic design & layout
Gema Navarro
wearerifle.com
Pablo Suárez
underbau.com

Copyediting
Harriet Graham

Translation
Wade Matthews

Graphic documentation
María Luisa Fruns

Printing
Artes Gráficas Palermo

Binding
Ramos

ISBN: 978-84-16714-45-2
DL: M-39737-2016

Printed in Spain

2016

The Search for Europe: Contrasting Approaches

This book aims to analyze and generate discussion on the present and the future of Europe and its integration project. European integration is an issue that affects not only Europeans but everyone in the world. Europe, as a whole, is now the leading economic and trading power in the world and also represents the most ambitious project of economic and political integration in history. Consequently both its achievements and its failures can have effects globally.

2015

Reinventing the Company in the Digital Age

The digital era has unleashed a far reaching tsunami that many are still trying to understand and come to terms with. Almost on a daily basis the rules of the game for doing business are changing and we have to struggle to keep up with the fast moving, constantly changing landscape. This has had a colossal impact in the workplace, and nowhere more so than in the so-called traditional sectors: to succeed in this new era, big organizations that up to now have been profitable and leading examples in their areas of business for decades are confronted with the need for swift, radical change.

2014

Change: 19 Key Essays on How the Internet Is Changing Our Lives

As a tool available to a reasonably wide public, the Internet is only twenty years old, but it is already the fundamental catalyst of the broadest based and fastest technological revolution in history. It is the broadest-based because over the past two decades its effects have touched upon practically every citizen in the world. And it is the fastest because its mass adoption is swifter than that of any earlier technology. It is impossible today to imagine the world without the Internet: it enables us to do things which only a few years ago were unthinkable.

2013

There's a Future: Visions for a Better World

This book seeks to integrate the various elements in the dissemination of knowledge. How do they interact with each other? Where are they leading us? And, more importantly, what can be done to ensure that this path, with all its acknowledged risks, leads us to improve people's quality of life in a sustainable way? The future seems to be hurtling towards us at full tilt. For this very reason, if predicting the future is particularly difficult today, preparing for it is also vital and urgent.

2012

Values and Ethics for the 21st Century

The main topic of this book is ethics and values. That is because shared values and ethics are necessary and vital for the proper functioning of the economic, political and social network and, therefore, for the well-being and development of the potential of every world citizen. The intention of this book is to discuss how we can understand and avail ourselves of universal ethical principles in order to meet the great challenges that the 21st century has placed before us.

2011

Innovation. Perspectives for the 21st Century

The decisive importance of innovation is the most powerful tool for stimulating economic growth and improving human standards of living in the long term. This has been the case throughout history, but in these modern times, when science and technology are advancing at a mind-boggling speed, the possibilities for innovation are truly infinite. Moreover, the great challenges facing the human race today—inequality and poverty, education and health care, climate change and the environment—have made innovation more necessary than ever.

2010

The Multiple Faces of Globalization

The book presents a panorama of globalization, a very complex and controversial phenomenon that is characteristic of present-day society and decisively influential in the daily lives of all the world's citizens at the beginning of the 21st century. Thus, the finest researchers and creators worldwide have been sought out so that, with the greatest rigor and objectivity, and in a language and approach accessible to non-specialists, they can explain and inform us of the advances in knowledge and the subject of the debates that are permanently active on the frontiers of science.

2009

Frontiers of Knowledge

Prestigious researchers from all over the world, working on the "frontiers of knowledge", summarize the most essential aspects of what we know today, and what we aspire to know in the near future, in the fields of physics, biomedicine, information and telecommunications technologies, ecology and climate change, economics, industry and development, analyzing the role of science and the arts in our society and culture.

These books are available for reading on
www.bbvaopenmind.com/en/books